BLACKS AND BLACKNESS IN EUROPEAN ART OF THE
LONG NINETEENTH CENTURY

Compelling and troubling, colorful and dark, black figures served as the quintessential image of difference in nineteenth-century European art; the essays in this volume further the investigation of constructions of blackness during this period. This collection marks a phase in the scholarship on images of blacks that moves beyond undifferentiated binaries like "negative" and "positive" that fail to reveal complexities, contradictions, and ambiguities.

Essays that cover the late eighteenth through the early twentieth century explore the visuality of blackness in anti-slavery imagery, black women in Orientalist art, race and beauty in *fin-de-siècle* photography, the French brand of blackface minstrelsy, and a set of little known images of an African model by Edvard Munch. In spite of the difficulty of resurrecting black lives in nineteenth-century Europe, one essay chronicles the rare instance of an American artist of color in mid-nineteenth-century Europe. With analyses of works ranging from Géricault's *Raft of the Medusa*, to portraits of the American actor Ira Aldridge, this volume provides new interpretations of nineteenth-century representations of blacks.

Adrienne L. Childs, PhD is an independent scholar and curator. She is an associate of the W.E.B. Du Bois Research Institute at the Hutchins Center for African and African American Research at Harvard University. Her interests are in the relationship between race and representation in European and American art.

Susan H. Libby, PhD is professor of art history at Rollins College in Winter Park, Florida. Her research interests are the visual and material culture of French Caribbean slavery.

Blacks and Blackness in European Art of the Long Nineteenth Century

Edited by Adrienne L. Childs and Susan H. Libby

ASHGATE

Published by
Ashgate Publishing Limited
Wey Court East
Union Road
Farnham
Surrey, GU9 7PT
England

Ashgate Publishing Company
110 Cherry Street
Suite 3-1
Burlington, VT 05401-3818
USA

www.ashgate.com

British Library Cataloguing in Publication Data
A catalogue record for this book is available from the British Library.

The Library of Congress has cataloged the printed edition as follows:
Blacks and blackness in European art of the long nineteenth century / edited by Adrienne L. Childs and Susan H. Libby.
 pages cm
 Includes bibliographical references and index.
 ISBN 978-1-4094-2200-6 (hardcover : alk. paper)
 1. Blacks in art. 2. Art, European—19th century. I. Childs, Adrienne L., editor.
II. Libby, Susan Houghton, editor.

 N8232.B56 2014
 704.9'49305896—dc23

 2014020404

ISBN 9781409422006 (hbk)

Printed in the United Kingdom by Henry Ling Limited, at the Dorset Press, Dorchester, DT1 1HD

Contents

List of illustrations

© 2014 The Munch Museum / The Munch-Ellingsen Group / Artists Rights Society (ARS), NY

8.4 Edvard Munch, *Stage Design for "Ghosts,"* 1906. Tempera on unprimed canvas. Munch Museum, Oslo, MM M 984 (Woll M 699). © 2014 The Munch Museum / The Munch-Ellingsen Group / Artists Rights Society (ARS), NY

8.5 Edvard Munch, *Death of Marat*, 1907. Oil on canvas. Munch Museum, Oslo, MM M 351 (Woll M 767). © 2014 The Munch Museum / The Munch-Ellingsen Group / Artists Rights Society (ARS), NY

8.6 Edvard Munch, *African in a Green Coat*, 1916–17. Oil on canvas. Munch Museum, Oslo, MM M 92 (Woll M 1214). © 2014 The Munch Museum / The Munch-Ellingsen Group / Artists Rights Society (ARS), NY

8.7 Edvard Munch, *Self-Portrait in Hat and Coat*, c. 1915. Oil on canvas. 90 × 68 cm. Munch Museum, Oslo, MM M 601 (Woll M 1143). © 2014 The Munch Museum / The Munch-Ellingsen Group / Artists Rights Society (ARS), NY

9 Race and beauty in black and white: Robert Demachy and the aestheticization of blackness in Pictorialist photography

9.1 Robert Demachy, *Contrasts (A Study in Black and White)*, 1901/3. Gum-bichromate print. Division of

Culture and the Arts, National Museum of American History, Behring Center, Smithsonian Institution, Washington, DC

9.2 Robert Demachy, *Untitled*, 1901. Gum-bichromate print. Société française de Photographie. Reproduced in *Photograms of the Year*, 1903. Photo: private collection, Paris

9.3 Robert Demachy, *Blanc et noir*, page detail from *La Revue de Photographie*, 1904. Photo courtesy of Julien Faure-Conorton

9.4 Arthur Da Cunha, *Etude*, 1896. Carbon print. Photo courtesy of PhotoSeed

9.5 Gertrude Kasebier, *Black and White*, 1903. Gum-bichromate print. Digital Image © The Museum of Modern Art / Licensed by SCALA / Art Resource, NY

9.6 F. Holland Day, *Ebony and Ivory*, c. 1899. Photogravure (derived from original c. 1897 platinum print). Image courtesy of The National Gallery of Art, Washington, DC

9.7 Jean-Baptiste Carpeaux, *La négresse*, 1872. Cast terracotta. The Metropolitan Museum of Art, Gift of James S. Deely, 1997, in memory of Patricia Johnson Deely, 1997 (1997.491)

9.8 Man Ray, *Noire et blanche*, 1926. Silver gelatin print. © 2014 Man Ray Trust / Artists Rights Society (ARS), New York / ADAGP, Paris

Notes on contributors

ALBERT ALHADEFF, PHD is Associate Professor of Art History at the University of Colorado at Boulder. A scholar of nineteenth-century French art with a prolific publishing history, Alhadeff published the book *The Raft of the Medusa, Géricault, Art, and Race* in 2002 and has recently written about Julian Barnes's description of *The Raft* in *The French Review*.

ALISON W. CHANG, PHD is the Andrew W. Mellon Curatorial Fellow at the RISD Museum in Providence, Rhode Island. She has curated *Fifty Works for Rhode Island: The Dorothy and Herbert Vogel Collection*, *Historias: Latin American Works on Paper*, and *Circus*. Her 2010 dissertation for the University of Pennsylvania is titled "Negotiating Modernity: Edvard Munch's Late Figural Work, 1900–1925."

ADRIENNE L. CHILDS, PHD (co-editor) is an associate at the W.E.B. Du Bois Research Institute at the Hutchins Center, Harvard University. She is a contributor to volume 5 of *The Image of the Black in Western Art*. She is an independent curator and lecturer in the history of art. Her research interests are race and representation in European art, exoticism, decorative arts, and the art of African-Americans. She has published books on the prints of Margo Humphrey and David C. Driskell. Her current book project is *Ornamental Blackness: The Black Body in European Decorative Arts*.

WENDY A. GROSSMAN, PHD is a Curatorial Associate at The Phillips Collection and lecturer in art history at the New York University Global Program in Washington DC, and at the University of Maryland, College Park. Her expertise and publications cover the fields of the history of photography, early twentieth-century European and American Modernisms, the intersections between non-Western and Western art, Surrealism, and the artist Man Ray. Her book *Man Ray, African Art, and the Modernist Lens*, which accompanied her traveling exhibition of the same title, was awarded the 2010 Prix International du livre d'Art Tribal.

EARNESTINE JENKINS PHD is Associate Professor of Art History at the University of Memphis. Jenkins has published *African-Americans in Memphis: 70 years of Hooks Brothers Photography* and *A Kingly Craft: Art and Leadership in Ethiopia: A Social History of Art and Visual Culture in Pre-Modern Africa*. She is currently working on the book project *Race, Representation and Photography in Nineteenth-Century Memphis: From Emancipation to Jim Crow*.

PAUL H.D. KAPLAN PHD is Professor of Art History in the School of Humanities at SUNY Purchase. He has published widely on blacks in Renaissance Italian art. He was a Fellow at the W.E.B Du Bois Institute at Harvard in 2008 and 2012. Kaplan contributed a long essay on black Africans in Italian art 1500–1700 for volume 3 of *The Image of the Black in Western Art*. He also wrote a new introduction for the 2010 reissue of volume 2 on medieval art in the same series. Recent essays include "Bartolomeo Passarotti and 'Comic' Images of Black Africans in Early Modern Italian Art," in *No Laughing Matter: Visual Humor in Ideas of Race, Nationality and Ethnicity*, edited by David Bindman and Adrian Randolph (forthcoming).

SUSAN H. LIBBY PHD (co-editor) is Professor of Art History at Rollins College in Winter Park, FL. She has presented her work on anti-slavery imagery and Caribbean plantation scenes in the *Encyclopédie* at the 2010 and 2014 conferences of the American Society for Eighteenth-Century Studies. Other conference activities include chairing or co-chairing panels on race in eighteenth-and nineteenth-century popular culture and illustrated travel accounts at ASECS meetings. Her essay on Girodet's portrait of Jean-Baptiste Belley, former slave from Saint-Domingue, appeared in *Performing the Everyday: The Culture of Genre in the Eighteenth Century*, edited by Alden Cavanaugh. With Adrienne L. Childs, she is co-curator of an exhibition on the exotic black body in European art which will originate at the Cornell Fine Arts Museum at Rollins College before traveling to other venues. She is currently at work on a book-length project on the visual culture of French Caribbean slavery.

JAMES SMALLS PHD is Professor of Art History and Theory and Affiliate Professor of Gender and Women's Studies at University of Maryland, Baltimore County. Smalls has recently written a book on *The Homoerotic Photography of Carl Van Vechten* among other publications on the visualization of blacks and blackness in nineteenth-century Europe and the US. Recent essays include "Feral Benga's Body" in *Africa in Europe: Studies in Transnational Practice in the Long Twentieth Century*, edited by Eve Rosenhaft and Robbie Aitken. He is currently working on a book manuscript titled *Féral Benga: Modernism's African Muse*.

Acknowledgements

We are grateful for this opportunity to present material that has been important to our scholarship for so many years, and we are delighted by the participation of our esteemed contributors who share our passion for this topic. The scholarship presented in this volume began as a session at College Art Association in Los Angeles, California in 2009. We are happy to say that all of the presenters in that session are contributors to this volume. We invited Wendy A. Grossman to join the group in order to add photography to the modes of visual culture discussed. The timeliness, good cheer, and patience of the contributors made the process of compiling this volume a rewarding and stimulating experience.

Margaret Michniewicz, our editor at Ashgate, has been unfailingly supportive at every stage of this volume's production and we sincerely appreciate her belief in this project. We would also like to acknowledge Meredith Norwich who first commissioned this volume with Ashgate. We appreciate the insights of our anonymous readers and we feel the publication has improved because of their suggestions. We thank all of the institutions that have granted us permission to use their images. Every attempt has been made to obtain permission to reproduce copyright material. If any proper acknowledgement has not been made, copyright holders are invited to inform the volume editors of the oversight.

We would like to acknowledge Rollins College for funding for Susan Libby to travel to Paris for research. Denisa Metko and Kristen Arnett in the Inter-Library Loan department of Rollins's Olin Library were invaluable for Libby. Special thanks go to the Historians of Eighteenth-Century Art and Architecture (HECAA) Publication Subvention Grant. Adrienne Childs would like to acknowledge friends and colleagues Wendy A. Grossman, David Bindman, June Hargrove, and Renée Ater who have been encouraging and extremely helpful in the process of this project. Childs thanks the Image of the Black in Western Art archive and the W.E.B. Du Bois Research Institute, both at the Hutchins Center at Harvard University, for the continued support. Special thanks and gratitude go to our husbands, Ronald Childs and David Walsh. Lastly, we have been fortunate to be such an enthusiastic, understanding, and mutually respectful collaborative team. We could not have asked for a better partnership.

Introduction: figuring blackness in Europe

Adrienne L. Childs and Susan H. Libby

In the midst of a dark thunderstorm, a replica of the infamous French ship *La Méduse* pitches over violent waves in Yinka Shonibare's 2008 photograph *La Méduse* (Figure 1.1). Billowing sails fashioned from "African"-style batik fabrics propel the ship over the angry ocean. The composed photo features Shonibare's mixed media sculpture of the ill-fated vessel that wrecked off the coast of Senegal in 1816. Not unlike the ships that implemented the slave trade and facilitated colonial incursions into Africa from the seventeenth through the nineteenth centuries, *La Méduse* set sail to Senegal with a retinue of French administrators and colonists sent to reestablish French control in the region. Shonibare, a British/Nigerian contemporary artist, presents a multi-level engagement with the history behind both the incident and its most famous visual incarnation—Théodore Géricault's epic painting *The Raft of the Medusa* (1918) (Figure 3.1). Shonibare sets his sights on European colonialism vis-à-vis the grand narratives of nineteenth-century history painting. As Albert Alhadeff discusses in this volume, Gericault's *Raft* focuses on the human tragedy in which survivors, including black sailors, were set adrift at sea facing death and cannibalism. Shonibare, however, presents the intact vessel before the wreck as it struggles with nature's fury. His use of batik fabric sails evokes a certain African-ness that is undermined by the fact that the fabrics are actually Dutch exports, not African in origin. His use of Dutch fabrics as incongruous elements in historical reanimation is a leitmotif that characterizes his entire oeuvre. Shonibare's hyper-realist version of the vessel in tumultuous seas prefigures not only the shipwreck, but also the cataclysmic upheaval of the entire colonial project. Without depicting one African body, the artist suggests the horror of the slave trade, the dynamics of the European presence in Africa, and complexities of the African presence in European art.

Shonibare's contemporary take on the history of nineteenth-century art and its relationship to the racial dynamics of the black Atlantic brings into relief the ironies, mythologies, and complex relationships between Europe and Africa under the colonial system. Artists like Shonibare who seek to reframe ideas

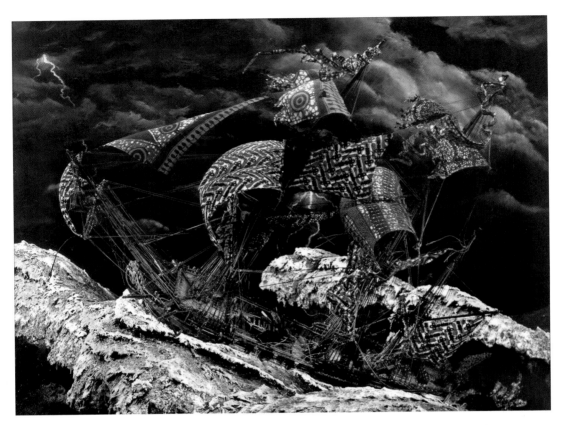

1.1 Yinka Shonibare, MBE, *La Méduse*, 2008. C-print mounted on aluminum. © Yinka Shonibare MBE. All Rights Reserved, DACS/ARS, NY 2014

of race and representation through a reconsideration of historic works of art have been particularly attracted to nineteenth-century European art because of the prevalence of black bodies and the variety of modes in which they were represented. Not the over-simplified and unabashedly racist caricatures often found in American visual culture of the same period, blacks in nineteenth-century European art were frequently depicted as exotic, beautiful, romantic, and alluring. They were likely to be pictured individualistically as opposed to rendered as types. Yet as compelling as these images might be, below the surface are often undercurrents of objectification, a celebration of servitude, and hierarchical attitudes about race and culture that result in a tension that David Bindman has called "a two-edged sword."[1] It is precisely the multifaceted, nuanced, and often vexed relationship between European artists and the black figure that the contributors to *Blacks and Blackness in European Art of the Long Nineteenth Century* seek to examine.

The black body was a fascinating source of visual inspiration for European artists over the long nineteenth century. From political print culture, academic history painting and portraiture, to Orientalist genre and ethnographic imagery, advertising, and photography, the black figure was a familiar sight in the nineteenth-century visual panoply. These representations were reminders of conquest, romanticized meditations on the exoticism and eroticism of

dark-skinned peoples and distant lands, caricatures, and objects of beauty that used blackness—at times literally—as an aesthetic tool or novelty. But seeing and understanding blacks in nineteenth-century Europe was not limited to the index of the image. Black people, although marginalized, were part of an increasingly international population in Europe. Even though the lived experiences of blacks in Europe during this period are difficult to reconstruct, black people were visible on the streets of major European cities. Black men and women from Africa, the Caribbean, and even North America worked in domestic service, as laborers and seamen, among other professions. Black musicians, dancers, artist's models and other entertainers were also commonplace. Their presence as free people of color in Europe was a sure sign of the nascent emergence of modern black identities, even in the face of colonial slavery and its legacies, empire, and an entrenched European sense of power and authority over all others.

Blacks and Blackness in European Art of the Long Nineteenth Century presents new scholarship in which the authors seek not only to decode and contextualize select images of unidentified black figures, but, when possible, to engage with the narratives of actual black lives that the images reflect. In addition to anonymous or invented black people configured in art as constructions of European notions of blackness, this volume features a variety of known black people: an artist, a Shakespearean actor, a circus performer, and some minstrels and models. They remind us that blacks were not simply tropes, but individuals whose historical presence is critical to understanding the images that portray them. What beliefs did this imagery reinforce, and what did it resist or challenge? On what combinations of empiricism and fantasy were these images modeled? What long-standing art-historical traditions do they embody and what new modes did they establish?

The black body caught in the sights of the nineteenth-century European eye became a star performer in the spectacle of modernity. We have focused on the nineteenth century precisely because this period offers such revealing glimpses into the formation of modernity as it plays out along the axis of race. Paul Gilroy has explicitly linked modernity to the historical conditions that brought black people into contact with Europeans, in particular the Atlantic slave trade:

Though largely ignored by recent debates over modernity and its discontents,
… ideas about nationality, ethnicity, authenticity, and cultural integrity are
characteristically modern phenomena that have profound implications for
cultural criticism and cultural history. They crystallized with the revolutionary
transformations of the West at the end of the eighteenth and the beginning of the
nineteenth centuries and involved novel typologies and modes of identification.[2]

Thus we begin at the close of the eighteenth century with the struggle to reconcile race, slavery, and liberty around the time of the 1789 French Revolution and proceed through the nineteenth century's trajectory toward colonization and imperialism. We consider such significant but overlooked

topics as the environment for the relatively new phenomenon of the artist of color in Europe, the impact of blackness as a performative spectacle in the widening sphere of public entertainment, and the role of blackness in the construct of the exotic. We conclude in the early twentieth century with black bodies as subjects at the crossroads of artistic and commercial modernism in photography and painting. This volume by no means offers an encyclopedic narrative of modernity and race in European visual art; instead, we look at the visuality of blackness, or the various ways in which the black figure becomes part of the visual register in the nineteenth century. The discourses weave in and out of this story at critical moments that reflect how the visualization of race is part of the very fabric of modern, imperial Europe.

Trajectories of slavery

From the early Arab slave trade that brought Africans into the Mediterranean and the Iberian peninsula to the epic ramifications of the Atlantic slave trade, slavery in its various incarnations was a major mover of black bodies in and around modern Europe through the middle of the nineteenth century. Whether originating from Africa, North or South America, or the Caribbean, European whites largely gained what knowledge they had about blacks through slavery and colonialism. Although there are notable exceptions, blacks were never far removed from the realities of slavery and servitude. In fact, Paul Gilroy has argued that slavery is the central, defining experience for the people of the African diaspora, and that modernity and postmodernity cannot be understood without recognizing the fact and effects of slavery.[3]

By the nineteenth century, the European engagement with Africans was defined by a complex matrix of forces that included not only slavery, abolition, paid servitude, and colonialism, but science, entertainment, and aestheticism. Personal encounters between blacks and Europeans, specifically relationships between artists and models, became more common in later decades of the nineteenth century. As the demand for exotic and ethnographic imagery grew in Europe, so did the presence of black models in European art centers such as Paris and London. Many who were brought to Europe from Africa or the Caribbean as slaves, servants, or ethnographic entertainment found their way into artists' studios. Artists such as Théodore Géricault, Jean-Léon Gérôme, Paul Cézanne, Charles-Henri Joseph Cordier, and Edouard Manet famously used black models, creating individualized likenesses in their painting and sculpture with striking verisimilitude particularly as compared to prior traditions.[4] In the absence of detailed accounts of the lives of black models in the nineteenth century, we can only imagine what their experiences would have been in the ateliers of some of the most important artists of their time. What we can glean from the imagery is that the artists came to the relationship armed with ideas of blackness that superseded the singular identities and histories of the individuals represented and, in spite of their

innovative approaches, more often than not, they reinforced and reinscribed shop-worn tropes of blackness. In this set of circumstances blackness could only be perceived by whites in opposition to notions of whiteness that placed whites as agents (economic, political, legal, intellectual, cultural) and blacks as objects of agency. Despite resistance or assimilation, there is virtually no situation in which Europeans and people of African descent came into contact with each other as true equals, an impossible situation when blacks were or could be property. Thus, it follows that representations of blacks as beautiful, desirable, or otherwise "benign" were inevitably bound up with the power relations inherent in the uneven circumstances under which whites were likely to encounter blacks or conceive of them; as Stuart Hall has observed, identities are "always constituted within, not outside representation."[5]

Further complicating the racial dynamics, a few artists of color, mainly from North America, began to appear in Europe in the nineteenth century, seeking training, patronage, and opportunities in flourishing art centers like London, Paris, and Rome—opportunities not available in America. Although their imagery was modeled on European visual traditions, the work of black or racially mixed artists offered new ways of thinking about identity and the humanity of the black artist. These chapters explore aspects of this varied landscape of representation, in which the image of the black figure is at once inflected by the legacy of slavery and subjugation, yet presented by a polyvocal cadre of artists with varied beliefs about race, divergent interests, and multiple aesthetic and ideological agendas.

Blacks and blackness

This collection addresses two related but distinct terms: blacks and blackness. By "blacks" we mean people of African descent, mostly sub-Saharan, and primarily encountered by nineteenth-century Europeans as part of the diasporas created by the slave trade, colonialism, and imperialism. "Blackness" is far more complicated. By this, we refer to the condition of being black as formulated by Europeans with interests at stake in notions of race. Toni Morrison's definition of "Africanism" is useful here: "the denotative and connotative blackness that African peoples have come to signify, as well as the entire range of views, assumptions, readings, and misreadings that accompany Eurocentric learning about these people."[6] For Europeans who believed their economies to depend on plantation slavery, blackness involved a pre-disposition to servitude; justifying the slave trade was most effective when blacks could be characterized as primitive creatures, and colonialism was best supported by conceptions of blacks as undisciplined and grateful for European intervention. Scientific study codified these beliefs, attributing to them an aura of irrefutable objectivity. Blackness, therefore, is the form given to content: black people in visual art may be depicted physically with apparent accuracy, but blackness is evident, for example, in relationships

of submission to whites, as evidenced in the numerous paintings from the Renaissance onward depicting aristocratic sitters, usually women, with black servants. More problematic are issues of intertextuality—or inter-visuality in this case. The contributions to this book show various ways in which blackness is a function of representation, and how blackness functions *in* representation, not just within the individual image but within a set of related discourses, visual and textual. Given that images of all kinds circulate in a wide and varied context of other images, texts, and events, one set of images can affect understanding of another. For example, the profile heads of black people in French abolitionist prints or salon paintings may portray African facial forms objectively and with no obvious racist agenda, but knowing that they existed alongside very similar illustrated profiles of black people in scientific tracts intended to prove the superiority of Europeans over other races helps us to understand how the former images might be understood, regardless of their intent.

Blacks in the history of art

While nineteenth-century images of blacks are of course characterized by conditions particular to that period, they also appear as part of a tradition in European art and culture that dates back to antiquity. Images of blacks represented not only shifting understandings of race, but specific art-historical trajectories.[7] In spite of distinct differences in the way that race, specifically blackness, was understood and fashioned over the course of Western history, representations of Africans survived epistemological shifts and consistently depicted blacks in terms of difference from Europeans. From the earliest sources in antiquity, racial differences were schematized into artistic and literary tropes that reflected and shaped the way Europeans understood Africans. Ancient writers described "monstrous" races that inhabited Ethiopia (the term often used for Africa in antiquity) and other remote locales. Those living in the mysterious lands of Africa were barbarians, outside of what the classical world considered as civilization.[8] In the early Christian Greco-Roman era, ideas about blacks and blackness shifted. Gay L. Byron contends that references to Egyptians/Egypt, Ethiopians/Ethiopia, and blacks/blackness in ancient Christian literature came to symbolize the extremes within early Christianity, the most remote manifestations of Christian identity.[9] On one hand, blacks symbolized immorality, sin, sexuality, and demonic behavior. On the other hand, biblical figures of the Ethiopian eunuch and Ethiopian Moses were revered as models of virtue.[10] By the early modern era when the European trade in African slaves began to escalate, images of blacks increasingly appeared in secular imagery. With the exceptions of the image of the black body as an allegorical personification of the continent of Africa, and the black Magus, the black servant/slave in portraiture was the most visible trope of blackness in early modern Europe.[11] Through the eighteenth century

this ubiquitous black servant encoded the power relations between blacks and whites and at the same time injected a sense of luxury and exoticism into European self-representation.

Science and Romanticism

Nineteenth-century Europe's fascination with images of black people participates in two seemingly divergent projects that characterize the complexities of race and representation during this era. Governed by an impulse towards documentation, science, and the positivist approaches that informed most areas of study, the art of the period provided apparently objective and irrefutable information about race and blackness in particular. Concurrently, fueled by romantic notions of the purity of savage cultures, Europeans often measured their own burgeoning modernity, manifest in increasingly industrialized urban landscapes and cultural systems, against what they perceived to be more natural, simple, primitive cultures, untainted by the complexities of modern life. Much of the imagery we investigate in this volume resides in the spaces between empiricism and imagination as they were conceived and visually expressed at the time.

 Although the modern conception of race as a function of physiognomy was introduced in the later seventeenth century, it was the eighteenth century that produced the notion of race as a scientific category.[12] Due to increased contacts and relationships with a growing variety of peoples and cultures overseas, eighteenth-century Europeans began to question and investigate the nature of human variances. The widespread attempt to understand human variety during the eighteenth century was also fueled by the need to establish the European at the height of a hierarchical continuum of peoples and cultures. Africans usually populated the lowest strata of these kinds of schemes. The widely disseminated and copiously illustrated accounts of the world's races by such prominent men of science as Johann Blumenbach, Paul Broca, Georges Leclerc, the Comte de Buffon, Petrus Camper, and Georges Cuvier, among others, provided apparently indisputable evidence of black inferiority on the continuum of savage to civilized. In the nineteenth century, Charles Darwin's groundbreaking publications, *Origin of Species* (1859) and *The Descent of Man* (1871), codified and substantiated the boundaries between the civilized and uncivilized world. Although these texts were not overtly racist by the standards of their time, the increasingly virulent attitudes toward race that culminated in the twentieth century were justified more by loose interpretations of the naturalist's work than by claims made explicitly by him. However, Darwin's acceptance of the binary of "civilized" and "uncivilized," not to mention his theories that humans evolve from primitive to civilized states, and that contemporary Africans could, among others, could provide glimpses into the distant human past, did much to lend a disinterested, scientific credibility to notions of racial hierarchy. Although the presence of these supposedly less

sophisticated cultures only reinforced the unquestioned superiority of the West in all arenas, Europeans shared a sense of romantic adoration for what they saw as innocent, primitive races. Hence, the physiognomies, costumes, and cultures of non-Europeans became popular subjects in nineteenth-century European art and visual culture, both as projections of desires for less complicated lives and as contrasts to advancing modernity.

Increased travel for exploration and tourism affected European modes of representing blacks and blackness, giving rise to bodies of images tied equally to science and notions of exoticism. Journeys of scientific exploration often resulted in the publication of illustrated travel journals and documentary volumes that described distant peoples, cultures, landscapes, and architecture in vivid detail. Vivant Denon's *Description de l'Egypte*, with its meticulous, elegant illustrations, set a new standard for the authority of images to define "otherness," both ancient and modern, for European audiences.[13] British topographical artist David Roberts produced volumes of lithographs entitled *Egypt and Nubia* that brought images of black Africans in Egypt to a wide Victorian public. In these large, richly illustrated editions, blacks and other exotic types could be viewed as parts of the scenery, just as they were in earlier travel accounts. In this respect, they stand as the continuation of a tradition of sensational accounts of rarely seen human curiosities. However, the greater empiricism typical of modern observation and styles of visual representation, along with claims to scientific objectivity lent these nineteenth-century books a degree of credibility lacking in ancient and early modern travel accounts. Artists, writers, scholars, and others regularly utilized such sources as guides for understanding and representing non-Europeans. Early in the nineteenth century these types of publications ignited the mania for the exotic, particularly Egypt. Demand for popular ethnography increased throughout the century, fueling the bourgeois taste for exotic subjects in art and literature, ethnographic entertainment, and popular travel journals that disseminated images of the darker races throughout nineteenth-century Europe.

Photography played an enormous role in the proliferation and dissemination of images of blacks in the nineteenth century. As the development of photography was a nineteenth-century phenomenon, the image of the black in photographic history grew along with the medium. All fields of visual representation were impacted by photography, including scientific documentation, travel imagery, academic art, and the diffusion of imagery through the popular media. With the advent of what was held to be an objective, neutral medium, the veracity of travel imagery seemed incontestable. For example, Maxime Ducamp's photographs of Egypt and the Near East, taken during his trip with Gustave Flaubert, as well as Francis Frith's photographs of the same regions, lent credence to earlier hand-illustrated documents such as those of Denon and Roberts. As photographs became important source materials for painters and sculptors, and photographers aspired to affirm the artistic value of their trade, black bodies were included in this emerging practice.

Painting, however, offered something photography could not: color. Eugène Delacroix made his mark in the French art world with his lavish use of color and expressive brushwork, deployed in the service of capturing the exotic people and locales he encountered in Algeria and Morocco. Writing in 1832, Delacroix claimed that in North Africa he had found the new Rome: "Beauty lies everywhere about one. I have Romans and Greeks on my doorstep … Rome is no longer to be found in Rome."[14] North Africa, the Holy Land and the Middle East indeed supplanted Rome as the ultimate destination for the education of the worldly European artist/traveler in search of fresh beauty and a noble, simpler past. In the wake of the Napoleonic incursion into North Africa and the colonization of Algeria by France in 1830, increasing numbers of French artists visited these lands in search of inspiration from the culture, color, and extraordinary sunlight. As a result of travel to these areas, representations of various "oriental" and exotic races abounded in Europe resulting in the phenomenon we now call Orientalism. Images of exotic blacks exponentially increased throughout Europe with the phenomenal popularity of nineteenth-century Orientalism. When exoticism and blackness, with their attendant powers of signification, are grafted on to one another the result is greater than the sum of its parts. In the nineteenth century, lust for the exotic black figure functions as a linchpin in the construct of the alluring Orient by marking the space as raced. Perhaps more than any other trend, the interest in a romanticized and fantastic Orient propelled the image of the black body to center stage in nineteenth-century art and visual culture. Gérôme's meticulous and dazzlingly chromatic academic renditions of the exotic East, coupled with his dramatic treatments of black and white skin, fed a European appetite for an ethnographic fantasy that was grounded in dramatic racial binaries nominally disguised as oriental genre. Linda Nochlin's groundbreaking essay, "The Imaginary Orient," however, showed how the "reality effect" of this imagery was no indicator of objectivity or accuracy, but rather, to use Edward Said's metaphor, a stage on which Europeans could act out their fantasies.[15]

Historiography

The first major attempt at a comprehensive investigation of the iconography of blacks in Western art was the landmark publication series by the Menil Foundation, *The Image of the Black in Western Art*, first published in 1974. This was Dominique de Menil's contribution to the civil rights movement and conceived as a counterforce against the toxic racial environment in the US. It was also part of a proliferation of American scholarship during the 1960s and 1970s on the history of African-Americans, Africa, and the black diaspora that emerged from activist efforts to bring blackness out of the margins of American historical memory and to redress exclusionary practices in the academy. The Menil Foundation's multi-volume series initiated a surge in interest in

the iconography of blacks in Western art and spawned a phase of scholarship that sought to document and contextualize images and objects featuring blacks. This volume is deeply indebted to Hugh Honour's sweeping coverage of the nineteenth century in volume 4 of the *Image of the Black in Western Art*. Honour produced a major contribution to the history of nineteenth-century art in what David Bindman praised as possessing "sympathetic insight, breadth of learning, and intellectual rigor."[16] After the project lost momentum in 1996 with the death of Dominique de Menil, it was revived in 2004 by the W.E.B. Du Bois Institute at Harvard University and Harvard University Press. Beginning in 2010 the press released new editions of the original five volumes with full color reproductions. Under the guidance of editors David Bindman and Henry Louis Gates Jr., the press has also published three new volumes to complete the project as it was originally conceived—to cover Western visual arts from antiquity through the nineteenth century. Paul H.D. Kaplan, a contributor to this volume, authored two essays for the revival of this historic book series, one in volume 3 and one in volume 4.[17] Adrienne L. Childs, co-editor of this volume, contributed an essay to volume 5, an extension of the original project that focuses on the rise of the black artist in the twentieth century. The idealism of the Menil Foundation's desire to redress racial ills in the West through the study of historic images has inspired some of the most significant scholarship of the last quarter century. Theories of race and representation that germinated in these publications have pushed the boundaries of art history to consider the primacy of the marginalized. The present volume has been nourished and energized by the inheritance of the *Image of the Black in Western Art* project.

Two 1990 publications made significant contributions to this field of inquiry, particularly regarding black images in American art. *Facing History: The Black Image in American Art, 1710–1940* by Guy McElroy was published in association with an exhibition of the same name at the Corcoran Gallery of Art. The text brought to life the function of painting and sculpture in the processes of oppression, both subtle and overt, in American culture. Albert Boime's 1990 text *The Art of Exclusion: Representing Blacks in the Nineteenth Century* combined a breadth of imagery with a socio-political point of view positioning the image of the black as operative in the power structures of racism, slavery, and colonialism. Jan Nederveen Pieterse took on the issue of blacks in popular imagery. His book *White on Black: Images of Africa and Blacks in Western Popular Culture*, like *The Image of the Black in Western Art*, attempted a study of the topic from the sixteenth century through the twentieth century. His sources were primarily prints, book illustrations, and advertisements; the populist nature of the imagery, from cartoons to postcards, reveals the ubiquitous character of distorted, prejudicial racial imagery and serves to underscore similar constructs in more traditional art forms.

An increased interest in feminist theory and critical race theory in the 1980s and 1990s spawned a generation of scholars who dealt with the intersection of European culture and ideologies of blackness. Specifically regarding the nineteenth century, Jennifer DeVere Brody's 1998 *Impossible Purities:*

Blackness, Femininity, and Victorian Culture tackles such issues as sexuality, miscegenation, and minstrelsy in Victorian literature, as does Roxann Wheeler's *The Complexion of Race* (2000). T. Denean Sharpley-Whiting examines the sexualized black female in French literature and culture from the Hottentot Venus to Josephine Baker in *Black Venus: Sexualized Savages, Primal Fears, and Primitive Narratives in French* (1999). Sander Gilman's pioneering *Difference and Pathology: Stereotypes of Sexuality, Race, and Madness* (1985) brought important insights into the linkages between European conceptions of deviance and the pathological, demonstrating how nineteenth-century European scientific ideas of blackness converged with medical theories of female sexuality to find expression in art and literature as the "diseases" of blackness and femaleness, both characterized by uncontrolled sexuality.

More recently, scholars across disciplines have begun to examine this area of art history through approaches inspired by postcolonial theory. A reexamination of visual representations of blacks in terms of gender and sexuality, exoticism, scientific racism, and hybridity situate images and objects as tropes in wider discourses often fraught with power relations. David Bindman's influential *Ape to Apollo: Aesthetics and the Idea of Race in the Eighteenth Century* charts the intersections of race and aesthetics and the forms of racism that develop in the wake of scientific assertions of hierarchies of human races. Cited by many of the authors in this volume, Bindman's work has been invaluable to the field of art history as it has clarified and documented the relationship between art and long-asserted notions of racial inferiority and superiority. Darcy Grimaldo Grigsby's 2002 *Extremities: Painting Empire in Post-Revolutionary France* addresses several paintings by Anne-Louis Girodet-Trioson, Théodore Géricault, Antoine-Jean Gros, and Eugène Delacroix as case studies for an examination of how politically conscious painting by ambitious artists could speak to the deep anxieties of a country facing the demise of revolution and the emergence of an imperial dictatorship. Grigsby contends that these anxieties—and the paintings that attempt to negotiate them—are deeply rooted in issues of race, however obliquely addressed. *Extremities* contributes to this area of study a model for understanding representations of race as unfixed and unstable, thus difficult to locate firmly, but which gain all the more power from repression and denial. In a similar vein, *Slavery, Sugar, and the Culture of Refinement: Picturing the British West Indies 1700–1840* (2008) by Kay Dian Kriz examines a wide range of imagery for insights into British conceptions of race, specifically blackness and whiteness. Like Grigsby, Kriz seeks to demonstrate how images can index race, while not necessarily describing it. Charmaine A. Nelson engages the intersection of gender and race in her publication *Representing the Black Female Subject in Western Art*. She employs a black feminist methodology to examine images of black women in Canadian, American, and European representations, offering a keen critical commentary that bridges race and gender studies. Most recently, Agnes Lugo-Ortiz and Angela Rosenthal edited *Slave Portraiture in the Atlantic World*, a major contribution to this literature that features a variety of essays focusing

on the slave as a subject of European portraiture. They question the notion of portraiture when it applies to the black and enslaved that are denied the subjectivity required of traditional portraiture.

Exhibitions

European institutions have begun to pay critical attention to the history of blacks in their societies and they are mining the vast numbers of objects that represent blacks in their collections. Several important exhibitions and related publications have emerged from this trend. The 2007 bicentennial of the abolition of the slave trade by the British Parliament inspired a new wave of scholarly inquiry into the image of blacks in British art and visual culture, as well as the history of British slavery in general. *Black Victorians: Black People in British Art, 1800–1900*, edited by Jan Marsh and published in 2005, includes critical essays surrounding representations of blacks in the Victorian era that touch upon popular imagery, travel illustration, painting, sculpture, and photography. The exhibition, organized by the Manchester Art Gallery and the Birmingham Museums and Art Gallery, uncovered and analyzed little-known images of blacks in Britain as well as images and objects from France and America that resonated in Victorian visual culture. In 2007 the National Maritime Museum in London mounted the exhibition *Representing Slavery: Art, Artefacts and Archives in the Collections of the National Maritime Museum*. The accompanying catalog, edited by Douglas Hamilton and Robert J. Blyth, brings to light a wide array of objects and images that reveal the "appalling dynamics" of the slave system. The catalog features essays on the material and visual culture of slavery and abolition that seek to marry the considerable scholarship on British slavery and abolition with lesser-known objects such as maps, decorative arts, coins, slave artefacts, paintings, prints, and jewelry. In 2008 Die Nieuwe Kerk museum in Amsterdam organized *Black is Beautiful: Rubens to Dumas*, an ambitious exhibition that surveyed images of blacks by artists from the Netherlands from the Middle Ages to the present. Departing from the American and British models that aimed to expose the problematic tropes of blackness, this exhibition and accompanying scholarship focused on the beauty that Dutch artists found in blacks and consciously avoided discussion of extreme stereotypes. Although the point of view is circumscribed, the number and quality of the images that the curators unearthed are a major contribution to the understanding of race and representation in Europe.

A special issue of the journal *Visual Resources* titled "Imaging Blacks in the Long Nineteenth-Century" continued the dialogue on the specific issues of blackness in the nineteenth century by looking at American, British, and French examples. Edited by Maria P. Gindhart, the essays in the issue investigated the constructed nature of race as it was fashioned across national borders in the nineteenth century, and revealed how the representation of blackness directly impacted the construct of whiteness.

The chapters

The contributions to this volume are case studies of the encounter, imagined and real, between the European artist and the black body. We are especially pleased to offer approaches that are part of a new phase in the scholarship on images of blacks that moves beyond the mapping of generalized binaries that fail to reveal nuances, toward a focus on particularized treatments of the images and objects in terms of their relationship to the meta-discourses of racialized imagery as well as the immediate circumstances of their production and art-historical milieu. Together the studies investigate select works, both canonical and lesser-known, that are emblematic of the era's confluence of race and representation. Presenting a diverse array of scholarly approaches and topics, they demonstrate the complexities inherent in representing race in visual material for which the description of "racist" simply does not suffice. Building on decades of pioneering research that legitimized the study of images of black people, the contributors employ critical approaches that interrogate notions of race and blackness, and they examine images of blacks that could at once confirm European racist assumptions and question them. This approach brings them into a dialogue with more recent scholarship, mentioned above, that acknowledges the instability of race as a concept as well as the significance of illuminating modes of resistance to racial stereotyping.

Because of the difficulty of resurrecting black lives in nineteenth-century Europe, it has been virtually impossible to link images of blacks to their specific models or subjects on a large scale, but four of the chapters in this volume address the presence of actual individuals and help to chronicle how their lived experiences impacted European art. We can therefore measure more accurately the extent to which tropes of blackness affected representations of real people. We can also attempt to discern how in some cases these individuals represented themselves in terms of preconceived notions of blackness. Blackness then was not a fixed idea or imposed category, but something that was at times negotiated and traded among those who assumed it and those who consumed it.

Susan H. Libby's chapter, "The color of Frenchness: racial identity and visuality in French anti-slavery imagery, 1788–94," examines the visual rhetoric and racial iconography of French anti-slavery imagery in the years leading up to and during the French Revolution and its linkages to European conceptions of blackness. Libby argues that in this variety of images, blackness, otherwise reviled by many Europeans, functions as a necessary precondition for liberty. Mostly book illustrations or single-leaf prints, these images deploy racial difference and blackness in particular as a means of defining French virtue, sensibility, and national identity during rapidly changing political conditions in the Caribbean colonies and on the mainland. Libby shows how depictions of the kneeling slave pleading for liberty exploit European notions of black inferiority to elicit the viewer's sympathy, whereas a series of profile portrait-style prints of slaves announcing their freedom after the 1794 abolition rely

on an intervisual play of racial difference that situates the slaves as "mimic men" (and women) whose blackness reifies the French "invention" of liberty. Another set of images, often interpreted as anti-slavery, in fact address the struggle of free people of color in the colonies to gain equal rights with white colonists. In this case, tropes of blackness serve to represent a transition to whiteness, equated with French citizenship.

Albert Alhadeff's chapter introduces the role of science, specifically craniology, in establishing "facts" about race and the inferiority of blacks to whites. By the beginning of the nineteenth century, scientists studying humans were unanimous in presenting evidence that the world's races were unequal in their intelligence, capacity for civilization, or beauty (these three conditions were often explicitly linked). Alhadeff examines the implications and complications of the science of race and aesthetics as they play out in French painter Géricault's magisterial *Raft of the Medusa* (Salon 1819). This study attempts to lay bare the artist's entanglement with race. Foregrounding the racist implications of the new science of craniology as founded by the Dutch anatomist and physiologist Petrus Camper, this chapter traces Géricault's unexpected formulations of Camper's "facial line" or *"ligne faciale."* Africans, according to Camper's influential posthumous publications, were characterized by a uniquely narrow and constricted skull configuration, one starkly at odds with the expansive craniums of whites. Géricault appears initially to have agreed with the racial demagoguery that finds its voice in the beseeching black figure flanked by Corréard and Savigny on the raft, where the black man's cranial measurements certify his links with the "lower races." However, a closer look at the preparatory sketches shows how the painter changed his mind; Alhadeff traces Géricault's evolving racial awareness, one that reveals the painter's struggles to overcome racial stereotypes as he first condones and then belies Camper's *ligne faciale*.

Before the black painter from Philadelphia, Henry O. Tanner, took up residence in Paris, and before the African-American sculptress Edmonia Lewis moved to Rome, Eugène Warburg, a promising young mulatto sculptor from New Orleans, attempted to forge a career as an artist in Europe. Warburg's fascinating experiences have been recovered by Paul H.D. Kaplan in "'A mulatto sculptor from New Orleans': Eugène Warburg in Europe 1853–59." Kaplan's discussion of this mixed-race American sculptor with abolitionist patronage affords us the opportunity to consider the rare instance of a person of African ancestry with the agency to represent blackness in Europe during this period in which black bodies were overwhelmingly the object of representation. Given our current conceptions of the black artist, black identity, and the kind of political consciousness embedded in the artistic process, we might be tempted to overstate Warburg's interventions as disrupting racism. While this may in fact be true, it is difficult to prove. Instead, Kaplan presents a measured analysis of the artist's few existing works and imagines what the possible influences were, and the circumstances specific to being a multiracial, transatlantic artist in the middle of the nineteenth century who was supported

by abolitionist patrons. Kaplan's study is a major contribution to the history of African-Americans in the visual arts as it begins to flesh out the presence of artists of color in what was a booming international exchange before the abolition of slavery in the US.

Transnational dialogues are similarly addressed in a portrait of the African-American Shakespearean actor Ira Aldridge by British portraitist James Northcote. In the chapter "Ira Aldridge as Othello in James Northcote's Manchester portrait" Earnestine Jenkins explores race, fame, and the "trope" of Othello as they are embedded in the Victorian portrait. Ira Aldridge is a crossroads figure, whose career as the first important Shakespearean actor of color transcends the disciplines of theater, history, literature, and art. The visual impact of a black American on the nineteenth-century Shakespearean stage was significant. His appearances as Othello influenced racial perceptions of Shakespeare's "Dark Prince." Aldridge was one of the first black actors to play Othello, who had traditionally been performed by whites in blackface. Although he was able to break the color barrier in that respect, he was still not allowed to perform on the London stage, so that most of his performances took place in British provincial theaters. However, it was in part due to this marginalization that he perfected his craft and made his Othello performances known throughout Europe. Furthermore, by performing in the anti-slavery centers of Manchester and Hull (the latter the birthplace of abolitionist William Wilberforce), he was able to influence public views about black people and slavery by playing white roles and by speaking to his audiences about slavery. In terms of visual representation, Jenkins suggests that Northcote's sensitive, subdued depiction of Aldridge affected conceptions of Othello, attributing to him a greater depth and complexity than previously allowed the raging, jealous Moor. Jenkins engages art and visual studies in her analysis of Northcote's portrait and contends that it represents both Aldridge *and* Othello, two racially charged, yet different subjects. The author employs a comparative approach, examining the influence of patronage, shifting racial environments, and the use of diverse artistic styles to unpack the portrait. Jenkins examines how Aldridge's success and fame allowed for activism on behalf of black people and how in turn Northcote's portrait, by merging the black actor and the black character, challenged popular notions of blackness.

The black female body in the imagined Orient is the subject of Adrienne L. Childs' analysis "'Exceeding blackness': African women in the art of Jean-Léon Gérôme." Childs considers the implications of the black female body that not only reifies historical tropes of blackness and exoticism in Orientalist representation, but operates in dialogical relationship to the white sexualized "Oriental" woman whom she inevitably accompanies. At the hands of Gérôme, arguably the most important academic Orientalist artist of the nineteenth century, the black woman is both a highly visible exotic body, saturated with blackness and foreign-ness, and incomprehensible except in her relation to the white sexualized female body. Her presence in countless tableaux by Gérôme and is a telltale sign of the Orient, an index of the exotic feminine sphere,

a sphere that is defined in part by blackness. Childs explores the contemporary rhetoric that focused on the various binaries between the dark servant and the white mistress, a construct that seemed to have broad appeal to audiences and critics. This study considers the multivalent implications of a figure who is female, slave, African, *and* exotic.

The colonialist underpinnings of encounters with race toward the end of the century, with their contradictions and inconsistencies, are addressed in James Smalls' study of black minstrelsy in France and what he terms "the visual shenanigans of race." Smalls considers the visual and conceptual/theoretical machinations for the simultaneous display and obfuscation of blackness as one of many means to define a French modern identity. The focus is on selected visualized racial "shenanigans"—specifically, the ideas generated from the transplantation of American blackface minstrelsy into France and its reception in the late nineteenth century. Through such imagery, closely associated with mass entertainment and French popular culture, the ambiguous performativity and mimetic instrumentality of blackness was exploited as alien and yet familiar identities against which the French chose to define themselves culturally. Smalls shows how the vogue for minstrelsy in *fin-de-siècle* Paris connects with its visual representation to form a kind of "commodity racism," in which blackness is played (literally) for white, urban consumption. As Smalls states, his analysis interrogates the kinds of symbolic work that images of racial performance and performativity can do in the modern French context.

The tensions and ambivalences rooted in the black and white binary inflecting the representation of black bodies in painting and sculpture pose a similar problematic in photography. Wendy Grossman's chapter "Race and beauty in black and white: Robert Demachy and the aestheticization of blackness in Pictorialist photography" enters the discussion at the turn of the twentieth century as the Pictorialist movement aspired to elevate photography to high art status by engaging the themes and aesthetic modes of painting. Grossman investigates issues of the uses of black and white, fundamental to photography as a form of image making, as they get embedded in racial and aesthetic discourses in the photograph *Contrasts* by Robert Demachy. The photograph features a young woman of color and a classical bust in a literal and figural tête-à-tête. Although *Contrasts* was produced in 1901 and disseminated through the first decade of the twentieth century, Grossman demonstrates that it is indebted to nineteenth-century tropes of the blackness that revel in the oppositionality of civilization and primitiveness, European-ness and African-ness, white and black. Yet the mixed-race, gender-ambiguous figure belies these binaries as she is by no means cast as the dark foil to the classical bust, but presents a complex conceptualization of beauty and artistry.

Edvard Munch's ambivalent approach to primitivism, modernism, and nineteenth-century notions of exoticism are explored by Alison Chang in "Staging ethnicity: Edvard Munch's images of Sultan Abdul Karim." In 1916, Munch, best known for his angst-ridden images of the 1890s, hired

an African circus performer named "Sultan" Abdul Karim to model for him. Munch executed approximately seven canvases featuring Karim. The largest composition is *Cleopatra and the Slave,* a painting which shows a clothed Western woman lounging on a bed while a nude African man stands beside her, situating Karim as the primitive attendant in an Orientalist-inspired work. Chang juxtaposes this portrayal of Karim with other portraits of the model dressed in modern Western clothing. In these canvases, Karim is stripped of any associations of primitivism related or imaged to be related to his ethnicity: instead, Munch portrays his model as a contemporary Western man. Munch saw Karim as more than representing the exotic "other," and created various combinations of the same image, complicating contemporary stereotypes about Africans. Given that Munch and his Nordic contemporaries would very likely only have encountered black people in circuses or zoos that included displays of humans, the painter's depictions of Karim are remarkably restrained, yet his very presence in Munch's milieu is predicated on his role as a performer. We know him only through his stage name as "Sultan" Abdul Karim, grounding him in a kind of performance of exoticism.

As Karim lends his body to the experiments of modernism, with its daring stylistic departures from tradition and its assertions of subjectivity and individuality coupled with the performativity of blackness, we find ourselves still contending with ambivalence and tension at the prospect of representing race. Despite their variety, the contributions to this volume all situate the black body as a site of conflict, where Europeans could negotiate, rationalize, interrogate, and disguise clashing European notions of beauty and ugliness, slavery and liberty, the familiar and the remote, tradition and innovation— and, of course, black and white.

Notes

1 David Bindman and Henry Louis Gates Jr., "Preface to *The Image of the Black in Western Art,*" in *The Image of the Black in Western Art*, vol. 4, *From the American Revolution to World War*, part 1, *Slaves and Liberators*, ed. David Bindman and Henry Louis Gates Jr. (Cambridge, MA: Belknap Press of Harvard University Press, 2012), ix.

2 Paul Gilroy, *The Black Atlantic: Modernity and Double Consciousness* (Cambridge, MA: Harvard University Press, 1993), 2.

3 Ibid.

4 The differences can be noted in comparing the generic treatment of the servants in William Hogarth's *Marriage à la Mode* series, c. 1743, to the exacting manner in which Gérôme, Cordier, and others later fashioned blacks in individualized modes, while retaining their status as types without singular identities.

5 Stuart Hall, "Cultural Identity and Diaspora," in *Diaspora and Visual Culture: Representing Africans and Jews*, ed. Nicholas Mirzoeff (London and New York: Routledge, 2000), 21.

6 Toni Morrison, *Playing in the Dark: Whiteness and the Literary Imagination* (Cambridge, MA: Harvard University Press, 1992), 6.

7 Ivan Hannaford asserted that the first stage in the development of an idea of race was from 1684 to 1815, encompassing the entire eighteenth century. Ivan Hannaford, *Race: The History of an Idea in the West* (Baltimore: Johns Hopkins University Press, 1996). See also Roxann Wheeler, *The Complexion of Race: Categories of Difference in Eighteenth-Century British Culture* (Philadelphia: University of Pennsylvania Press, 2000); Michael Banton, *Racial Theories* (Cambridge: Cambridge University Press, 1998); and David Bindman, *Ape to Apollo* (Ithaca, NY: Cornell University Press, 2002).

8 A. Buluda Itandala, "European Images of Africa from Early Times to the Eighteenth Century," in *Images of Africa: Stereotypes and Realities*, ed. Daniel M. Mengara (Trenton, NJ: Africa World Press, 2001), 63.

9 Gay L. Byron, *Symbolic Blackness and Ethnic Difference in Early Christian Literature* (London: Routledge, 2002), 1.

10 Ibid., 45.

11 Paul Kaplan points out that Titian's portrait of Laura Dianti is the first instance of a black page in portraiture. Paul H.D. Kaplan, "Titian's "Laura Dianti" and the Origins of the Motif of the Black Page in Portraiture," *Antichità viva* 4 (1982). See also Peter Erickson, "Invisibility Speaks: Servants and Portraits in Early Modern Visual Culture," *Journal for Early Modern Cultural Studies* 9, no. 1 (2009); and Paul Kaplan, "Ruler, Saint and Servant: Blacks in European Art to 1520" (PhD diss., Boston University, 1976).

12 See Pierre Boulle, *Race et esclavage dans la France de l'Ancien Régime* (Paris: Editions Perrin, 2007), 47–58, for a discussion of the shift from a conception of "race" as pertaining to family or dynasty to the more modern conception of ethnicity. Also valuable is Paul C. Taylor, *Race: A Philosophical Introduction* (Cambridge: Polity Press, 2004).

13 This massive project to record the monuments, flora, fauna, and people of Egypt first appeared in 1808 in 23 volumes, 13 of them illustrated.

14 Todd Porterfield, *The Allure of Empire: Art in the Service of French Imperialism 1798–1836* (Princeton: Princeton University Press, 1998), 136. Letter to Auguste Jal, June 4, 1832, in *Correspondance générale d'Eugene Delacroix*, ed. Andre Jouin, 3 vols. (Paris: Plon, 1936), vol. 1: 329–30.

15 Edward Said, *Orientalism* (New York: Vintage Books, 1979), 63.

16 Bindman and Gates, "Preface," 1.

17 Kaplan was one of the few new contributors to Honour's nineteenth-century volume.

1 Anonymous, "Les mortels sont égaux," 1791 or 1794. Engraving. Bibliothèque nationale de France

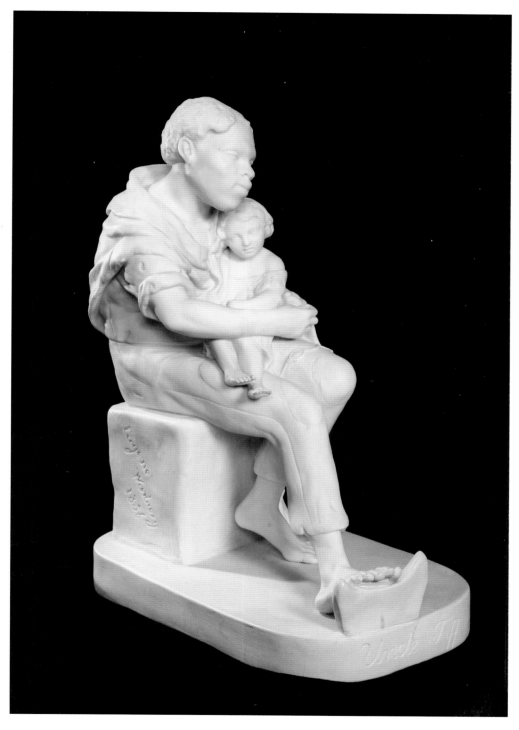

3 Eugène Warburg, *Uncle Tiff*, 1856. Parian. New Orleans, private collection. Photo: Ray Palmer

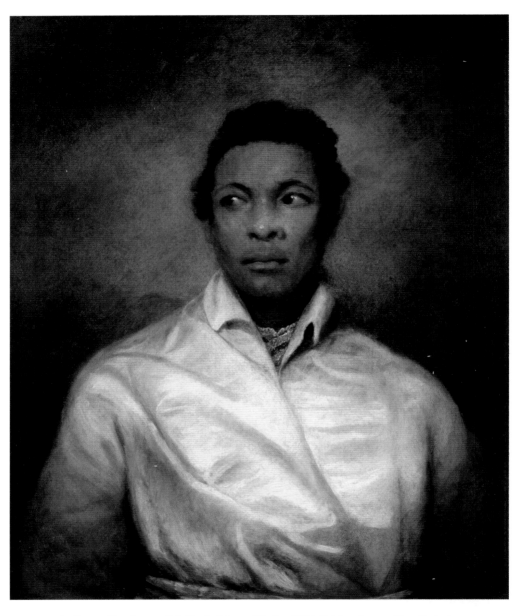

4 James Northcote, *Othello the Moor of Venice*, 1826. © Manchester City Galleries

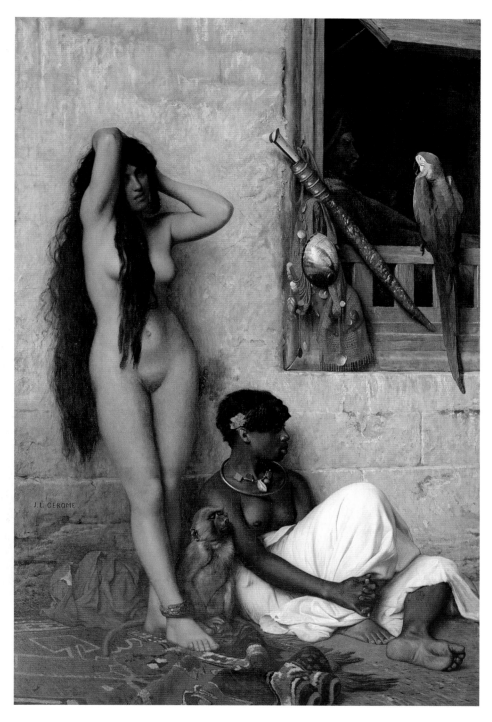

5 Jean-Léon Gérôme, *The Slave for Sale* (*A Vendre*), 1873. Oil on canvas. Musée d'Art
et d'Industrie, Roubaix, France / Giraudon / The Bridgeman Art Library

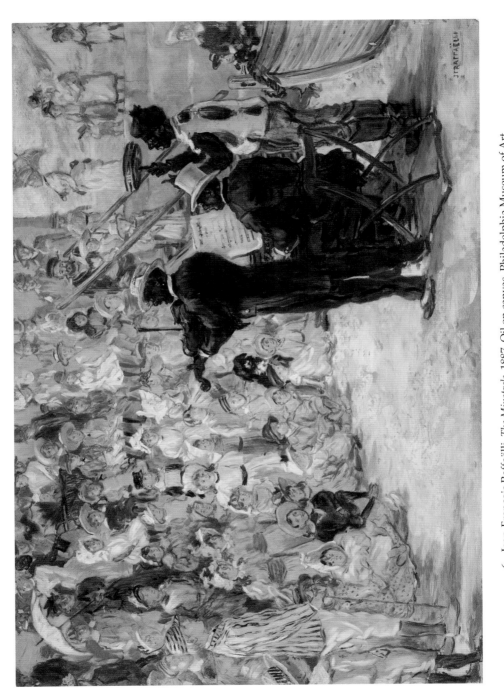

6 Jean-François Raffaëlli, *The Minstrels*, 1887. Oil on canvas. Philadelphia Museum of Art

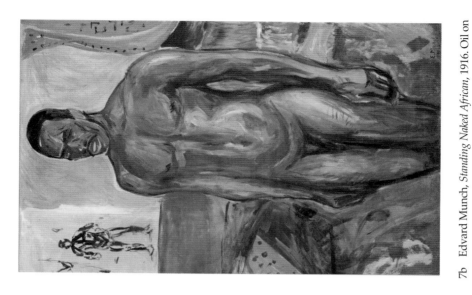

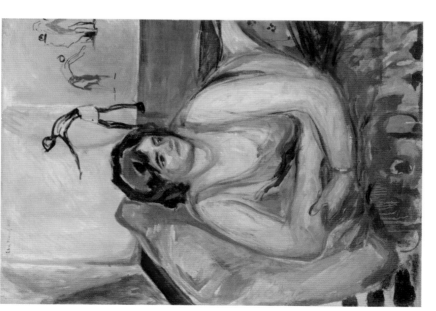

7a Edvard Munch, *Cleopatra*, 1916. Oil on canvas. Munch Museum, Oslo MM M 307 (Woll M 1218). © 2014 The Munch Museum / The Munch-Ellingsen Group / Artists Rights Society (ARS), NY

7b Edvard Munch, *Standing Naked African*, 1916. Oil on canvas. Munch Museum, Oslo (Stenersen Collection), RES A 8 (Woll M 1219). © 2014 The Munch Museum / The Munch-Ellingsen Group / Artists Rights Society (ARS), NY

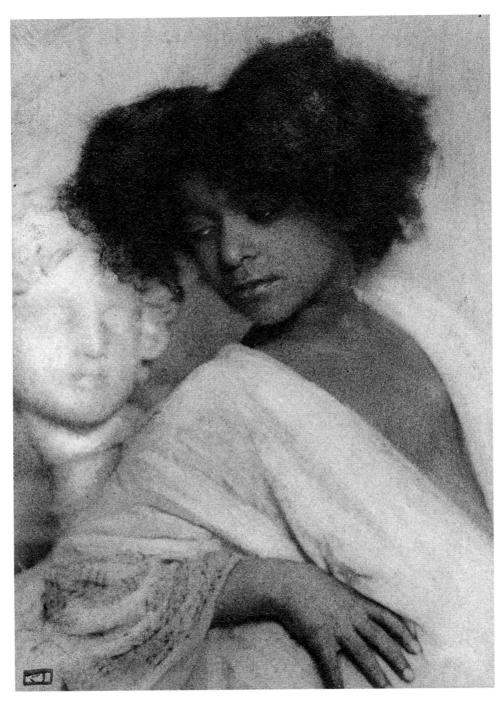

8 Robert Demachy, *Contrasts (A Study in Black and White)*, 1901/03. Gum-
bichromate print. Division of Culture and the Arts, National Museum of
American Art, Behring Center, Smithsonian Institution, Washington, DC

The color of Frenchness: racial identity and visuality in French anti-slavery imagery, 1788–94

Susan H. Libby

Introduction

In the years leading up to the 1789 Revolution, an anti-slavery movement began to gain momentum in France, culminating in the 1794 abolition of slavery in the French colonies.[1] While the campaign was largely textual, a number of images were produced that condemned slavery and other race-based colonial policies in the French Caribbean colonies. Mostly single-leaf prints or book illustrations, these images visualized indelible linkages between European conceptions of blackness and slavery by employing both well-established and newly invented visual devices that connected the conditions of blackness and slavery in ways designed to elicit sympathy for the enslaved. As I argue below, tropes of blackness that would seem to work against eliciting sympathy for slaves in fact proved useful in order for the French viewer of the images to respond as a humane, virtuous member of an enlightened society.[2] Much of this imagery depended on two, sometimes overlapping strategies: one to elicit sympathy for slaves while emphasizing the power and virtue of their liberators, and the other by constructing slaves as both other than and the same as their French liberators. In this way, the slaves' alterity is emphasized such that the French viewer can see, literally, how slaves are different from the white French in order that they can be made the same as a precondition for recognition leading to emancipation. During the Revolution, these images served political aims by promoting French abolitionists as the upholders of liberty for a victimized population. Relying on tropes of the primitive, childlike African typical of travel accounts and ethnography, creators of anti-slavery imagery portrayed slaves as deserving of empathy while inscribing their bodies with markers of blackness that identify them as slaves without calling up fear or repugnance in the white viewer.[3] Post-emancipation imagery also invoked tropes of racial difference, but in such a way as to produce black mimicry of white liberty. Yet another strategy, deployed in prints addressing race-based colonial policies, was to emphasize or invent racial distinctions as a means of managing fears of racial indeterminacy, and thus control over slave populations.

The typical identifier of slaves in such imagery is their skin color and facial physiognomy, since slaves were by then almost exclusively sub-Saharan Africans. Slavery had been practiced for centuries in nearly all times and cultures by the time Europeans began to question the practice, but it was not always connected with race.[4] In fact, for European slave owners, slavery was not linked with any particular ethnicities until the rapid rise of the trans-Atlantic African slave trade in the late seventeenth and early eighteenth centuries. The reasons for turning to Africa as a source for slaves, as well as the question of whether racism accounted for this choice or was created by it, is the subject of some debate, but what is clear is that by the middle of the eighteenth century colonial chattel slaves were almost exclusively African, and slavery and race—or more precisely, slavery and blackness—had become firmly linked in textual and visual discourse.[5]

While there were people of African descent in France, some of them slaves or former slaves, slavery was for the most part invisible to the French in the metropole. This contrasted with the plantation systems in the British colonies of North America and the French colony of Louisiana.[6] Without exposure to plantation slavery on the mainland, imagery became the means by which the French could visualize their country's participation in the trade in Africans. As Christopher L. Miller has observed,

The citizens of France could see the ships and trade goods going out and the colonial products coming back, in blissful ignorance of what was happening on (and between) the two other points of the triangle … It was easy for French people to think of slavery as a metaphor for intra-European oppression, since real slavery was nowhere to be *seen*.[7]

Imagery, especially widely circulated prints like most of the ones discussed here, provided this missing visualization; the black, docile slave pleading for freedom, the free person of color in the colonies winning equality with whites, or the post-emancipation slave mirroring revolutionary allegories of liberty and equality reassured the French that slaves were manageable, redeemable, and worthy of admittance to civilization. At the same time, slaves were subject to a kind of hypervisuality, in that in daily plantation life, they were controlled, in Saidiya Hartman's terms, "by the surveilling gaze of the master and/or its surrogate figure, the overseer."[8] The images thus corrected an erasure and "restored" slaves to the gaze of a white French population implicated but not always present in the practice of slavery. In what follows, I provide an introduction to the history of the French colonies and the slave trade, European conceptions of race and blackness, and colonial racial politics before turning to an examination of selected images.

Colonial beginnings

France began to colonize the Caribbean islands in the seventeenth century, where, over the course of the century, increasing demand in France for colonial

products like sugar, coffee, and indigo led to a need for more workers; by the end of the century, slaves outnumbered colonists.[9] Colonial slavery had become such an important feature of the French economy that in 1685, Louis XIV's Minister of Finances, Jean-Baptiste Colbert, drew up the *Code Noir*, a set of policies dictating the management of slaves on the island plantations. By the 1730s, Saint-Domingue (present-day Haiti) was the richest colony in the world, and by the beginning of the 1789 Revolution, France led the world in sugar production, and Martinique alone led in coffee production.[10] None of this vast and extremely lucrative agriculture would have been possible without the forced labor of generations of African slaves, whose blackness became the visible sign of their status. As Gwendolyn Midlo Hall notes: "As the slave population began decisively to outnumber the white population in the countryside, the visible evidence of racial difference was seized upon as a means of convincing the slaves of their own innate inferiority."[11] A 1777 *Mémoire au Roi* claims that "they always keep the stain of slavery, and are declared incapable of all public functions … his color is inextricably linked with servitude …."[12] The visual representation of slaves as black figures might seem to be merely a convenient, thus neutral, identifier were it not for the European conviction that black people were uncivilized, possibly dangerous, and at best childlike and simple-minded, beliefs often used to justify slavery. In fact, not surprisingly, the term "*nègre*" came to mean "*esclave*" in French dictionaries during the eighteenth century.[13] This is reflected in the frequent textual interchangeability of the terms, including in Diderot and d'Alembert's *Encyclopédie*.[14] To take one obvious example, the *Code Noir* refers to slaves as "*noirs*," starting with the title, although the subtitle refers to the "*commerce des nègres et esclaves*." In the rest of the document, "*nègre*" and "*esclave*" are used to mean the same thing; the image of a black boy on the cover of the 1743 edition of the *Code Noir* visually emphasizes this connection.[15]

Europeans and race

European conceptions of blackness were informed by varied sources of information, including scientific and philosophical publications, travel literature, and encyclopedias; many of these texts were illustrated, and most portrayed black people as inferior to whites. Until the late seventeenth century, "race" referred to lineage and breeding, not ethnicity. During the eighteenth century, scientists and philosophers sought to fix human beings into distinct, empirical, visual categories that came to be understood as the human races, and the modern conception of race as a function of physiognomy and corresponding internal characteristics was born.[16] These studies involved meticulous examination of visual evidence, including heads, skin color, and other body parts; these were compared to other ethnicities in order to establish racial hierarchies. Along with this wave of observation, categorization, and documentation came increasingly entrenched notions of racial superiority,

and black Africans especially were described in terms of their inferiority to white Europeans.[17] Even when not explicitly stating a hierarchy of races with white people at the top, Europeans premised their research on questions of black difference from whiteness, pathologizing blackness by searching for its causes, a subject of great interest in France.[18]

These European conceptions of blackness tended to fall into two basic categories, perpetuated in the imagery of slavery: the childlike, backward, harmless type and the vicious, animalistic type, or, in France, "*le bon sauvage*" and "*l'ignoble sauvage*," the former a variety of the "Noble Savage."[19] Much of the "evidence" for these competing characteristics of Africans was visual, such that it was easy for the European viewer to infer a connection between racial physical characteristics with barbarity even when not explicitly directed to do so. Thus the images addressed in this chapter functioned in a wider intertextual—and intervisual—context in which, even while soliciting sympathy for slaves, reminders of inferiority circulated widely in other contexts. Moreover, accounts of slavery in African societies served both to justify subjugation to colonial powers and to bolster the self-serving belief shared by many Europeans that Africans were naturally suited for slavery. With this rationale, Africans were deemed better off as the slaves of Europeans, who could baptize them and transform them into "civilized" Christians.[20]

Race and rebellion in the colonies

In the colonies, however, race was not nearly as clear-cut as it was in these texts and illustrations. Many generations of interracial relationships, both consensual and non-consensual, resulted in a large population of free mixed-race people referred to as *gens de couleur*. White colonists devoted considerable effort toward devising increasingly precise systems of racial differentiation, largely to secure white liberty and power. By the end of the eighteenth century, in Doris Garraway's words, "hysteria over race and purity of origins coalesced with official policies designed to protect white blood and hold its power"[21] The islands' inhabitants who had any black ancestry were denied equal rights with "pure" whites. Legal status and French citizenship were entirely race-based, such that Frenchness came to be equated with whiteness.[22] Not surprisingly, the *gens de couleur* protested their treatment and loss of rights as the eighteenth century progressed.[23]

The French jurist and historian Médéric-Louis-Elie Moreau de Saint-Méry, writing in 1797, identified 13 distinct racial categories, starting with whites, that could be produced by all possible combinations of black and white couplings.[24] This amounted to 110 possible combinations, from pure white to pure black.[25] The more racial distinctions became blurred, and thus the legal and political status of the islands' inhabitants, the more colonial power was expended on policing race. Even white authorities supporting rights for the

gens de couleur favored maintaining racial distinctions in order to promote white superiority. The colonist Michel-René Hilliard d'Aubreteuil argued in his 1776 *Considérations sur l'Etat Présent de la Colonie Française de Saint-Domingue* that "leaving them enslaved would only weaken in the mind of the Blacks the respect that must be inspired in them by Whites; all that proceeds from Whites must appear to them as sacred."[26]

To compound these conditions of racial instability and indeterminacy in the colonies, *marronage* (the escape of slaves to remote locations) and slave rebellions became a growing threat to French hegemony. In 1791 a massive, well-organized uprising erupted on Saint-Domingue, eventually leading to the island's independence from France in 1804. However, not all of the insurgents and their supporters could be identified by skin color, exacerbating fears that already plagued colonists; outnumbered by their slaves, planters lived in fear of poisoning or other retaliation and managed their persistent unease with everyday brutality and legal micro-management of racial distinctions.

> [T]he difference between the fear experienced by slaveholders and the enslaved can be viewed as the difference between predictable and unpredictable terror [writes Vincent Brown]. Slaves had always to fear the outburst of slaveholders. For slaveholders it was the *un*certainty of slave violence that made it so feared. Colonists strove for predictability in a capricious environment ... For this they needed an almost mechanized obedience from their slaves.[27]

Managing race was a way of managing fear in an unpredictable environment in which slavery and blackness were conceived as inseparable. In this constant, anxious calibration of colonial anxiety, anti-slavery imagery participated by creating unthreatening black characters grateful for the mercy of powerful whites, or by visually fixing mixed race as distinctly black in an effort to "see" race as it became more and more difficult to perceive.

Race and sympathy: the trope of the pleading slave

It was against this backdrop of racial indeterminacy, violence, and terror in the colonies that the best-known abolitionist image appeared first in England in 1787 in the form of a silhouette of a chained black slave pleading for recognition of his humanity; his face in profile looks upward toward the caption, "Am I Not a Man and a Brother?" The kneeing slave became the most ubiquitous symbol of the abolitionist cause, inspiring pity among white European viewers at the sight of the imploring, half-clothed figure asking only to be recognized as a fellow human. Designed by William Hackwood as the official seal of the London Committee for the Society for the Abolition of the Slave Trade, it was made by Josiah Wedgewood into small black and white jasperware medallions.[28] The emblem quickly became the official symbol of the French abolitionist group, the Société des Amis des Noirs, with the shortened title, "Ne suis-je pas ton frère?" (Am I not your brother?) (Figure 2.1).

6.

ADRESSE

A L'ASSEMBLÉE NATIONALE,

POUR

L'ABOLITION DE LA TRAITE DES NOIRS.

Par la Société des Amis des Noirs de Paris.

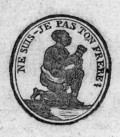

FÉVRIER 1790.

A PARIS. De l'Imp. de L. POTIER DE LILLE,
Rue Favart, Nº. 5. 1790.

2.1 "Ne suis-je pas ton frère?" Cover page of Société des Amis des Noirs, *Adresse à la Convention Nationale*, 1790. Engraving. Courtesy of the John Carter Brown Library at Brown University

The Société des Amis des Noirs was founded in 1788 by Jacques-Pierre Brissot de Warville. Other members included Honoré-Gabriel Riqueti, comte de Mirabeau, and other prominent men of the French élite, including the marquis de Lafayette, Henri (Abbé) Grégoire, the marquis de Condorcet, and Emmanuel-Joseph Sieyès.[29] Committed to a "politics of pity," the members were primarily devoted to the abolition of slave trade, not to ending slavery, and to the "softening" of colonists' treatment of their slaves, as outlined in their 1790 *Adresse à l'Assemblée Nationale pour l'abolition de la traite des noirs par la Société des Amis des Noirs* (Address to the National Assembly for the abolition of the slave trade by the Société des Amis des Noirs).[30] Much of their other writing employed familiar tropes of blackness, employed as reasons to gradually abolish slavery. In fact, in what Laurent Dubois terms "republican racism," many arguments in favor of abolition were identical to those of pro-slavery groups making a case for Africans' natural suitability for slavery.[31] For example, in reference to perceptions of life in Africa, what opponents of slavery would call "innocent" or "unspoiled," supporters of slavery might term "stupid" or "uncivilized." Believing that the temperament of slaves was "sweet, confiding, and timid," the Société advocated the creation of colonies in Africa as a means for ending the slave trade. They did not, however, support the immediate abolition of slavery, arguing that the slaves were not yet ready.[32] Mirabeau's 1757 *L'ami des hommes, ou Traité de la population* (The friend of man, or The peoples' treatise) argued forcefully against the African slave trade and slavery as it was practiced in the Americas. However, this was not because he viewed Africans as equal to Europeans; in fact, he claimed that "our slaves in America are a race of men separate and distinct from our own species by the most indelible of traits, that of color," further referring to Africans as "brutish or endowed with an instinct that is foreign to us."[33] In his *Réflexions sur l'esclavage …* (Reflections on slavery …) Condorcet noted what he saw as the slaves' "stupidity," but blamed it on the condition of slavery:

> If, because of their lack of education and the stupidity contracted through slavery by the corruption of their morals … the slaves of the European colonies have become incapable of fulfilling the duties of free men, we can … treat them as men who have been deprived by misery or sickness of a portion of their faculties. We cannot, therefore, grant them the full exercise of their rights without exposing them to the risk of hurting others or harming themselves.[34]

It is not surprising, therefore, that the imploring slave motif would be appealing as a visual means of persuading a reluctant French public that black slaves should be better treated and that their trade should end.

The trope of the docile, helpless slave had begun to appear in French book illustrations earlier in the eighteenth century.[35] One example is an engraving after Moreau le Jeune in Bernardin de Saint-Pierre's 1773 *Voyage à l'isle de France* (Voyage to the Isle de France) entitled "Homo sum; humani nihil a me alienum puto. Je suis homme; et rien de ce qui intéresse l'homme m'est étranger" (I am human; nothing that concerns man is alien to me). In what

is intended as a critique of slavery, a black man and a white man sit across from each other at a table in the white man's study. The setting appears to be tropical, and the white man has been studying maps and local fauna. Holding out a copy of the *Code Noir*, the black man, wearing chains— "the instruments of slavery," according to the text—appears to be beseeching the white man, although it is unclear about what.[36] These power relations, typical of anti-slavery imagery, are reduced to an abstraction in "Ne suis-je pas ton frère?" in which narratives of dominance and subjugation, cruelty and mercy, inhumanity and compassion, are condensed into one multi-purpose icon. Easily adapted to other media, such as jewelry, hairpins, and dishes, it could spread its message widely for many audiences and consumers.[37] For all its simplicity, the emblem announced several rhetorical strategies: it presents the slave as harmless and unthreatening to the unseen rescuer, and it marks him as a black man whose difference from his liberator is emphasized so that his rescue is all the more meaningful to a white community sharing sympathy for the slave. Moreover, a single figure is less threatening than a group, especially one in which there are no white figures depicted or suggested. By asking a question that could be refused—similar to the scene in Bernardin's book mentioned above—the slave cedes control of his very humanity.[38] In the medallion, the suspense will end only with the master's decision, whose absence places him or her in the domain of the viewer and consumer of the print. This slave is also safely subjugated, his shackles acting both as identifiers of slavery and as reassurance that he is confined. The European spectator could easily recognize the figure as a type of African, also encountered in literature and the theater, one whose submissiveness and willingness to recognize a merciful European dominance confirms his suitability for emancipation and entry into a rational world of shared humanity.[39] The figure's blackness is emphasized not only by the contrast of his black body against the white background, but by the prominent markers of his African facial physiognomy in profile. Add the chains and the plea to the spectator's empathy, and the emblem achieves its effectiveness as a perfect abolitionist image for its time and place in that it presents difference as a condition that can be managed by the white spectator.

Another image generated in England, an engraving of a cutaway view of a slave ship, similarly aroused pity by indexing the hideous mistreatment of slaves during their transport from Africa. Like "Ne suis-je pas ton frère?" this image gains much of its power from its stark, schematic rendering of black bodies. With the ship's interior shown from above, viewers could see dozens of tiny, identical black figures representing slaves—or percentages of slaves— packed together for transport to the colonies.[40] "Plan of an African ship's lower deck with Negroes in the Proportion of only one to a Ton" was first produced in England in 1789, and, like the kneeling slave medallion, it quickly attracted the attention of the Société des Amis des Noirs.[41] It was published in the British French-language journal *Le Courrier de l'Europe* in 1789 and widely disseminated in France in 1790.[42] Although the figures are little more than

outlines, their size compared to that of the ship communicates the inhumanity of the slave trade and conveys their victimization and vulnerability.

Virtually the same kneeling, pleading slave as in "Ne suis-je pas ..." appears in reverse in the frontispiece to Benjamin Frossard's *La Cause des Esclaves Noirs*, an abolitionist history published in 1789.[43] Titled "Soyez libres et citoyens" (Be free and citizens) and designed by Pierre Rouvier, the image depicts an allegorical figure of France granting liberty to a group of barely clothed slaves, a rare instance of representations of slaves in a group (Figure 2.2).

In "Soyez libres," France, towering over the slaves and taking up almost half of the composition, literally lends them a helping hand as she appears to bless them with the other, while their broken chains symbolize their transition from bondage to freedom. The male slave closest to the foreground faces left and kneels before France in an almost exact reversal of the kneeling figure in the Wedgewood medallion. The primary difference is that in Rouvier's composition, the chain and shackle are affixed only to his ankle, and the shackle is conspicuously broken on the ground. Directly behind him is a female slave, still in chains, with a baby on her back, the three figures forming a family group. The other slaves, also still kneeling, glance toward France with somber, imploring looks. The inclusion of a family group further reminds the white viewer that slaves include women and children and that they can be united by the same bonds as white families, alluding to their frequent separation in the slave trade. Unlike "Ne suis-je pas ...," the slaves' benefactor appears in the Frossard image; if the former image destines its figure to ask his question indefinitely of a rescuer who may never arrive, the latter image presents the figure of the French nation appearing like an angel of mercy to save the deserving slaves with her promise of French citizenship.

Frossard's text provides a view of Africans much like that of the Société des Amis des Noirs. He saw Africans as the original, innocent inhabitants of nature, noting that "the ease and tranquility of the Negroes who rest in the shade of their thick foliage ... presents an image of the world in its primitive state,"[44] further observing that "even though they have no regulated government, no arts, and no civilization that they live in peace and abundance."[45] "If Africans are cruel, vindictive, cheats, and thieves in business," Frossard explained, "it is not nature but the Europeans to whom they owe these vices."[46] This ode to a peaceful African life of primitive innocence was surely intended to show Africans in a positive light, in keeping with Frossard's anti-slave trade position. This scenario is the inverse of pro-slavery accounts of Africans' savagery and lack of civilization (to which Frossard was responding with his reference to cruel, vindictive cheats). However, both views are premised on the same conceptions of African backwardness, with Frossard's fantasy one of Arcadian bliss and the other one of imbecilic barbarism. For example, the missionary Pierre Poivre observed in 1754, "These stupid men are content to live from day to day in an environment where there are few real needs,"[47] a condition that Frossard saw as a sign of virtue. As a naturalist, Buffon wrote at length about the lack of civilization and intelligence of Africans.[48]

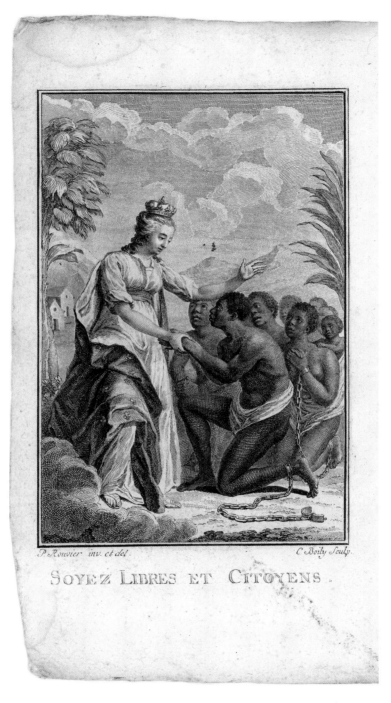

SOYEZ LIBRES ET CITOYENS.

2.2 Charles Boilly after Pierre Rouvier, "Soyez libres et citoyens," frontispiece
to Benjamin Frossard, *La Cause des Esclaves Noirs*, vol. 1, 1789. Engraving.
Courtesy of the John Carter Brown Library at Brown University

His observation about the slaves of Saint-Domingue, "all of these savages, though they never think, have a pensive melancholy aspect,"[49] echoes those of the Jesuit missionary Pierre-François Charlevoix, writing in 1730: "With respect to the mind, all the *nègres* of Guinea are extremely limited; many seem idiotic, as if stupefied. One sees that they could never count past three … They are machines that must be rewound whenever one wants to make them move."[50] Blackness could thus act as a shifting signifier depending on the context and the author's point of view, but it always indicated a pre-civilized state.

The preceding images employ various visual and textual devices to persuade the white viewer to experience their difference from the black slaves so that they can discover their humanity, thus a degree of identification. As Lynn Festa and Sarah Watson Parsons have pointed out, these attempts at gaining sympathy operate by emphasizing difference so that the viewer can negate or excuse it. Festa describes this response to the Wedgewood medallion as a process of locating humanity hidden under black skin:

> The question invites the reader of the medallion to *find* likeness in the slave—to attribute the similitude to the figure that will render him human. The question thus presupposes the difference it claims to cancel out: the slave is made unlike in order to invite the reader to make him like but it also implicitly negates the slave's humanity by inviting the reader to *restore* that humanity ….[51]

In order to "undifference" the black slave, the white viewer must first notice difference, then identify with an injured humanity in order to rescue the slave from his (or her) otherness, that is, his unfree blackness. The slave has been granted just enough subjecthood to ask for recognition of his humanity, of his selfhood, while iconographically conforming to the visualized slave's body, which "appears as the site of a nonsubject, of an identity without memory or history …."[52] Just as slave masters could subject their chattel to branding, renaming, and separation from their families, native land, religion, and language, so the kneeling slave's rescuer could confer full subjecthood by responding affirmatively to the question "Ne suis-je pas ton frère?," an utterance that both affirms a human self and exposes its limits. Variations on this play of difference and sameness, subjecthood and objecthood, discussed below in connection with images produced during the Revolution, serve to demonstrate the virtues of liberty and French citizenship by emphasizing blackness, both chromatic and physiological, in order to redeem it in the new republic.

Race and visuality: *gens de couleur* and the color of Frenchness

During the Revolution, the activities of the Société des Amis des Noirs were diverted from advocating for abolition of the slave trade in favor of the struggle for rights for free people of color, or *gens de couleur*, in the colonies.

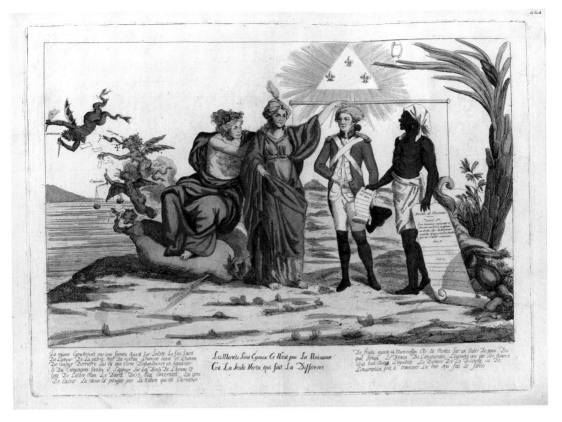

2.3 Anonymous, "Les mortels sont égaux," 1791 or 1794. Colored engraving. Bibliothèque nationale de France

Accordingly, pictures like the kneeling slave emblem and the illustration to Frossard's abolitionist tract were replaced by images supporting the *gens de couleur*. These formed a small part of a massive output of visual propaganda during the Revolution. Most of these revolutionary prints, usually etchings and varying widely in quality, were produced in huge editions of several thousand and could be widely disseminated as publicly posted broadsides, sold by street vendors or exhibited in printers' shops.[53] They were also printed to accompany journal articles, often sent to subscribers after the story was published.[54] Frequently coarsely drawn, the majority of revolutionary prints were not commissioned but printed by printers and engravers in response to rapidly changing political events.[55]

"Les mortels sont égaux" (Figure 2.3) and "La liberté des côlon" [*sic*] (Figure 2.4) are sometimes categorized as abolitionist prints, but in fact they address debates in the colonies and the mainland about the rights of free people of color in the colonies, not slavery or the slave trade. In both cases, the prints call for equality between people of color and the white French, celebrating a process of assimilation in which the whites admit the former into the realm of the latter. In these images, white figures recuperate an elusive but still troublesome blackness and grant equality to free people of color,

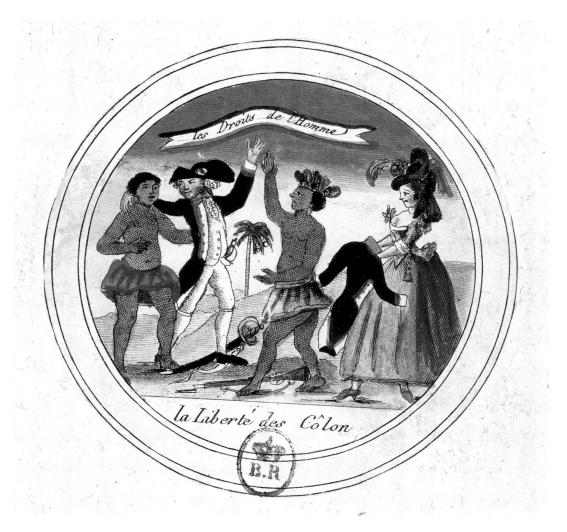

2.4 Anonymous, "La liberté des côlon," 1791 or 1794. Engraving. Bibliothèque nationale de France

represented as brown, half-clothed male figures accepting French liberty. In that respect, the prints are not unlike the Frossard image, except that the later figures do not represent actual slaves, nor necessarily dark-skinned people, but rather employ visual codes of slavery and blackness that serve to secure the disappearing racial binaries on which the colonial regime depended.

In the colonies, whites were seen as belonging to two classes, the *grands blancs* and the *petits blancs*; the former were the wealthier planters, often from old families, and the latter were working-class Frenchmen who had arrived later. *Esclaves*, of course, were the slaves, and *affranchis* were slaves who had been manumitted or had purchased their freedom. After the abolition of slavery on Saint-Domingue in 1793, the term *"anciens libres"* was used to refer to *affranchis* who were free before abolition. The term *"gens de couleur,"* as discussed above, was generally reserved for free mixed-race people.

However, their African heritage could be so distant as to be indiscernible. Consequently, in the colonies, race could be invisible, thus losing its most convenient determining factors—shape and color—but not its existence. As if hidden inside bodies like a disease, blackness had to be monitored and contained in order to maintain white hegemony. Even though many *gens de couleur* were from old creole families who had amassed fortunes and owned plantations and slaves themselves, they were barred from certain professions.[56] They were also subjected to dress codes and segregated from whites in some public spaces.[57] In 1773, the law stipulated that *gens de couleur* had to have their race—black—indicated on notarial records, and on Saint-Domingue, as in the other French colonies, property-owning free men of color paid taxes like the white planters, but had no role in the administration of the colonies, nor the same rights.[58] An aggressive campaign for equal rights, led by Julien Raimond, a free person of color from Saint-Domingue, culminated in 1791 and 1792 with laws granting equal rights to all *gens de couleur*. The first decree awarded equal rights to those *gens de couleur* born of two free parents; the following year, all *gens de couleur* gained rights equal to those of whites. The cause of the *gens de couleur* was extremely contentious both in the colonies—where it was especially violent—and on the mainland. It was only after the gruesome execution on Saint-Domingue of Vincent Ogé, a free man of color punished for his activism, that the movement began to attract sympathy outside of groups like the Société des Amis des Noirs.[59]

"Les mortels sont égaux," a single leaf polychrome engraving probably produced in 1791, celebrates the more limited law (Plate 1). The print's full title, "Les mortels sont égaux, ce n'est pas la naissance, c'est la seule vertu qui fait la difference," is a line from Voltaire's play *Mahomet*. This print is variously dated 1791 and 1794. However, the earlier date is the more plausible one, since the black figure conspicuously holds a copy of the May 15, 1791 law, and it is unlikely that such an image produced in 1794 would ignore the national decree of abolition passed that year.[60]

In this unsigned print, a black man wearing a loincloth and cloth headdress stands next to a white man in military uniform. A figure of Reason, with a flame representing love of country on her head, and urged forward by Nature, holds a level over the men's heads, indicating their equality, an iconographic device that appears widely in revolutionary propaganda. It also echoes Julien Raimond's insistence that "Les hommes libres doivent être tous au meme niveau" (Free men should all be at the same level).[61] In one hand, the black man holds a copy of the *Déclaration des droits de l'homme et du citoyen*, which had been drafted in 1789; in the other hand he holds a paper titled "Decret du 15 mai." On the left of the composition, the demons of aristocracy, egotism, injustice, and disorder flee over the ocean (disorder is probably a reference to the threat of *gens de couleur* supporting a slave revolt). The print thus brings the *gens de couleur* into the symbolic world of the Revolution, where they achieve equality and liberty by the agency of reason and nature. However, an actual free person of color and a French official would easily have been difficult to

distinguish in actuality, as the former could well have had skin as light as the Frenchman's, or nearly so. It is possible that the *gens de couleur* affected by the May 15 decree were dark-skinned, since specifying that the law applied to people born of two free parents suggests that one of them could have recently been enslaved, but it is still not certain that their offspring would be visibly black or a slave him- or herself. The intricate nuances of skin color and its meaning in the colonies also may not have been clear to the print's producers in Paris. Nevertheless, in order to distinguish the two men and make the allegory comprehensible against the backdrop of persistent racial confusion, the artist resorted to portraying the mixed-race man as a colonial slave, as if rendering visible the aspect of the man's ancestry that accounted for his lesser status in the colonies. In effect, the scantily clothed black man is what French colonists "saw" when confronted with *gens de couleur*: black slaves whose African "stain of blackness" is indelible and whose whiteness is canceled out by their blackness, in a fashion analogous to the notarial documents marking past blackness.[62] Even the cornucopia situated to the right of the man of color can allude to the black figure's African heritage, as cornucopias appear in Cesare Ripa's *Iconologia* as symbols of the African continent. As Joan Dayan notes about blackness and colonial *gens de couleur*:

These new whites had to be recolored, inventively darkened; and the resulting "onamastics of color" depended on a fiction of whiteness threatened by what you could not always see, but must learn to fear, and always suspect: a spot of black blood ... The epistemology of whiteness, absolutely dependent for its effect on the detection of blackness, resulted in fantasies about secret histories and hidden taints that would be backed up by physical, explicit codes of law.[63]

The print effectively "recolors" the dark-skinned recipient of France's virtue, fixing and regulating blackness as a means of stressing the significance of the colonial law admitting the *gens de couleur* into the realm of whiteness, with its privileges of citizenship and liberty. As an allegory of transition from one state to another—unequal/equal, unfree/free, not French/French—it conflates politics and race into a visualization of metamorphosis of blackness into whiteness.

"La liberté des côlon" (1791 or 1794) presents many problems of interpretation but, whatever its exact meaning, it bears certain similarities to "Les mortels sont égaux," especially in its figuring of blackness as a primitive state that can be remedied, indeed, transformed, by white intervention.[64] The style, content, and even the spelling in the caption indicate a lack of education on the part of the printer. Slaves did not wear feathers on their heads, although feather headdresses have indicated both Africa and America in allegories of the continents, and "*côlon*" with the circumflex refers to the digestive system, not to the "*colon*," or in English, "colonist," which should have been plural in this context.[65] The symbolism of "La liberté," however, is obvious: the issue is that of Frenchness and citizenship for free men of color. Two barely clothed brown-skinned men, one wearing feathers, joyously receive French military uniforms from a uniformed white man and a woman.

Above them floats a tri-color banner with the words, "Les droits de l'homme," and on the ground near the central black figure lie a sword and a rifle. A palm tree in the background fixes the location as a tropical island. The 1791 date would lead to an interpretation much like that of "Les mortels sont égaux": the *gens de couleur* attain legal equality with whites, and their assimilation into Frenchness, represented by the white figures offering uniforms to cover the uncivilized bodies, represent France. The weapons on the ground would stand for a cessation of slave violence on Saint-Domingue and a truce between the insurgents and the French colonial authorities; many whites believed that the law of 1791 would pacify the slaves, whose revolt began in earnest in August of that year. Laurent Dubois, however, argues that the print should be dated 1794 and that it represents the post-abolition conscription of former slaves into the French army in order to support the French side in their conflicts with Britain over control of the Caribbean colonies.[66] That interpretation would lend more significance to the uniforms and could change the meaning of the sword and rifle to a symbol of peace between France and Britain instead of between rebelling slaves and colonists. Dubois' date would also explain the theme of assimilation in terms of French citizenship, granted to the freed slaves in February 1794. In either case, however, skin color and allusions to Africa signify a primitive condition of statelessness, which might or might not have been identifiable by skin color in the colonies. Both prints find the people of color worthy of liberty and equality but on solidly French terms; both offer equivalence by a promise of assimilation, visualized by difference and contrast in a process of transition made possible by French law. Like colonial mimicry, in which the colonized figure imitates but can never resemble or replace the colonizer, assimilation stabilizes the colonizer's identity by providing reminders of the difference now under the colonizer's control.

Race and mimicry: abolition and assimilation

On February 4, 1794 the Convention Nationale in Paris pronounced the end of slavery in the colonies. Slavery had been abolished on Saint-Domingue the previous year, but the 1794 law emancipated the slaves in all the French colonies and declared them French citizens. Prints celebrating the event ranged from detailed compositions showing jubilant crowds to a group of images consisting of roundel profile renderings of black men and women with the caption "Moi libre aussi," of which there are several variations[67] (Figure 2.5).

Unlike the rapidly produced "Les mortels" and "La liberté," these prints were designed by a known and accomplished sculptor (Louis-Simon Boizot), carefully executed, and many are expertly hand-colored and printed on high-quality paper.[68] The female and male figures appear separately (as shown here), or in facing pairs. The female figures wear headwraps, often arranged in a shape resembling a Phrygian cap, a revolutionary symbol of

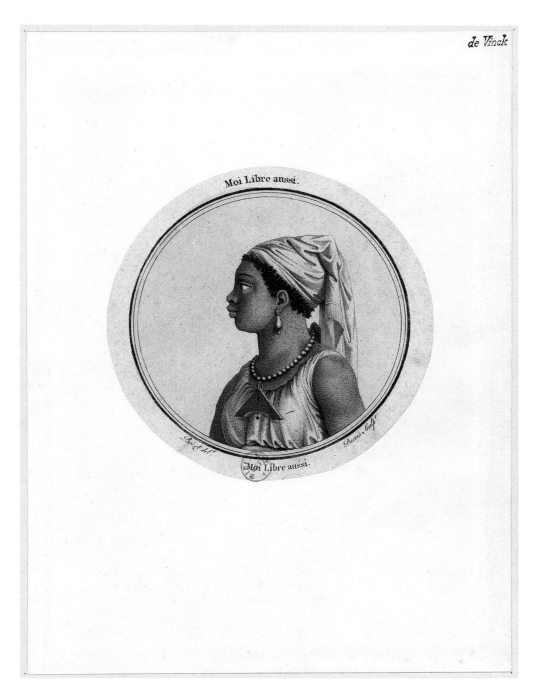

2.5 Louis Darcy after Louis-Simon Boizot, "Moi libre aussi," 1794.
Colored engraving. Bibliothèque nationale de France

liberty, and triangular pendants symbolizing equality. The male figures wear more recognizable Phrygian caps and loose white tunics recalling classical attire. Circulating in an intervisual field of revolutionary iconography, these images invite comparison with the ubiquitous female allegories of Liberty and Equality produced during the Revolution; in addition to the visual parallels, both types of images share the message of liberty and equality. Like the "Moi libre aussi" figures, Liberty and Equality appear as busts in oval compositions, wear headgear resembling Phrygian caps (Liberty), triangular pendants (Equality), and classicized drapery (both).[69]

The abolitionist images also circulated in a visual field of profile studies that illustrated ethnographic investigation, as facial profiles were seen as the most useful visual indicators of racial difference, often presented in terms of hierarchies from Caucasian (most civilized) to African (least civilized).[70] Petrus Camper's racial comparisons of facial angles are one example (addressed in Albert Alhadeff's contribution to this volume). Viewers familiar with these revolutionary allegories would easily have been able to make a comparison between those and the profiles of the "Moi libre aussi" figures, whose African features in profile are carefully delineated, sealing the figures' identity as forever contingent on whiteness.

The "Moi libre aussi" prints' compositional and iconographical similarities to the Liberty and Equality images call attention to their racial difference, so that the viewer could read the black figures as imitations of the more familiar and numerous white ones, as "others" copying that from which they deviate. Even their utterance, "Moi libre aussi," is an imitation. Written in *petit-nègre*, the phrase is a distortion of French usage spoken by uneducated slaves. For all of the accoutrements of revolutionary liberty and equality, the figures retain traces of their enslaved past, their symbols of liberty and equality changing meaning on the black body. The male figures' classicizing attire leaves them lightly clothed, as plantation slaves typically were, and the female figures' headdresses and clothing are those of Caribbean women of color, as in the "Moi libre aussi" prints. Thus what locates the Liberty and Equality images as classicizing allegories shifts when the same visual codes can be read as both abstract and concrete. If whiteness is neutral and "normal," providing a blank space for assigning abstract meaning, blackness, as "other" is particular (although not particular enough to be an actual person), thus anchored in actuality. This doubling of the actual and the allegorical works because "… the singular and hyper-contingent difference of this 'otherness' … grants Africans the status of a nonuniversal 'generality' lacking in *subjectivity* …."[71] This destabilizing of the real and the symbolic, past and present, captive and free, suggests a liminal state for the "libres aussi," whose liberty is approximate and contingent, thus mimetic, as the caption tells us: "Me free *also*." Neither fully symbolized as black nor white, these figures function as "mimic men" and women who fulfill a need for a manageable "other" who can imitate and mirror the dominant subject; simultaneously, their alterity points to their ineradicable difference and process of assimilation, thus their masters' power.

One form of colonial dominance is the civilizing mission to transform the "other," to elevate him or her to the colonizer's status by requiring that the colonized imitate the colonizer, with the latter's superior form of civilization. But mimicry requires distance as well as difference from the mimicked, thus paradoxically securing the mimic man's alterity and stabilizing the colonizer's status and identity. Homi Bhabha's formulation of the mimic man is especially pertinent to an understanding of these images:

> … colonial mimicry is the desire for a reformed, recognizable Other, *as a subject of difference that is almost the same but not quite*. … the discourse of mimicry is constructed around an *ambivalence*; in order to be effective, mimicry must continually produce its slippage, its excess, its difference … Mimicry is, thus, the sign of a double articulation: a complex strategy of reform, regulation and discipline, which "appropriates" the Other as it visualizes power.[72]

"Almost the same but not quite": these black emblems of liberty and equality are just similar enough to their white counterparts to call attention to their difference, which reifies the whiteness of the French revolutionaries, along with the ideologies of liberty, equality, and fraternity wielded to define the Revolution's purpose.

Conclusion

When the Convention Nationale abolished slavery in 1794, the members saw an opportunity to "elevate themselves to the height of the principles of liberty and equality" in freeing the slaves "who have wanted like us to break their chains."[73] This moment of recognition occurred after speeches concerning the true nature of slaves; whether they were primitive and childlike, or if they were treacherous and vicious, it was not due to their character but to the evils of slavery, as Condorcet had previously argued. When the members could see slaves as virtuous people, abused by a corrupt system, who longed only for liberty—that is, as French revolutionaries—the advantages of abolition became clear. However, this act of rescue was possible not only because slaves could be visually and discursively made similar to the French, but because the otherness of slaves could become a condition that the French could control in the midst of colonial violence, racial hybridity, and unpredictability. By employing codes of blackness as the visible marker of the slave, these images allowed the viewer to notice, define, and transform difference in a cycle of virtuous thought and action that corresponded with the ideals of the Enlightenment and the new republic. These ideals coalesce in another image, the well-known painting of a former slave by Anne-Louis Girodet de Roussy-Trioson, *Portrait of Jean-Baptiste Belley (1747–1805), Deputy of Santo Domingo at the French Convention* (Salon 1798) (Figure 2.6), the first black deputy to the French government; he was present at the Convention Nationale when the 1794 decree of abolition was passed.

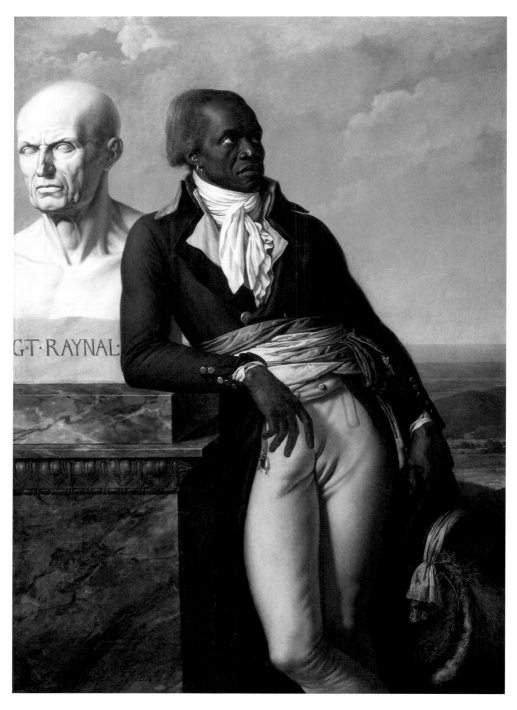

2.6 Anne-Louis Girodet de Roussy-Trioson, *Portrait of Jean-Baptiste Belley (1747–1805),*
Deputy of Santo Domingo at the French Convention, 1797. Oil on canvas. Château de
Versailles et de Trianon, Versailles, France. © RMN-Grand Palais / Art Resource, NY

In Girodet's portrait, Belley stands looking into the distance, with what appears to be Saint-Domingue in the background. Elegantly dressed in his deputy's uniform, he leans his elbow on the base of a portrait bust of Guillaume-Thomas Raynal, whose multi-edition *Histoire philosophique et politique des établissements et du commerce des Europeéns dans des Deux Indes* (Philosophical and political history of the commercial establishments of the Europeans in the two Indies) first published in 1770, was both admired and reviled for its criticisms of the slave trade and French colonial policies. The painting differs from the prints discussed in this chapter in many obvious ways, not the least of which is the attention lavished on a nearly full-length oil on canvas portrait of an individual black man of distinction and accomplishment in a white society that had only recently ruled that owning him would be against the law. Nevertheless, for all his dignity, Belley remains a mimic man, dependent on Raynal, whose brilliantly white cranium contrasts sharply with Belley's dark head, his liberty and authorization to bear the French uniform compositionally contingent on French wisdom. Indeed, the politically astute Belley was publicly willing to give full credit to the French, declaring, "I am one of those men of nature whom the wisdom and the principles of the French nation has torn from the yoke of despotism."[74] Girodet's Belley is the quintessential "bon sauvage," the "reformed, recognizable Other" whose difference serves to guard and protect the virtue of the liberators, calling to mind Hal Foster's observation that in white modern culture, "the primitive is sent up into the service of the Western tradition (which is then seen to have partly produced it.)"[75] Long after abolition, the black slaves in these well-intentioned images are fixed in positions of difference and servitude, providing the labor needed to fuel the technologies of the colonial biopolitical regime.

Notes

1 France had several abolitions. In 1793, slavery was abolished on Saint-Domingue by the colony's Civil Commissioner, Félicité-Léger Sonthonax. The Convention Nationale abolished slavery in all the colonies in 1794. However, Napoleon reinstated slavery in 1802, and it was not finally abolished until 1848. The slave trade was abolished in 1817, going into effect in 1825, although clandestine trading continued.

2 An essay by Peggy Davis also interprets French anti-slavery imagery as an expression of French racism. My analysis focuses more on colonial history, especially attitudes toward race in the colonies, while Davis concentrates on the Revolution and on print culture; see "La réification de l'esclave noir dans l'estampe sous l'Ancien Régime et la Révolution," in Catherine Gallouët, David Diop et al., eds., *L'Afrique au siècle des Lumières: Savoirs et représentations* (Oxford: Voltaire Foundation, 2009), 237–53.

3 This was also true of written narratives. Doris Lorraine Garraway, *The Libertine Colony: Creolization in the Early French Caribbean* (Durham, NC: Duke University Press, 2005), 246.

4 John D. Garrigus, *Before Haiti: Race and Citizenship in French Saint-Domingue* (New York: Palgrave Macmillan, 2006), 32.

5 The question of slavery and racism is enormously complex, and there is much evidence to support both views. It is certainly the case that as the eighteenth century progressed, blackness and slavery were connected as a means to demean slaves and argue against their emancipation. However, scholars have noted that Europeans held unfavorable views about black people before the rise of the Atlantic slave trade. See William B. Cohen, *The French Encounter with Africans: White Response to Blacks, 1530–1880* (Bloomington: Indiana University Press, 1980). Sue Peabody recounts a legal case in France in 1759 in which an Indian man had to prove that he was not black in order to secure his freedom. The fact that this distinction mattered as much as it did indicates the importance of blackness in determining fitness for slavery. See Sue Peabody, *"There Are No Slaves in France": The Political Culture of Race and Slavery in the Ancien Régime* (New York and Oxford: Oxford University Press, 1996), 57–71. In this section, Peabody also addresses racial rationalizations for slavery. David Eltis argues that "the ethnic divide provided Europeans with the blinkers necessary to [have slavery]…." See David Eltis, *The Rise of African Slavery in the Americas* (Cambridge: Cambridge University Press, 2000), 18. Robin Blackburn offers an economic explanation: "[the choice was] made on economic grounds by merchants and planters who found out … that a construction of an economic system based on racial exploitation served their purposes well." See Robin Blackburn, *The Making of New World Slavery: From the Baroque to the Modern* (London and New York: Verso, 1997), 315. In an article on the history of race, Nicholas Hudson asserts that since even abolitionists held disparaging views about blacks, it cannot be claimed that "race" was invented to justify slavery. See Nicholas Hudson, "From Nation to 'Race': The Origin of Racial Classification in Eighteenth-Century Thought," *Eighteenth-Century Studies* 29, no. 3 (Spring 1996): 251.

6 The presence of black people in France in the eighteenth century is thoroughly examined by Peabody, *"There Are No Slaves in France."*

7 Christopher L. Miller, *The French Atlantic Triangle: Literature and Culture of the Slave* Trade (Durham, NC and London: Duke University Press, 2008), 60. Catherine A. Reinhardt makes much the same observation in *Claims to Memory: Beyond Slavery and Emancipation in the French Caribbean* (New York: Berghahn Books, 2006), 35.

8 Agnes Lugo-Ortiz and Angela Rosenthal, eds., *Slave Portraiture in the Atlantic World* (New York: Cambridge University Press, 2013), 6.

9 Laurent Dubois, *A Colony of Citizens: Revolution and Slave Emancipation in the French Caribbean, 1787–1804* (Chapel Hill, NC: Published for the Omohundro Institute of Early American History and Culture, Williamsburg, VA, by the University of North Carolina Press, 2004), 32.

10 Miller, *French Atlantic Triangle*, 26.

11 Gwendolyn Midlo Hall, *Social Control in Slave Plantation Societies; a Comparison of St. Domingue and Cuba*, Johns Hopkins University Studies in Historical and Political Science. Ser. 89, 1 (Baltimore: Johns Hopkins University Press, 1971), 136.

12 Ibid., 136.

13 Simone Delesalle and Lucette Valensi, "Le mot 'Nègre' dans les dictionnaires français d'ancien régime: Histoire et lexicographie," *Langue française*, no. 15 (1972): 87.

14 Andrew S. Curran, *The Anatomy of Blackness: Science and Slavery in an Age of Enlightenment* (Baltimore: Johns Hopkins University Press, 2011), 6–10. The *Encyclopédie* entry on "Nègres considérés comme esclaves dans les colonies de l'Amérique," defines the black African in terms of Atlantic slavery. See Jean-Baptiste-Pierre Le Romain in *Encyclopédie, ou Dictionnaire raisonné des sciences, des arts et des métiers, etc.*, eds. Denis Diderot and Jean le Rond d'Alembert, University of Chicago: ARTFL Encyclopédie Project (Spring 2013 Edition); also Robert Morrissey, ed., at http://encyclopedie.unchicago.edu/. See also Antoine-Gaspard Boucher d'Argis, "Esclave," in the same publication.

15 See Gabrielle De la Rosa, "The Trope of Race in Portraiture and Print Culture of *Ancien-Régime* France" (PhD diss., Harvard University, 2008), 175–79, for an intriguing discussion of the *Code Noir* figure.

16 The first publication to categorize humans by skin color and other physical attributes was published in 1684 by the physician François Bernier. See François Bernier, "Nouvelle division de la terre, par les différentes espèces ou races d'hommes qui l'habitent," *Journal des sçavans*, April 1684 (Paris: Jean Cusson). The history of conceptions of race is discussed thoroughly in David Bindman, *Ape to Apollo: Aesthetics and the Idea of Race in the Eighteenth Century* (Ithaca, NY: Cornell University Press, 2002). See also Curran, *Anatomy of Blackness*; and specifically with reference to French slavery, Garrigus, *Before Haiti*.

17 David Bindman, "Am I Not a Man and a Brother? British Art and Slavery in the Eighteenth Century," *RES: Anthropology and Aesthetics*, no. 26 (Autumn 1994): 80. As Bindman notes, "… if knowledge and reason offered the possibility of classifying all forms of nature … it could also allow for the codification of blacks as inferior beings …."

18 David Bindman with contributions from Bruce Boucher and Helen Weston, "Introduction," *The Image of the Black in Western Art*, vol. 3, *From the "Age of Discovery" to the Age of Abolition*, part 3, *The Eighteenth Century* (Cambridge, MA and London: Belknap Press of Harvard University Press in collaboration with the W.E.B. Dubois Institute for African and African-American Research and the Menil Collection, 2011), 7. For example, Claude Nicolas Le Cat's *Traité de la couleur de la peau humaine en général, de celle des nègres en particulier* (Amsterdam, 1765) addresses the "problem" of black skin color. Much of the *Encyclopédie* entry on "Nègre" is devoted to the causes of black skin color and hair texture; see Johann Heinrich Formey, "Nègre" in the *Encyclopédie* of Diderot and d'Alembert.

19 Davis, "La réification," 251–3; Bindman, *Ape to Apollo*, 11, 30–34; see Jean-Léon Hoffmann, *Le nègre romantique* (Paris: Payot, 1973), chapter on Enlightenment, 49–98, for literary tropes of the innocent, unspoiled African.

20 Curran, *Anatomy of Blackness*, 76.

21 Garraway, *Libertine Colony*, 213.

22 Dubois, *Colony of Citizens*, 104.

23 Ibid., 73.

24 Doris Garraway, "Race, Reproduction, and Family Romance in Moreau de Saint-Méry's *Description … de la partie française de l'isle de Saint-Domingue*," *Eighteenth-Century Studies* 38, no. 3 (Winter 2005): 230. See also Garraway, *Libertine Colony*, 260ff.

25 Joan Dayan, "Codes of Law and Bodies of Color," *New Literary History* 26, no. 2 (Spring 1995): 299.

26 Hilliard D'Auberteuil, *Considérations sur l'état présent de la colonie française de Saint-Domingue*, vol. 2 (Paris: Chez Granger, 1777), 88. Quoted in Yvonne Fabella, "Inventing the Creole Citizen: Race, Sexuality, and the Colonial Order in Pre-Revolutionary Saint-Domingue" (PhD diss., Stony Brook University, 2008), 45.

27 Vincent Brown, in Thomas Bender, Laurent Dubois, and Richard Rabinowitz, eds., *Revolution! The Atlantic World Reborn* (New York and London: New-York Historical Society in association with D. Giles Limited, 2011), 181.

28 Sam Margolin, "'And Freedom to the Slave': Antislavery Ceramics, 1787–1865," *Ceramics in America 2002* (Hanover, NH and London: Chipstone Foundation, distributed by University Press of New England, 2002), 81.

29 Daniel P. Resnick, "The Société des Amis des Noirs and the Abolition of Slavery," *French Historical Studies* 7, no. 4 (Autumn 1972): 560. See also Miller, *French Atlantic Triangle*, 254.

30 Miller, *French Atlantic Triangle*, 85, "politics of pity"; see *Adresse à l'Assemblée Nationale pour l'abolition de la traite des noirs par la Société des Amis des Noirs, février 1790* (Paris: l'Imprimerie de L. Potier de Lille, 1790).

31 "… republican racism: an abolitionist version of the history of slavery became a vehicle for justifying continued racial exclusion." See Dubois, *Colony of Citizens*, 182. A longer discussion of this phenomenon is in Dubois, "Republican Racism and Anti-Racism: A Caribbean Chronology," in Herrick Chapman and Laura L. Frader, eds., *Race in France: Interdisciplinary Perspectives on the Politics of Difference* (New York: Berghahn Books, 2004), 23–35. For the Société des Amis des Noirs' agenda about abolishing the slave trade and "softening" slavery, see Pétion de Villeneuve and Brissot de Warville, *Adresse à l'humanité par la Société des Amis des Noirs sur le plan de ses travaux* (Paris: L'Imprimerie du Patriote François, 1790), 1. For negative views of Africans and slaves, see Claude Wanquet, "Un 'Jacobin' esclavagiste, Benoît Gouly," in the same volume, 444–68; and *Observations pour servir aux différens faits avancés par les prétendu Amis Des Noirs … par les capitaines du Havre de Grace, navigans de la côte d'Afrique* (1790).

32 On the Amis' notions of the benign character of slaves and the colonization of Africa, see Michel Dorigny, "La Société des Amis des Noirs et le projet de colonization de l'Afrique," in Société des Etudes Robespierristes, *Annales historiques de la Révolution française* (Paris: Société des Etudes Robespierristes, July–December, 1993), 425.

33 Curran, *Anatomy of Blackness*, 180.

34 Condorcet, *Réflexions sur l'esclavage des nègres … par M. Schwartz* (Neufchatel: La Société Typographique, 1781), 15. Author's translation.

35 These include Voltaire's *Candide*; in the 1787 edition, an image of a partially dismembered slave says to two European men, "C'est à ce prix que vous mangez du sucre en Europe" (It's at this price that you eat sugar in Europe). The multiple volumes of Guillaume-Thomas Raynal's *Histore des Deux Indes*, first published in 1770, similarly contain scenes designed to elicit pity for the plight of slaves, such as an image of slaves being beaten and brutalized by slave traders at a slave market.

36 "La planche première représente un voyageur occupé à décrire des coquillages, des plantes, des cartes marins, etc. Un nègre suppliant lui montre le 'Code Noir': on voit à ses pieds les instrumens de l'esclavage …" (The first picture represents a traveler occupied with describing shells, plants, marine maps, etc. A supplicating negro shows him the "Code Noir"; we see at his feet the instruments of slavery …).

Bernardin de Saint-Pierre, *Voyage à l'isle de France*, vol. 1 (Amsterdam and Paris: Chez Merlin, 1773), 277. Author's translation.

37 Lynn Festa, *Sentimental Figures of Empire in Eighteenth-Century Britain and France* (Baltimore: Johns Hopkins University Press, 2006), 165; Sarah Watson Parsons, "The Arts of Abolition: Race, Representation, and British Colonialism," in Byron R. Wells and Philip Stewart, eds., *Interpreting Colonialism* (Oxford: Voltaire Foundation, 2004), 345.

38 In addition to Festa and Parsons, the power relations implicit in this image have been addressed by Darcy Grimaldo Grigsby in "Food Chains: French Abolitionism and Human Consumption (1787–1819)," in Dian Kay Kriz and Geoff Quilley, eds., *An Economy of Colour: Visual Culture and the Atlantic World* (New York: Manchester University Press, 2003), 156.

39 On black people in literature in this period, see Hoffmann, *Le nègre romantique*, 101ff. On representations of blacks in the French theatre, see Sylvie Chalaye, *Du noir au nègre: L'image du noir au théâtre* (Paris: Harmattan, 1998).

40 Each figure represents a ratio of one body to a ton of human cargo. See Cheryl Finley, "Committed to Memory: The Slave Ship Icon in the Black Atlantic Imagination" (PhD diss., Yale University, 2002), 54.

41 Ibid., 128.

42 Ibid., 130; Marcel Chatillon, "La diffusion de la gravure du *Brooks* par la Société des Amis des Noirs et son impact," in Serge Daget, ed., *De la traite à l'esclavage: Actes du Colloque international sur la traite des Noirs, Nantes, 1985*, vol. 2 (Paris: L'Harmattan, 1988), 139–40.

43 Similarity also noted by Davis, "La réification," 240.

44 " ... l'aisance de la tranquilité des Nègres qui reposent à l'ombre de leur feuillange épais...lui présentent le tableau du monde dans son état primitif." Frossard is referring to the first-hand observations of naturalist Michel Adanson. Author's translation. Benjamin Frossard, *La Cause des Esclaves Noirs*, vol. 1 (Lyon: Imprimerie de la Roche, 1789), 156.

45 " ...quoique sans gouvernement réglé, sans arts, sans civilisation, vivoient dans la paix and dans l'abondance." Author's translation. Ibid., 118.

46 "Si quelques-uns sont lâches, vindicatifs, trompeurs dans le commerce...ce n'est point à la nature, c'est aux Européens qui'ils doivent ces vices." Author's translation. Ibid., 149.

47 Quoted in Curran, *Anatomy of Blackness*, 119.

48 Quoted in Curran, ibid., 107–18.

49 Quoted in Emmanuel Chukwudi Eze, ed., *Race and the Enlightenment* (Cambridge, MA: Blackwell, 1997), 19.

50 Quoted in Curran, *Anatomy of Blackness*, 119.

51 Festa, *Sentimental Figures*, 167, 170.

52 Lugo-Ortiz and Rosenthal, *Slave Portraiture*, 7.

53 Joan Landes, *Visualizing the Nation* (Ithaca, NY and London: Cornell University Press, 2001), 36.

54 Robert Darnton and Daniel Roche, eds., *Revolution in Print: The Press in France 1775–1800* (Berkeley: University of California Press, 1989), 224; Jeremy D. Popkin,

Revolutionary News: The Press in France, 1789–1799 (Durham, NC: Duke University Press, 1990), 102; Rolf Reichardt and Humbertus Kohle, *Visualizing the Revolution: Politics and Pictorial Arts in Late Eighteenth-Century France* (London: Reaktion Books, 2008), 37.

55 Reichardt and Kohle, *Visualizing the Revolution*, 41.

56 Dubois, *Colony of Citizens*, 74; Garraway, *Libertine Colony*, 214; Garrigus, *Before Haiti*, 142.

57 Garraway, *Libertine Colony*, 237; Garrigus, "Colour, Class, and Identity on the Eve of the Haitian Revolution: Saint-Domingue's Free Coloured Elite as *Colons américains*," *Slavery and Abolition* 17, no. 1 (1996): 26.

58 Garraway, *Libertine Colony*, 214–15.

59 Dubois, *Colony of Citizens*, 104. Ogé was accused of starting a revolt on Saint-Domingue in 1790, for which he was tortured and killed.

60 The Bibliothèque nationale dates the print to 1794, and Dubois places it in 1791 (Dubois, *Colony of Citizens*, 103). Other features that support the 1791 date are the banishment of "disorder and insurrection" as described in the caption below the image, which refers to the hope that granting these rights would quell any plans for a slave rebellion. However, just a few months later, a massive, organized slave revolt broke out on Saint-Domingue, dashing hopes of peace in the colonies. It is unlikely that a print produced in 1794 would ignore the rebellion, not to mention the national decree of abolition passed in February 1794, unless it had been produced before February.

61 Julien Raimond, *Observations sur l'origine et les progrès du préjugé des colons blancs contre les homes de couleur* (Paris: Dessene, Bailly, 26 janvier, 1791), 7.

62 Blackness as appearance is discussed by David Bindman and Henry Louis Gates Jr. in "Preface to *The Image of the Black in Western Art*," in *Image of the Black*, vol. 3, part 3, xvi.

63 Dayan, "Codes of Law," 298–9.

64 The first date is supplied by the Bibliothèque nationale and the other by Dubois, *Colony of Citizens*, 223–4. The round shape of the print suggests that it may have been intended for the lid of a container. See Reichardt and Kohle, *Visualizing the Revolution*, 130.

65 *Dictionnaire de l'Académie française*, 4th and 5th editions, ARTFL Project, University of Chicago, available at http://artfl-project.uchicago.edu/.

66 Dubois, *Colony of Citizens*, 223.

67 These prints were first produced in 1794 at the Depeuille print shop and widely disseminated by the Socété des Amis des Noirs. See Davis, "La réification," 244–5.

68 Boizot was the director of the Sèvres porcelain manufactory from 1773 to 1800; in 1794 he created a porcelain figure group titled *Moi égale à toi, moi libre auusi*, depicting a pair of two young freed slaves.

69 Davis makes a similar observation. However, she interprets these similarities as an expression of egalitarianism rather than one of colonial mimicry. See Davis, "La réification," 244.

70 Bindman, *Ape to Apollo*, 17.

71 Lugo-Ortiz and Rosenthal, *Slave Portraiture*, 8.

72 Homi Bhabha, *The Location of Culture* (London and New York: Routledge, 1994), 122.

73 *Archives Parlementaires*, vol. 84 (Paris: CNRS, 1962), 277. Author's translation.

74 Susan H. Libby, "'A Man of Nature, Rescued by the Wisdom and Principles of the French Nation: Race, Ideology, and the Return of the Everyday in Girodet's Portrait of Belley," in Alden Cavanaugh, ed., *Performing the Everyday: The Culture of Genre in the Eighteenth Century* (Newark: University of Delaware Press, 2007), 117. For a comprehensive discussion of this painting, see Sylvain Bellenger, *Girodet 1767–1824* (Paris: Gallimard and Musée du Louvre Editions, 2005), 322–35.

75 Hal Foster, "The 'Primitive' Unconscious in Modern Art," *October* 34 (Autumn 1985): 49. By "primitive," Foster is referring to art, not people; however, the term as it relates to European conceptions of black people is also applicable in this context.

US and THEM: Camper's odious *ligne faciale* and Géricault's beseeching black

Albert Alhadeff

... le cri des africains

From the start, Géricault's *Raft of the Medusa* inspired controversy: its scale was unacceptable, its title misleading, it lacked color, it was poorly drawn, its figures were too massive, too gross, hideously scattered about its boards, a feast for carrions, for "vultures,"[1] to quote a petulant voice. Moreover, the *Raft* was exasperatingly short on rhetoric, pedigree, and pedagogy. The spokesmen for the *beau idéal* sought a body of comely nudes, but found to their dismay a clutch of prostrate and desperate castaways, survivors from the wrecked *Medusa* (Figure 3.1).[2]

When prominent Restoration critic Gault de Saint-Germain, using the obsequiously familiar second person pronoun, gruffly snapped at Géricault's colossal canvas with the query, "Tableau, que me veux tu?"[3] (Hey canvas, what do you want from me?), he was addressing the canvas as an irate master would address an underling, a servant, or his slave—disrespectfully, impatiently, dismissively. Why should he do otherwise? Géricault's transgressions were outrageous. The most egregious breach of all was his canvassing blacks—Negroes the press chose to ignore! Of the numerous reviews of 1819 which appraise the *Raft* none take note that blacks play a role in the canvas.[4] The press's cryptic silence might be summarized as: left unspoken then forgotten. But this was not Géricault's way. Ultimately, he allowed the blacks on the *Raft* to mingle with whites, he gave them voice, even assigned them leading roles![5] These were offenses the Salon's watchful arbiters could hardly forgive. After all, we cannot forget the prevailing racial codes of Géricault's day, entrenched codes that guided visual representations and that strictly defined interactions between blacks and whites.

Albeit different in pose and magnitude of importance, the blacks peopling Géricault's raft (and there are three in all!) share a robust presence, a sturdy mien that belies their plight as men of color, the abuses they and their kin,

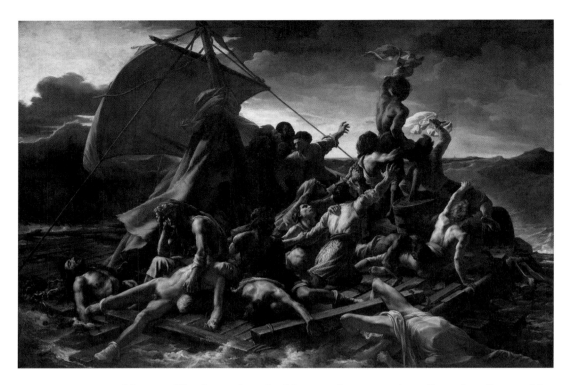

3.1 Théodore Géricault, *The Raft of the Medusa*, 1819. Musée du Louvre © RMN-Grand Palais / Art Resource, NY

Negroes like themselves, had known for generations. Long handicapped by ingrained prejudices nourished by self-righteous bigots—racists, pedagogues with their learned sciences, and apologists for *la traite* (the slave trade, that onerous exchange in human flesh that abased blacks and whites alike)—dark-skinned men, women, and children were literally whipped into submission as the Bourbons promoted their duplicitous racial policies, positions that at once outlawed and yet advanced the slave trade.[6] Géricault painted his *Raft* when a thirst for slavery seemed unquenchable. By the time the Salon Carré hosted Géricault's *Raft*, *le cri des africains*[7] was muffled at best. Barely audible, the anguished cries of untold slaves were dismissed as they themselves were dismissed as expendable goods, chattel marked for profit. Yet although blacks were reviled before, during, and after the Restoration and the on-and-off reign of Louis XVIII, Géricault's images of men of dark skin, as studies for the *Raft* demonstrate, neither palliate their plight nor favor them. On the contrary, washes, oils, and pen-and-ink studies that lead up to the final canvas often demean black men and convey late eighteenth-century sentiments reducing Negroes, an abject people of dusky color, to liminal sightings. By examining Géricault's reconfigurations in certain critical studies for the *Raft*, our awareness of the mixed signals and contradictions that define his response to men of dark skin grows proportionately. This analysis, then, attempts to lay bare Géricault's entanglements with race, his sensitivities to the racial codes that affected his cohorts and the dominant structure they navigated.

Conscious of his culture's demeaning views of blacks, views, I trust, he never consciously formulated, Géricault, in time, through several demonstrable shifts, came to terms with their denotations. Ultimately, as the *Raft* confirms, he freed himself from their grasp. This struggle, then, and its evolution, is of uppermost concern to us.

To generalize on Géricault's racial views is a hazardous enterprise, and one not always welcome. Who is to know the truth on accusations that cannot be seen or weighed? As a member of the upper classes, at ease with wealth and ready to be served by dark-skinned figures,[8] we can surmise with a modicum of certainty that Géricault shared his peers' preconceptions and biases towards people of color. But where disinterest, tempered with a strong dose of racist hauteur, defined his stance at first, Géricault did shift his course: it is certain that as his work on the *Raft* progressed his views towards blacks evolved— from insouciant acceptance to impolitic qualms, from passive indifference to a bold, assertive, confident reassessment of blacks. Concomitant with this reappraisal are new determinations, benchmarks, norms. Questions arise; troubling questions he might have welcomed. Amongst these, Géricault might have considered his own semblance to blacks. Were blacks like himself and other whites? Were they a different species of mankind—a different order? And, if not, must they all be relegated to slavery, bound as merchandise is bound, institutionalized property? Surely these queries were far from rhetorical. Or, again, he might have worried over their negritude: what were their virtues or were they in fact mere detritus, chattel to be purchased, to be used, wasted? The *Raft* in its final form pursues these questions and ultimately accepts certain resolutions. Critics must have known this, for their responses to his work, even in the midst of encouraging reviews, were often hostile. Géricault's probings and ultimate findings offended all those who believed blacks were below the "norm"—the norm as whites defined it. Our task then is clear: to review and track Géricault's determinations on blacks, and particularly, as his work evolved on the *Raft*, on the beseeching black by the mast, a figure who in Géricault's initial studies proclaimed the triumph of Camper's *ligne faciale* … but here we best pause and explain.

Camper's *ligne faciale*

Let us begin with certain pedagogical treatises that argue through the science of phrenology and craniology that blacks are inferior to whites. With dissections, case studies, and empirical observations to further their views, late eighteenth-century doctors, physiologists, and anatomists—Petrus Camper, Franz Joseph Gall, Johann Friedrich Blumenbach, Johann Caspar Lavater, to cite some of the key figures in our study[9]—wove an unassailable web attesting to the indomitable place of whites in history; contrariwise, blacks, they said, are but a step above primates, orangutans in particular … wantonly cruel speculations Géricault's generation hardly challenged.[10]

Not unlike his peers and their publications in the early 1800s, whether social scientists like Julien-Joseph Virey (1775–1847) or men of science like Camper (1722–89), Géricault denigrated blacks, a position that was recently spelled out by Albert Boime in his immensely informative study on Géricault and blacks: "Géricault assumed 'the white man's burden' by aligning himself with a liberal elite who acted paternalistically on behalf of blacks. He and his colleagues were unable to conceive of blacks as capable of ordering their own lives outside the institutionalized ravages of slavery."[11] The liberal elite Boime had in mind found their voice in the membership of the Société des Amis des Noirs (founded in 1788), men influenced by the ambiguous ideals of the *philosophes* at the end of the eighteenth century.[12] Their seal depicts a kneeling black man in profile, bound and tethered, his gestures constrained by the irons on his ankles and wrists. Even racists like Julien-Joseph Virey would not deny his degradation. Virey, a naturalist and apologist for *la traite*, paints such a horrid picture of blacks encumbered by chains that he felt it necessary to warn his readers that the picture he was about to draw of the trans-Atlantic trade in human flesh "makes one shudder."[13] Writing for the much-quoted *Dictionnaire des sciences médicales* for 1819, the year of the *Raft*, Virey's 54-page essay on *le nègre* states that once blacks from West Africa were brought to markets from the interior—with wooden forks clamped to their necks to hold them at bay[14]—they were pressed into the holds of *négriers* (slave ships) in such numbers that it was "impossible for them to even turn around with their shackles"[15]

With slavery a repulsive and repugnant sight, the Société sought to abolish the slave trade but not slavery itself. Blacks, given their abject condition, could not be set free. As the Société espoused in a writ from 1790, blacks were seen as "useless and helpless beings, children in their cribs."[16] Voltaire, like other *philosophes*, shared this view and was outspoken on the matter. Nothing, however, highlights the Société's ambivalence towards blacks more than the shibboleth that bordered the Société's seal: *Ne Suis-Je Pas Ton Frère?* (Am I not your brother?)—a troublesome question strikingly revealing in its indecision, echoing the Société's own irresoluteness. But these vacillations were not unique. Likewise, the *Raft* irresolutely swayed back and forth: though it ultimately elevates blacks (and does so quite literally), its narrative shifted as his studies evolved, thus where he initially demeaned and disparaged men of dark skin, the *Raft* in its final form champions them.

An early pen sketch for the *Raft*, currently in Lille,[17] shows a black man at one end of the raft whose pose echoes the Société's engraved emblem. As the Société's Negro kneels and pleads, his hands clasped before him, so Géricault's black kneels and pleads, his hands clasped before him. But the correspondence between the two tearful blacks does not end here. The speaker who cries out—*Ne suis-je pas ton frère?*—is as powerless as Géricault's supplicant. Each is grievously exposed. As bystanders to their own ordeal, uncertain of their fate, they are painfully vulnerable; one prays for his rescue; the other that someone will acknowledge his bonds with his fellow men, will see him as his *frère*, and rescue him from his ordeal.

The Société's paternalism places the recipient of its attention in a servile position, a position which the Société des Amis des Noirs, with its belief in the elite reign of whites, found inevitable.[18] Before ineffectual and retiring blacks, the members of the Société des Amis des Noirs and its descendent, the Société de la Morale chrétienne, professed the Christian view that whites should shield blacks from their own ineptness. Virey earnestly argued the same: *Tendons au faible une main protectrice* (Let us extend a hand to the weak) and thus "help them rise to an honorable rank."[19]

With blacks "favoring indolence to activity, it's only natural for them to be led than for them to lead others," and as Virey continues, "they seem to be born to obey rather than to dominate."[20] With a venomous pen, and relying on eighteenth-century precedents from Voltaire to Montesquieu to Condorcet, Virey does not hesitate to elaborate on the differences between blacks and whites. His examples are numerous and they often go on for pages, but we can cite only a few:

If we [whites] aspire to glory, to grandeur, to fortune, blacks prefer indolence ... Work is more insupportable than misery, and they only work as a last extreme. Europeans must have goods ... a thousand luxuries and commodities; all his life he tries to grow, to better his existence; he would like to probe the universe, which denotes the boundlessness of his soul and the restlessness of his ambitions which gnaws at him and elevates him above the vulgar: blacks, on the other hand, stay as they are ... We have a boundless ardor for change, for novelty: blacks aspire to rest; our delights are for him pain, and apathy, which for us is a terrible thing, is for him pure delight.[21]

This sample of inspired racism, was not, for Virey, the product of his imagination or even the product of his own direct observation. It was, he tells his readers, based on treatises by men of science. It was science itself. To understand such "science," it is best we turn the clock back to 1801 and to Virey's influential tome on the *Histoire naturelle du genre humain*, a two-volume study which attempts to break down humanity into five types or genres.[22] Needless to say, the highest or most elevated genre is manifested in the European genre; and amongst the lowest lies *les peuplades de nègres* (Negro people)—imperfect "eunuchs,"[23] in Virey's words, when it comes to the hierarchy of civilized men. In turn, these genres and their hierarchies are based upon certain studies, scientific pronouncements propounded, as Virey proudly informs his readers, by *le celèbre P. Camper*,[24] the Dutchman Petrus Camper, artist, physiologist, and anatomist *par excellence*.

Virey knew his Camper well. In Camper's study exploring the laws of beauty, the Dutchman discovered, as Virey wrote, that beauty is directly affected by "different facial inclinations"[25]—that is to say, by the prognathic extensions of a subject's jaw and the slant of her or his forehead. Strange as this may seem to the modern reader, its veracity was (in general) never questioned by Virey and his generation. Although Camper took pride in his anatomical experiments and dissections, he viewed himself as an artist. His writings abound with references to art theorists and artists, from Lomazzo to Durer,

Caylus, and Winckelmann, not to mention the ancients—Myron, Pliny, Cicero, Lysippus, and others. His observations on angled foreheads were written with a pedagogical intent, namely to instruct artists in "sketching heads, national features, and portraits of individuals, with accuracy."[26] His remarks, which had great currency in France, were ostensibly written to facilitate the art of drawing by stressing rules he viewed as universally applicable. His thesis, *Dissertations physiques sur la différence réelle que présentent les traits du visage chez les hommes de divers pays*, first published in Dutch in 1782 and subsequently in French and English in 1791 and 1794 respectively, is replete with heartfelt injunctions imploring his readers to follow his arcane calculations and thus to concur with his observations, principles and computations. One such set of mystifying numbers elucidates his methodology:

The facial line M G. made also an angle of 70 degrees with the horizontal line N D.
N C compared with C D was as 7¾ to 8, or as 31 to 32.
EC : CF : 8½ : 5, or as 17 : 10.[27]

Daunting arithmetic!

As a craniologist, Camper had not only dissected cadavers to arrive at his numbers, he had also assembled a wide spectrum of heads to corroborate his views. Thus, with candid objectivity, Camper could observe: "The two extremities therefore of the facial line are from 70 to 100 degrees, from the Negro to the Grecian antique; make it under 70, and you describe an ourang or an ape"[28]—a welcome conclusion for all those who sought to strengthen their *a priori* conviction of the superiority of the white race over all others. Nowhere is this more evident than in his overlapping diagrams of a white man's head over a black man's, as seen in his text (Figure 3.2).[29]

Camper's theories were not universally accepted.[30] Nonetheless, in spite of all opposition, Camper's views found welcome champions in Lavater[31] and in Virey. With Camper's numbers shaping his own, Virey then posits the following argument: as a black man's facial angle "squeezes" and draws to a point, his "muzzle" (Virey favors the word *museau*, a noun normally applied to animals) lengthens, recalling "ignoble and stupid brutes,"[32] thus likening blacks to forest monkeys, orangutans.[33] Virey's "enlightened" logic grows ever more offensive as he draws *d'après Camper* a black with a shaved head and an extended jaw.[34] Bracketed by the head of an orangutan and a *profil de l'Apollon* in a columnar arrangement (Figure 3.3), Virey's bald Negro pales in comparison with that with which he is paired: he is too close to the prognathously jawed monkey below him to dispel the inevitable similarities between himself and his simian counterpart, and he is too far from the sharply profiled Apollo above him for his features not to be disparaged.

Time only strengthened Virey's racist convictions.[35] By 1819, with Virey's lengthy essay on *le nègre* in print, white dominance over blacks is reiterated *ad absurdum*. With the certitude of the inferiority of blacks confirmed by the cranial limitations of their race,[36] Virey does not hesitate to remind us that as

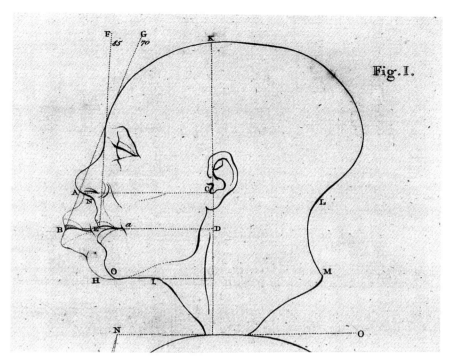

3.2 "Superimposed
Heads Showing
the Comparative
Structures of a
European and an
African Profile,
Metamorphosis
of a Black Man
into a White Man
and Vice Versa,"
1794, from *The
Works of the Late
Professor Camper
on the Connexion
Between the Science
of Anatomy and the
Arts of Drawing,
Painting and
Statuary* (1821)

a man of science, he had poured liquids into the skulls of whites and into the skulls of blacks to compare how much they could hold, only to note "that in the latter there were as much as nine ounces less of [liquid] than in the skulls of the Europeans”[37] Hence, Virey's unstated but inevitable conclusion: the cavity of a black man's cranium is too limited to pour any sum of knowledge into it.

And so it comes as no surprise that when Virey published another long essay on blacks in 1824—the 1819 essay expanded into a full-blown volume coupled with impressive color plates—he includes an image of an antique sage in another vertical rise where a black man sits at the center of the construct and a monkey with an extended jaw at its base (Figure 3.4);[38] clearly the massive Greco-Roman head with its cascading hair, 90-degree brow, and ample curls, overpowers the black man directly below him who, with his vaulted brow, underscores what his *ligne faciale* says: namely, that he and his brethren are not unlike the prognathic unassuming simian set beneath him.

While the plates of 1801 (Figure 3.3) and 1824 (Figure 3.4) share a columnar construction of profiled heads with an *orang*'s head at their base, there are significant differences between them: the *Pythian Apollo* is absent from the 1824 version, as is the profiled Negro with his shaved skull and slanted forehead; in their stead stand a white elder and a black with kinky hair. The white denotes command and capacious learning. His noble features overpower (by comparison) the black below him who gives way before the authority of the Jovian head above him. Just look, Virey seems to say, as he enlists one more plate to his cause, one that compares the skull or *crâne* of an Apollo with the

Pl. IV. T. II. P. 134

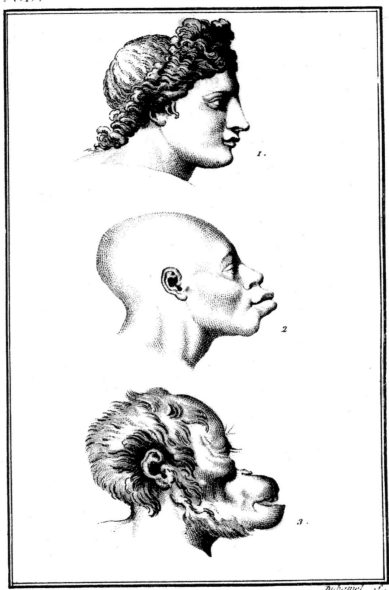

1. Profil de l'Apollon. 2. celui du nègre.
3. celui de l'Orang-outang.

3.3 "Columnar Rise of Heads in Profile, with Head of Apollo, that of a Negro and an Orangutan," from Julien-Joseph Virey, *Histoire naturelle du genre humain. Recherches sur ses principaux fondemens physiques et moraux*, vol. 2 (1821)

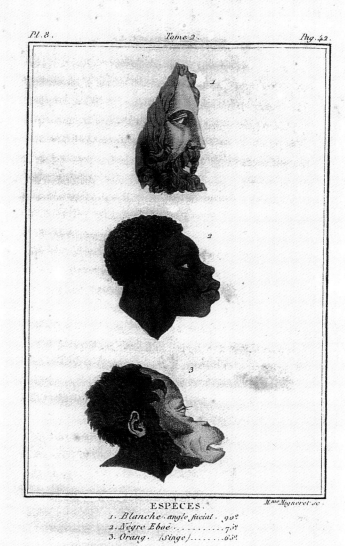

3.4 "Columnar Rise of Heads in Profile, with Head of White Man, a Negro
and an Orangutan," from Julien-Joseph Virey, *Histoire naturelle du genre humain.*
Recherches sur ses principaux fondemens physiques et moraux, vol. 2 (1824)

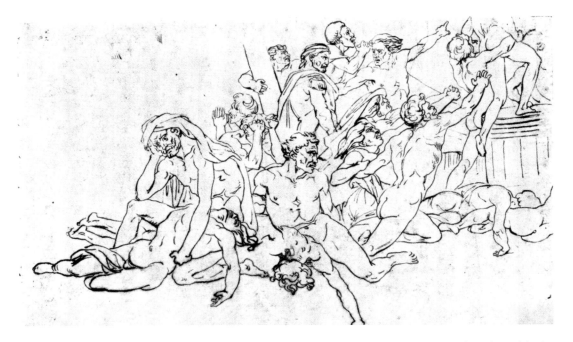

3.5 Théodore Géricault, *Study for the Raft of the Medusa*, formerly with the Bühler Collection, Winterthur, Switzerland. Private collection, location unknown

crâne of a negro and of a monkey, and you will know exactly where blacks belong in the scale of things![39]

Might Géricault have been swayed by such views? Two highly finished studies for the *Raft* at the Louvre and at Winterthur—depicting a beseeching black man standing with two of the canvas's lead actors by the mast—ostensibly support the argument that Géricault was actively engaged in issues of racial typology. To focus on one of our two images, we can turn to the more detailed study from Winterthur (Figure 3.5).[40]

Given the raft's graphic narrative, a decisive moment is unfolding: Corréard, a vocal protagonist in our story, is informing his cohort, Savigny, an assistant surgeon, that their ordeal is all but over.[41] With his left arm extended towards the horizon line, Corréard informs Savigny that rescue is imminent: after 13 grueling days at sea, a brig hovers in the far distance. But Corréard's declaration is selective: the object of Corréard's address is the surgeon Savigny, while the black at his side, the capstone of the trio, is ignored.[42] In short, Corréard's bold gesture frames parameters that exclusively include and exclude, parameters marked by the skin color of our protagonists.

Before us, then, lies an apparently untenable situation: a figure, a black, framed by two whites, has literally been elevated above his cohorts yet is overlooked by them, glossed over. The problem is not that our two light-skinned figures disparage the beseeching black between them, pleading, hands clasped. The problem is one of insouciant neglect: Corréard and Savigny are blithely unaware of the black between them. Ostensibly, given their dynamics, he is not there, not even present—and this in spite of the fact that he caps the pyramid they form. Admittedly, our apical black is himself distracted

(his gaze is focused on the distant horizon) and this in turn allows us to surmise that he is as neglectful of them as they are of him. A *quid pro quo* is at play. Still, legitimate questions arise. Of the possible queries that come to mind, we might ask the following: what if the black standing by the whites at the mast were expunged from their midst, from their tight unit? Since neither party is aware of the other, we might plausibly consider his demise. Is he expendable? Could he be effaced, done away with? A tantalizing conjecture. After all, if he were not there, would the narrative be affected? Would Corréard and Savigny miss him? Would anyone?

Let us pause and review our position: the third figure in our pyramidal grouping is isolated from the other two. A paradox is thus at hand: the black by the mast is there but is not, is engaged but is not. But then why should Géricault keep him at bay from the men who frame, define, and accent his person? True, it is self-evident that in any threesome, two figures can be engaged in a dialogue without ostracizing the one who is not, stamping him as unwanted. But what allows us to focus on this pretermission is our understanding of the historical situation: it is not too much to say that men of color, disparaged for their dark skin in Géricault's day, were at once superfluous and suppressed. One could neither entertain nor acknowledge their presence. The black by the mast then, as the Louvre and Winterthur pen studies attest, is in effect absent—absent even when present, a troubling fact Géricault's pen underscores.

Indeed, Corréard and Savigny may well have had their reasons for distancing themselves from the black between them (differences of class, for example, come to mind)—one cannot discount the fact that they (or Géricault) may well have ignored him because his facial features and the color of his skin confirm his thralldom.[43] Inevitably, we are drawn to a racist conclusion: whites tend to favor whites, an equation that foregrounds Virey's callous observation disclaiming any semblance of equality between the races as a grotesque delusion; an *egalité chimérique* (a chimeric bond)[44] is how he phrased it—a sentiment that defines the 1820s *per se*.

Undoubtedly, the dissemination of Camper's theorems and Virey's subsequent publications shaped Géricault's vision of the beseeching black by the mast. If proof were needed that Géricault envisioned his prayerful black as our craniologists envisioned him, a being of limited intelligence and a few facial degrees above monkeys, one might transpose—as I do here with a little help from modern technology, collage and *decoupage*—Virey's black man from his 1801 study (Figure 3.3) for Géricault's beseeching black man from Winterthur (Figure 3.5). Once Géricault's Negro finds his place in Virey's vertical rise, we may conclude with certainty that our artificial reconstruction (Figure 3.6) of Virey's calumnious construction is embarrassingly apt; one *ligne faciale* substitutes for another, one prognathous jaw for another. Its discomfitingly perfect fit argues that Géricault's image of a man of color can seamlessly stand for Virey's image of a man of color. And by effectively introducing Géricault's prayerful black in Virey's column, we find that Géricault depictions of blacks

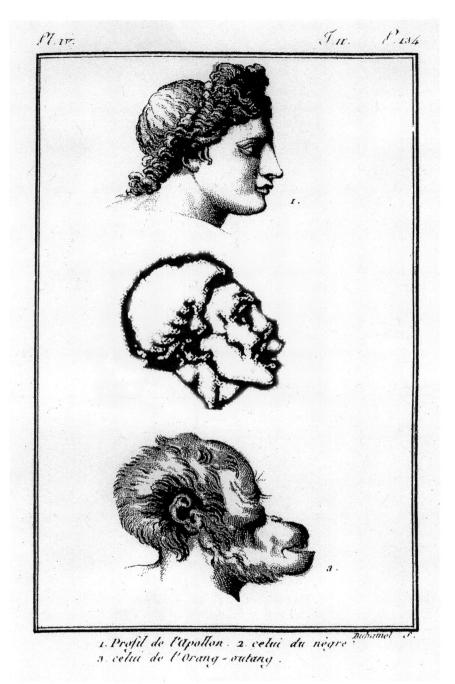

Pl. IV. T. II. P. 134.

1. Profil de l'Apollon. 2. celui du nègre.
3. celui de l'Orang-outang.

Duhamel S.

3.6 Adjusted "Columnar Rise of Heads in Profile" with head of a Negro by
Géricault inserted in Virey's "Columnar Rise of Heads in Profile"
from 1801 (compare Figure 3.3). Photo: author

reflects Virey's math, arguing, as Camper did, that the facial line of "blacks barely rise beyond 75 degrees"—a number that stresses the innate inferiority of the Negro race, an inferiority borne from cranial limitations.

On the other hand, Europeans' skulls literally brim with knowledge. Camper, Virey, and Géricault all seem to say so—all three, given our past remarks, favored a facial line for whites somewhere between 100 and 90 degrees. Turning to Géricault's Winterthur study (Figure 3.5), we see that Géricault conceived Savigny and Corréard with Camper's and Virey's injunctions in mind. Accordingly, Savigny's features, a man of distinction (in contradistinction to the other survivors, all naked, he is still wearing his uniform, epaulettes and all), are defined by a razor-sharp profile, a profile *all antica* whose sheer vertical drop recall Virey's glorious *profil d'Apollon* of 1801 (Figure 3.3) or his antique sage of 1824 (Figure 3.4), lucid silhouettes that denote study, authority and steadfastness, qualifiers proper to *les facultés intellectuelles* (the intellectual faculties) of a surgeon and, as Virey never tired of stating, of whites in general.

With these observations in mind, it is time we backtrack, pause, and focus once more on our canvas of 1819 and its unholy trio by the mast—Corréard, Savigny, and the black stationed between them (Plate 2). This black, drawn in three-quarter view in contradistinction to the sketches that preceded it, has lost his preeminent place at the triangle's apex. No longer exclusively linked with Corréard and Savigny, he has moved aside to leave room for a newcomer, a sturdy lad with swept-back hair, whose profiled face partially covers the swarthy Negro adjacent to his robust self.[45] Seeking salvation, warding off death, he and the black at his side scan the horizon for a passing vessel; their differences—differences of skin color and the aspersions that come in its train—have fallen by the wayside. Focusing on the dark-skinned figure, we see that Géricault neither silhouettes his profile nor accents his *ligne faciale à la* Camper. On the contrary, the defining features of the black from the Louvre and Winterthur studies now define the newly introduced brawny youth: seen from the side his profile, though pronounced, does not form a 90-degree thrust—on the contrary! And when the slope of his forehead, deviating from Camper's dictates, is paired against the same of his dark-skinned mate on his left, the pitch of the latter's forehead is the more pronounced. With this pairing, thus, Camper is denied. Then again, with our two figures baldly juxtaposed it is, or so I believe, especially revealing that the head of one party (the strapping youth) partially overlaps the head of the other (his black counterpart), a juxtaposition that alludes to Camper's oft-reproduced illustration of 1794 (Figure 3.2) where black and white profiled faces are overlapped. Here the white man's face covers the black man's visage with the former thus advancing his racial prognosis over the latter. Géricault is not as blunt or as coarse. But given his past treatment of the black by Corréard and Savigny's side, I believe that Géricault's coupling of the two races, black and white, should be seen against Camper's engraving. Whereas Camper's strict overlapping of profiled heads denigrates blacks, Géricault's tentative

overlappings disrupt racial codes: now the wind-swept youth is assigned a profile whose slant calls to mind men of dark skin, while the dark-skinned man at his side is assigned an all but acute profile. Camper's theorems thus witness a *tour de force*, an unexpected twist that redefines the *Raft*: what has been abased has been uplifted, and what was uplifted (dare we say!) abased. One thing is sure: if the canvas of 1819 does not perversely assign to whites what Camper had assigned to blacks, it reconciles the races and effaces their differences, and insists by their ironic rapprochement a syncretic linkage between blacks and whites that neither Camper nor Virey would or could accept.[46]

Virey, with his racist blinders, would have seen Géricault's juxtaposition as an aspersion, an affront to his prized "Celts."[47] Had he not favored the *Pythian* or *Belvedere Apollo* (Figure 3.3), a comely figure with unruffled coiffure in his 1801 *Histoire naturelle*? But the white profiled youth Géricault favored was anything but winsome; with his wind-blown, tousled hair and prominent cheekbones, his roughhewn face is the very antithesis of Virey's radiant *Apollo*, a being who in his perfection trumpets the infinite glories of his race over all others. This, in effect, is just what Géricault's young salt spurns. In fact, he not only rejects all elitist championing of races, he emphatically vetoes their claims. In short, it is not too much to say that Géricault's robust youth is Géricault's answer to Virey's ideal *Apollo*. Or, to phrase our thought somewhat differently, Géricault's stalwart stripling is for him what Virey's *Apollo* was for him. The lines were now drawn between "us" and "them" and Géricault was ready to reconcile the two.

Géricault's black is leagues away from the debased black Virey had drawn with such relish. No longer to be compared with orangutans, the black in Géricault's canvas, his forehead far from demonstrating the verity of Camper's analyses, stands by the lad at his side as his equal—who, we should note, has co-opted for his own the supplicating gesture—hands clasped before him, fingers intertwined—that Géricault had heretofore assigned to his beseeching black (Figures 3.5 and 3.6). Bruno Chenique, a most exacting student of the *Raft*,[48] however, sees here what as yet has not been observed in the literature, namely that the black by the hardy mariner laces his hands about the latter's in an *iconographie de fraternité* (an iconography of fraternity). As Chenique phrases it: "the Black's two hands clasp the wrists of the White man's joined hands."[49] Fraternity thus rules! In sum, once the subject of benign condescension, the black by the mast is now an immediate participant in the drama that is the *naufrage de la Méduse*. Where before, as with our Winterthur sketch (Figure 3.5), the black set by Corréard and Savigny was uncomfortably marginalized, excluded from the exchanges between the lead figures to his left and right, the black of the composition in its final format has joined his counterparts in their yearnings and anxieties. By thus thwarting racial expectations, Géricault's canvas is singularly unique for the early nineteenth century. No longer an ineffective ornament, a prop, or quaint garniture, our figure pins his hopes, like the whites at his side, on the pivotal nude at the forward-most end of

the *Raft*. But where the others are white, he, like the man who plays a central role in their salvation, is black.[50] No longer is he a hapless being, fodder for the slave trade, but whether exhausted or exalted, he is, like the others at his sides, a castaway at sea who yearns to be saved. In effect, a *volte-face* has taken place, one with totemic significance as it sets him free—and by implication all other blacks *per se*—from Camper's odious *ligne faciale*.

Notes

1 "[O]n dirait que cet ouvrage a été fait pour rejouir la vue des vautours." ("Beaux-Arts. Exposition de 1819," in the *Gazette de France*, no. 243, August 31, 1819, page 1050). The lengthy review, rich in angry retorts, can be read in full in Germain Bazin, ed., *Théodore Géricault: Etude critique, documents et catalogue raisonné*, 7 vols. (Paris: La Bibliothèque des Arts, 1987), 1: 43, document 140.

2 The shipwreck of the *Medusa* frigate in July 1816 has long fascinated maritime historians, students of the Restoration and Louis XVIII, and art historians. For most recent studies on the *Raft* see Gregor Wedekind and Max Hollein, eds., *Géricault: Images of Life and Death*, exh. cat., Schirn Kunsthalle Frankfurt, Frankfurt, 2014; for heretofore unpublished material see esp. Bruno Chenique, ed., *Géricault, au coeur de la création romantique. Etudes pour le Radeau de la Méduse*, exh. cat., Musée d'art Roger-Quilliot de Clermont-Ferrand, Clermont-Ferrand, 2012; Nina Athanassouglo-Kallmyer, *Théodore Géricault* (New York: Phaidon Press, 2010); Bruno Chenique, ed., *Géricault. La folie d'un monde*, exh. cat., Musée des Beaux-Arts de Lyon, Lyon, 2006; Albert Alhadeff, *The Raft of the Medusa: Géricault, Art and Race* (London: Prestel, 2002); Darcy Grimaldo Grigsby, *Extremities: Painting Empire in Post-Revolutionary France* (New Haven: Yale University Press, 2002). For a contextualized reading of the shipwreck, see Jonathan Miles, *The Wreck of the Medusa. The Most Famous Sea Disaster of the Nineteenth Century* (New York: Atlantic Monthly Press, 2007). For the *Raft*'s reception in England, see Christine Riding, "*The Raft of the Medusa* in Britain: Audience and Context," in *Constable to Delacroix, British Art and the French Romantics*, exh. cat., ed. Patrick Noon (Tate Britain, London, 2003), 66–73.

3 De Saint-Germain's galling impatience reflects classicist tropes. Hence his bitter irony: "J'y cherche la crainte, la douleur, le regret, l'ingratitude, l'espérance; le désespoir, je consulte, je médite, je demande sans cesse: tableau, que me veux tu?" For de Saint-Germain's impolitic query, see his *Choix des productions de l'art les plus remarquables exposés dans le Salon de 1819* in Bazin, *Théodore Géricault*, 1: 47, document 150; and Michael Marrinan, *Romantic Paris: Histories of a Cultural Landscape, 1800–1850* (Stanford, CA: Stanford University Press, 2009), 38.

4 The known reviews for the *Raft* were compiled in Bazin's multi-volume study on Géricault. See Bazin, *Théodore Géricault*, 1: 43–8. For a discussion of these reviews which passionately ran the gamut for or against the *Raft* see Albert Boime, *Art in an Age of Counterrevolution, 1815–1848* (Chicago: University of Chicago Press, 2004), 145–9; Bruno Chenique, *Les cercles politiques de Géricault (1791–1824)*, 2 vols. (Paris: Presses universitaires du Septentrion, 2002), 1: 360–373; Lorenz Eitner, *Géricault: His Life and Work* (London: Orbis, 1983), 197–201; Lorenz Eitner, *Géricault's Raft of the Medusa* (London: Phaidon, 1972), 57–61; Jean Sagne, *Géricault* (Paris: Fayard, 1991), 179–91.

5 Only recently have historians attempted to probe the rich historical lode that is Géricault and blacks. Among the richest veins is Albert Boime's study,

The Art of Exclusion: Representing Blacks in the Nineteenth Century (Washington, DC: Smithsonian Institution Press, 1990); also see Maureen Ryan's study "Liberal Ironies, Colonial Narratives, and the Rhetoric of Art: Reconsidering Géricault's Raft of the Medusa and the Traite des Nègres," in *Théodore Géricault. The Alien Body: Tradition in Chaos*, eds, S. Guilbaut, M. Ryan, and S. Watson, exh. cat., Morris and Helen Belkin Art Gallery, Vancouver, 1997; Grigsby's *Extremities* is also most rewarding in its pronouncements on blackness. And, finally, my own book, *The Raft of the Medusa*, is largely devoted to the question.

6 For a review of the endless machinations by Louis XVIII's ministers over the slave trade, see Boime, *Art in an Age of Counterrevolution*, 133–40; and Alhadeff, *Raft of the Medusa*, 131–7. For a classic discussion of the problem, see Serge Daget, "L'abolition de la traite des Noirs en France de 1814 à 1831," *Cahiers d'études africaines* 11, no. 41 (1971): 14–58.

7 I draw this phrase directly from Thomas Clarkson's influential study, *Le cris des africains contre les européens, leurs oppresseurs, ou coup d'oeil sur le commerce homicide appelé, traite des noirs* (London: Harvey and Darton, 1822). For a detailed critique of Clarkson's study, see Michel Erman and Olivier Pétré-Grenouilleau, *Le cris des africains, regards sur la rhétorique abolitionniste, une étude à partir des textes de Thomas Clarkson …* (Paris: Editions Manucius, 2009). For an introduction to Clarkson and the abolitionist movement, see Adam Hochschild, *Bury the Chains: Prophets and Rebels in the Fight to Free an Empire's Slaves* (Boston: Houghton Mifflin, 2005).

8 For an informed review of Géricault's upbringing, see Athanassoglou-Kallmyer, *Théodore Géricault*, 14–26; Géricault's bond to his personal servant Mustapha, a dark-skinned Turkish man, is aptly discussed in Grigsby, *Extremities*, 161–2. Mustapha himself was deeply attached to his master, as his grief at Géricault's funeral testifies: "On remarqua beaucoup dans le cortége un homme en costume oriental qui suivait en sanglotant, et qui, selon l'usage de son pays, portait dans un pan de sa robe de la cendre dont il se jetait des poignées sur la tête en signe de deuil. C'était Moustapha …." Cited in Charles Clément, *Géricault: Etude biographique et critique avec le catalogue raisonné de l'oeuvre du maître* (New York: Da Capo, 1974), 252–3.

9 The list goes on: Geoffroy Saint Hilaire, Cuvier, and Buffon immediately come to mind, and there are many more. For an overview of the field, see Londa Schiebinger, *Nature's Body: Gender in the Making of Modern Science* (Boston: Beacon Press, 1993), esp. ch. 5, "Theories of Gender and Race." Also see Nicholas Hudson, "From 'Nation' to 'Race': The Origins of Racial Classification in Eighteenth-Century Thought," *Eighteenth-Century Studies* 29 (1996): 247–64; and Gilles Boëtsch and Yann Ardagna, "Human Zoos: The 'Savage' and the Anthropologist," in *Human Zoos: Science and Spectacle in Age of Colonial Empires*, eds. Pascal Blanchard, Nicolas Bancel, et al. (Liverpool: Liverpool University Press, 2008), 114–22.

10 As Léon-François Hoffmann notes in his extensive study on blacks and literature in the early nineteenth century, *Le nègre romantique, personnage littéraire et obsession collective* (Paris: Payot, 1973), at 126: "Retenons simplement que, d'une façon générale, l'infériorité naturelle des Noirs est admise. Certitude pour les uns, probabilité pour les autres, possibilité pour les plus sceptiques, rares sont les esprits éclairés qui l'ont catégoriquement niée."

11 See Boime, *Art in an Age of Counterrevolution*, 163, where he rehearses arguments first presented in his all-important study "Géricault's *African Slave Trade* and the Physiognomy of the Oppressed," in *Actes du colloque international sur Géricault*, ed. Régis Michel, 2 vols. (Paris: La documentation française, 1996), 2: 561–93 and esp. 587.

12 For the Société des Amis des Noirs, see Marcel Dorigny's richly documented study, "La Société des Amis des Noirs: Antiesclavagisme et lobby colonial à la fin du siècle des Lumières (1788–1792)," in Marcel Dorigny and Bernard Gainot, *La Société des Amis des Noirs, 1788–1799, Contribution à l'histoire de l'abolition de l'esclavage* (Mémoire des peuples: Editions Unesco, 1998); for broader references, see Emmanuel Chukwudi Eze, *Race and the Enlightenment* (Cambridge, MA: Blackwell, 1997).

13 Julien-Joseph Virey, "Nègre," in *Dictionnaire des sciences medicales, par une société de médecins et de chirurgiens* (Paris: Panckoucke, 1819), 421.

14 Ibid., where Virey graphically describes the procedure: "… on les attache à une chaîne, on leur saisit le cou dans une fourche dont la queue, longue et pesante, les empêche de fuir avec rapidité. Ces bandes, semblables à celles des galériens, sont ramenées de deux à trois cents lieues de l'intérieur des terres …." The number of Africans brought to the Americas (from Canada to Brazil) during the eighteenth century was enormous—seven million is the number scholars cite today. Otherwise, recent scholarship adduces that the number of slaves who suffered the Middle Passage from 1500 to the mid-nineteenth century was between 11 and 12 million.

15 Ibid. As Virey informs his readers, he drew his information from Thomas Clarkson's work *Sur l'esclavage et le commerce de l'espèce humaine* (Essay on the slavery and commerce of the human species). First written in Latin and subsequently translated into English, Clarkson published an expanded edition of his essay in 1786 with a slightly altered title that now targets Africans. For a reprint of the 1788 edition, see Thomas Clarkson, *An Essay on the Slavery and Commerce of the Human Species, Particularly the African* (New York: AMS Press Inc., 1972).

16 In an address written to the Assemblée nationale (January 21, 1790), the Société listed its reasons why bondage is best for blacks: "L'affranchissement immédiat des Noirs serait non seulement une opération fatale pour les colonies, ce serait même un présent funeste pour les Noirs dans l'état d'abjection et de nullité oú la cupidité les à reduits. Ce serait abandonner à eux-mêmes et sans secours des enfants au berceau, ou des êtres inutiles et impuissants." As cited in Jean Michel Deveau, *La France au temps des négriers* (Paris: France-Empire, 1994), 258. Adhering to a gradualist approach, Condorcet, Mirabeau, Grégoire, Corréard et al. believed that slavery should only gradually be effaced from the Antilles (West Indies). See also Claude Wanquet, *La France et la première abolition de l'esclavage, 1794–1802* (Paris: Editions Karthala, 1998), 15–18.

17 Eitner, who illustrates and discusses this study in his *Géricault's Raft*, 147–8, cat. no. 16, pl. 14, omits our pleading mendicant from his outline, although he lingers over the other figures on the page, describing their pose and noting their gestures. If Eitner glosses over our figure, might it be because he dismisses or otherwise discounts the role of blacks in Géricault's oil? Eitner's other extensive study on the *Raft* may be faulted for the same omission; see Eitner, *Géricault, His Life and Work*, 169.

18 For this view, see Grigsby's discussion of the Société's emblem in *Extremities*, 28–9; also see David Bindman's "'Am I not a Man and a Brother?': British Art and Slavery in the Eighteenth Century," *RES*, no. 26 (Autumn 1994), 81, where Bindman suggests a link between Camper's "influence" and Géricault's lithograph of 1818, *The Boxers*—a paradoxical position, as Bindman phrases it, for as a " strong abolitionist," Géricault might have questioned rather than "adopt[ed] Camper's typology …."

19 Virey, "Nègre," 426.

20 Ibid., 406: "Comme leur caractère a plutôt de l'indolence que de l'activité, ils paraissent plus propres à être conduits qu'à conduire les autres, et plutôt nés pour l'obéissance que pour la domination."

21 Ibid., 409: "Si nous aspirons à la gloire, aux grandeurs, à la fortune, les noirs préfèrent l'indolence … . Le travail leur est encore plus insupportable que la misère, et ils ne se mettent à l'ouvrage qu'à la dernière extrémité. Il faut à un Européen des biens … mille objets de luxe et de commodités particulières; il cherche toute sa vie à grandir, amplifier son existence; il voudrait envahir l'univers, ce qui dénote l'immense capacité de son âme et l'active ambition qui le ronge, qui l'élève audessus de la nature vulgaire: le nègre, au contraire, reste comme il se trouve … Nous avons une ardeur surabondante qui nous fait désirer le mouvement, la nouveauté: le nègre aspire au repos; nos plaisirs seraient pour lui des peines, et l'apathie, qui est un malheur pour nous, fait toutes ses délices."

22 Julien-Joseph Virey, *Histoire naturelle du genre humain*, 2 vols. (Paris: Dufart, 1801), 2: 120–123. In spite of—or because of—its racist bias, Virey's *Histoire naturelle* of 1801 was "the standard study of race published in the early nineteenth century." For this quote see Sander L. Gilman, *Difference and Pathology: Stereotypes of Sexuality, Race, and Madness* (Ithaca, NY and London: Cornell University Press, 1985), 85.

23 Virey, *Histoire naturelle*, 2: 122. Blacks, as apathetic as "eunuchs," belong in the fourth category: "Cette division-ci comprendra les peuplades de nègres … ces peuples paroissent en quelque sorte eunuques, si je puis m'exprimer ainsi …."

24 Ibid., 1: 297. The bibliography on Camper is long. For a detailed study of Camper's work, ideas and influence, see esp. ch. 6, "The Intersection of Race and Beauty" in Miriam Claude Meijer, *Race and Aesthetics in the Anthropology of Petrus Camper (1722–1789)* (Amsterdam: Rodopi, 1999); also see C. Blanckaert's "Les vicissitudes de l'angle facial et les débuts de la craniométrie (1765–1875)," in *Revue de synthèse* 108, no. 3–4 (1987); esp. 420–27.

25 Virey, *Histoire naturelle*, 1: 298. Virey then goes on to say: "Des différences inclinaison faciale … le dégrés d'inclinaison de cet angle donneront une mesure de la beauté. Plus cet angle est redressé, plus la face a de noblesse, de majesté, de sublimité."

26 I borrow my quotation from the title page of the 1794 English edition of Camper's 1791 posthumous publication. Camper's study, the result of lectures first given in 1770 in Amsterdam, and subsequently in Paris (1777) and London (1785), was first published in French two years after his death. It is important to note that the illustrations for the 1791 French edition, *Dissertation physique, sur les différences réelles que présentent les traits du visage chez les hommes de différents pays et de différents âges* (Utrecht: Chez B. Wild et J. Altheer, 1791), were subsequently reprinted in the 1794 edition. For Camper's wide-ranging interests in antiquity, art and anthropology, see Meijer, *Race and Aesthetics*, 1999.

27 Petrus Camper, *The Works of the Late Professor Camper, on the Connexion Between the Science of Anatomy and the Arts of Drawing, Painting, Statuary, etc. etc. … With a New Method of Sketching Heads, National Features, and Portraits of Individuals, with Accuracy, etc., etc.*, trans. T. Cogan (London: J. Hearne, 1821), 38. This first English edition was published in 1794.

28 Ibid., 42 and further, 9: "When I make these lines to incline forwards, I obtained the face of an antique; backwards, of a Negroe; still more backwards, the lines which mark an ape, a dog, a snipe, etc. This discovery formed the basis of my edifice."

29 For our plate, see ibid., pl. 6, fig. 1.

30 Among his critics was the father of phrenology, the German physician Franz-Joseph Gall (1758–1828) who in 1810 called upon "les naturalistes et les physiologistes" to renounce "la ligne faciale de Camper." See F.J. Gall and Johann Caspar Spurzheim, *Anatomie et physiologie du système nerveux en général, et du cerveau en particulier*, 2 vols. (Paris: Schoell, 1810), 2: 322. Johann Friedrich Blumenbach (1752–1840) as well took exception to Camper's theories arguing that his collection of skulls (which was quite extensive) told a different story. For Gall's disagreements with Camper, see Blanckaert, "Les vicissitudes," 449–50; for Blumenbach's differences, see Schiebinger, *Nature's Body*, 118–19. For a recent appraisal of Gall's views in the context of Géricault studies see Wedekind, *Géricault, Images of Life and Death*, 109–18.

31 Lavater's unstinting praise of Camper deserves a full citation: " ... mais rien dans ce genre ne mérite autant d'être relu qu'une dissertation de Camper, pleine de profondeur & de sagacité, sur la différence naturelle des linéamens du visage." See J.C. Lavater, *Essai sur la physiognomie, destiné à faire connoître l'homme et à le faire aimer*, 4 vols. (The Hague: Van Cleef, 1781–1803), 4: 319. Otherwise, Lavater quotes Camper *in extenso* (ibid., 4: 176). For a discussion of Lavater's response to Camper, see "Measuring the Skull: Pieter Camper," in David Bindman, *Ape to Apollo* (Ithaca, NY: Cornell University Press, 2002), 209–11; for Lavater's physiognomic theory as fiercely racist," see Grigsby, *Extremities*, 50. Boime, *Art in an Age of Counterrevolution*, 163, speaks of Lavater's "gender and racial bias." Asserting Lavater's debt to Camper's *ligne faciale*, recent scholarship has observed the "clash" between Lavater's and Camper's "humanitarian motivations ... and the inhumane, demeaning, and destructive practices manifest in the concrete judgments it passes ... [judgments soon to be] defended and put into practice by the Nazis." See Richard T. Gray, *About Face: German Physiognomic Thought from Lavater to Auschwitz* (Detroit: Wayne State University Press, 2004), 109–13.

32 Virey, *Histoire naturelle*, 1: 299.

33 Ibid., where Virey argues that as the brain cavity recedes, "la sphère de l'entendement décroît par une semblable raison... Non seulement cette considération est applicable au genre humain, mais ... dans la série des singes" Elsewhere, Virey, *Histoire naturelle*, 1: 182, cites a 1798 publication by Cuvier linking orangutans with blacks, for as Virey writes the "[Orang-Outang] ... offre un angle facial de soixante-cinq dégrés," a facial angle that, as Virey would not be the first to observe, links orangutans with blacks!

34 For our plate, see Virey, *Histoire naturelle*, 1: 185. The list of plates is found in the second volume of the *Histoire naturelle*. Here we read the following: "Profil de l'Apollon, celui du nègre, et celui de l'orang-utang pour termes de comparaison ... D'après Camper," 2: 396.

35 Léon Poliakov's important study on race notes that Virey's *Histoire naturelle* was translated into English in 1837 as *The Natural History of the Negro Race*, a publication that "gave a new lease on life" to pro-slavery arguments in both Britain and America. See Léon Poliakov, *The Aryan Myth, a History of Racist and Nationalist Ideas in Europe* (New York: Basic Books, 1971), esp. ch. 8, "The Anthropology of the Enlightenment," 155–82. And Gray underscores, as if it were needed, the overwhelming influence Camper's thought had on his contemporaries and those who would follow after him: "Over the course of the eighteenth and nineteenth centuries, Camper's *linea facialis* became the foremost material criterion for human racial classification" (Gray, *About Face*, 229).

36 Asserting the primacy of whites over blacks, we read in Virey's "Nègre," 412:
 "A quel titre posséderions-nous la suprématie sur les animaux, si ce n'était par
 cette élévation d'intelligence … que nous accorda manifestement la nature,
 comme à des maîtres, pour gouverner toutes les créatures? Si notre empire
 est légitime; si l'ordre éternel a voulu que les faibles, les incapables d'esprit se
 soumissent aux plus forts, aux plus intelligens, leurs protecteurs-nés, comme la
 femme à l'homme, le jeune au plus âgé; de même le nègre, moins intelligent que
 le blanc, doit se courber sous celui, tout comme le boeuf ou le cheval, malgré leur
 force, deviennent les sujets de l'homme; ainsi l'a prescrit une éternelle destinée."
 For an informed discussion of Virey's view on white supremacy in the context of
 Camper's theories, see Hugh Honour, *The Image of the Black in Western Art*, vol. 4,
 From the American Revolution to World War I, part 2, *Black Models and White Myths*,
 ed. Karen C.C. Dalton (Cambridge, MA: Harvard University Press, 1989), 12–21.

37 Virey, "Nègre," 412: "M. Palisot de Beauvois, qui a voyagé en Afrique, et moi,
 nous avons comparé les quantités de liquides que peuvent contenir des crânes de
 blancs et ceux des nègre: nous avons observé que chez ces derniers il se trouvait
 jusqu'à neuf onces de moins que dans les crânes des Européens …."

38 For our plate see Julien-Joseph Virey, *Histoire naturelle du genre humain*, 2 vols. (Paris:
 Crochard, 1824), 2: 42, pl. 8. True to form and following Camper's math, Virey lists
 the facial angles of his three profiled faces as follows: "1) Blanche … angle facial 90
 [degrees]; 2) Nègre … 75 [degrees]; 3) Orang (singe) … 65 [degrees]."

39 For this image, see ibid., 1: 58.

40 For our studies see Bazin, *Théodore Géricault*, 6: 14–51. Also see Eitner, *Géricault's
 Raft*, 149, pls. 19 and 20, cats. 22 and 23; the Winterthur sketch is the latter.

41 For a discussion of Corréard and Savigny as arbiters of the horrific events on
 the raft, see Alhadeff, *Raft of the Medusa*, 45–83; also Boime, *Art in an Age of
 Counterrevolution*, 133–45.

42 Defining "le groupe principal" in one of the earliest published discussions of the
 Raft, Auguste Jal, an eminent critic of the day and a friend of Corréard, states: "…
 le groupe principal [est] composée de M. Savigny au pied du mât, et de
 M. Corréard, dont le bras étendu vers l'horison et la tête tournée vers M.
 Savigny, indique à celui ci le côté où se dirige un batiment …." Auguste Jal,
 L'Ombre de Diderot et le Bossu du Marais; Dialogue critique sur le Salon de 1819
 (Paris: Chez Corréard, 1819), 124. Nowhere in this passage is there any mention
 that anyone else may be standing by Savigny's side or, given our argument, that
 Corréard is addressing anyone other than Savigny.

43 As vast as the literature is on the *Raft*, no one to date has suggested that
 Corréard may be addressing both the black at his side and Savigny. Whether
 one is discussing the preparatory studies for the *Raft* or the *Raft* itself, students
 of Géricault have always assumed that Corréard is addressing Savigny and
 Savigny alone! Clément, Géricault's authoritative biographer, does not hesitate to
 describe the "sighting" as follows: "Corréard, qui, le bras étendu, montre le brick
 au chirurgien Savigny" (Clément, *Géricault: Etude biographique*, 151).

44 Virey, "Nègre," 413. Addressing abolitionists in general, Virey goes on to write,
 "Que prétendent donc les défenseurs d'une égalité chimérique? … Une parfaite
 et constante égalité est impossible à maintenir entre tant d'êtres inégaux, ou elle
 ne promet que l'inertie du tombeau."

45 Commentaries on this figure are at best minimal; it is not too much to say that
 the Géricault literature has barely noticed his presence with the exception of
 Chenique, *Les cercles politiques*, 1: 400. Largely anonymous, with few if any

preparatory studies, the youth, like other elements in the canvas, was probably a last minute addition to the oil, an important complement to Géricault's evolving conception of the *Raft*.

46 To our list of nay-sayers we may add Caspar Lavater. It is important to note that Lavater reproduced Camper's image (our own Figure 3.2) in his *L'Art de connaitre les hommes par la physionomie* (Paris, 1805–9), vol. 4, pl. 179.

47 Recalling that Virey divided the human race into five categories which in turn subdivided into two groups, either "belles et blanches" or "laides … et noires." "Celts" figured in the first realm: "Les lignées celtiques … présentent en effet une face ovale, agréable, très-symmétrique … un front droit …" See Virey, *Histoire naturelle* (1801), 1: 145–6.

48 See especially his *Géricault, au coeur de la creation romantique*, where Chenique unearths a body of new material directly affecting our understanding of the *Raft* and reconsiders the role of Géricault's nineteenth-century biographers.

49 Chenique, *Les cercle politiques*, 1: 400: "Il s'agit … de l'union de mains blanches et noires. Cette iconographie de fraternité nous semble tout à fait inédite: les deux mains du Noir enlacent les deux poignets des mains jointes d'un Blanc." Chenique goes on to argue that this joining of hands denotes Géricault's adherence to free-masonry and its ideology. For further discussion of the blacks on the *Raft*, see Albert Alhadeff, "Julian Barnes and the *Raft of the Medusa*," in *The French Review* 82, no. 2 (December 2008): 276–91.

50 The exalted role of the black man at the apex of Gericault's composition was first highlighted in the 1840s. See Charles Blanc, *Histoire des peintres français au dix-neuvième siècle* (Paris: Cauville Frères, 1845), 421. Blanc first espoused this view in an article "Etudes sur les peintres français. Géricault," in *Le National*, August 30, 1842. For more recent readings, see Boime, *Art in an Age of Counterrevolution*, 133–45; Grigsby, *Extremities*, 165–235; Chenique, *Les cercles politiques*, 1: 389–401; and Alhadeff, *Raft of the Medusa*, 163–85.

"A mulatto sculptor from New Orleans": Eugène Warburg in Europe, 1853–59[1]

Paul H.D. Kaplan

Though the mixed-race sculptor Eugène Warburg (1825/26–59) was certainly not a major artistic figure in his day—he did not live long enough to make a really notable career—it would be a mistake to underestimate his significance. He is a very early instance of an American of African descent working in an emphatically "high" artistic form; sculpture in marble was perhaps the most elevated visual medium of the mid-nineteenth century in the US. He may have been the first African-American visual artist to become an expatriate in Europe—and his departure from the US may well have been prompted, at least in part, by the same discriminatory obstacles that led so many later African-American artists to follow his example. He was known to and supported by a wide range of influential political and cultural figures, encompassing both virulently pro-slavery and radically anti-slavery individuals. Perhaps most importantly, Warburg's image of an African-American character from the work of Harriet Beecher Stowe marks him as connected to the central political/cultural controversies of the 1850s, not only in the US but also in Europe. Warburg's story is one which links art, abolition, and varied conceptions of racial identity in a surprisingly intricate transatlantic setting. This study seeks to bring together what is currently known of his life and art, from his birth as a slave in New Orleans to his premature death in his early thirties in Rome, with an emphasis on his final years (1853–59) in Europe.

Warburg is often cited as a groundbreaking but ultimately obscure predecessor of the much better known Edmonia Lewis (c. 1844/45–1907), a sculptor of African and Native American descent, who reached Italy in 1865 and settled in Rome in 1866, remaining there for many decades.[2] The two sculptors would never have met, though it is easy to imagine that both Lewis and her white abolitionist patrons were aware of Warburg's career. Warburg and Lewis, however, were not the only African-American visual artists in Europe in the mid-1800s. Warburg's fellow New Orleanian Florville Foy (1820–1903), also a marble-worker, appears to have accompanied his French

father on a brief trip to Paris in the 1830s, while he was still in his teens, and in 1837 the painter Julien Hudson (1811–44, also of New Orleans) spent a few months in Paris as well; the painter Robert Duncanson travelled widely in Europe for seven months in 1853, and made another visit to England after the Civil War.[3]

Though Warburg is cited in most histories of African-American art and in a number of reference works, relatively little of substance is to be found in most of these sources.[4] The most reliable modern summary of what is known about Warburg is found in Charles Edwards O'Neill's "Fine Arts and Literature: Nineteenth Century Louisiana Black Artists and Authors," of 1979;[5] O'Neill depends in part on Bertram Korn's well-researched 1969 study of Jews in early New Orleans,[6] and O'Neill's information is ably recapitulated and somewhat augmented in Patricia Brady's four essays of 1989–94.[7] In addition to archival and city directory information in New Orleans about Warburg and his family (best consulted in O'Neill and Korn), there are also five useful contemporary pieces between 1850 and 1859 in the New Orleans newspapers *Picayune*, *Daily Crescent*, and *The Bee/L'Abeille* (the English and French versions of a similar publication); all but one of these notices report on Warburg once he had gone to Europe.[8] To these home-town journalistic sources we can now add a short 1857 piece from a very different publication, the *Art Journal* (an important and widely read London periodical), two fascinating articles from an American newspaper in Paris, as well as briefer notices from two further American newspapers.[9] There are also four valuable passages detailing encounters with Warburg by white American travelers in Europe between 1855 and 1857; only one of these has previously been noted in print by modern scholars, and they will be discussed in detail below. Then there is the brief biography in Rodolphe Lucien Desdunes' 1911 book about notable New Orleanians of color.[10] Desdunes was born in 1849, so he would hardly have known Warburg, but he is likely to have spoken with Warburg's younger brother Daniel (and Daniel's son, usually known as Daniel Jr.), and his information may be taken as an indication of a local oral tradition. Desdunes also seems to have been familiar with a lengthy posthumous appreciation of Warburg published in *L'Union*, an African-American newspaper in New Orleans, in 1862.[11] To Desdunes goes the considerable credit for the survival of Eugène Warburg's name and achievements in modern times.

Eugène's father, the German Jew Daniel Warburg (1789–1860), left the Hamburg area and settled in New Orleans by 1821, where he later abjured all religion.[12] He was a commission merchant and real estate investor. Quite affluent in the early 1830s, he lost most of his fortune in the panic of 1837, was in bankruptcy in 1839–41, and never recovered his wealth. (In the late 1830s Daniel also began to promote himself as an inventor, though there is more than a touch of delusion in his self-advertisements.[13]) Soon after his arrival in New Orleans Daniel took a slave mistress—perhaps the young daughter of another slave woman he also owned—who was known as Marie Rose Blondeau (c. 1804–37?). Marie Rose and her mother, Venus, came from Santiago, Cuba,

and perhaps originally from Haiti, and her (unknown) father was evidently white. Daniel and Marie Rose had five children, and by 1837 (the year of her early death) she must have been free, as she then owned a slave herself. Eugène was the oldest child, born in 1825 or early 1826, and at the age of four years, in 1830, he was manumitted. The other children, including Joseph Daniel (later just called Daniel) who was born in 1836, were apparently born free.[14]

At Eugène's manumission, his father and the ambitious French immigrant Pierre Soulé (1801–70, in New Orleans from 1825) served as guarantors for the boy's future solvency, and pledged to provide him with a trade. That trade was marble-cutting, and Eugène clearly took to it. He received instruction from Philippe Garbeille, a French sculptor who had studied in 1838 with the famous Danish master Bertel Thorvaldsen, the dominant neoclassical sculptor in Rome.[15] Garbeille was already in New Orleans in 1841 or 1842, and may have remained there off and on until the early 1850s; he had made a bust of Soulé, and as Soulé had served as Daniel Warburg's lawyer, participated in a real estate transaction with him, and acted as a godfather to the boy, the choice of Garbeille as a teacher is understandable.[16] In 1849 Eugène set up his own shop, on St. Peter Street, and by 1850 he had moved the shop to St. Louis Street where marble-cutters were concentrated. Apart from the black and white squares of the pavement of the cathedral of St. Louis, it has proved difficult to attribute any particular works to Warburg in New Orleans, though one presumes funerary monuments were a staple.[17] Desdunes writes of busts of "generals, magistrates, and other notables," and of masterpieces in the old cemeteries of the city; but as Eugène's brother and nephew, both called Daniel, were long-time marble-cutters in the city after his departure, it is hard to feel sure that Desdunes is absolutely correct in his claims.[18] He does, more particularly, speak of a single block carved with two angels on a common base, which made the young man's reputation, though the patron who ordered it did not claim it, and the work was eventually sold to one Panniston.[19]

In December of 1850 Warburg raffled a statue he carved of *Ganymede as Cup-Bearer to Jupiter* at Hall's gilding shop on Canal Street; the estimated value was $500, but we have no record of the result of the raffle, and nothing is known today of the work.[20] As this was a favored subject of Thorvaldsen's (see for example the work in the Minneapolis Institute of Arts, 1817–29; Figure 4.1), the influence of Garbeille might be inferred, though this artist had left New Orleans in 1848.[21] In 1850, however, another notable European sculptor arrived in the city. The Milan-born Achille Perelli (1822–91) had been a student of Pietro Galli (1804–77), one of Thorvaldsen's students and closest associates; Galli may well have worked on one or more of Thorvaldsen's six Ganymede sculptures,[22] one of which had visited America, having been exhibited at the Pennsylvania Academy in 1839.[23] Warburg, then, might have had multiple means of hearing about Thorvaldsen's images of this mythological subject. In any case, Warburg's *Ganymede*, even if it did not sell, was admired: the New Orleans *Bee* (December 13, 1850) wrote of "this exquisite specimen of sculpture … by a young Creole of our city," and opined that the artist, with further study, would "attain deserved excellence."

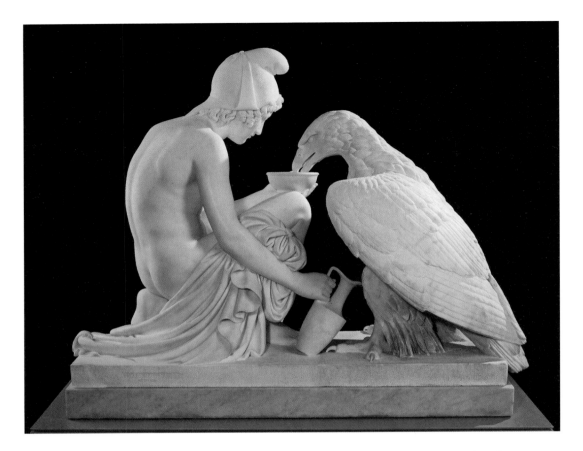

4.1 Bertel
Thorvaldsen,
Ganymede as Cup-
Bearer to Jupiter,
1817–29. Marble.
Minneapolis
Institute of Arts

One might wonder whether the raffle was already part of a plan to raise money to cross the Atlantic. Desdunes affirms that Warburg's racial status held him back in his New Orleans career, and Brady, on relatively slight evidence, suggests he was no longer comfortable in antebellum New Orleans.[24] The ascendancy of Achille Perelli, who quickly established a thriving shop, may have also limited Warburg's opportunities for advancement.[25] But there were certainly more positive reasons for him to think about a European sojourn. In the middle of the nineteenth century ambitious American sculptors typically sought to study in Italy and travel in Europe, and their sponsors and patrons often helped them to do so. Warburg's father was European-born; his teacher Garbeille was French, and had studied in Rome; Perelli had an even deeper connection to contemporary sculpture in Rome; Warburg's father's associate Pierre Soulé was French, and was now an extremely influential political figure (a US senator from 1849 to 1853, when he resigned to become the US minister to Spain).[26] Furthermore, the experience of another New Orleanian of color, the writer Victor Séjour (1817–74), may have been well known to Warburg. Séjour's wealthy parents, both free, were of mixed race; he was sent to Paris at 19, and almost immediately published a vivid short story ("Le mulâtre,"

1837) on the theme of slavery. He soon shifted to drama, and built a successful career as a mainstream playwright in Paris in the 1840s and 1850s.[27]

To finance his European voyage, Eugène and his now impoverished father turned to one of the few family assets that still remained. In a complicated legal transaction involving a "friendly" suit between father and son, and consultation with a group of free men of color charged with protecting the interests of the sculptor's four younger siblings, Eugène was able to realize $252.36 from the sale of his long-deceased mother's three slaves.[28] That both Eugène and his mother had been born into slavery themselves only heightens the cruel and poignant irony of this transaction; in effect, his share of the sale was worth three-fifths of a human being — precisely the value assigned to each slave in the Constitution. The sculptor, in fact, did not quite wait for the cash to come through (in January of 1853), but departed New Orleans toward the end of November 1852.

Warburg presumably settled in Paris, though the only data that has come to light about his whereabouts in 1853 shows that he crossed the English Channel from France to London twice in that year.[29] Quite a number of mixed-race Louisianans were to be found in Paris at this juncture. The remarkable David Dorr (1827/28–72?) was a light-skinned slave who traveled in Europe and beyond with his New Orleans master, Cornelius Fellowes, between 1851 and 1854, and then (after fleeing to the North) wrote a memoir of his European journey.[30] Late in 1851 Dorr met a wealthy "quadroon" tailor in Paris called Cordevoille, with whom his master and other New Orleans whites were eager to socialize.[31] From men such as Cordevoille and Séjour, Warburg would at least have received advice and some companionship. At some point he entered the studio of François Jouffroy (1806–82), an active and respected sculptor who had studied in Rome (1826–35?); Jouffroy later became a professor at the Ecole des Beaux-Arts, where he taught the young Augustus St.-Gaudens. Jouffroy is described as Warburg's teacher in a publication of May 1855.[32]

The first sure confirmation we have of Warburg in Paris is dated August 26, 1854, when the American celebrity dentist (!) Eleazar Parmly (1797–1874) mentioned the sculptor in the odd rhyming couplets with which he recorded his European travels:

Called with our Consul here, McRae,
Eugene Warburg to see;
A colored artist having skill
Of very high degree.
One modeled bust and plaster form,
The two extremely fine;
The head from nature, but the cast
Was wholly his design
All executed with the skill
Of those who highest stand;
A credit to the realm of art,
And to his native land.[33]

The particular nature of these two works is made clearer in an article of March 7, 1855 in the New Orleans *Daily Picayune*. Under the heading "Another

American Sculptor," the *Picayune* republished on its front page a notice from an anglophone Parisian paper called *The American* of January 27. In a preamble, the *Picayune* noted that Warburg had been studying in a "prominent atelier," left unnamed. The text from *The American* begins: "At the very end of the rue des Martyrs, near the Barriere Montmartre, in a building destined to ateliers of sculptors, we found Mr. Warburg's unpretending studio." The artist himself was absent, but the visitor found many plaster casts, including one of a seated 12-year-old boy playing with a crab, which Warburg was in the process of rendering in marble. This the writer admired, as he also did a marble bust of the American consul in Paris, Duncan K. McRae.[34] The text concludes with the opinion that Warburg, modest and hard-working, "will arrive at eminence" if he perseveres with his arduous studies. Nothing is said of the artist's race or family background.[35]

From May to November of 1855, four of Warburg's sculptures appeared in the major Parisian and indeed European art exhibition of the year: the Salon, which in 1855 — exceptionally — was combined with an ambitious international fair of industry and the arts known as the Exposition Universelle.[36] The main section of the printed catalogue lists three sculptures: a fisher-boy in plaster (no. 731), a bust in marble (no. 732), and a bust in plaster (no. 733).[37] The bust in marble may well have been that of McRae, and the "fisher-boy" is presumably the boy with crab — evidently the marble version was not yet complete. A supplement to the catalogue lists a fourth work: a portrait bust of the US minister to France, in marble.[38] This is certainly the bust of John Young Mason of Virginia (1799–1859), who occupied that post from 1853 to 1859; this handsome object (Figure 4.2) is now in the collection of the Virginia Historical Society in Richmond.[39] Until recently, the bust of Mason was regarded as the only figurative work by Warburg to have survived. The cost of Mason's bust was paid by a subscription of sixty American expatriates and visitors to Paris, who then donated the sculpture to Mason's wife, and arranged for its temporary display at the Exposition Universelle, on September 1, 1855.[40]

The portraits of Mason and McRae, minister and consul, strongly suggest that Warburg had been adopted as a kind of semi-official artist by the American government representatives in Paris, and it is likely that this was due to the intervention of Pierre Soulé. Soulé had begun his adult life, in Paris, as a radical, anti-royalist journalist — this part of his career is recorded in the memoirs of his fellow-radical Alexandre Dumas *père*. Threatened with imprisonment by the Bourbon government in 1825 for an article critical of French policy toward Haiti, he fled first to Britain and then to Haiti itself, carrying a letter of recommendation from the famous anti-slavery and republican French cleric the Abbé Grégoire (1750–1831) to the mixed-race Haitian president, Jean-Pierre Boyer. After a brief stay in Haiti — Soulé later said that his visit there had cured him of "dreams of liberty" — he went to the US, and settled in New Orleans in November of 1825. By 1830, when he served as a guarantor of the very young Eugène's manumission, he was close to the Warburg family. In the 1840s he rose in the Democratic Party, and in

4.2 Eugène Warburg, *Portrait of John Young Mason*, 1855.
Marble. Richmond, Virginia Historical Society

1847 and again in 1849–53 he was a US senator from Louisiana.[41] He was close to the pro-slavery leader John Calhoun, but was admired even by some of his abolitionist opponents for his oratorical skills, and there was evidently a hope (*not* really to be fulfilled) that his early progressive views might re-emerge. On December 31, 1852, Harriet Beecher Stowe wrote to the anti-slavery stalwart Charles Sumner, senator from Massachusetts:

Can it be that no man of honor—no man thirsting for immortal fame will yet rise *from the South*—and win himself eternal glory by being the leader of a movement for *universal* freedom—Can such a man as Soulé—I know not if I have rightly conceived of him, but I think of him as an impersonation of nobility and chivalry, can he be willing to be the tool of tyranny and the leader of despotism—when Freedom is holding up an unfading crown to be worn by some *deliverer*? What a glory would be that Southern man's who should liberate his country and the world from his shame![42]

This speculation may have been prompted by the fact that a few weeks earlier in December Soulé had made a significant intervention in the rescue of the illegally enslaved freeman Solomon Northup; one wonders whether Soulé's connection to Warburg—just then en route to Europe—had any impact on his assistance to Northup.[43]

From 1853 to 1855 Soulé was in Madrid, as the US minister to Spain, but he visited Paris in the fall of 1853 and the fall of 1854, and he had occasion to work closely with both Mason and McRae.[44] By the 1850s Soulé, ever more vigorously pro-slavery and imperialist, was an important figure in the Young America movement, which sought to expand the US into Hispanic areas bordering the Caribbean, as a means of introducing new slave states and countering the influence of Northern abolitionism. Soulé's plan to buy (or seize) Cuba from the Spanish was advanced by a document known as the Ostend Manifesto, which was prepared over the course of several days in October of 1854 in that Belgian town and then in Aachen, not far away across the Prussian border.[45] Soulé and Mason were joined there by James Buchanan, then the American minister to Great Britain, who in fact may have drafted much of the Manifesto itself; McRae's job was to carry the document back to Washington.[46] It is even possible that Warburg accompanied these statesmen to Ostend—Desdunes in 1911 reports that the sculptor had made a brief stay in Belgium—but it is unlikely any work on the portraits was done in Ostend, as the diplomats were quite busy.[47] As word of the Manifesto's contents got out, a political scandal arose, and the planned annexation of Cuba came to naught. Warburg may have been fascinated by all this, especially given his mother's Cuban origins, but he may also have been perplexed to find himself still enmeshed with the issue of slavery: the sale of family slaves helped him reach Europe, and the pro-slavery scheme hatched at Ostend may have encouraged the commission of the busts, as Mason and even McRae may have imagined that their role in the Manifesto would make them especially worthy of sculptural commemoration.

In April of 1855, as the collapse of the plan became clear, Soulé resigned his post and returned to the US, and this constituted a potential setback for Warburg. By November, however, he was hard at work on a different sort of project, one with the kind of mythological/erotic content that harks back to his early *Ganymede*. Once again, our information comes from *The American*:

Another Visit to Mr. Warburg's Studio

In a former number of our paper, we have alluded to Mr. Warburg, the sculptor (a native of New Orleans), and to his productions. Lately we have had occasion to make another visit to his modest studio, and found him intently occupied in modeling a figure, — the representation of a female, ornamenting her hair with the genial grape from which Bacchus pressed the heavenly juice. She is of the size of life, in a standing position, with one arm raised over her head in the act of embellishing her floating locks; in the other hand she holds flowers and fruit. The attitude is easy and graceful, the expression of the face pleasing, and as far as the work is finished it evinces a close study of human nature; all the movements of the muscles are delicately indicated, and the work bids fair to be a master-piece of sculpture.

Mr. Warburg is fully aware of the difficult task he has undertaken. He studied Nature, and the works of ancient and modern artists in the Louvre — the School of Art; he studied also at the Great Exhibition, and he drew his inspirations from standard models, each recommended by some perfection.

The lineaments of this youthful female figure, are very exquisite. The bold chisel of the artist has well rendered the expression of the beautiful, — the bewitching smiles of conscious beauty. Buoyant life seems to animate every feature of his charming creation.

A few weeks more and the figure will be ready to be cast and wrought into marble; and we hope next Spring to see the completion of this conception of a Southern genius.[48]

We do not know if this work was ever rendered in marble, but by 1856 Warburg began to pursue a more radically different career plan. Warburg and/or his work had somehow caught the eye of Harriet Elizabeth Georgiana Howard Leveson-Gower, Duchess of Sutherland (1806–68). The duchess, an intimate of Queen Victoria and a fervent ally of American abolitionists, was enormously wealthy, culturally sophisticated and influential. She and her husband, the second duke of Sutherland, owned the most lavish town house in London, which contained an extensive art collection.[49] How exactly she learned of Warburg is a mystery; the Salon/Exposition Universelle catalogue said nothing of his racial background, and in any case the primary source here (see below) indicates that she visited the sculptor's studio at 66 rue des Martyrs before the Exposition had opened — that is, prior to May 15, 1855. Given her anti-slavery views, she would have had little association with men like Soulé, Young or McRae. Perhaps Warburg himself took the initiative. Her anti-slavery position was widely known, as was that of her brother, the earl of Carlisle, who had written the preface to one of the early British editions of *Uncle Tom's Cabin*.[50] Warburg may also have learned that the duchess's husband, the second duke, had in fact commissioned Thorvaldsen's most

famous *Ganymede* (Figure 4.1), which had long been displayed in a place of honor in the couple's London residence.[51] However he managed to attract the duchess's attention, in doing so Warburg had embarked on a profoundly new course in terms of patronage and the overall direction of his career.

To understand what happened next, it is easiest simply to quote a long passage (not previously used by modern writers on Warburg) from the 1874 memoirs of the wealthy New York lawyer Maunsell Bradhurst Field (1822–75), who, among other posts, served as the New York State commissioner to the 1855 Exposition Universelle, and as the president of the board of all US commissioners to that exhibition. Late in 1855 (perhaps after the Exposition closed on November 15), he returned to London:

I had not been there very long, when I received a call one day from a mulatto sculptor from New Orleans, who had exhibited some very creditable and promising works at the recent Paris Exposition. By some chance the *Duchess of Sutherland* had been attracted to his studio in Paris before the opening of the Exposition, and it was indirectly through her agency that my attention had been originally called to him. I am not quite certain of his name, but think that it was *Warberg* [sic]. The poor, foolish fellow, having exhausted his means, had come over to London to find his Duchess, hoping that she would relieve his wants and give him the advantage of her protection. Upon going to Sutherland House, he was informed that the Duchess was then in Scotland, and would not return to town for several weeks. He also learned that *Mrs. Harriet Beecher Stowe* was with her Grace. In his disappointment he looked me up, having, I believe, not a single other acquaintance in the great city. To make matters worse for him, he had brought with him a charming little quadroon wife, of whose existence I had hitherto known nothing. They were residing in a wretchedly squalid place on the Surrey side, and were in imminent danger of starvation. I did the little that I could to relieve their immediate wants, and gave him an order for a bust. I had not the honor of *Mrs. Stowe's* acquaintance, nor have I ever since met the lady. But I took the liberty of immediately writing her a full account of my *protégé*, knowing that it would be laid under the Duchess's eye. At that time I had some doubts about *Mrs. Stowe's* sincerity in the cause of the negroes. I was not sure she was any thing more than a writer of sensational fiction. An answer soon came, to the effect that the Duchess and herself would be in London in a few days, when the matter should have attention. When these ladies did return, they associated with themselves in their benevolent purpose *Lady Byron*, and, for aught I know to the contrary, some others. Shortly thereafter they took a nice suite of apartments for *Warberg*, as I shall call him, and his wife, in the artists' quarter, on one of the streets leading into Bedford Square, paid the rent in advance, and furnished them with every comfort. After a further interval of time, *Warberg* informed me that the same ladies had arranged to send him to Italy, that he might have the opportunity of pursuing his studies in the studio of a famous sculptor. Never since that time have I doubted *Mrs. Stowe's* sincerity in the great work of African emancipation.[52]

This fascinating account requires several clarifications. Although Field here claims that he first learned of Warburg through the duchess, this is actually most unlikely. In the fall of 1854 Field arrived in Paris with no particular plan of action, but upon making the acquaintance of the American envoy, John Y. Mason, he was unexpectedly offered a position as the interim secretary of the American legation there, which he accepted. (Field was at this time enrolled

in the Democratic Party, to which Mason belonged, though he later served in the Treasury under Lincoln and became a Republican.) In his memoirs Field provides an extended characterization of Mason, who he seems to have liked. His main activity, during the few months of his diplomatic service, was to carry the diplomatic dispatch dashing the hopes of the writers of the Ostend Manifesto to Pierre Soulé in Madrid, and then return to Paris bearing Soulé's letter of resignation. He liked Soulé as well, and enjoyed the weeks spent in Madrid as he waited for Soulé to decide on his course of action. In another passage of his memoirs, related to the controversy surrounding the Ostend Manifesto, he also mentions Duncan K. McRae.[53] In other words, it is far more likely that Field met Warburg through his association with these men than through the duchess of Sutherland. Field's is the first name on the list of subscribers for Warburg's marble bust of Mason, and he also served as president of the American commissioners to the Exposition Universelle, where the bust was displayed with others of the sculptor's works. Warburg's ties to Field, Soulé and Mason were no doubt vital to his appearance at the Exposition.

Then there is the question of Warburg's wife. New Orleans documents seem to indicate that Warburg was *already married* when he left his native city, to a German immigrant by the name of Catherine Haselbach. Catherine was five years older than Eugène, and together they had a daughter, Lorenza. There is, however, no record of Catherine's having left New Orleans, and from 1871 to 1875 the census locates her there and describes her as Eugène's widow. Field's "charming little quadroon wife" is therefore probably a different person, and indeed a later source names her as Louise Ernestine Rosbò. We do not know where they met. There is, in fact, yet another account of Warburg's matrimonial history, which asserts that he married a local woman during his stay in Florence in 1857, but this cannot be squared with Field's narrative of 1855.[54] These puzzling and contradictory details suggest something of the complexity of life for a transatlantic artist of color, and perhaps of a need for both Warburg and those who followed and reported on his career to periodically re-construe his identity.

Finally, it should be noted that Field's account refers to a commission he gave Warburg—perhaps a bust of Field himself, but we do not know if it was carried out. But Field's modest contribution to Warburg's support, it is clear, was far exceeded by that of the triumvirate of the duchess of Sutherland, Stowe, and Lady Byron. These three women had in common their intense support for the abolition of slavery in the US, but the two British subjects, Sutherland and Byron, were not close friends, though each was an intimate of Stowe. Anna Isabella, Lady Byron (1792–1860), the poet's widow, had attended the 1840 World Anti-Slavery Conference in London, and was one of the few women incorporated in Haydon's famous group portrait of the event.[55] Stowe, touring England in 1853 in the glow of the fame she had procured with the publication of *Uncle Tom's Cabin*, met Byron, and their friendship deepened when Stowe returned to Britain in the summer of 1856.[56]

(In 1869, nearly a decade after Lady Byron's death, Stowe published a defense of Anna Isabella's behavior toward her husband the poet, which revealed to the world Lady Byron's affirmation that her distance toward him had been caused by Lord Byron's incestuous relations with his half-sister.[57])

Stowe had also met and befriended the duchess of Sutherland in 1853. In 1852, at her palatial London residence, the duchess had launched the Stafford House Address, a famous anti-slavery petition soon signed by well over half a million British women, and on May 8, 1853, Stowe was presented with the completed document in a moving ritual held in the same grand dwelling.[58] (On May 12, the vituperatively racist and anti-abolition Thomas Carlyle conflated Harriet Stowe and Harriet Sutherland by referring to Stafford House as "Aunt Harriet's Cabin."[59]) Stowe spent several weeks at the Sutherlands' Highland home, Dunrobin Castle, in the middle of September 1856, where she received an eager note from Lady Byron.[60] Stowe was back in London, but only briefly, in late October and early November, and this is the most likely period for a meeting with Warburg. The American author already had some experience in promoting a person of color in the arts: in 1855 she had written a one-person dramatization of *Uncle Tom's Cabin*, called *The Christian Slave*, for the relatively light-skinned African-American actress Mary Webb (1828–59), performed to mixed reviews in the US and, in 1856, in England. On July 28, 1856, shortly before Stowe arrived in England, Webb performed this work at Stafford House, with her hostess the duchess of Sutherland in the audience.[61] As we shall see, Stowe apparently had something similar in mind, allowing for the difference in medium, for Warburg. Maunsell Field's memoir, however, alludes to no works to be produced by Warburg in exchange for the financial support of the three women, but only to the bust which Field himself commissioned.

Desdunes, in his 1911 account of Warburg's life, writes that "in London he met the Duchess of S— —, who engaged him to make some bas-reliefs representing scenes from Harriet Beecher Stowe's *Uncle Tom's Cabin*," which took a year to complete.[62] As Desdunes' sources include most probably Eugène's brother Daniel, one ought not to take this claim lightly, yet no such work has surfaced, nor is there any other early citation of it. Though the relief format would have been unusual, illustrations of the novel certainly proliferated from the moment of its publication. It is not impossible to imagine the duchess of Sutherland desiring such a work, rendering the popular work of literature in a high-art medium, perhaps as an ornament for the classicizing interior of Stafford House. What is now clear, however, is that late in 1856 Warburg did produce a work (Plate 3, Figures 4.3 and 4.4) depicting characters from Stowe's *second* "slavery novel," *Dred*. Desdunes' reference to the *Uncle Tom* reliefs is most probably a distorted reflection of the *Dred* work.[63]

The key early source for this sculpture is an anonymous short piece in the well-known London periodical *Art Journal* (volume 19, September 1857, page 295):

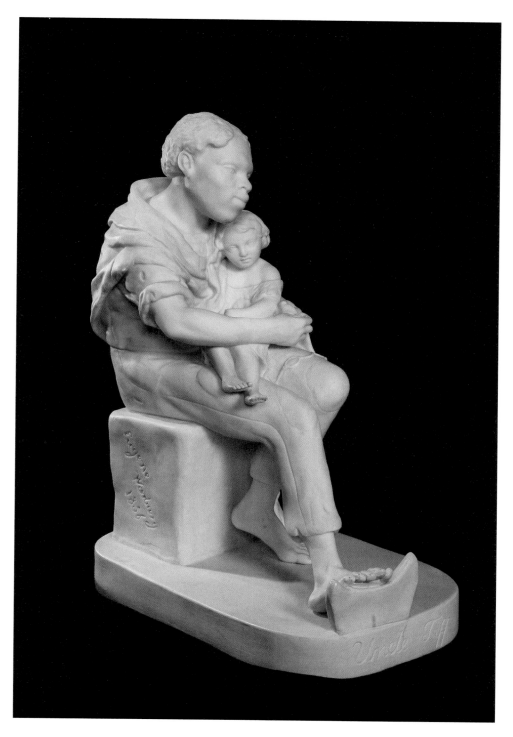

4.3 Eugène Warburg, *Uncle Tiff*, 1856. Parian. New Orleans, private collection. Photo: Ray Palmer

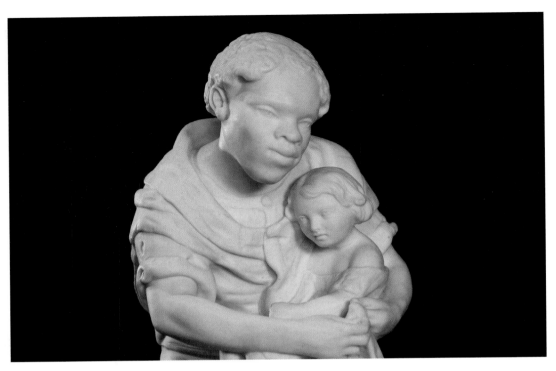

4.4 Eugène Warburg, *Uncle Tiff*, 1856, detail. Parian. New Orleans, private collection. Photo: Ray Palmer

Statuette of "old Tiff."—A statuette of much merit and considerable interest has been recently produced by Mr. Alderman Copeland, in statuary porcelain; it is the work of Mr. Warburg, an American sculptor of "mixed blood," an artist of great ability and general intelligence, who is now resident in England. The group represents "old Tiff," the hero of Mrs. Stowe's latest novel, nursing the little maiden who is the heroine of the story; and at the same time rocking a cradle with his feet and busied with his hands. It is a striking work, and cannot fail to find favour with the tens of thousands who in England, and in the United States, sympathize with the subjects whom Mrs. Stowe has pictured with so much feeling and pathos. The accomplished authoress has criticised this group of Mr. Warburg's, in a letter which we have perused:—"It is," she writes, "beautifully truthful, and shows how far the expression of love and fidelity may go in giving beauty to the coarsest and plainest features." Certainly the sculptor has exaggerated rather than mellowed the peculiarities of the African type.

Fortunately, this work survives, though because of its unfamiliar medium, a reproducible ceramic known as Parian or statuary porcelain, it has escaped the attention of most scholars of nineteenth-century American sculpture.[64] It is inscribed with Warburg's signature, the year 1856, and the words "Uncle Tiff"—not "old Tiff" as in the passage above. The object is invaluable in helping to understand the trajectory of Warburg's career and its intersection with the interests of both Stowe and the duchess of Sutherland.

The object is 12 inches (30 cm) high, and depicts one of the primary characters of Stowe's *Dred*, the older male slave Tiff, embracing the little white boy, Teddy, who sits in the slave's lap.[65] In nearly all respects, the sculpture

keeps closely to Stowe's text, in the passage where Tiff and Teddy's poor white family are introduced in Chapter 8:

Beside her [Teddy's mother's] bed was sitting an old negro, in whose close-curling wool age had begun to sprinkle flecks of white. His countenance presented, physically, one of the most uncomely specimens of negro features; and would have been positively frightful, had it not been redeemed by an expression of cheerful kindliness which beamed from it. His face was of ebony blackness, with a wide, upturned nose, a mouth of portentous size, guarded by clumsy lips, revealing teeth which a shark might have envied. The only fine feature was his large, black eyes, which, at the present, were concealed by a huge pair of plated spectacles, placed very low upon his nose, and through which he was directing his sight upon a child's stocking, that he was busily darning. At his foot was a rude cradle, made of a gumtree log, hollowed out into a trough, and wadded by various old fragments of flannel, in which slept a very young infant. Another child, of about three years of age, was sitting on the negro's knee, busily playing with some pine-cones and mosses.

The figure of the old negro was low and stooping; and he wore, pinned round his shoulders, a half-handkerchief or shawl of red flannel, arranged much as an old woman would have arranged it. One or two needles, with coarse, black thread dangling to them, were stuck in on his shoulder; and, as he busily darned on the little stocking, he kept up a kind of droning intermixture of chanting and talking to the child on his knee.

"So, ho, Teddy!—bub dar!—my man!—sit still!—'cause yer ma's sick, and sister's gone for medicine. Dar, Tiff'll sing to his little man."[66]

Though color, especially of skin, is absent in the white, marble-like sculpture, most other features from the text are apparent: the cradle (the abbreviated front end of which Tiff rests his foot on), the eyeglasses (not worn, but resting on his knee), the darning work, the shawl, the emphatically African features of the man. Stowe describes these features almost as a kind of frightening caricature. Warburg is less exaggerated in his approach, concealing Tiff's teeth, and the figure's age is mostly expressed in his receding hairline. In the sculpture Teddy has no pine-cones or mosses in his little hands, but a small crude doll resting on the ground behind the child may be Warburg's replacement for this missing detail; home-made dolls were sometimes made of such materials. As in Stowe's description, Tiff's expression is kind, though perhaps more consoling than cheerful. The almost maternal affect of Tiff toward the child is in fact most appropriate to the text. For Teddy's mother expires a few pages further into the novel, and Tiff becomes in all meaningful ways the adoptive parent of Teddy and his two siblings, offering them all the tender physical and psychological care expected of a mother. Surrounded by brutal oppression, and eventually adhering to the escaped slave Dred's plans for an insurrection, Tiff and his wards survive and finally prosper, finding refuge in New York.[67] (There are several more dramatic mixed-race characters in the novel, such as Harry and Cora, but they have more tragic fates, and for whatever reason they were not selected for illustration in this medium.)

How did Warburg's *Uncle Tiff* come to be made? Many works in Parian (and I will henceforth use this term rather than its alternative, statuary porcelain)

were copies after marble sculptures, sometimes famous ones, but neither the *Art Journal* piece nor any other source suggests that this was the case here. *Uncle Tiff* was a commercial product, priced by its maker Copeland, one of the foremost Staffordshire potteries, at a guinea wholesale, and 31 shillings and sixpence retail.[68] Such cast porcelain statuettes, given a more vitreous and therefore translucent surface to approximate marble, were marketed to both aristocratic and middle-class audiences. The Copeland firm would have paid Warburg a fee for the design, but who put him in touch with Copeland? It could easily have been the duchess of Sutherland, who—with her husband the duke—was a devoted promoter of the Staffordshire potteries.[69] The other major Sutherland country estate was at Trentham, near Stafford, and the duke (who also bore the title of marquis of Stafford, after which his London house was named) controlled the water rights that were essential to the operation of the mills. Copeland produced a Parian version of a portrait of the duke (and much later, one of the duchess), and of works in their collection.[70]

Portrait busts of contemporary figures were in fact rather common Parian subjects, but vignettes from contemporary literature were somewhat rarer. Dickens' *Old Curiosity Shop* (1841, depicted in Parian c. 1848) and *David Copperfield* (1850, immediately illustrated) were drawn from, and there survives a photograph of an undated Parian group, made by Worcester, depicting Uncle Tom and Little Eva, from *Uncle Tom's Cabin*; the designer of this last work is not known, but the very melodramatic composition does not resemble Warburg's *Uncle Tiff*, and looks to be derived from book illustration.[71] The early editions of *Uncle Tom's Cabin* were profusely illustrated, by Cruikshank in Britain, and in London visual images of the protagonist were soon to be seen beyond the pages of the book—in barber shops, in literary advertising in railway stations, and in quite a number of the crude, fully colored Staffordshire figurines that sold for a tiny fraction of the price of Parian ware.[72] The grouping of Uncle Tom and Little Eva was the most common theme from *Uncle Tom's Cabin* in these simple ceramic objects, and the white Eva is shown both standing and sitting on Tom's knee in several models (Figure 4.5), which suggests a source of inspiration for the general composition of Warburg's *Uncle Tiff*.[73]

These rough works, however, have none of the detail or polish of Warburg's composition, and depend almost entirely on intense dark color for their characterization of racial identity. Indeed, their dependence on color highlights the striking absence of color in *Uncle Tiff*. Some Parian images, including those depicting Africans, were in fact tinted; this was the era when the Rome-based English sculptor John Gibson attempted to introduce the tinting of marble itself, though not to suggest African identity.[74] In Warburg's piece, of course, facial physiognomy is more than enough to indicate Tiff's African identity, and, given both Stowe's and the anonymous *Art Journal* reviewer's apparent distaste for the physical appearance of people of color, perhaps it was felt that tinting the Parian work would carry things too far.

Stowe's *Dred*, rather remarkably, was hardly illustrated at all, and never— as far as we know—in the kind of simple Staffordshire objects just discussed.

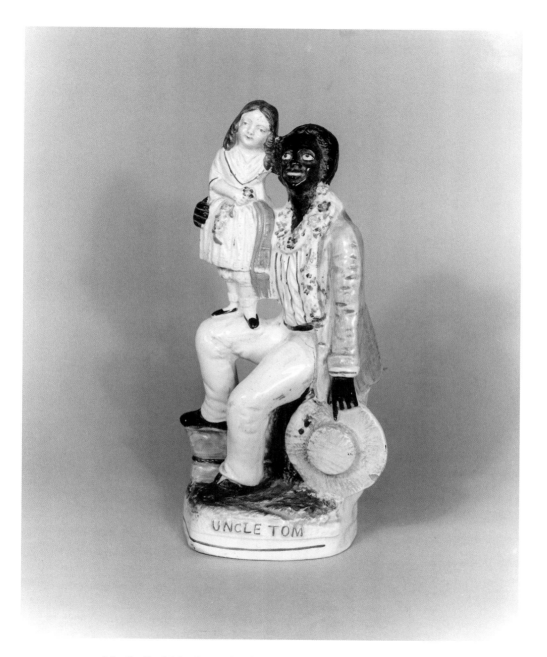

4.5 Staffordshire figure, *Uncle Tom and Little Eva*, c. 1852. Ceramic.
Royal Pavilion and Museums, Brighton & Hove

Scholars have not really addressed this strange disparity between the two novels, which appears to be—at least initially—the result of the circumstances under which *Dred* was published. Stowe, after both enjoying the general praise of *Uncle Tom's Cabin* and listening to criticism of it by African-Americans, plunged suddenly into the writing of *Dred* in February of 1856, just as the controversy over the violence between pro- and anti-slavery forces in Kansas was coming to a head. She may well have had in mind a publication date early enough to have an impact on the 1856 presidential election, in which slavery was promising to be a major issue. The novel was still unfinished when she left for England in July, but this was part of another important plan: Stowe wanted to be in England when she completed it so that she could obtain copyright protection in Great Britain, where the author was legally obliged to apply in person. She wrote furiously on board ship, landed on August 7, and sent the novel to both her American and British publishers on August 13; it was issued in both countries, rather amazingly, on August 22. There had obviously been no time to have the manuscript illustrated before publication, and rapid sales demonstrated that illustrations were not crucial to popular success. By October, 100,000 copies had been sold, and at the end of a year, the total sales in Britain and the US were over 300,000.[75]

Its first-year sales rivaled those of *Uncle Tom's Cabin*, but the response of literary critics to *Dred* was distinctly less favorable. This was perhaps to be expected given the book's more radical and even despairing analysis of slavery and the prospects for abolition. Having been contacted by Warburg in September, it is not difficult to imagine Stowe encouraging the young sculptor at an October meeting to use her new novel, read everywhere but as yet un-illustrated, as inspiration for a work of art. We do not, alas, have a direct account of this meeting, but we do have a letter of Stowe's that must have been written shortly after it. On November 3, 1856, Stowe wrote to the English sculptor Joseph Durham as follows:

Since seeing you I have called on Mr Warburg and found him as I expected in poverty and distress. I am going to make an effort to raise enough among different friends to pay his present debts and enable him to hire a respectable studio where he may have the means of working with better light and better means than at present. I[t?] does seem to me that he has a genuine enthusiasm for art and that as you remarked *there was that in him which* might be brought out and developed. Your encouraging word *for* and *to* him just at this crisis has been of great value and I trust you will still continue to feel a friendly care of him. There is a *hard bridge* to be crossed to success in every art and they who are upon it ought to have the sympathy of those who have entered the palace of success on the other side. I trust you will cooperate with my efforts for him mainly by still giving a good word for him to enquirers—for a man often is in that position that a word may sink or save him.

Significantly, the rest of the letter is mostly a request that Durham consider reproducing his own work in Parian (he soon did so), which Stowe lauds as the medium of the future which will allow the cultivated American middle classes to enjoy great works of sculpture.[76]

Two days later (on November 5) Stowe wrote to Lady Byron about Warburg, but Stowe's son Charles, who published a portion of the letter in 1890, regarded this material as unimportant. Assuming his mother's voice he simply remarks that the "rest of the letter was taken up in the final details of charity in which Lady Byron had been engaged with me in assisting an unfortunate artist."[77] The letter's current location is, alas, unknown. As of mid-October Harriet Beecher Stowe was planning a November trip to the North of England to see Harriet Martineau, one of the leading lights of transatlantic feminist abolitionism, and though the trip had to be cancelled, there is some chance that Stowe also planned to ask Martineau to help assist Warburg. A few weeks earlier, on September 19, Martineau was promoting a performance by Stowe's African-American theatrical protégé Mary Webb near her house in the Lake District, and a request on behalf of Stowe's other protégé would have made sense.[78]

We cannot be certain how the idea of Warburg's *Uncle Tiff* was generated. One imagines that Warburg was an eager early reader of *Dred*, and it may have been the sculptor who proposed to the author that he depict some figure from it. Stowe, in turn, would have suggested the medium of Parian, and the duchess's connections to the manufacturer Copeland would have made the plan especially attractive for all three. Beyond the goal of advancing abolitionist views, dear to Stowe and the duchess, the artist and the author would draw personal advantage from a work directed at a wide audience. Sutherland, Stowe, and even Warburg may have had in the back of their mind the vast success of another anti-slavery product of the Staffordshire potteries: the "Am I Not a Man and a Brother" medallion produced by Josiah Wedgwood beginning in 1787–8.[79]

There is other evidence that Stowe was especially interested in the power of sculpture to shape perceptions of people of color. In attempting to describe what the eloquent escaped slave and abolitionist Sojourner Truth must have looked like as a young woman, Stowe (in an essay in the *Atlantic Monthly* of 1863) compared her to the sculptor Charles Cumberworth's *Negro Woman at the Fountain* (also known as the *Nubian Water-Carrier* or simply as the *Negress*) (Figure 4.6). This is no casual reference; Stowe emphatically states that "she [Truth] so strongly reminded me of that figure, that, when I recall the events of her life, as she narrated them to me, I imagine her as a living breathing impersonation of that work of art."[80] Cumberworth's attractive and even eroticized statuette of c. 1846 exists in bronze—Stowe owned one—but it was widely disseminated in Parian.[81] The son of an English father and a French mother, Cumberworth (1811–52) was trained in France, but his work (and that of many other French sculptors of the period) was adapted for productions in Parian; a number of these French sculptors came to England for a time and played an important role in the industry.[82] As Stowe also described Sojourner Truth as the inspiration for Milly, another slave protagonist in *Dred*, a second (though more indirect) link between Parian statuettes and the major African-American characters in the novel can be established.[83] The most famous of

these mid-century French sculptors to be involved with Parian, Albert-Ernest Carrier-Belleuse (1824–87), also had significant abolitionist connections. Carrier-Belleuse was in England from 1850 to 1855, working for several of the Staffordshire potteries, and was particularly affiliated with Minton, Copeland's chief rival in the production of Parian. Philip Ward-Jackson has argued that Carrier-Belleuse was brought into this artistic orbit by his first cousins in the Arago family, one of whom was the scientist François Arago (1786–1853), a political ally and good friend of the duke and duchess of Sutherland.[84] François Arago was briefly the minister of the marine and colonies (and also the minister of war) in the radical French republican government in the spring of 1848, during which time he successfully promulgated the abolition of slavery in the French colonies.[85] Carrier-Belleuse produced a number of important works for the Sutherlands, and, having returned to Paris in 1855 and taken a studio around the corner from Warburg's in the rue des Martyrs, he is another candidate for having apprized the American sculptor of Sutherland patronage and the possibility of work in the medium of Parian.[86]

For Warburg, however, the patronage of the two Harriets (Sutherland and Stowe) in England appears to have been a means rather than an end. *Uncle Tiff* was not followed by any other Warburg productions in Parian.[87] Using the funds raised in London, he may have gone to Berlin and elsewhere in Germany, and by 1857 he was in Italy.[88] On July 16, the American painter Sanford Robinson Gifford (1823–80) wrote to his father, from Venice:

> We had a call from Eugene Warburg, a negro sculptor from New Orleans. On his way to Florence, and out of money. His manner was prepossessing. He had letters from people we knew. He was modest, but full of hope and confidence. Together with Wild, Perry, Field and Mrs. Tappan we made up a purse for him the next day, and sent him on his way rejoicing.[89]

Warburg's letters of reference were apparently from the odd trio of Soulé, Stowe, and Sutherland (see below), but they must hardly have been necessary, since Maunsell Field (whom Warburg had previously met in Paris and London) himself was one of the five Americans in Gifford's party. Of the others, Gifford and Hamilton Gibbs Wilde (1827–84) were painters. Gifford was in the second year of an interval of European travel, while Wilde was based in Rome for much of 1855–60.[90] Perry and Mrs. Tappan are rather more interesting, from our point of view. Enoch Wood Perry Jr. (1831–1915) was also a painter, but it is probable that this was not the first time he had met Warburg. Born in Boston, his family had moved to New Orleans in 1848, and he had begun his working life as a clerk there, even as he began to study art.[91] If by some chance he had never encountered Warburg, he at least would have been impressed by Soulé's letter of recommendation. Like Warburg, he left New Orleans in 1852 for Europe, studying in Düsseldorf and Paris (where he again may have run into Warburg). By 1855 he was in Italy, and from 1856 to 1858 he served as the American consul in Venice. He was, clearly, the local host at the get-together at which Warburg appeared.

4.6 Charles Cumberworth, *Negro Woman at the Fountain*, c. 1846.
Bronze. Formerly Florence, Holderbaum Collection

"Mrs. Tappan" was Caroline Sturgis Tappan (1818–88), the most politically progressive and intellectually sophisticated member of this group. Like Field, she was not a visual artist, though she was an early collector of photographs. A poet and writer, she was an adherent of Transcendentalism, and a close friend and correspondent of both Emerson and Margaret Fuller; she was also known to and admired by Henry James. Her father-in-law and his brother, Lewis and Arthur Tappan, were among the foremost white abolitionists. Caroline Tappan traveled in Europe between 1855 and 1861, and her foreign experiences are recorded in many letters.[92] Her surviving missives do not, alas, mention Warburg, but she must have found his appearance apposite, and welcomed the chance to contribute to his support. Less than two months earlier, on May 23, she had written to Emerson as follows:

Yet I felt at home in Rome as I have never done. Rome seems larger than America, with all its backwoods. And America from here looks so sad, so almost lost and dead before it is well born! I often think, "How can I ever go back to that monotonous, formal life, to snows and slavery." Here one is so hopeless about the people that they are like a thing apart—something dramatic and picturesque—and merely to look at, they seem happy too, living their graceful social life in the open air. I should like to live out here until I could quite forget all the "great moral questions of the day," and not care much whether Kansas and Massachusetts are slave states or not. But I find here that Art seems less and Right more than even at home.[93]

That particular tension between the Italian artistic tradition and the great moral question of the day must have been brought home to Warburg in an almost shocking fashion on the morning immediately following his meeting with the five Americans. In a letter of July 17, Gifford notes: "Met Warburg, and went with him to the Frari."[94] This great Venetian church would have been on the itinerary of any cultivated tourist, for its soaring Gothic architecture and Titian's famous Pesaro altarpiece. Next to that masterpiece, however, the two Americans could hardly fail to have noticed the enormous Baroque wall-tomb of Doge Giovanni Pesaro (1669), in which a rather bland image of the deceased is supported by four colossal, struggling black African atlantes.[95] The tomb was stylistically deeply out of fashion in the 1850s, but American visitors to the church could hardly take their disapproving eyes off the almost demonic Africans, their skin carved in black marble contrasting with the white marble of the rags they wear. One American traveler in 1860 pronounced it "a monument in honor of negro slavery," and Mark Twain in 1867 was (in his usual way) perplexed by it.[96] What Warburg made of it we do not know; perhaps it occurred to him that it was an absurd variation on his *Uncle Tiff*, with its large African characters physically supporting a smaller, whiter burden, or perhaps it brought back to his mind his own black and white marble decoration for the floor of the cathedral in New Orleans.[97]

Soon Warburg was en route to Florence, a considerably more important destination for any sculptor in this era. Two rather similar brief notices in New Orleans newspapers show that he had arrived by November 17, 1857,

bearing the letters of Soulé, Stowe, and Sutherland. The *Daily Picayune*, of December 26, 1857, reports as follows: "A Mulatto Sculptor from New Orleans.—A letter from Florence, Italy, dated Nov. 17, says: 'We have here a mulatto sculptor from New Orleans (Eugene Warbourg) who brings commendations from Mr Soulé, Mrs. Stowe, and the Duchess of Sutherland, who gives some promise of respectable attainments in the profession.'" The *Daily Crescent*, more snidely, cited the report as from a "northern paper" (so far unidentified), professed not to know if the report (or the attainments) were true, and ironically congratulated "Mr. Soulé upon his good fortune in being placed in such distinguished juxtaposition" with Stowe and Sutherland.[98] The *Charleston Courier*, however, provided more particular information in an article of February 25, 1858:

Eugene Warburg, an artist now residing in Florence, is a Louisianian by birth, and by the high rank secured for him by some of his works, has conferred honor on his native State. He represented Louisiana at the Paris Exhibition with much *éclat*, and has executed some pieces of statuary for distinguished persons in Europe. We have before us a photograph of one of his works "The First Kiss," which fully sustains his reputation. This work he proposes to dispose of by raffle— 400 tickets at $2.50 per ticket. The lottery will be drawn at Florence, under the superintendence of Messrs. Maquay & Packenham, bankers. It would be desirable that this work of a Louisana [sic] artist should be brought to our shores as an illustration and a memento of native genius.[99]

According to the highly romanticized and elliptical account of Warburg's life published by the New Orleans African-American newspaper *L'Union* in 1862, the sculptor fell in love with "a spiritual child of Florence, from a distinguished family," and married her before heading on to Rome.[100] Though several notable anglophone residents of Florence, including Elizabeth Barrett Browning, held strong anti-slavery views, Desdunes claims that Warburg encountered there racial discrimination of the sort he had suffered in New Orleans, leading to a further move to Rome, where he found contentment.[101]

We currently know little about Warburg's stay in Rome, but there are several reasons why he may have found it more congenial than Florence. In these years it was a far more cosmopolitan place than Florence, with a visible presence of Africans and African-Americans among the priests and seminarians at the Vatican's Propaganda College in the Piazza di Spagna; these dark-skinned Catholics were much noticed by American visitors such as Margaret Fuller.[102] Warburg's residence was in the vicolo Alibert, not far away, and this whole district was frequented by foreign artists, whose diversity Henry James likened to the clerics at the Progaganda.[103] In Rome, as in certain other parts of Europe, white Americans sometimes encountered local inhabitants who assumed that *all* Americans were black; this had first happened to the American painter Benjamin West in the eighteenth century, when he was introduced to the (blind) Cardinal Albani—or at least, so the story went.[104] As in Florence, there were also present in Rome politically progressive anglophone expatriates, like the American sculptor William

Wetmore Story. Nevertheless, no traces of contact between Warburg and such expatriates, or for that matter, between Warburg and any Italian artists (such as Pietro Galli), have as yet been discovered. Perhaps Warburg was already ill when he arrived in Rome, and had little chance to pursue these connections. Less than a year after he was last documented in Florence, on January 12, 1859, aged 33 or 34, Warburg died in Rome. The news was disseminated, with a sorrowful encomium, in his native city by *L'Abeille* on March 9.[105] Catholic funeral services were held at S. Maria del Popolo, near his residence, with burial at the huge Roman cemetery of Campo Verano; his grave has not been identified.[106]

It had been a striking career in its trajectory, but a very short one, and Warburg's oft-emphasized promise remained largely unfulfilled. In a future study, I will take up the question of whether his life and work were reflected to any degree in novels by Hawthorne and Lydia Maria Child. For the moment, however, it is necessary to consider some of the salient aspects of Warburg's European career. As little as we know of it, we have much more information about his time in Europe than we do about his earlier professional work in New Orleans; his two surviving signed, figurative works were made in France and England. This suggests that Warburg was right to leave his native city and land.

Those two surviving sculptures, however, reveal a great deal about the tensions and sometimes paradoxical connections that defined Warburg's career. He was the epitome of a person of complexly mixed elements—not merely slave and free, and black and white, but of German Jewish, French and/ or Spanish, and African ancestry—yet his two surviving works focus on the "purely" white and the "purely" black. Would he have personally identified with either of these extremes, or with both? (One of the many things we do not know about Warburg is what he looked like, and whether he could or did "pass.") Stowe's *Dred* has several mixed-race protagonists; did Warburg select the more intensely African Tiff, or was this Stowe's (or Sutherland's) preference? Would he have continued with such subjects or abandoned them? He seems to have made a conscious decision to seek abolitionist patronage, but he did not exist entirely within that radical realm (as Edmonia Lewis largely was to do), and it is significant that his death in 1859 was reported back in New Orleans but apparently not in anti-slavery circles. Warburg belonged to a transatlantic, multi-racial cultural world, but one with a shape rather different from that inhabited by such contemporaries as Frederick Douglass and Edmonia Lewis. His ability to bridge the gap between Soulé and Stowe was remarkable, and one wonders whether he ever spoke to either about the other, but without such an ability to deal with wildly different patrons it is unlikely he would ever have fulfilled his goal to work in Italy.

In the end, it is Warburg's collaboration with Stowe (and perhaps Sutherland) that stands out. Was it a collaboration which could only have taken place in Europe? Probably, but not entirely for "racial" reasons. Stowe was a committed amateur painter herself (largely of still life and landscape

subjects) and took the visual arts seriously. But she, Warburg, and many other Americans regarded study in Europe as essential for the development of serious American artists. Stowe had already worked hard to promote the African-American Mary Webb as a theatrical performer in the US, but she soon encouraged Webb to tour in England. No doubt part of Warburg's appeal to Stowe was that he had already taken a fundamental step in moving to Paris and then London—he had begun the crossing of the "hard bridge" to success that Stowe had spoken of in her letter to Durham. Stowe had relatively little to say about the numerous American illustrations of *Uncle Tom*, which were mostly not very ambitious in aesthetic terms. When she wanted to use the visual arts to help conceptualize African-American identity, she more often turned to works produced in Europe: Warburg's *Uncle Tiff* (Plate 3, Figures 4.3 and 4.4), Cumberworth's *Negro Woman at the Fountain* (Figure 4.6), and another work she linked to her image of Sojourner Truth, William Wetmore Story's *Libyan Sibyl*, a large marble figure of a woman with some unmistakable traces of African identity, produced in Rome during 1860 and 1861. Stowe in fact laid claim to the genesis of this work in 1863, affirming that her description of Truth to Story when she visited Rome in 1857 had planted the seed of his "anti-slavery sermon in stone" (as Story put it).[107] Whatever the truth of that story, we now know that Stowe had surely played a vital role in engendering Warburg's *Uncle Tiff* in England a year earlier.

Notes

1 For ideas and access to images in this chapter, I am deeply indebted to Ray Palmer, Robert Bain of the Gallery Sunsum in Memphis, David Bindman, Beth Burgess of the Harriet Beecher Stowe Center in Hartford, and to my late parents, Sidney Kaplan and Emma Nogrady Kaplan. For the quoted description of Warburg, see the New Orleans *Daily Picayune*, Saturday December 26, 1857.

2 On Lewis, see Kirsten P. Buick, *Child of the Fire: Mary Edmonia Lewis and the Problem of Art History's Black and Indian Subject* (Durham, NC, 2010); Melissa Dabakis, "'Ain't I a Woman?': Anne Whitney, Edmonia Lewis, and the Iconography of Emancipation," in Patricia A. Johnston, ed., *Seeing High and Low: Representing Social Conflict in American Visual Culture* (Berkeley, 2006), 84–102; Lynda Roscoe Hartigan, *Sharing Traditions; Five Black Artists in Nineteenth-Century America* (Washington, DC, 1985), 85–98; Lynn Moody Igoe with James Igoe, *250 Years of Afro-American Art. An Annotated Bibliography* (New York, 1981), 899–905; Charmaine A. Nelson, *The Color of Stone: Sculpting the Black Female Subject in Nineteenth-Century America* (Minneapolis, 2007), 159–78. On Warburg as a predecessor of Lewis, see for example Sharon F. Patton, *African American Art* (Oxford, 1998), 91; Regenia A. Perry, *Selections of Nineteenth-Century Afro-American Art* (New York, 1976).

3 On Foy and his trip, see Patricia Brady, "Black Artists in Antebellum New Orleans," *Louisiana History: The Journal of the Louisiana Historical Association* 32 (1991): 5–28, 18. On Hudson, see William Keyse Rudolph, Patricia Brady, and Erin Greenwald, *In Search of Julien Hudson: Free Artist of Color in Pre-Civil War New Orleans* (New Orleans, 2010). On Duncanson, see: Lynn Moody Igoe, ed.,

Duncanson: A British-American Connection (Durham, NC, 1984); Joseph D. Ketner, *The Emergence of the African-American Artist: Robert S. Duncanson, 1821–1872* (Columbia, MO, 1993).

4 Rudolph et al., *In Search of Julien Hudson*, 6, 23, and 67, and Igoe and Igoe, *250 Years*, 1186–1187, are among the more useful compilations. See also John A. Mahé II and Rosanne McCaffrey, eds., *Encyclopaedia of New Orleans Artists, 1718–1918* (New Orleans, 1987), 401–2.

5 In Robert R. MacDonald, John R. Kemp, and Edward F. Haas, eds., *Louisiana's Black Heritage* (New Orleans, 1979), 74–78.

6 *The Early Jews of New Orleans* (Waltham, MA, 1969), 179–82, 320–321, ns. 41–4.

7 Primarily Brady, "Black Artists," and her "Free Men of Color as Tomb Builders in the Nineteenth Century," in Glenn R. Conrad, ed., *Cross, Crozier and Crucible; A Volume Celebrating the Bicentennial of a Catholic Diocese in Louisiana* (New Orleans, 1993), 478–88, esp. 480–486; but see also the brief notices in "The Warburg Brothers: Sculptors," *Historic New Orleans Collection Newsletter* 7, no. 3 (1989): 8–9; "Footnote to History," *Historical New Orleans Collection Quarterly* 12, no. 3 (Summer 1994): 7. Both Brady and O'Neill make extensive use of the "Artists of New Orleans" clipping file, produced under the WPA, in the New Orleans Museum of Art; I have not been able to consult this source.

8 *Picayune*, March 7, 1855: 1 (not previously cited in scholarly discussions) and December 26, 1857; *Daily Crescent*, December 26, 1857; *Bee*, December 13, 1850; *L'Abeille*, March 9, 1859: 1.

9 *Art Journal* 19 (1857): 295 (September); *The American* [Paris] 1, no. 8 (January 27, 1855): 1 (incompletely reprinted in the *Picayune* of March 7, 1855, cited in the previous note), and vol. 1, no. 50 (November 10, 1855): 1; *Courrier des Etats-Unis* [New York], June 9, 1855: 2; *Charleston Courier*, February 25, 1858: 1.

10 *Nos hommes et notre histoire: notice biographique accompagnées de reflexions et de souvenirs personnels* … (Montreal, 1911), 95–8; there is a slightly abridged English translation, *Our People and Our History*, trans. and ed. Sister Dorothea Olga McCantis (Baton Rouge, LA, 1973), 69–71. (All references to Desdunes below are to this 1973 version.) Desdunes gives the artist's last name as Warbourg, which form is used in several other more recent sources as well.

11 December 6: 3. For some further newly located census and customs documents concerning Warburg, see the discussion of Warburg's wife below.

12 The best account of Daniel is in Korn, *Early Jews*, 179–81. To show Daniel's and Eugène's relation to the rest of the influential Warburg clan, Korn cites the family's privately printed genealogy, *Stamm- und Nachfahrentafeln der Familie Warburg Hamburg-Altona* (Hamburg, 1937), esp. sheet 22. The family trees therein make it clear that the famous italophile and pioneering scholar of Renaissance art and culture Aby Warburg (1866–1929) was Eugène's sixth cousin, once removed. One wonders if Aby, a longtime resident of Florence, had ever heard tell of Eugène and his somewhat earlier visit to Tuscany. None of the contemporary sources on the artist (or Desdunes) mentions his father's Jewish ancestry. Eugène was also one of the first American sculptors of Jewish ancestry.

13 Korn, *Early Jews*, 180–181.

14 Ibid., 181, 321, n. 44; O'Neill, "Fine Arts and Literature," 74. Korn gives a death date of November 1, 1837 for Marie Rose, but as discussed below her inheritance was still being divided in 1852, and he finds this puzzling. O'Neill (ibid., 74,

n. 30) notes that our artist was officially named as Joseph Eugène, but "Joseph" is only used in legal documents.

15　Desdunes, *Nos hommes*, 69 (Garbeille is named as "Gabriel"); O'Neill, "Fine Arts and Literature," 74; Brady, "Free Men of Color," 482; Brady, "Footnote to History," 7; Saur, *Allgemeines Künstlerlexikon*, s.v. "Garbeille, Philippe."

16　O'Neill, "Fine Arts and Literature," 75; Brady, "Free Men of Color," 481.

17　O'Neill, "Fine Arts and Literature," 74; Brady, "Black Artists," 21; Brady, "Free Men of Color," 484. A letter of February 12, 1851 from Warburg to the cathedral's Construction Committee includes a proposal to decorate the entire interior with painting and stonework; New Orleans, Historic New Orleans Collection, gift of Samuel Wilson Jr., 86-74-L1. I will discuss this letter in a future publication.

18　Desdunes, *Nos hommes*, 69; on Eugène's brother (1836–1911) and nephew, see ibid., 70–71; O'Neill, "Fine Arts and Literature," 77–8; Brady, "Black Artists," 24; Igoe and Igoe, *250 Years*, 1186.

19　Desdunes, *Nos hommes*, 69; perhaps a member of the Peniston family, after whom a street in New Orleans is named.

20　O'Neill, "Fine Arts and Literature," 74–5; Brady, "Black Artists," 21; Brady, "Free Men of Color," 484.

21　Eugene Plon, *Thorvaldsen: His Life and Works*, trans. Mrs. Cashel Hoey (London, 1874), 249–50, 258, 264–5.

22　*Daily Picayune*, October 10, 1891: 3 (obituary of Perelli); on Galli, in Thorvaldsen's shop from the 1820s and living in the master's house from 1838–41, see Saur, *Allgemeines Künstlerlexikon*, s.v. "Pietro Galli"; Alberta Campitelli, "La scuola di Thorvaldsen nelle Ville Torlonia di Roma e Castel Gandolfo," in Patrick Kragelund and Morgens Nykjaer, eds., *Thorvaldsen: l'ambiente, l'influsso, il mito* (Rome, 1991), 59–76.

23　Lauretta Dimmick, "Mythic Proportion: Thorvaldsen's Influence in America," in Kragelund and Nykjaer, *Thorvaldsen*, 169–91, 171.

24　Desdunes, *Nos hommes*, 70; Brady, "Warburg Brothers," 8; Brady, "Black Artists," 22. In the original 1911 French version of Desdunes (97), there also appears one sentence omitted in the English translation: "A l'étranger, le genie de Warbourg avait pris un essor."

25　Brady, "Free Men of Color," 484. However, Perelli was on good terms with Florville Foy, another mixed-race New Orleans marble-worker, and is said to have made a bust of him; Brady, "Black Artists," 18.

26　J. Preston Moore, "Pierre Soulé: Southern Expansionist and Promoter," *Journal of Southern History* 21 (1955): 203–23.

27　On Séjour, see Werner Sollors, *Neither Black nor White yet Both. Thematic Explorations of Interracial Literature* (New York, 1997), 164–7; Charles Edwards O'Neill, *Séjour; Parisian Playwright from Louisiana* (Lafayette, LA, 1995). In mid-nineteenth-century Paris, of course, the most prominent literary figures of partly African descent were Alexandre Dumas *père* and *fils*; Dumas *père* was the grandson of a mixed-race Haitian woman.

28　Korn, *Early Jews*, 321, n. 44; O'Neill, "Fine Arts and Literature," 75.

29　February 4, vessel *City of Rotterdam*, Dunkirk to London, declaration of aliens, signature and identification as sculptor; August 21, vessel *Fame*, Calais to

London, signature, and identification as artist; UK, National Archives, Public Record Office, Home Office, Alien Act 1836, Returns and Papers, pieces 68 and 70. My thanks to Ray Palmer for providing this information.

30 *A Colored Man Round the World. By a Quadroon* [Cleveland?, 1858]; facsimile edition, *A Colored Man Round the World*, ed. Malini Johar Schueller (Ann Arbor, 1999).

31 Dorr, *Colored Man*, 38–40. In this era, the term "quadroon" signified a person with one black grandparent; "octaroon" a person with one black great-grandparent. Dorr calls Cordevoille a "quadroon," and may have referred to himself with the same word—see the title of his book.

32 *Exposition Universelle de 1855, Explication des ouvrages de peinture, sculpture, gravure, lithographie et architecture* (Paris, 1855), 84; on Jouffroy, see Stanislas Lami, *Dictionnaire des sculpteurs de l'école française au dix-neuvième siècle*, vol. 3 [Paris, 1919] (reprint ed., Nendeln, Liechtenstein, 1970), 213–18.

33 *Thoughts in Rhyme* (New York, 1867), 208. Thanks to my colleague Michael Lobel for finding this unexpected source. Parmly is likely to have sought out Warburg on the advice of his equally famous dentist brother, Levi Spear Parmly (b. 1790), who practiced in New Orleans from 1822 to 1852, when he left for Europe; he died in Versailles in 1859. See Christopher Hoolihan, *An Annotated Catalogue of the Edward C. Atwater Collection of American Popular Medicine and Health Reform*, vol. 2, M–Z (Rochester, NY, 2004), s.v. "Parmly, Levi Spear."

34 1820–88, of Fayetteville, North Carolina. See Robert J. Wynstra, *Politics, Gettysburg, and the Downfall of Confederate Brigadier General Alfred Iverson* (New York, 2010), 52–4; William S. Powell, ed., *Dictionary of North Carolina Biography*, vol. 4 Chapel Hill, 1991), s.v. "Duncan Kirkland McRae," 189–90.

35 The original piece in *The American*, probably written by its editor, Charles L. Fleischman, is entitled "A Visit to Mr. Warburg's Studio," and the first and most relevant section of it runs as follows:

"At the very end of the rue des Martyrs, near the Barriere Montmartre, in a building destined to ateliers of sculptors, we found Mr. Warburg's unpretending studio. The artist was not there, and we had to be our own cicerone. Among a number of plaster casts, the inmates of all ateliers of sculptors, the cast of a figure representing a boy about twelve years of age, in a sitting posture and playing with a crab, attracted our notice. We found that the artist was engaged in producing it in marble. The figure of the boy, and position, is very natural, the proportions good, and the whole produces a very pleasing effect. We are curious to see this figure, sculptured in marble, which admits that beautiful finish and life like expression of feature and muscle.

"We observed also a bust in marble, intended, no doubt, for Mr. McRae, our Consul at Paris, whom it resembles strikingly. The plaster-cast figure of the boy and the marble bust show talent, and from what we have seen of the works of the artist, we have all reasons to believe that he will arrive at eminence. Mr. Warburg is modest; he feels that he has to study. He appreciates the works of the ancient and modern sculptors, and loses no time or occasion to perfect himself. The road to perfection is long and difficult, but perseverance, study, and a due consideration of the works of others, will surely lead to it.

"We have seen a photographic picture of the piece last referred to, certified as a correct one by our consul at Paris. The work would seem, though undoubtedly open to criticism, to be very creditable."

36 Dominique Lobstein, "L'Exposition Universelle des beaux-arts de 1855," in Pierre Sanchez and Xavier Seydoux, *Les catalogues des salons*, vol. 6 (1852–57) (Dijon, 2002), 9–21.

37 See above, n. 32. A French-language paper in New York City, the *Courrier des Etats-Unis*, mentioned Warburg's presence at the Exposition on June 9, 1855: 2.

38 Sanchez and Seydoux, *Les catalogues des salons*, 630 (fourth supplement, no. 2369).

39 Alexander Wilbourne Weddell, *Portraiture in the Virginia Historical Society with Notes on the Subjects and Artists* (Richmond, 1945), 131–2, 174; Frances L. Williams, "The Heritage and Preparation of a Statesman, John Young Mason, 1799–1859," *Virginia Magazine of History and Biography* 75 (1967): 305–30.

40 Virginia Historical Society, Richmond, Mss2 M3814, including a presentation note to Mason, and thank-you note from him, and the list of subscribers. Warburg is mentioned in both notes, and Mason calls him a "modest and meritorious artist"; nothing is said of his ethnicity. Among the subscribers were Maunsell Field (see an extended discussion below) and Charles Fleischman, the editor of *The American*. My thanks to Miles Hall for research assistance with these documents.

41 Amos A. Ettinger, *The Mission to Spain of Pierre Soulé, 1853–1855: A Study in the Cuban Diplomacy of the United States* (New Haven, 1932), 100–127, for Soulé's early career, esp. 103–6; Caryn Cossé Bell, *Revolution, Romanticism and the Afro-Creole Protest Tradition in Louisiana, 1718–1868* (Baton Rouge, 1997), 160–162, 165–6, 175–6 (generally following Ettinger); also Alfred Mercier, *Biographie de Pierre Soulé sénateur à Washington* (Paris, 1848); "Political Portraits with Pen and Pencil. Pierre Soule [*sic*] of Louisiana," *United States Magazine and Democratic Review* 29 (1851): 267–73, at 270; Alexandre Dumas *père*, *My Memoirs*, trans. E.M. Waller, vol. 3 (London, 1908), 227, with the reference to the subject of Soulé's transgressive article. Soulé edited and wrote for the satirical journal *Le Nain*, which ran for the first six months of 1825; for evidence of his difficulties with the government and his views on Haiti and Grégoire, see vol. 1, nos. 1 (January 25, 7), 2 (January 30, 33), 7 (February 25, 113), 9 (March 10, 144–7), and 18 (April 25, 78–80). Boyer was president of Haiti from 1818, and of the whole island of Hispaniola (Ste.-Domingue) from 1822 to 1843.

42 Ettinger, *Mission to Spain*, 121, and also cited in Bell, *Revolution*, 175–176; inserted in a letter to Sumner from Stowe's husband, C.E. Stowe (now Houghton Library, Harvard University). Bell effectively brings out the tension between Soulé's allegiance to French republicanism, renewed in 1848, and his pro-slavery stance in the 1850s; see 165–6, 171–9, 184–5, 183 (brief comments on Warburg).

43 Solomon Northup, *Twelve Years a Slave* (Auburn, NY, 1853), 293.

44 Brady, "Black Artists," 22.

45 Moore, "Pierre Soulé"; Ettinger, *Mission to Spain*.

46 Ettinger, *Mission to Spain*, 365, 368, 376.

47 Desdunes, *Nos hommes*, 70; repeated by Brady, "Black Artists," 23.

48 *The American* 1, no. 50 (November 10, 1855): 1.

49 K.D. Reynolds, *Aristocratic Women and Political Society in Victorian Britain* (Oxford, 1998), 122–7; James Yorke, *Lancaster House: London's Greatest Town House* (London, 2001).

50 George William Frederick Howard (1802–64), known as Lord Morpeth before 1848; his preface appears in several editions published in London by

G. Routledge and Co., 1852–53. In 1853, when we know Warburg twice traveled to London, the duchess was much in the news for her energetic anti-slavery activities.

51 George Granville Leveson-Gower, 1786–1861. On the *Ganymede* (bearing a cup to Jupiter who appears in the form of an eagle), commissioned by the duke in 1817 but not delivered until 1829, see Yorke, *Lancaster House*, 127–8, 130, pl. 86; "Visits to Private Galleries. No. XIV. The Collection of His Grace the Duke of Sutherland, K.G., Stafford House, St. James," *Art Union* 8 (1846): 237–9, at 238; Plon, *Thorvaldsen*, 250. This sculpture was probably Leveson-Gower's most major acquisition during his stay in Italy in 1816–17; it is now in the Minneapolis Institute of Arts, inv. 66.9.

52 Maunsell B. Field, *Memories of Many Men and of Some Women* (New York, 1874), 138–40 (the passage appears in an excerpt published in *Harper's Magazine* 48, no. 283 (December 1873): 106–115 ("A Chapter of Gossip," 111). Although Field implies this all took place late in 1855 or early 1856, for reasons outlined below the encounter must have transpired in the late summer or early fall of 1856.

53 Field's book is the primary source on his life. On his dealings with Mason, see Field, *Memories*, 57–64, 75, 99–100; with Soulé, see ibid., 69, 75, 77–86, 95–9; with McRae, see ibid., 70. See also his obituary, *New York Times*, January 25, 1875: 5.

54 1850 US Census, New Orleans, LA, Eugène listed as 24, Catherine as 29, born Germany, and Lorenza as one year old. Eugène and Lorenza, but not Catherine, are listed as "M" (mulatto). Lorenza later married a white man by the name of William McGreevy, and the birthplace of her mother is listed as Hamburg, Germany (whence Daniel Warburg had originally come); New Orleans, LA, Birth Records Index, 1790–1899, vol. 61, p. 359, vol. 63, p. 210, vol. 71, p. 23, vol. 74, p. 187; New Orleans, LA, Death Records Index, July 24, 1898 (Lorenza Magreevy dead at 48, no race specified); 1880 US Census, New Orleans, LA, roll 459, p. 510D, district 23. Catherine is listed as Eugène's widow in New Orleans City Directories of 1871 (p. 628), 1872 (p. 415), 1874 (p. 769), and simply as Mrs. Catherine Warburg in the 1875 directory (p. 693). (My deep thanks to Ray Palmer for having located this information.) Louise Ernestine Rosbò's name is given in Eugène's 1859 death records in Rome, cited in O'Neill, "Fine Arts and Literature," 76–7, n. 38. On the purported Florentine wife, see the discussion of the posthumous appreciation of Warburg in *L'Union* below. Desdunes does not mention any spouse.

55 Joan Pierson, *The Real Lady Byron* (London, 1992).

56 Ibid., 293, 300; Harriet Beecher Stowe, *Life and Letters of Harriet Beecher Stowe*, ed. Annie Fields (Boston, 1897), 217–18.

57 Jennifer Cognard-Black, *Narrative in the Professional Age; Transatlantic Readings of Harriet Beecher Stowe, George Eliot, and Elizabeth Stuart Phelps* (New York, 2004), 63–85.

58 Stowe, *Life and Letters*, 195–6.

59 Reynolds, *Aristocratic Women*, 127.

60 Stowe, *Life and Letters*, 216–18.

61 Sarah Meer, *Uncle Tom Mania; Slavery, Minstrelsy and Transatlantic Culture in the 1850s* (Athens, GA, 2005), 185–93; Yorke, *Lancaster House*, 105.

62 Desdunes, *Nos hommes*, 70.

63 Desdunes may have misunderstood the vague statement in a posthumous 1862 appreciation of the artist (discussed in the final part of this chapter) in which

this passage appears: "In London, he continues to work; he works on statues of the main characters in one of the books of this lady [Mrs. Stowe]." *L'Union*, December 6, 1862: 3.

64 I learned of this work through the efforts of Robert Bain, of Gallery Sunsum in Memphis, TN, and Ray Palmer, the present owner; I am most grateful to both for information and advice. The work was included at the last minute in the Worcester Art Museum venue of a touring exhibition of the work of Julien Hudson in 2011–12, but was not reproduced or discussed in the catalogue accompanying the show (see above, n. 3). As this was a reproducible work produced in some quantity, it is likely that the two previously published photographs and brief discussions refer to at least one other surviving example; see Paul Atterbury et al., *The Parian Phenomenon; A Survey of Victorian Parian Porcelain Statuary and Busts* (Shepton Beauchamp (UK), 1989), 162, fig. 540 (in illustrations following Maureen Batkin and Martin Greenwood, "Copeland," in ibid., 130–137); Robert Copeland, *Parian: Copeland's Statuary Porcelain* (Woodbridge (UK), 2007), 93. As the latter text is a semi-official history of this type of production by the firm (now part of Spode), they may still possess an example.

65 Copeland, *Parian*, 93, is confused about which novel of Stowe's Tiff appears in, and mistakenly believes the figure to be based on *Uncle Tom's Cabin*. The *Art Journal* author makes a related error, describing the child as a "little maiden," an unconscious assimilation of the figures to Uncle Tom and Little Eva of the earlier Stowe novel. The wall-text on this work at the Worcester exhibition (see previous note) incorrectly identified the child as Fanny, an older sister to Teddy.

66 Harriet Beecher Stowe, *Dred; A Tale of the Great Dismal Swamp*, 2 vols. (Boston, 1856), 1: 98 (ch. 8).

67 There are two useful modern editions of *Dred*: one edited by Judie Newman (Krumlin, Halifax (UK), 1992) and the other by Robert S. Levine (Chapel Hill, NC, 2000).

68 Copeland, *Parian*, 93.

69 Philip Ward-Jackson, "A.-E. Carrier-Belleuse, J.-J. Feuchère and the Sutherlands," *Burlington Magazine* 127, no. 984 (1985): 146–53, at 146, 148–9; Vega Wilkinson, *Spode-Copeland-Spode: The Works and Its People, 1770–1970* (Woodbridge (UK), 2002), 74, 84.

70 Ward-Jackson, "Carrier-Belleuse," 149–50; Wilkinson, *Spode*, 84; Atterbury, *Parian Phenomenon*, 65, fig. 84, 129, fig. 480.

71 From Dickens: Copeland, *Parian*, 137 (S4), 152 (S93), 156 (S104). Tom and Eva: Atterbury, *Parian Phenomenon*, 218, fig. 715 (1862?).

72 Henry T. Tuckerman, *A Month in England* (New York, 1853), 119–127; Julia Thomas, *Pictorial Victorians; The Inscription of Values in Word and Image* (Athens, OH, 2004), 21–51; Jo-Ann Morgan, *"Uncle Tom's Cabin" as Visual Culture* (Columbia, MO, 2007); Marcus Wood, *Blind Memory; Visual Representations of Slavery in England and America, 1780–1865* (New York, 2000), 143–52; P.D. Gordon Pugh, *Staffordshire Portrait Figures and Allied Subjects of the Victorian Era* (New York, 1971), 30, 50 (pls. 14 and 14A), B238 (pl. 26, fig. 75), B226–7 (pls. 26–30, figs. 75–91), B239–40; Hugh Honour, *The Image of the Black in Western Art*, new edn., vol. 4, *From the American Revolution to World War I*, part 1, *Slaves and Liberators* (Cambridge, MA, 2012), 170–173, 319, nn. 29–30.

73 Pugh, *Staffordshire Portrait Figures*, B226, pl. 26, figs. 75–6, 78, pl. 27, fig. 78(a), B227, pl. 29, figs. 88–9.

74 See for example John Bell's *Abyssinian Slave*, Atterbury, *Parian Phenomenon*, 7 (color ill.), 61, no. 450, fig. 126.

75 Newman's edition of Stowe, *Dred*, 11, 13–14. *Dred* remained largely unillustrated in the short term, except for two frontispieces in Italian, Dutch, and French editions of 1857. Of these, I have only been able to find the examples from the Italian edition (Milan, N. Battezzatti, 2 vols.), which do not depict Tiff. A lithograph signed by the otherwise unknown Cecilia Boyle may date to the late 1850s or early 1860s, and shows Tiff and the three white children in his care listening to a biblical passage read by Nina, the sympathetic daughter of a local slaveholder. Tiff is shown as very dark, and with the pronounced African features also found in Warburg's sculpture, but in the presence of the white woman, his pose is more deferential. The lithograph appears to have been a study for a book illustration. The work is English in style and may be connected with Eleanor Vere Boyle ("EVB"), who began to develop a reputation as a skillful illustrator in the 1850s; Michael McGarvie, "Eleanor Vere Boyle (1825–1916) (E.V.B.): Writer and Illustrator: Her Life, Work and Circle," *Transactions of the Ancient Monuments Society*, n.s. 26 (1982): 94–145; Robin de Beaumont, "Eleanor Vere Boyle (EVB)," *Imaginative Book Illustration Society Newsletter* 14 (Spring 2000): 22–48. My thanks to David Bindman for making this work available to me.

76 The rest of this unpublished letter (New York Historical Society) reads as follows:

> "Give me leave to say now a word on your two subjects 'The Sunbeam' and the 'Lady of Comus.' They would be extremely popular and it seems to be a pity to confine them to those who could afford to pay for marble, when they might adorn a thousand homes of people of taste who have more appreciation than they have money to testify it with. Plaster casts are as compared with biscuit or Parian so frail and they require so much care in a sea voyage that there is a great objection to them—But should you not mean to publish in Parian allow me to engage a plaster copy of 'the Lady' for a friend in America to be ready in the spring when I return to London. I think it will be greatly appreciated there—The statuette you were so kind as to give me may be sent by French Wells and Co's express to Paris No 17 Rue de Clichy—where I expect to be tomorrow evening. Allow me to say that there is something in the general style and tone of your works unusually interesting to me. It seems to me that you have expressed the deeper sentiments of the characters you have attempted in an uncommon degree—*Not* mere physical beauty but that higher beauty of which it is the type is to be the sphere of artists of this age and I was glad to hear you renouncing Venuses and Dolphins which were well enough in their day but of which the world has had enough. One of my favorite ideas is the making of good art so cheap that every young couple entering life shall be able to have in their rooms forms of ideal beauty—and of suggestions of noble sentiments. I have felt the want of soul and expression in many of the Parian works—and yet I rejoice in their advent because it distributes works of art thro all the middle classes. In America it is true we have much wealth but it is wealth distributed. We are a nation of people with moderate fortunes and *great* wealth is as much the exception as poverty. But there is now a great awakening of attention to art in the body of the people and engravings and statuettes meet every year increasing sale and whenever I see a valuable thought or beautiful form I want to see it distributed far and wide among our people
> "Pardon ths rambling note and believe me very sincerely Yr friend
> "H B Stowe"

I found this letter by consulting the E. Bruce Kirkham Collection of the letters of Stowe, book 10, at the Harriet Beecher Stowe Center in Hartford; my thanks to

E. Bruce Kirkham and Beth Burgess. On Durham, a real study is wanting, but see Benedict Read, *Victorian Sculpture* (New Haven, 1982), 65, 209–10, 212; Rupert Gunnis, *Dictionary of British Sculptors, 1660–1851*, new revised ed. (London, 1968), 135–6; Saur, *Allgemeines Künstlerlexikon*, s.v. "Durham, Joseph"; Copeland, *Parian*, 86, 120–121 (with entry on a Parian figure of Africa of 1864, related to his figures of the continents for the London monument to the Great Exhibition of 1851, cat. S3); Atterbury, *Parian Phenomenon*, figs. 19, 495, 521, 530, 588–9, 612, 701, 799; and his letter of October 28, 1856 to Stowe (New York Public Library, Berg Collection, #245932B) in which he invites her to come visit his studio to select a piece — this visit must have been the occasion of their initial discussion about Warburg. Stowe therefore must have seen Warburg between October 28 and November 3.

77 Harriet Beecher Stowe, *Life of Harriet Beecher Stowe, Compiled from Her Letters and Her Journals, by Her Son Charles Edward Stowe* (Boston, 1890), 450.

78 Stowe's letter to Lady Byron of October 16 speaks of this planned visit; Cambridge, MA, Schlesinger Library at Radcliffe. Martineau's reference to Webb is in her letter to Philip Pearsall Carpenter; Harriet Martineau, *The Collected Letters of Harriet Martineau*, ed. Deborah Anna Logan, 5 vols. (London, 2007), 4: 21–2.

79 Honour, *Image of the Black*, vol. 4, part 1, 42–5, fig. 23.

80 "Sojourner Truth, The Libyan Sibyl," *Atlantic Monthly* 11 (April 1863): 473–81, at 473; Nell Irvin Painter, *Sojourner Truth: A Life, A Symbol* (New York, 1996), 154; Kirk Savage, *Standing Soldiers, Kneeling Slaves; Race, War, and Monument in Nineteenth-Century America* (Princeton, 1997), 15.

81 Several casts of the bronze are known, including one still in Stowe's house in Hartford; see for example http://www.jennmaur.com/scsubjectindex/ scartistspages/CUMBERWORTHfeaturedartistpage.htm, accessed 23 August 2011; on the Parian versions (18 inches/46 cm and 21 inches/56 cm), see Copeland, *Parian*, 161, S116; Maureen Batkin and Paul Atterbury, "Origin and Development of Parian," in Atterbury, *Parian Phenomenon*, 14, fig. 13; Atterbury, *Parian Phenomenon*, 160, fig. 535. The work was apparently first designated as a likeness of Marie, the nurse in Bernardin de Saint Pierre's *Paul et Virginie*; H.W. Janson, ed., *Catalogues of the Paris Salon 1673–1881* (New York, 1977), 246, no. 2137.

82 Copeland, *Parian*, 86; Wilkinson, *Spode*, 79, pl. 48; Ward-Jackson, "Carrier-Belleuse."

83 Newman's edition of Stowe, *Dred*, 21.

84 Ward-Jackson, "Carrier-Belleuse," esp. 146, 149–50; June Hargrove, *The Life and Work of Albert Ernest Carrier-Belleuse* (New York, 1977), 2.

85 Horace Chauvet, *François Arago et son temps* (Paris, 1954).

86 His studio was at 13 (now 15) rue de la Tour d'Auvergne; ibid., 13.

87 There are designs by other artists in Parian representing figures of African descent: several of a series (1853–60s, initially in bronze and other materials) of young female slaves of various ethnicities by John Bell (see Atterbury, *Parian Phenomenon*, 61, 112, nos. 377, 450, figs. 26, 126, 375; Benedict Read, "Parian and Sculpture," in ibid., 40–47, at 47; Richard Barnes, *John Bell: The Sculptor's Life and Works* (Kirstead (UK), 1999), 44–45, 49, 137, 152–3, pls. 37, 52–3), one of which was derived from a life-size figure of an "octoroon" (without discernibly African features), a marble version of which is now in the town hall of Blackburn, Lancashire; a fine anonymous 1861 bust of a black slave (Copeland, *Parian*, 227–8,

B75, and Atterbury, *Parian Phenomenon*, 135, fig. 621) perhaps associated with the Civil War; also works in ibid., 131, 252, fig. 863, and Copeland, *Parian*, 120–121, S3 (the work by Joseph Durham discussed above, see n. 76). On the small statuary groups with African-American characters by the American John Rogers, see Atterbury, *Parian Phenomenon*, 257, figs. 897–8, and, more broadly, Kirk Savage, "John Rogers, the Civil War, and 'the Subtle Question of the Hour,'" in Kimberly Orcutt, ed., *John Rogers; American Stories* (New York, 2010), 59–75 (and figs. 43, 56, 59, 88, and 92 throughout this volume). Rogers was in Rome from January to March 1859 (ibid., 136), close to the date of Warburg's death there (January 12).

88 The German trip is alluded to in *L'Union*, December 6, 1862: 3.

89 Washington, DC, Archives of American Art, Sanford Robinson Gifford Papers, Letters, vol. II, no. 36, p. 173 of typescript transcription, http://www.aaa.si.edu/collections/container/viewer/European-Letters-Volume-II—204620, accessed August 17, 2011; discussed by Theodore E. Stebbins Jr., *The Lure of Italy: American Artists and the Italian Experience, 1760–1914* (New York, 1992), 24, 27, n. 14 (incorrectly described as from a letter to Elihu Vedder); Nelson, *Color of Stone*, 195, n. 80.

90 Gifford quoted in Ila Wiess, *Poetic Landscape: The Art and Experience of Sanford R. Gifford* (Newark, DE, 1987), with comments on Warburg on 80. Wilde quoted in Stebbins, *Lure of Italy*, 438.

91 *Who Was Who in American Art 1564–1975* (Madison, CT, 1999), s.v. "Perry, Enoch Wood."

92 George Dimock, *Caroline Sturgis Tappan and the Grand Tour* (Lenox, MA, 1982), 43–69.

93 Ibid., 66–7; see also Paul H.D. Kaplan, "Contraband Guides: Twain and His Contemporaries on the Black Presence in Venice," *Massachusetts Review* 44, nos. 1–2 (2003): 182–202, at 196.

94 As in n. 91.

95 By Melchior Barthel; Paul H.D. Kaplan, "Italy, 1490–1700," in David Bindman and Henry Louis Gates Jr., eds., *The Image of the Black in Western Art*, vol. 3, *From the "Age of Discovery" to the Age of Abolition*, part 1, *Artists of the Renaissance and Baroque* (Cambridge, MA, 2010), 93–190, at 183, 185–6, figs. 99–100.

96 Kaplan, "Contraband Guides," 195–6, 202, n. 48.

97 On the floor, see Brady, "Black Artists," 21. There seem to have been some works in dark wood or stone produced in Europe as illustrations of figures in *Uncle Tom's Cabin*. The Alabama traveler Octavia Walton Le Vert referred to "the little ebony busts of 'Uncle Tom and Topsy' we frequently see in the shops" while she was serving as a commissioner at the 1855 Paris Exposition Universelle; Frances Gibson Satterfield, *Madame Le Vert. A Biography of Octavia Walton Le Vert* (Edisto Island, SC, 1987), 160–161. The Swedish traveler Frederika Bremer suggested to an intrigued Harriet Hosmer (Rome, November 1858) that she might "model a 'Topsy,' and cut her out of black marble," though no work seems to have resulted from this; Harriet Hosmer, *The Life and Letters of Harriet Hosmer*, ed. Cornelia Carr (London, 1913), 135–6.

98 Also December 26, 1857.

99 P. 1, reprinted from the *New Orleans Delta*, which I have not been able to locate. According to *L'Union*, December 6, 1862, 3, the kiss in question was between a

girl and a bird on her shoulder, and both this subject and the deployment of a lottery are reminiscent of Warburg's early *Ganymede*. See also Desdunes, *Nos hommes*, 70.

100 December 6, 1862: 3. This strange essay is mostly directed toward the moral improvement of young Louisianans of color, and its factual basis remains unclear.

101 Desdunes, *Nos hommes*, 70. On Browning, see Andrew M. Stauffer, "Elizabeth Barrett Browning's (Re)Visions of Slavery," *English Language Notes* 34, no. 4 (June 1997): 29–48.

102 Kaplan, "Contraband Guides," 188–9, 199, nn. 21–2.

103 *William Wetmore Story and His Friends*, 2 vols. in 1 [Boston, 1903] (reprint ed. New York, 1969), 1: 350: "The art-world was indeed a collection of little worlds of contrasted origin and speech, bands almost as numerous and as separately stamped and coloured as the little promenading 'nations'—black, white, red, yellow, purple—of the Propaganda college." A French painter of partly African descent, Guillaume Guillon-Lethière of Guadeloupe, had in fact directed the French Academy, just up the hill atop the Spanish Steps, in 1807–16; Darcy Grimaldo Grigsby, "Revolutionary Sons, White Fathers and Creole Difference: Guillaume Guillon-Lethière's *Oath of the Ancestors* (1822)," *Yale French Studies* 101 (2001): 201–26.

104 Kaplan, "Contraband Guides," 190.

105 "La mort vient de frapper la Louisiane dans un de ses enfants qui promettait d'illustrer son pays. Nous apprenons de la mort de M. Eugène Warburg, de la Nouvelle Orleans, decedé a Rome le 12 Janvier dernier.
 "M.E. Warburg, après avoir etudié la sculpture dans la ville immortelle, etait parvenu deja à un talent remarquable qui laissait esperer un bel avenir. La mort, en l'atteignant au debut d'une carrière qui s'ouvrait si brillante devant le jeune artiste, ne lui a pas laissé le temps de completer son oeuvre. Eugène Warburg eut pris incontestablement une place eminente dans la pleiade de ces artistes americains qui etudient à ajouter un rayon de plus à l'illustration de leur patrie. C'est une perte pour l'Amerique, un deuil pour la Nouvelle-Orleans, un vide dans les arts."

 The Bee did not carry this obituary.

106 O'Neill, "Fine Arts and Literature," 77.

107 Thayer Tholles, ed., *American Sculpture in the Metropolitan Museum of Art. Volume 1. A Catalogue of Works by Artists Born before 1865* (New York, 1999), 90–92, cat. 36. For Stowe's claim to have inspired Story in 1857 (and also again in 1860 on a second visit), see above, n. 82, and also Mary E. Phillips, *Reminiscences of William Wetmore Story* (Chicago, 1897), 130–31.

Ira Aldridge as Othello in James Northcote's Manchester portrait

Earnestine Jenkins

The modern era for Shakespeare's *Othello* began with the African-American actor Ira Aldridge (1807–67).[1] A cross-cultural figure of great import, Aldridge created a body of dramatic work for which he achieved international fame (Figure 5.1). Represented on canvas by British painter James Northcote, *Othello, the Moor of Venice* was visually stunning, compelling, and utterly complicated. As Aldridge ruptured the practice of "blacking-up," it became unacceptable for European actors in dark make-up to continue to perform the role in this archaic tradition.[2] This study considers how this far-reaching development in the history of Shakespearean performance impacted how visual artists such as Northcote represented the complex figure of Aldridge as Othello. Several mid- to late nineteenth-century European artists took up the peculiar conundrum of representing the African-American actor Ira Aldridge as Shakespeare's Othello. Aldridge was the first to perform *Othello* "black." A number of works in museums and private collections that previously described the subject as a "black" or "Negro" in the role of Othello, have been re-identified as portraits of Ira Aldridge in character as the "tawny Moor." One remarkable example is a painting by British portraitist James Northcote. Presently known as *Othello, the Moor of Venice* , the painting was originally titled *Head of a Negro in the Character of Othello* (1826) (Plate 4, Figure 5.2). It is believed to be the earliest academic portrait of Ira Aldridge. James Northcote therefore set a precedent followed by artists and creators of popular imagery alike. He visually immortalized the indelible relationship between Aldridge and Shakespeare's character.

In addition to examples of academic art, the image of Ira Aldridge was widely distributed in the popular media on playbills and posters, as lithographs, and in newspapers celebrating his story as the "African Roscius" (Figure 5.3). As his fame spread, Aldridge was depicted in the modern medium of photography, making the actor probably one of the most visually documented public black figures of the mid-nineteenth century in Europe.

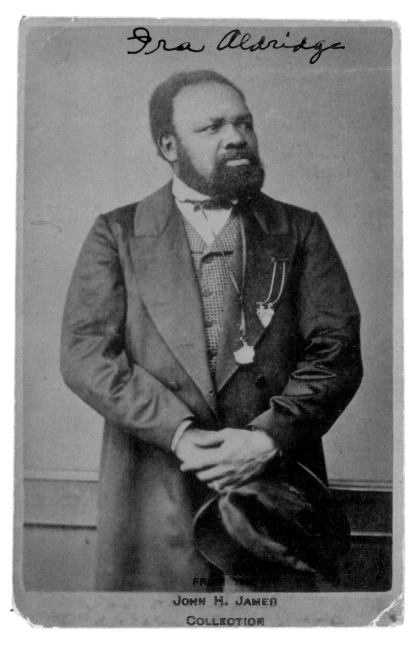

5.1 Ira Aldridge, n.d. Billy Rose Theatre Collection, New York Public Library
for the Performing Arts, Astor, Lenox and Tilden Foundations

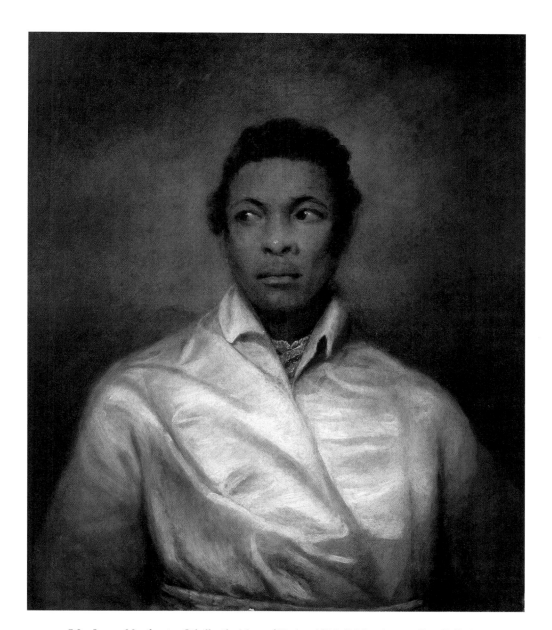

5.2 James Northcote, *Othello, the Moor of Venice* , 1826. © Manchester City Galleries

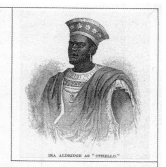

IRA ALDRIDGE AS "OTHELLO."

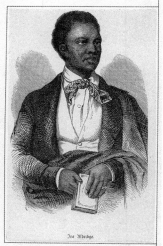

Ira Aldridge

Theatre Royal, Covent-Garden.

COMPLETE SUCCESS!!!

THE NEW SERIO-COMIC LEGENDARY FAIRY TALE, called

The ELFIN SPRITE,
AND
The Grim Grey Woman,

was received on its 2d representation with roars of laughter and applause.—The SPLENDID SCENERY and MACHINERY were honored throughout with enthusiastic approbation. This HIGHLY SUCCESSFUL NOVELTY will therefore be repeated

Every Evening until further notice.

This present WEDNESDAY, April 10, 1833,
Will be performed SHAKSPEARE's Tragedy of

OTHELLO.

The Duke of Venice, Mr. RANSFORD,
Brabantio, Mr. DIDDEAR, Gratiano, Mr. TURNOUR,
Lodovico, Mr. PAYNE, Montano, Mr. HAINES,
Othello by Mr. ALDRIDGE,
(A NATIVE OF SENEGAL,)
Known by the appellation of the AFRICAN ROSCIUS,
who has been received with great applause at the Theatres Royal, *Dublin*, *Edinburgh*, *Bath*, and most of the principal provincial Theatres.
His First Appearance on this Stage.
Cassio, Mr. ABBOTT,
Iago, - Mr. WARDE,
Roderigo, Mr. FORESTER, Antonio, Mr. IRWIN, Julio, Mr. Matthews
Giovanni, Mr. J. COOPER, Luca, Mr. BRADY, Lorenzo Mr. Bender
Messenger Mr MEARS, Marco Mr Collet, Cosmo Mr Heath, Paolo Mr Stanley
Desdemona, - Miss E. TREE,
Emilia, Mrs. LOVELL.

To which will be added, (3d time) a New SERIO-COMIC LEGENDARY FAIRY TALE, called The

Elfin Sprite;
AND THE
Grim Grey Woman.

The Scenery, Machinery, Dresses and Decorations are entirely new.
The Overture and Music composed and selected by Mr. G. STANSBURY
The Scenery painted by Mr. GRIEVE, Mr. T. GRIEVE, & Mr. W. GRIEVE,
Assisted by Messrs. PUGIN, THORN, MORRIS, &c.
The Tricks, Decorations, Changes & Transformations by Mr. W. BRADWELL.
The Machinery by Mr. SLOMAN.—The Dresses by Mr. HEAD & Mrs. HALDING.
The whole arranged and produced by Mr. FARLEY.

The ELFIN GLEN,
In the DRACKENFIELDT,
Elfin Moth, (the Elfin Sprite,) Miss POOLE,
The Grim Grey Woman, Mr. W. H. PAYNE, Principal Elfin, Master W. MITCHINSON
Elfins, Sprites, and Fairies, Masters Platt, Melvin, Mears, Norman, Daly, Stansbury, Waite, Addison, Burton,
Erwood, Flowers, Wells, W. Wells, Simpson, Bull, G. Matthews, Girrard, Packer, Cross, Clark, May, Alger.

A FERRY across the RHINE,
Sir Joddril's Chateau in the distance.
Julian of Hilldersheim, Mrs. VINING,
Vintagers, Messrs. RANSFORD, HENRY, IRWIN, Butler, Guichard, May, Newcomb, Shegog,
S. Tett, C. Tett, Willing, &c.
Vintage Girls, Mesdames Davis, Ryalls, Blaire, Fairbrother, Jones, Hall, Hill, Payne, Vials, Wells, &c.
INTERIOR of JULIAN's COTTAGE.

Grand Tapestry Chamber,
In the CHATEAU of HILLDERSHEIM,
Sir Joddril, *of Hilldersheim,* Mr. KEELEY,
Glibbert, (his Steward) Mr. F. MATTHEWS,
Michael and Martin, Mr. T. MATTHEWS and Mr. BENDER,
Tailor, Mr. ADDISON, Hatter, Mr. STANLEY, Bootmaker, Mr. LEG,
Agatha, (Confidant to Lady Blanch) Mrs. KEELEY.

5.3 *Ira Aldridge's first appearance at Covent Gardens in the role of Othello—a play bill dated 1833 plus 2 small engraved portraits and an article in German, mounted together.* By permission of the Folger Shakespeare Library Shelfmark: ART File A365.5 no.5 (size L)

While the significance of Ira Aldridge as the first black Shakespearian actor attracts the attention of scholars in the fields of drama, African-American studies, and cultural and race studies, art historians and visual studies specialists have been slow to investigate his impact on artists, and issues of race and representation.[3]

Aldridge's presence as an actor of African descent in the world of theater in early nineteenth-century Britain brought discussions concerning race to the foreground. It was not a simple matter to represent the idea of "blackness" in art.[4] Complicating the issue was Aldridge's physical appearance as an individual of African descent originating from Britain's former colony across the Atlantic. As a man with medium-brown skin, he was not easily racially "typed." In fact Aldridge could visually accommodate a number of racial or ethnic identities; a descendant of slaves in America, an African from the continent, or a "black subject" from one of Europe's colonies.[5]

The issue was perplexing for the first European artists grappling with the dynamics of cultural contact and conflict in art. These were themes critical not only to Shakespeare's original setting for *Othello*, but the modern colonial experience of the long nineteenth century. Revolutionary subject matter demanded novel approaches and methods of representation. By the turn of the nineteenth century subject matter related to colonization, the slave trade, slavery, and abolitionist movements were increasingly displayed in the arts, including the refined expression of portrait painting. The impact of these contexts on race and representation is critical to understanding James Northcote's exceptional work of art. I argue that Northcote's sensitive imaging of his two subjects of color endures as an innovative approach to the aesthetic dilemma of representing race in early nineteenth-century British art.

Ira Aldridge: artist-activist and anti-slavery symbol

The early nineteenth century in Britain was a period of reform and upheaval. As the population increased new towns and cities quickly sprang up all over the British Isles. Accelerated growth in the sciences and industry brought about dramatic change in lifestyles and working conditions as machines replaced handmade work, and rural peasants moved to cities to find work in newly built factories. While the middle class gained strength, demanded access to education, and pushed for human rights, the working classes also demanded that the powerful extend democratic ideals and practices to their group.[6] Cultural growth and development accompanied this new spirit. Entertainment in public theaters was increasingly popular. The working classes filled the minor theaters in London to see *burlettas*, plays that included music and song, while the aristocracy and upper classes patronized the powerful select theaters like Covent Garden, Drury Lane, and the Haymarket where they preferred to see operas.[7]

Aldridge migrated to England in 1824 or 1825 when he was only 17 or 18 years old. After his initial performances in London he realized that the major theaters in the city would never offer him a permanent position. Critics wrote hostile and extremely negative reviews of the young novice.[8] Audiences responded enthusiastically but the ridicule of mean-spirited critics effectively prevented Aldridge from establishing a long-standing presence on the London stage. Yet, according to biographers Herbert Marshal and Mildred Scott, Aldridge arrived when the political and social climate was in his favor.[9] His very first engagement at the Royal Coburg Theatre was in a leading role, and they argue that Aldridge learned to turn what was a liability in America into a significant asset in Europe.

He arrived in England when slavery was one of the great issues of public discourse. The slave trade had been abolished in 1807 and the movement to outlaw slavery in all British territories was gaining momentum. The Anti-Slavery Society organized in 1823 and started publishing the *Anti-Slavery Reporter* in 1825. Local branches published the newspaper and organized petitions against slavery that were sent to Parliament. The plight of the enslaved aroused such intense feelings that popular entertainment became an important avenue of expression regarding the topic.

Plays frequently dealt with racial themes and those that featured blacks in sympathetic roles were immensely popular. A number of such plays like *Oroonoko* and *The African's Revenge* (also known as *The Slave's Revenge*) were already favorites with theater audiences before Aldridge migrated to England, and he was soon offering his own interpretations of these performances.[10] Aldridge performed other popular anti-slavery plays including *The Padlock, Paul and Virginia, The Ethiopian,* and *The Galley Slaves.* He presented *The Padlock,* considered one of the best musicals of the time, throughout the British Isles and continental Europe for the duration of his career. Aldridge is credited with transforming the role of Mungo from a passive oppressed character into that of a rebellious heroic figure who challenged slavery.

Aldridge retreated into the provinces after his first year in London, not to return until eight years later. Records of public appearances or performances for the year 1826 are sparse. Some scholars suggest his marriage to a white woman exacerbated hostile reaction to his ambitions to not only enter the acting profession but also perform Shakespeare. The next year he began touring the provinces, performing in the towns of Sheffield, Halifax, Newcastle, Lancaster, Sunderland, Liverpool, Manchester, and Hull, as well as Edinburgh. It was in the provinces and in Scotland where Aldridge perfected his skills as an actor, constructing a diverse repertoire of dramatic work that featured black men in prominent roles, primarily as heroic rebels.

Manchester and Hull were important centers of the anti-slavery movement.[11] Aldridge first played Othello at the Theatre Royal in Manchester in February of 1827. The *Manchester Courier* of February 24 announced the benefit for that evening with this statement:

... that a generous public will show their liberality to this descendant of the suffering sons of Africa. It need not be said that worth and merit are confined to no country. The African Roscius in those characters for which his complexion is peculiarly adapted, approaches closer to nature than any European actor we ever saw.[12]

The town of Hull was especially significant in Aldridge's early career in reference to his work with the abolitionist movement. Hull was the birthplace and home of William Wilberforce, the leading figure in the British abolitionist movement famed for his speeches beginning in the 1790s in the House of Commons to abolish slavery in Britain's colonies. Gretchen Gerzina in *Black London: Life before Emancipation* writes that the figure of Wilberforce was so completely linked to the abolition of slavery and those of African descent that blacks in London referred to Wilberforce as "Father." Wilberforce was still at the forefront of the anti-slavery struggle when Aldridge migrated to Britain. In Hull Aldridge played the Royal Theatre, the Adelphi, and the Royal Clarence Theatre. The liberal atmosphere in 1830s Hull allowed him to test many of his new roles as a Shakespearean actor. Throughout his career Aldridge returned to Hull to test audience response to a black man playing Shakespearean roles such as Shylock, Macbeth, Richard III, and King Lear in "whiteface."[13]

Aldridge initiated other practices that linked him with resistance and the anti-slavery movement on both sides of the Atlantic. For instance he played the Theatre Royal in Liverpool on October 20, 1827. Liverpool, the center of the slave trade in the UK, was well known for its strong pro-slavery position.[14] Liverpool's unsavory reputation did not prohibit Aldridge from entertaining the city's anti-abolitionist audiences with the two most popular anti-slavery plays of the day: *Oroonoko* and *The Padlock*.

During his first tours in the provinces Aldridge also began a tradition that he referred to as his "farewell address."[15] Turning the performance stage into a public platform Aldridge regularly spoke to his audiences concerning slavery. His public statements proclaimed concern for the plight of his people held in bondage, and expressed a hope of freedom for all people of African descent. Aldridge wrote the farewell addresses, had them printed, and distributed them to audiences on his farewell benefit nights.

In 1828 Aldridge was given his first official recognition as an actor when the Republic of Haiti honored him as the "first man of color in the theater." He was awarded a commission in the army of Haiti with the rank of captain and aide-de-camp extraordinary in the 17th Regiment of the Grenadier Guards of the President of the Republic.[16] Aldridge played Christophe, one of the heroes of the Haitian revolution, in the play *The Death of Christophe* at his first Coburg engagement in London in 1825. Black revolutionary generals Toussaint L'Ouverture, Dessalines, and Christophe were victorious against Napoleon, the greatest military leader in recent European history. Portraits of these masculine-warrior models of African diaspora resistance were among the rare images of "heroic" black figures tolerated within the canon of representation in late eighteenth- and early nineteenth-century European art.[17]

Aldridge maintained ties across the Atlantic by contributing to the fund-raising campaigns of the Negro State Conventions held in America between 1830 and 1861.[18] He made a fortune as a result of his European tours and donated money to abolitionist organizations in the US. He even sent funds so that the Society for Manumission of Slaves in New York could purchase the freedom of a slave family re-captured under the Fugitive Slave Act, after reading about the family's plight in British newspapers.[19]

However, for all of his success, Aldridge's achievements as a free American black man associated with the anti-slavery movement in Britain were problematic. He achieved international fame after his first Continental tour in the 1850s, but never broke down racial barriers to procure a long run in London, the surest sign of recognition in the acting profession. At the same time, as his first biographers argue, his free status and American origins allowed some Europeans to generally separate Aldridge from stereotypical images of black slaves or servants from the colonized West Indies, or "uncivilized" Africans. However, it is important to note that Aldridge did not apply for British citizenship until 1863. Complicated racial attitudes were operative on both sides of the Atlantic.

Place and time: Manchester 1827

Northcote's portrait *Othello, the Moor of Venice* is a noteworthy work of art on multiple levels. Currently the Manchester City Galleries describes it as a fine art portrait representative of British painting of the nineteenth century, identifying Northcote as the artist and noting alternative titles, *A Moor* or *A moor*:

Half length frontal portrait of Ira Aldridge, celebrated nineteenth century black actor, in the role of Othello. He is dressed in a white wrapper-like garment of which the striped coral-and-white sash is just visible at the bottom of the picture. He has a white lace neckerchief. His eyes look to the left. The plain dark grey background is paler behind his head than it is in the corners of the painting. His close-cropped, parted hair is therefore silhouetted.[20]

Northcote, according to Ruth Cowhig in her *Burlington Magazine* notes, claimed that the painting was purchased by the Royal Manchester Institution after he showed the work in that group's first exhibition of work by living British artists held in August 1827. The exhibition catalogue described it as the "best executed painting shown there."[21]

From the very beginning the presence of the portrait in the Manchester collection was connected to abolitionism, as the city was an early site of anti-slavery activity. Northcote's painting was the first work of art purchased by a group of wealthy textile merchants originally known as the Royal Manchester Institution, which later became the Manchester City Art Gallery when it finally opened 55 years later in 1882.

In 1827 the significance of a professional actor of color, particularly one performing Shakespeare, was not lost on the citizens of Manchester. Perhaps the Royal Manchester Institution purchased the artwork because it documented the novelty of a "black actor" playing Shakespeare. Collecting Northcote's painting may also have been viewed as progressive, indicating a growing interest in non-European subjects in the fine arts. And because it effectively conveyed a sense of the innate talent and intelligence of non-Europeans, the act of purchasing the artwork supported abolitionist sentiments.[22] From an anti-slavery position, *Othello, the Moor of Venice* encouraged all who saw it to interrogate pseudoscientific notions of racial inferiority.

According to local newspapers Aldridge's first performance in Manchester was at the Theatre Royal in February 1827. As noted before, few documents pinpoint the young actor's whereabouts in 1826, during which time Northcote produced his portrait. Northcote was then in his eighties and reaching the end of a long and respected career as one of England's most successful portrait and history painters. He also regularly attended the theater. The details remain unknown, but it is likely that Aldridge himself sat for the portrait. Whether Aldridge commissioned the portrait or Northcote was inspired on his own, the uniqueness of the historical situation demanded representation.

Following Aldridge's first performance in Manchester, critics wrote enthusiastic reviews in the *Manchester Guardian* and the *Manchester Courier*, exclaiming that they were looking forward to his performance of *Othello*. The Royal Manchester Institution purchased the portrait later that same year following its August exhibition.

Northcote's portrait: a question of identity

Over the course of almost two centuries Northcote's portrait accumulated a somewhat confusing history that revolved around determining the individual identity of its subject. The sitter has always been identified as an individual of African descent. The painting was originally exhibited in Manchester with the title *Othello, the Moor of Venice*.[23] Afterwards the first permanent catalogue of the Manchester Gallery referred to the portrait only by the title *A Moor*. From about 1912 it was erroneously labeled as being of Francis Barber, the black man whose portrait was painted by Sir Joshua Reynolds, Northcote's mentor and teacher.[24]

Northcote's original descriptive title along with the subject matter can both be interpreted as important signifiers of the times in which this extraordinary portrait was produced. In her definitive 1983 article Cowhig suggested that the Manchester Gallery did not use Northcote's original title because of nineteenth-century racial attitudes. She states that the cataloguer may have found the descriptive term "Negro" problematic since tawny-skinned "Arab chieftains" in the role of Othello were more common during the first part of the nineteenth century.[25]

Still, Aldridge's first year in London was a climactic one in which he made a mark as a young, professional black actor portraying Shakespearean roles and appearing in anti-slavery productions. It is likely that viewers of Northcote's portrait would have known that *A Negro* could be none other than the "black actor" Ira Aldridge. He was not an anomaly solely because of his race as early nineteenth-century London had a significant black population. Aldridge attracted notoriety because he had the audacity to assert himself as a professional actor of color competing with other actors and touring companies staging Shakespeare's work throughout the British Isles. Although Aldridge was just starting to develop his craft he was from the beginning immediately recognized, persistently referred to in playbills and described in press reviews of 1825 as an "actor of color," "a genuine nigger," one of "Afric's swarthy sons," "the Tragedian of Color," and "a real bona-fide black man."[26] Playbills advertising his 1827 performances in Manchester likewise refer to Aldridge as "an actor of color" in large bold script.

Intersections of word and image: European critics and "race"

Visual descriptions of Ira Aldridge were prolific in the critical reviews generated by the novelty of a foreign black man from America calling himself an actor and playing Shakespeare. It is useful to examine how mainstream critics described Aldridge as their accounts of his physical appearance reveal a familiarity with prevailing, early nineteenth-century ideas about race, as well as more commonly held notions and prejudices about non-Europeans. The first critiques interpreted Aldridge's appearance in racial terms then common to the British Isles. Was he African, was he black, or was he mulatto? However his hybridity was defined, European critics were also concerned with whether "race" made a "Tragedian of Color" naturally suited to play the role of Othello. The written descriptions of what Ira Aldridge looked like as well as the visual impact of his appearance highlight intriguing points of comparison between word and image.

Written comments frequently expressed personal opinions concerning the "blackness" of Aldridge. There was concern about whether his skin color was appropriate for the different roles he was playing. The earliest review written in response to the actor's debut appeared in the London *Times* on October 11, 1825. The critic referred to Aldridge as "this gentleman" and as having the complexion of the color of a "new half penny" without the brightness. He wrote that his hair was woolly and his features, although possessing much of the "African character," were "humanized." The same critic advised the management at the Coburg that if they were to continue using the "African Roscius" they were not to dress him in black worsted stockings that contrasted inappropriately with his copper-colored skin, pointing out the young black actor was not dark enough to play the descendant of slaves in the play *Oroonoko* anyway. On October 11, 1825 the critic for *The Globe* wrote that Aldridge's

features were too firm and hard to express dark passions and suffering, "but he looks the part." The critic from the *Drama* in November of 1825 stated the Aldridge was well proportioned and tall with not "very Negroish" features.

Critics outside of London also made specific references to Ira Aldridge's physical appearance when he began his professional tours there in the 1830s. After his first performances in Dublin in 1831 at the Theatre Royal, Aldridge was defined as not being an "absolute negro but a very dark mulatto." The same critic also stated that in addition to the novelty of the actor's color his "features were forbidding." In spring of 1833 while on tour through southern Ireland a critic reviewing a performance at the Grand Jury Room of the County Court House in Clonmel wrote that Aldridge was tall, robust, and in possession of all the "peculiarities of the Negro race as to his features," except in reference to his skin color, which was a "deep brown or bronze rather than black."[27]

When Aldridge was invited to return to London in April 1833 after eight years of touring in the provinces of the British Isles to play at the great theater of Convent Garden in London, critics were still fascinated with determining the actor's racial identity. The *Morning Post* critic recorded that Aldridge did not present as black a face "as representatives of Othello generally assume," as "his complexion is almost a light brown."[28] This may have been a comparison to the extremely black make-up white actors smeared over the face in their performances of *Othello*. The critic also noted that Aldridge was a tall man with a noble carriage and a dignified manner of walking across the stage. The evening newspaper *The Globe* printed that upon his return to London Aldridge had developed well beyond the "mere novelty of an African Othello" into a "first rate actor with fire and spirit." It went on to state that nature might have given Aldridge the "identity of complexion" most suited to play the Moor, but he also had a good figure, speaking voice, and an intelligent face that was "not black, but of that oily and expressive mulatto tint which can easily and skillfully allow the passions to play over its surface."[29] How then, do written descriptions in newspapers act as "physical evidence" when compared to the visual arts? Can we detect both Aldridge and Othello in Northcote's painting of the noteworthy black actor, and Shakespeare's tragic character?[30]

Painting Romantic masculine beauty

James Northcote renders Aldridge's skin tones using the highly developed, masterful skills as a colorist for which he was justly admired. His painting rejects past examples of eighteenth- and nineteenth-century depictions of people of African descent which often juxtaposed dark, flat skin color against light-skinned Europeans for simple contrasting effects. Instead, the actor's face is beautifully colored using light to medium brown tones with tints in pink, yellow, and green highlighting the features of the face. Thick brushstrokes of dark brown and black create the cap of soft, curled hair framing the face. The same tints of color are reflected in Othello's brilliant white satin shirt, and

in the pink and white sash wrapped around the sitter's waist. The background area enveloping the face is made up of blue, green, and gray tones that gradually blend with shading around the perimeter of the composition.

The artist's painting style is typical of early nineteenth-century Romantic portraiture in its display of picturesque effects.[31] Northcote expertly manipulates not only color, but light, form, and texture in order to create interest and variety. Othello stands in a frontal position facing the viewer but his eyes look hard to his right. His extreme glance to the right contrasts strongly with the frontal position of his head and face, increasing the level of ambiguity in the portrait. The intense sense of animation expressed on the face is at odds with the body held in a stiff and unnatural position against a minimal background and composition. It gives a sense of the psyche associated with the character of Othello: he appears backed up against a wall, pressed in by forces he cannot trust.

Northcote does not include any of the overt exotic props or attributes normally associated with representations of Othello as the "tawny Moor." For example, he does not wear a heavily embroidered, flamboyant robe, nor does he wield a sword. He is not depicted as the high-ranking officer-warrior in military gear. In such instances Othello's clothing, the result of nineteenth-century artists' imagination concerning the Near East, was intended to be "Oriental" in appearance and feeling. In this manner European artists used clothing to identify Othello as "Other," signifying an ethnicity that was foreign and non-white.

Northcote's portrait is also absent of dramatic gestures and movements. Strong movements expressing intense emotions defined the classical histrionic styles of acting preferred during the early nineteenth century. Similarly, strong gestures and extreme emotions were believed to be traits of non-rational racial types. Northcote's elimination of objects or props and stereotypical gestures readable in a literal manner force the viewer to identify the subject and interpret the character of Othello through the expressive qualities of the artist's painterly technique, and the title of the artwork. Northcote's approach is characteristic of the Romantic style and its rejection of the aloof, distant, idealized subjects modes of painting typical of neoclassicism, the dominant academic style of the late eighteenth century.

Another important feature of nineteenth-century Romantic portraiture is its use of dramatic lighting effects.[32] Concentrated lighting and/or shading accentuated distinctive features by drawing attention to the face. Pictorial effects like chiaroscuro intensified expressive qualities in portraiture. Compositional arrangements that emphasized the sitter's head emerging from a black background were representative of Romantic portraiture. These were particularly effective ways of painting, taken for granted when the sitter was European. Northcote makes innovative use of these visual techniques, accommodating them to the specific physical-visual characteristics of the sitter and the subject. Chiaroscuro methods are employed in reverse. In a traditional composition chiaroscuro was usually achieved by contrasting the

light skin color of European subjects with dark clothing and backgrounds.[33] The darker skin tones and features of Northcote's *"Negro ..."* subject would not stand out effectively with this manner of painting. Instead, Northcote achieved dramatic light and dark effects by arraying the figure of his sitter in brilliant raiment of white. The luminous satin shirt is striking against the brown skin tones. The facial features are accented with the use of dark brown tones and black on the eyes, eyebrows, and hair. Instead of implementing a blackened background Northcote lightens the area with bluish grey tones that gradually fade to dark.

The result is a portrait that is still well within the tradition of nineteenth-century Romantic portraiture, with its confrontational closeness to the picture frame and emphasis on very personal, close-up views of the head and face. The technique effectively conveys psychological depth and expresses strong emotion without stereotypical gestures that connote racial type or conventional styles of acting.

Northcote's approach to representing Aldridge as Othello is consistent with early nineteenth-century methods intended to convey what was commonly referred to as the "likeness of an individual." It was regarded as no small achievement to construct a realistic portrait. Artists working within the style of Romanticism thought beyond the construction of a portrait as simple mimicry, or literal copying of the outer form. Northcote asserted that portraits were ultimately valued because they inspired the imagination or, as he wrote, the best of portraiture created a "feeling in the mind" that ultimately revealed the essence or inner character of the sitter.[34]

Northcote may have been influenced by late eighteenth-century notions concerning the relationship between the arts and sciences.[35] Late eighteenth-century artists, responding to concepts related to the pseudoscientific science of physiognomy, believed that facial structure revealed much about the character of an individual. At the time Sir Joshua Reynolds, Northcote's instructor-mentor and the best-known portrait painter of the era, warned artists against overly particularizing expression in painting. However, Reynolds did believe that the portrayal of character should relate to the individual's rank. In other words the emotions or sensibilities varied in intensity and quality based on the individual's position in society and "racial inheritance."[36]

The visual techniques used to convey notions about race, human character, and personality were, on the other hand, dependent upon artistic skill. Aesthetic demands were placed upon artists that required them to capture the particularities of detail and expression of face and features that resulted in what was considered great portraiture. Such ideas were increasingly important during the early nineteenth century when artists were fascinated with documenting the great historical figures of the period, particularly great men. Early nineteenth-century portraiture then was a highly refined, intricate blend of aesthetics, Romanticism, and the ethnographic.[37]

How to frame non-European subjects within this model was challenging. Reynolds' first experimentation with representing race was the grand-scale painting entitled *Tahitian*, also known as *Omai*, painted in 1776. The portrait depicted Omai, the famed Polynesian Captain Cook brought back to London after his second voyage to the South Pacific in 1774. Late eighteenth-century thought was dominated by the "Rousseauian notion" of the natural man or "noble savage" and his superiority to the "civilized" man. The Reynolds portrait displays Omai as the exotic romanticized "primitive." Reynolds achieved his unique portrait through an accomplished blend of the classical idiom with a somewhat realistic or ethnographic representation of his subject. He modeled Omai's figure after the *Apollo Belvedere*, but gave him flattering soft brown skin tones and sensual features. And although Reynolds dressed Omai in the traditional costume of Tahitian nobility his treatment resembles the flowing white robes of Grecian dress.[38]

Northcote's portrait was to some extent influenced by his mentor's earlier approach to similar subject matter. He likewise appears interested in visualizing the relationship between race and character. In this case both of his subjects (Aldridge and Othello) share an identity as romanticized heroic masculine figures of African descent. Aldridge's physical appearance, shaped by his New World experience as an American black, may have influenced the artist's interest in the depiction of a mixed racial type as well. For example, Northcote "truthfully" depicted the actor with the medium brown skin tones, curling hair, handsome features, impressive carriage, expressive face, and intelligent eyes that were frequently remarked upon by European critics. While critics used the terms "African," "Negro," "black," and "mulatto," they appear generally to confirm Aldridge's racial identity as that of a mixed type, a man they would have described as "mulatto." Photographs of Ira Aldridge, reportedly of mixed black-Native American heritage, also support an interpretation of Northcote's portrait that considers this varied perspective.

Captivated by the exotic masculine beauty of the young actor, Northcote did not paint the generic stereotype of the black sub-Saharan African or the "tawny Moor" from North Africa. His visual interpretation of both Aldridge and Othello broadens the idea of "blackness," responding to increasing complexities of racial identity in reference to the African diaspora during the nineteenth century. Just as Reynolds's painting *Tahitian* portrayed the noble savage as a symbolic figure representing the collision of two worlds, Northcote's *Othello, the Moor of Venice* exhibits similar themes of cultural contact, conflict, and multiple identities.

A question of character: merging identities

In *Othello, the Moor of Venice* Northcote visualizes Othello as an uncharacteristically young man. The artist portrays Shakespeare's character at the vulnerable age of 18, approximating the real-life age of Aldridge.

The image is far removed from the middle-aged experienced leader of men who married a much younger woman from a different social strata, culture, and country. From this viewpoint the portrait is more Aldridge than Othello. Northcote even represents the young actor as clean-shaven, except for a semblance of facial hair above the upper lip. Existing imagery suggests that Aldridge started to grow a mustache during the 1830s but did not sport a full beard until the 1850s–60s. Later the Italian sculptor Pietro Calvi produced a work that portrayed a mature Othello with a thick mustache and full beard. Calvi's polychrome bust in the Torre Abbey Museum, dated to 1868 (a year after Aldridge's death), may have been modeled after photographic portraits of Ira Aldridge (Figure 5.4).

A comparison of Calvi's bust to Northcote's 1826 painting strengthens the argument that Northcote chose to depict Shakespeare's mature character as the young actor, Ira Aldridge. The inexperience and youthful vulnerability that play across the subject's face are Aldridge's contributions, whereas the strong display of jealousy and suspicion are emotions most appropriate to Othello. This particular reading is reinforced when compared to *Ira Aldridge as Othello* by Henry Perronet Briggs, wherein Aldridge possesses a confidence in his professional abilities absent from Northcote's earlier portrait. The artist's concern with conveying such emotional depth suggests that he perhaps identified the young Ira Aldridge with the life experiences of Othello's older character. Northcote observed a shared racial identity and history as the isolated "Other," in a foreign land. The reviews of the period indicate that British audiences were beginning to entertain similar thoughts, drawing connections to the broader global experiences of people of African descent in the Western world then dominated by slavery and colonialism.

When we look at the portrait again it is as if Northcote's painting of Ira Aldridge as Othello continually shifts between two racially charged identities. Visually and carefully rendered so that one individual does not supersede the other, both men move easily in and out of each "Other's" African diaspora identities. On one level Othello is the original African in Shakespeare's play, sold far away from homeland, family, friends, and community. The North African Moor rose to great heights of political accomplishment in a foreign land, but not without enduring extreme isolation. He experienced high levels of anxiety and grew suspicious of everyone around him. The portrait is also of the "modern" Othello, a multi-racial person from America who could be designated as "mulatto," "colored," or "black." By the early nineteenth century, two centuries of the slave trade, slavery, and the emergence of free populations of color in the Western world were shaping current notions about race. Both Othello and Aldridge could be identified as men of African descent, expatriates who leave their countries of birth to achieve high levels of success that distinguish them from the common plight of most Africans.

Perhaps the recent success of the anti-slavery movement in ending the slave trade in England suggested to the 80-year-old Northcote that there was a promise of hope and freedom for people of African descent in the Western

5.4 Pietro Calvi, *Othello*, 1868. Torre Abbey Historic House and Gallery

world. If so, this perspective demanded from artists more challenging ways of looking at race and the representation of non-whites in nineteenth-century academic art. The brilliant highlights reflecting off Othello's lustrous white shirt, balanced by the grayish-blue shadows around his head, envelop him in an almost spiritual light. Perhaps Northcote is reminding us of the full breath of character and humanity that non-European men such as the African-American actor Ira Aldridge or Shakespeare's Moor could possess. After all he originally titled his work *Head of a Negro in the Character of Othello*. Lest we forget, before Othello was brought low by malevolent forces around him and that all too familiar emotion, jealousy, Shakespeare imagined the African a man of noble and good character.[39]

Notes

1 Virginia Mason Vaughn, *Othello: A Contextual History* (Cambridge: Cambridge University Press, 1944), 1–9. Since Vaughn's critical work an increasing number of scholars have examined Shakespeare's work in relationship to race, including Catherine Alexander and Stanley Wells, eds., *Shakespeare and Race* (Cambridge: Cambridge University Press, 2000); Celia R. Daileader, *Racism, Misogyny, and the Othello Myth: Inter-Racial Couples from Shakespeare to Spike Lee* (Cambridge: Cambridge University Press, 2005); Peter Erickson and Maurice Hunt, eds., *Approaches to Teaching Shakespeare's Othello* (New York: Modern Language Association of America, 2005); Ania Loomba, *Shakespeare, Race, and Colonialism* (Oxford: Oxford University Press, 2002); Virginia Mason Vaughn, *Performing Blackness on English Stages, 1500–1800* (Cambridge: Cambridge University Press, 2005); Bernth Lindfors, ed., *Ira Aldridge: The African Roscius* (Rochester, NY: University of Rochester Press, 2007); Ayanna Thompson, *Colorblind Shakespeare: New Perspectives on Race and Performance* (New York: Taylor & Francis, 2006); Lemuel Johnson, *Shakespeare in Africa (and Other Venues): Import and the Appropriation of Culture* (Trenton, NJ: Africa World Press, 1998); and Martin Luther Patrick, "The Myth of the Black Male Beast in Postclassical American Cinema: Forging Stereotypes and Discovering Black Masculinities" (PhD diss., University of Birmingham, 2009).

2 See Ruth Cowhig, "Actors Black and Tawny, in the Role of Othello,— and Their Critics," *Theatre Research International* 4, no. 2 (1979): 134. Cowhig discusses the problems with the tradition of "blacking-up," describing the hideous appearance of actors made even more repulsive when combined with mismatched, brightly colored "Oriental" costume. Edmund Keene was the first British actor to play *Othello* as the "tawny" Moor at Drury Lane in 1814. Cowhig suggests Keene presented the character as dark or brown rather than black, after performing the role of Kojah, the "noble savage" in *The Savages*, based on Captain Cook's voyage to Tahiti. British audiences and performers were therefore already dissatisfied with the appearance and discomfort of the unnatural practice.

3 Two of the few art-historical approaches to imaging *Othello* are Paul Kaplan, "The Earliest Images of Othello," *Shakespeare Quarterly* 39, no. 2 (1988): 71–186; and Bernard Harris, "A Portrait of a Moor," in Catherine Alexander and Stanley Wells, eds., *Shakespeare and Race* (Cambridge: Cambridge University Press, 2000), 23–36. Thematic studies investigating the relationship between the fine arts, race, and representation in Europe include Hugh Honour, *The Image of the Black in*

Western Art, vol. 4, *From the American Revolution to World War I*, part 1, *Slaves and Liberators*, and part 2, *Black Models and White Myths* (Cambridge, MA: Harvard University Press, 1989); T.F. Earle and K.J.P. Lowe, *Black Africans in Renaissance Europe* (Cambridge: Cambridge University Press, 2005); Reina Lewis, *Gendering Orientalism: Race, Femininity and Representation* (London and New York: Routledge, 1996); Mary Sheriff, ed., *Cultural Contact and the Makings of European Art since the Age of Exploration* (Chapel Hill: University of North Carolina Press, 2010); Maria Gindhart, guest ed., "Imaging Blackness in the Long Nineteenth Century," Special Issue of *Visual Resources: An International Journal of Documentation* 24, no. 3 (2008); and Peter Mason, *Infelicities: Representations of the Exotic* (Baltimore and London: Johns Hopkins University Press, 1998).

4 For an excellent study on eighteenth-century thinking on aesthetics and race see David Bindman, *Ape to Apollo: Aesthetics and the Idea of Race in the Eighteenth Century* (Ithaca, NY: Cornell University Press, 2002).

5 Scholarship focusing on race, Ira Aldridge, and *Othello* in relation to colonialism include Krystyna Courtney, "Ira Aldridge, Shakespeare, and Color-Conscious Performances in Nineteenth- Century Europe," in Thompson, *Colorblind Shakespeare*, 103–21; Loomba, "Race and Colonialism in the Study of Shakespeare," and "Othello and the Racial Question," in *Shakespeare, Race, and Colonialism*, 1–21, 91–111.

6 Mary Malone, *Actor in Exile: The Life of Ira Aldridge* (London: Crowell-Collier Press, 1969), 22–3.

7 Ibid., 21.

8 See Hazel Waters, "Ira Aldridge and the Battlefield of Race," *Race & Class* 45 (July 2003): 1–30, at 4–5.

9 Hubert Marshall and Mildred Stock, *Ira Aldridge: The Negro Tragedian* (London: Rockliff, 1958), 53.

10 Malone, *Actor in Exile*, 23.

11 Marshall and Stock, *Ira Aldridge*, 76–7, 93–5.

12 Ibid., 76–7.

13 Bernth Lindfors, "Mislike Me not for my Complexion …": Ira Aldridge in Whiteface," *African American Review* (Summer 1999): 2–3.

14 Marshall and Stock, *Ira Aldridge*, 80.

15 Ibid., 83.

16 Ibid, 79–80.

17 See Darcy Grigsby, "Black Revolution Saint-Domingue: Girodet's Portrait of Citizen Belley, Ex-Representative of the Colonies, 1797," in *Extremities: Painting Empire in Post-Revolutionary France* (New Haven: Yale University Press, 2002), 8–63.

18 Marshall and Stock, *Ira Aldridge*, 197–8.

19 Scott McCrea, "Tragedian of Colour," *American Legacy* (Spring 2005): 56–64.

20 See http://www.manchestergalleries.org, accessed May 30, 2011.

21 See Ruth Cowhig, "Northcote's Portrait of a Black Actor," *Burlington Magazine* 125, no. 969 (December 1983): 741–2. She also discusses Aldridge and the portrait in Cowhig, "Ira Aldridge in Manchester," *Theatre Research International* 11, no. 3 (1986): 239–47.

22 Bernth Lindfors, "Dressing in Borrowed Robes: Masquerading as African in the Nineteenth Century," in *Signs and Signals: Popular Culture in Africa*, ed. Raoul Granqvist (Umeå (Sweden): Acta Universitatis Umensis, 1990), 210.

23 Honour, *Image of the Black*, vol. 4, part 1, 324, n. 314.

24 Cowhig, "Northcote's Portrait," 741.

25 Ibid., 742.

26 See series of critical reviews in Marshall and Stock, *Ira Aldridge*, 61–5.

27 Marshall and Stock, *Ira Aldridge*, 111.

28 Ibid., 122.

29 All quotes from *The Globe*, in ibid., 123.

30 During this time English artist Henry Perronet Briggs painted *Ira Aldridge as Othello* (1833–34). This portrait is now in the National Portrait Gallery at the Smithsonian Institution. Like Northcote, Briggs probably painted the portrait in response to this important juncture in the actor's professional career. Therefore the Briggs portrait, like Northcote's artwork, indelibly links Aldridge to the role of *Othello*.

31 Nadia Tsherney, "Likeness in Early Romantic Portraiture," *Art Journal* 46, no. 3 (Autumn 1987): 197. For a general history of eighteenth-century portraiture see Marcia Pointon, *Hanging the Head: Portraiture and Social Formation in Eighteenth-Century England* (New Haven: Yale University Press, 1993).

32 Tscherny, "Likeness," 197.

33 Ibid., 197.

34 Ibid., 94.

35 For an excellent study on the relationship between artists and the representation of human types during the nineteenth century, see Mary Cowling, *The Artist as Anthropologist: The Representation of Type and Character in Western Art* (Cambridge: Cambridge University Press, 1989).

36 Cowling, *Artist as Anthropologist*, 178.

37 Ibid., 95.

38 For further discussion of the painting see Jocelyn Hackforth-Jones, "Mai/Omai in London and the South Pacific: Performativity, Cultural Entanglement, and Indigenous Appropriation," in Joanna Sofaer, ed., *New Interventions in Art History: Material Identities* (Oxford: Blackwell, 2007), 13–30.

39 Most recently, *Othello, the Moor of Venice* is on the cover of a new Broadview edition of *Wuthering Heights* by Christopher Heywood. It is used to illustrate Heywood's provocative re-interpretation of Emily Brontë's text. Heywood's well-researched scholarly analysis advances the idea of an African origin for Heathcliff, a central character in the novel. The author, in suggesting that Othello inspired the creation of Heathcliff, discusses Ira Aldridge's performance of Othello in the "industrialized parish of Bradford," the home of the Brontës in 1841. Heywood explores new literary ground by addressing the impact of the slave trade economy and slavery on the societies in northern England during the nineteenth century. Heywood's situation of this classic work in time and place creates a provocative reading of Heathcliff, as influenced by Africa origins and aspects of Othello, that cause us to regard this enigmatic character, like Othello, as "a martyr and hero of social change." See Christopher Heywood, ed., *Wuthering Heights* (Toronto: Broadview Press, 2002), 68.

Exceeding blackness: African women in the art of Jean-Léon Gérôme

Adrienne L. Childs

They were negresses from Senaar, and indeed no species could be so far removed
from our standard conceptions of beauty. The prominence of their jaws, their
flattened foreheads, and their thick lips are characteristics which class these poor
creatures in an almost bestial category; nevertheless, apart from this strange
physiognomy which nature had endowed them with, their bodies were of a rare
and exceptional beauty; pure and virginal forms were clearly visible under their
tunics; their voices were sweet and vibrant like the shrill but subdued sounds of
fresh mountain springs.

<div align="right">Gérard de Nerval, Voyage en Orient, 1851[1]</div>

Sensuality, servitude, abhorrent physiognomy; beauty, non-beauty, a
blackness that enhances whiteness; Gérard de Nerval's travelogue *Voyage
en Orient* presented a catalogue of conflicted ideas about black women. His
depiction of "Negresses" in a Cairo slave market is a confluence of exoticism,
fantasy, and ethnography, ideas that saturate nineteenth-century Orientalism.
His description of the women's prominent jaws, flat foreheads, and thick
lips, coupled with the employment of terms such as "species" and "bestial,"
recalled ethnographically tinged discourses proclaiming Africans were lowest
of the human species, closer to animals than Europeans.

Then, in a dizzying about-face, Nerval abandoned the rhetoric of flawed
science in praise of the "rare and exceptional" black beauties. In the very
next sentence the author continued to reflect on the plight of the women for
sale:

I had no desire for the lovely monsters; but without doubt the beautiful women
of Cairo should love to surround themselves with chambermaids like them. There
could be delightful oppositions of color and form; these Nubians are not ugly in
the absolute sense of the word, but form a total contrast to the beauty we know.
A white woman should arise admirably among these girls of the night, that their
slim bodies seemed destined to braid hair, to pull back fabrics, carry bottles and
vases as in ancient frescos.[2]

Admitting no *real* desire for the "lovely monsters," Nerval projected them into an archetypal Orientalist tableau as shadowy servants destined to attend the beautiful women of Cairo. Drawing upon conventional constructs of light and dark, Nerval claimed that the black Nubian women, when paired with the pale Cairene (not a dark Cairene), would provide the requisite contrast of form and hue that ultimately showcased the latter's dazzling whiteness. Nerval's ambivalent reaction to these black female slaves exemplifies the approach taken by many European Orientalists whose attempts to represent the enigma of the black female body were often fraught with a mixture of ethnographic inquiry, fantasy, repulsion, and taboo desires.

Two decades after the publication of Gerard de Nerval's *Voyage en Orient*, the French academic painter Jean-Léon Gérôme (1824–1904) produced the paintings *The Slave for Sale (A Vendre)* (Plate 5, Figure 6.1) and *Moorish Bath (Bain Maure)* (Figure 6.4), two works that virtually translated Nerval's passage into what are arguably some of the artist's most intriguing Orientalist tableaux. In these works Gérôme distilled the relationship between the black and the white body to their essential kinetic tensions.

While both the sexualized white female and the black female in the slave market or harem are signifiers in their own right, when united, the total is greater than the sum of the parts. Though Gérôme's pale odalisques are meant to represent the nebulous concept of the "Oriental" woman, the models are clearly European types who are exoticized and racialized in large part because of their relationship to their black servants. The artist's provocative conjoining of black and white female bodies in a sensuous play on race, rank, and servitude marked the beginning of a thematic preoccupation that would continue over the last quarter of the century, the final leg of his long and prestigious career.

Gérôme's fascination with the black and white "oriental" women and the charged spaces between resulted in nearly thirty paintings and countless prints based on the original works. While much has been said about Gérôme's female nudes, faithful Muslims, and dancing *almehs*, less attention has been paid to the critical role that black female figures occupy in defining Oriental sexuality in his works. Edward Said theorized Orientalism by exposing the manner in which the West, through interrelated texts and images, created a fictive reverie of the Orient that was in part defined as a hotbed of exotic sexuality. Not a fixed locale, the Orient was an amorphous region that encompassed the Mediterranean Near East, North Africa and the Holy Land. While we now understand the constructed and problematic nature of this space we call "Orient," I freely use it here because the nineteenth-century fictions of this space that were crafted by Gérôme, Nerval, and others were part and parcel of the discursive and visual practice that was Orientalism.[3]

Gérôme's images of exotic and racially inverse women present a broadly conceived set of binaries that draw upon nineteenth-century racial discourses, conceptions of slavery and abolition, female sexuality, colonialism, and more.

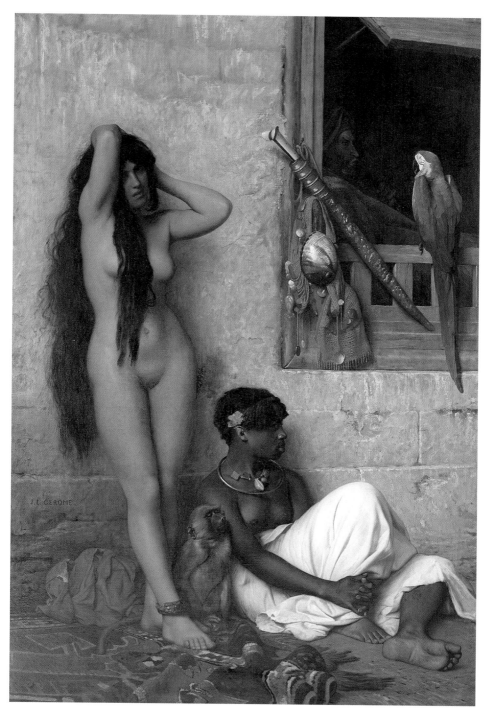

6.1 Jean-Léon Gérôme, *The Slave for Sale* (*A Vendre*), 1873. Oil on canvas. Musée
d'Art et d'Industrie, Roubaix, France / Giraudon / The Bridgeman Art Library

Although the notion of the binary as a theoretical framework for understanding Gérôme's complex images seems limiting in some respects, these works are firmly and consciously grounded in oppositionality as an operative mode. The black/white axis not only animates this body of work, it is consistently invoked as a principal compelling aspect of the imagery in the contemporary critical reception. This analysis considers Gérôme's characterization of the spaces of Oriental eroticism that he fashioned through a rigorous negotiation of the social, cultural, and aesthetic dualities at the nexus of the black and white female body.

Gérôme and Orientalism in the critical eye

Ever since the interest in Orientalist art burgeoned in the 1970s Gérôme's ethnographic exotica has been interpreted as the embodiment of both the triumphs and the imperfections of the Orientalist project. In 1986, Gerald Ackerman single-handedly initiated a revival of interest in Gérôme through his scholarly output and an exhaustive catalogue raisonné.[4] Linda Nochlin, following Said's example, was the first art historian to point out that Gérôme's unflinching realist style diverted his viewers, past and present, from the power dynamics of European colonialism, the horrors of slavery, the extreme sexualization of the "exotic" female, and the rhetoric of European cultural domination.[5] However, in recent years as European academic art has gained increasing respect and attention, Gérôme has been reassessed. In 2010 the J. Paul Getty Museum in Los Angeles and the Musée D'Orsay in Paris organized the exhibition *The Spectacular Art of Jean-Léon Gérôme (1824–1904)*. A significant reconsideration of the artist's work, scholars and writers from Europe and America brought fresh eyes and new methods to Gérôme's oeuvre. However, neither the substantial catalog nor the accompanying volume of essays addresses Gérôme's images of blacks or the importance of his work to "image of the black" studies.[6] Gérôme's construction of exotic blackness had impact beyond his own production. His imagery was widely disseminated in Europe and America through paintings, prints, and reproductions, and was regenerated through the work of his students and followers who sustained his brand of hyper-realist, racialized exotica into the twentieth century.

In his time, Gérôme was the foremost purveyor of Orientalist visual representation and his works now provoke us to consider the important relationship between Orientalist practice and the representation of blackness in the nineteenth century. Gérôme's multifaceted representations of black men and women were the polar opposites to the international cadre of white consumers of his imagery. In his works, dark bodies were saturated with key elements of an imagined Orient. Black figures embodied sexuality, aggression, servitude, barbarism, and ethnographic degeneration, defining themselves *and*, by association, the Orient. They were also cast as powerful, elegant characters, often rendered alluringly ornamentalized. Known for his

obsession with the intricate, decorative nature of Islamic material culture, Gérôme often objectified black figures such that they became ornamental props, providing fascinating passages of texture, color, and pattern as part of the visual cacophony of the Orient. The endlessly repeated depictions of marginal black figures as laborers and slaves in Gérôme's oeuvre and in European Orientalist output more broadly, reflects the symbolic currency and complex history of exotic blackness.

Lineages

The conventional aesthetic interplay of the black and white female body was, according to Griselda Pollock, the major trope of nineteenth-century Orientalist erotica. Pollock astutely observes that the African servant in the Oriental harem represents a historical intersection of Europe's domination of both colonized and enslaved peoples.[7] This historical junction dates back centuries and began to take shape in European visual traditions long before the height of the Atlantic slave trade. Gérôme's African slave is part of the conventional practice of depicting exotic black females in European painting that conflated ideas about the Orient with ideas about Africa since the Renaissance.

Since the sixteenth century, the black female attendant could be found in mythological and biblical subjects serving some of the most famous beauties in the history of art. Titian's *Diana and Acteon* (1556–9), Rubens's *Venus in Front of the Mirror* (1614–15), Rembrandt's *Toilet of Bathsheba* (1643) all present the primping white nude in the company of a black companion. The increasing presence of black servants in Europe during this era was linked to the escalation of the European economy fueled by the slave trade and slave labor.[8] With dark skin and sumptuous livery, they were fashionable ornaments in courts and aristocratic households, and as such they became trendy possessions amongst the elite. Many of the most elegant and powerful had their likenesses painted in the company of a black slave. To be pictured with a darker subordinate signaled prestige, wealth, taste, and luxury consumption.[9]

Luxury consumption itself took on a new flavor in the eighteenth century with the French fashion for *turqueries*, or themes evoking French fantasies of Turkish courtly life. *Turquerie* was one of the frameworks in which black servants were popularly depicted in the fine and decorative arts during the *Ancien Régime*. In this sometimes frivolous and often excessive style popular among the French nobility, black servant figures were an important part of the exotic racial mix and helped to characterize Oriental social hierarchies and relationships that fascinated the Western voyeur. The black exotic body at once evoked the Orient, European court spectacle, Africa, and slavery. As if to channel their sixteenth- and seventeenth-century predecessors, white female beauties depicted *à la turque* were often accompanied by one or more black servants while bathing or at the *toilette*.

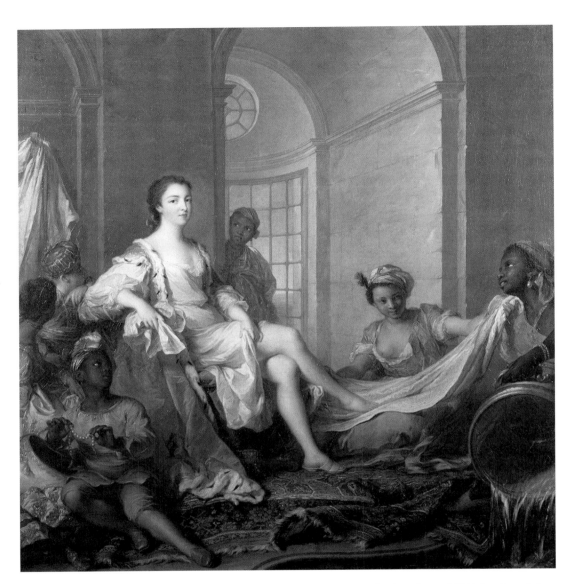

6.2 Jean-
Marc Nattier,
*Mademoiselle
de Clermont en
sultane*, 1733.
Oil on canvas.
© Wallace
Collection,
London, UK /
The Bridgeman
Art Library

The well-known portrait of Anne Marie de Bourbon (1733) by Jean-Marc Nattier titled *Mademoiselle de Clermont en sultane* (Figure 6.2) is a case in point. A portrait *deguisé* in which the young princess of royal blood is "disguised" as a sultana in a harem bath, this conspicuous display of a woman surrounded by multiple black servants is highly unusual for its era. In a space more classical than exotic, the servants and objects are the essence of *turquerie*. The emotive entourage of adoring slaves not only create the sense of exoticism in what would be an otherwise conventional portrait, but they are the emotional core of the portrait and form a rich polarity to the rigid, pale, and impassive mistress. The bath setting has historically implied the titillating promise of a tryst between the bathing woman and an inferred but seldom pictured lover.

The fairer-skinned black female servant holding a towel at the feet of Mademoiselle de Clermont forms a focal point of sensuality, her bare breast and direct gaze provide a less than subtle hint at the sexual context of the sultana's bath. By the eighteenth century the black female servant had become a conventional signifier of sexuality and exoticism in the private female sphere.[10] Kathleen Nicholson has deemed Nattier's painting the first odalisque, a character who, with her black servant in attendance, would become a defining construct of Oriental female sensuality in the nineteenth century.[11]

Voyager

In the wake of the French Revolution, the exoticist language of *turquerie* represented the excesses and abuses of the overthrown monarchy and was summarily dismissed as symbolic of the crown's frivolous luxury. However, the interest in North Africa and the "exotic" remained strong in post-Revolutionary France as a result of Napoleonic incursions into North Africa and the Middle East at the end of the eighteenth century. Napoleon's "savants" or scientists who accompanied the military expedition brought back to France documentation, objects, images, and ideas about the remains of the once-great civilization. Notably, the publication of Dominique-Vivant-Denon's *Voyage dans la Basse et la Haute Egypte* in 1802 presented the findings of the scholarly mission that included images of ancient and modern architecture, artifacts, and culture ways to a popular audience. Their revelations inspired an Egyptian revival that ranged from the craze for Egyptian motifs in decorative arts to the deciphering of ancient hieroglyphics.[12] Travel routes into Africa, both northern and sub-Saharan, were increasingly opened up. Framing this focus on North Africa was the larger colonial/imperial project in which the French and the British were battling for control in Ottoman-ruled Egypt. This interweaving of scholarly interest and popular tastes with expansionist pursuits in Egypt and across the Middle East is what Edward Said described as modern Orientalism.[13]

A far cry from *turquerie*'s comparatively artificial mode of fanciful self-representation, modern Orientalism was predicated on the desire to accurately and evocatively represent the Oriental, Oriental life, peoples, objects, histories, and cultures. Firsthand engagement with the Orientalist subject was of prime importance to post-Napoleonic Orientalist artists. Eugène Delacroix's journey to Morocco and Algiers in the 1830s set a precedent for artists who found that North Africa gave them access to an ancient albeit primitive culture that possessed a compelling contradistinction to modern European society. For many worldly European artists travel to the Orient became a necessary part of their education, a way to expand their experiences beyond the European horizons and gain access to new and authentic subjects. The sense that artists and writers were reporting their experiences gave Orientalist subjects in art

and literature an aura of truth, as if they were transcriptions of the artists' romantic journeys. From our contemporary vantage point, the association of Orientalism with truth seems absurd. We understand that it was laced with notions of European political and moral authority that ultimately compromised any claim to authenticity. At the time, however, the Orientalist art of practitioners like Gérôme resonated with the "real."

By the middle of the nineteenth century Gérôme had become a consummate painter/traveler, witness to the spectacle of the Orient, and a purveyor of what were considered authentic, even ethnographic representations of this illustrious locale. Beginning in 1852 through 1880 Gérôme travelled to the Orient ten times, visiting Egypt, Syria, Algeria, and Turkey, where he and his traveling companions often stayed months at a time.[14] Gérôme was a serious student of the visual panorama of the Orient, taking in its variety of people, their dress, their customs, their material culture and architecture. He returned to France with copious sketches of Oriental peoples and landscapes, and a collection of objects that were destined to ornamentalize and authenticate his canvases.

Because of his extensive travel experiences and his exacting, photo-realist style, Gérôme's Orientalist work was touted by contemporary commentators as ethnographic, affording it the authority of documentary accuracy that, in the tradition of Vivant Denon, enlightened and excited his audiences. Far from objective, however, Gérôme's finely wrought Orientalist themes were frequently a choreographed pastiche of objects and places that viewers read as Oriental. James Clifford described the "unruly experience" of ethnographic cultural interpretations such as these as a "garrulous, overdetermined cross-cultural encounter shot through with power relations and personal cross-purposes"[15] In other words, the position of the ethnographer, or the artist with ethnographic interests, is not guided by dispassionate observation. Therefore interpretations of Oriental blacks by nineteenth-century authors and artists such as Gérôme were shaped by literary, aesthetic, and popular notions of the Orient as a subject, and were skewed by the unquestionable sense of superiority of Europeans over "Orientals" and blacks on all conceivable levels.

A heavily charged rhetoric around black ethnicities can be found in the commentary on Gérôme's Orientalist imagery. Critic and writer Théophile Gautier was a champion of Gérôme's Orientalist work and praised his exacting ethnographic realism as necessary for the modern artist who, because of his mobility, could visit and accurately represent people from all over the planet. Gautier described a visit to the artist's studio during which he was allowed to peruse Gérôme's portfolio of sketches of Oriental types. "There are Fellahs ...," Gautier reported, "Copts, Arabs, mixed-blood negroes, men from Sennaar and from Kordofan, so exactly observed that they could have served as anthropological dissertations"[16] Gautier continues his review by offering detailed descriptions of the types of Orientals represented in Gérôme's portfolio. He reiterates many now familiar and value-laden descriptions of

Orientals as sensuous, strange, and likened to frescos in Ancient Egyptian tombs.[17] Perhaps the most bizarre, according to Gautier's description, were the blacks: "… the blacks were barely comprehensible, in their expressions an animalistic calm or an infantile indifference, their souls black like their skin; their flat nostrils and their broad mouths could easily inhale the flaming wind of the desert …."[18]

As literary historian Christopher L. Miller has proposed, black Africa was a nullity, an absence, a difference so vast that it was unknowable to the European. If Europe is the self and the Orient is the "other," Africa is a third party, a kind of blankness, according to Miller.[19] Gautier's characterization of Gérôme's sketches is a telling example of Miller's conclusions. The racial and cultural divide is evidently so great that Gautier imagines the blacks as soul-less and infantile, more monstrous than human. For Nerval, the Nubian women for sale in the market were not "ugly," they were the unknown, unknowable, a "total contrast to the beauty we know." In the absence of conceptual tools or frames of reference to understand the Nubians or black Africans, the imagined Orient provides the context that renders the figures knowable. In Gérôme's high-resolution renditions of the racialized Orient, black women are similarly unreadable and function only as they relate to white figures. As dark foils, they are oppositional figures that work in tandem with the white body to define the exotic. Orientalism then is a way to access the black female body, a mediating methodology for deciphering an undecipherable blackness.

Slavery and seduction

While titillating fictions of sexual servitude were often tethered to ideological dynamics of white and dark bodies in European Orientalism, Gérôme's interest in sexual concubinage and black slavery was not pure fantasy. The harem was a well-known aspect of "Oriental" culture dating back centuries, the most famous being the harem within Ottoman Sultan's Topkapi Palace in Istanbul. The presence of white concubines in the harem had long been documented in ethnographic, historical, and fictional sources that referenced harems from historic Constantinople to Cairo.[20] Influential nineteenth-century British ethnographer Edward Lane describes white slaves in the Egyptian harem as Greek, Circassian, and Georgian, and black slaves as Abyssinian, Nubian, or simply black. Lane's 1860 book *An Account of the Manners and Customs of Modern Egyptians* was the definitive source for information on Egyptian society in the nineteenth century.[21] In it he elaborates on the status of the white slave:

The white slaves, being often the only female companions, and sometimes the wives, of the Turkish grandees, and being generally preferred by them before the free ladies of Egypt, hold a higher rank than the latter in common opinion. They are richly dressed, presented with valuable ornaments, indulged, frequently, with almost every luxury that can be procured ….[22]

Black women in harems were almost exclusively slaves. In fact, the vast majority of all slaves within the Ottoman system were black females.[23] By 1872, Europe and America had abolished slavery, but it was only nominally prohibited in North Africa and the Middle East. In spite of the attempts to eradicate the ancient tradition, the trans-Saharan trade in Nubian or Sudanese blacks continued to supply Egypt and other Islamic countries with slave labor throughout the nineteenth century.[24]

In the Islamic system, black female slaves held the lowest rank, performing most of the coarse household duties.[25] Lane wrote that "Most of the Abyssinian and black slave-girls are abominably corrupted by the Gellábs, or slave-traders, of Upper Egypt and Nubia, by whom they are brought from their native countries; there are very few of the age of eight or nine years who have not suffered brutal violence …."[26] In the context of the harem, their primary duties were to serve the higher-ranking concubines and wives. Although domestic servants, they were not exempt from the role of sexual servant.[27]

Gérôme, certainly a witness to the racial spectrum of Egyptian society, drew upon the cultural practices and coupled them with the ideological and expressive potential of race and gender in the Western imaginary. European concepts of Oriental and African alterity, complete with their own frameworks, foibles, and trajectories, collide in the Gérôme's representations of the black female slave.

Gérôme imagines

In the early 1870s, while living in exile in London with his family after the Franco-Prussian War broke out in Paris,[28] Gérôme began to actively explore the pictorial and ideological relationships between the black and the white female body within his ongoing Orientalist project. There he embarked on a series of paintings that would occupy him for the last third of the century. By this time he was an established French academician and commercially successful artist. Gérôme regularly exhibited at the Royal Academy where he had been induced as an honorary member in 1869. In 1871 he created a splash with this controversial painting of a Cairo slave market, *The Slave for Sale*.[29]

Seeming to echo Nerval's reflections on the Cairo slave market, sexual slavery is the subject of *The Slave for Sale* (Plate 5, Figure 6.1). Here Gérôme revisits the underbelly of the Oriental system of concubinage that he notoriously depicted in his 1866 canvas *The Slave Market*. *The Slave for Sale* explicitly highlights the racial dynamics of the sexual slave trade in a public space. Perhaps an ambivalent reflection of the British abolitionist movement to suppress the Ottoman trade, Gérôme's presentation is an artful and complex mélange of the vulgarities of human trafficking and the taboo erotic appeal of slavery.

Far from the cloistered spaces of the imagined harem, a turbaned slave dealer lurks in the shadows of an open kiosk as he serves up two women for sale. Pictured against the backdrop of a crumbling wall are a nude white female and a seated black woman in drapery. Between them sits a monkey.

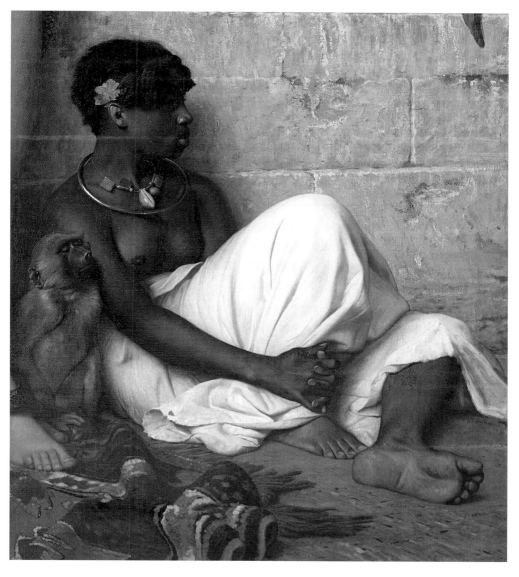

6.3 Jean-Léon Gérôme, *The Slave for Sale* (*A Vendre*), 1873, detail. Oil on canvas.
Musée d'Art et d'Industrie, Roubaix, France / Giraudon / The Bridgeman Art Library

The standing pale nude is seductively distraught as she glances at the viewer through her disheveled hair. Her explicit display of full frontal nudity is a departure from Gérôme's more reserved Roman slave market nudes who often turn their backs to the viewer. The seated black companion looks off to her left with an aloof and expressionless profile (Figure 6.3). They complement each other in form and content, true to the convention of contrast they embody. The pairing of black and white slaves reflects the variety of women that were sold in the Cairo marketplaces, from Circassian to Abyssinian. In this respect, Gérôme drew upon what he could have witnessed in the streets of Cairo.

The black woman's slave collar, dirty feet, proximity to the monkey, and position on the ground firmly establish her racial and sexual degeneracy. Gérôme depicts her in profile, emphasizing her facial angle in a manner that reflects scientific demarcations of racial difference based on physiognomy. Since the seventeenth century the distinct profile of the black face with upturned, rounded nose and prominent lower jaw was the tell-tale marker of African-ness, even more so than skin color. This frank reference to the hierarchy of human races had currency with contemporary viewers. Critic E.B. Shuldham described the painting in a review after it was exhibited at London's Royal Academy in 1871:

There is an honesty, as it were, about the slave girl's nakedness, as she stands there in the market, a dark, strong-limbed Eve, but—and here is the pathos of this picture—an Eve who is irrevocably doomed to dishonour. The jet black Abyssinian semi-nude sits careless of her fate, whilst a marvelous monkey, worthy of Landseer, squats huddling by her side, from the terms of the sale almost an acknowledged equal, the monkey and the negress evidently going together as one lot.[30]

Shuldham likened the white slave to Eve, honestly naked, yet sadly destined for the corruption of Oriental slavery. He ascribed to the white woman feelings of dishonor and shame, imbuing her with a kind of humanity not extended to the black woman. Alternatively, Shuldham asserts that the "jet black" woman shows no emotion and accepts her fate not only as a slave, but also as an equal to the monkey. The sentiment infers that the sale of white women in Eastern slave markets should elicit the pathos of the viewer whereas slavery is a condition commensurate with the black body. With his vacillating and symbiotic moral position between lust and outrage, Gérôme nominally indicts the barbarity of the Oriental trade in white female flesh through the seductive yet anemically pathetic white nude, while inviting the male spectator to imagine himself as both client and critic.[31]

In spite of the unquestionable effort to mark the black woman as degenerate, Gérôme adds alluring decorative appointments to her body and indeed the entire tableau. His modes of embellishment seem to mitigate or at least obfuscate the real horrors of sexual slavery. A red flower adorns the black slave's hair and tattoos are visible on her hand and leg. Along with the slave ring around her neck is a decorative cowry shell necklace. The cowry was a

form of currency in Africa dating back centuries. Featured here by Gérôme as adornment for the black female slave, the cowry signifies her status as a commodity in a monetized transaction while at the same time functioning as a form of beautification. Along with the white nude's languorous body language, and ornate bejeweled ankle bracelet, these details become diversionary tactics projecting mixed messages of sensuous materiality that could draw focus from the degraded and barbaric nature of the scene.

Equally distracting and compelling is the ornate Turkish Yatagan sword with an ivory handle that is hanging on the outside of the kiosk window flanked by the stunningly blue parrot.[32] This still-life vignette of exotica showcases the artist's virtuosity as a painter and echoes the sexuality of the narrative. The phallic sword is an inanimate avatar of both the hyper-masculine buyer and seller. The parrot is a symbol of exotic luxury and eroticism that dates back centuries. Parrots and black servants, or Moors, were often among the array of objects that signaled references to distant lands, trade, and conquest in Dutch still-life painting of the Baroque period.[33] Nineteenth-century paintings like Eugene Delacroix's *Woman with Parrot* of 1827 and Gustave Courbet's *Woman with Parrot* of 1866 combined assertively erotic nudes with the tropical bird in a play on female sexuality and nature. Gérôme is once again straddling the line between the transgressive contemporary art scene of Courbet and Edouard Manet and the safety of academic tradition. Gérôme managed to engage ideas infamously explored by modernists, yet through the lens of the Orient avoid the taint of modern life.

The Slave for Sale drew critical attention with its political theme and provocative display of sexuality. During that same year Gérôme produced *The Slave Market* (1871), another canvas featuring women for sale at a Cairo kiosk. *The Slave Market* is a more expansive view of the sexual slave trade, featuring six women of various shades of black, brown and white, including one with an infant. The same white nude figure featured in *The Slave for Sale* appears here among the demoralized lot of women for sale in *The Slave Market*. After completing these two canvases, Gérôme seemed to abandon the unsavory sexual underworld of Oriental slavery for a more romantic, perhaps more palatable and commercial approach to erotic potential of black and white bodies. Channeling Nattier's *Mademoiselle de Clermont* (Figure 6.2) and Ingres' *Bain Turc*, Gérôme turned to the sumptuous, decorative interiors of the Eastern harem in *Moorish Bath*. Although the explicit commercial exchange of women is avoided, the bath scenes employ slightly more subtle aesthetic devices that, like the slave market scenes, exploit racial binaries and offer female bodies for consumption. Gérôme was not the first to invest in the seductive imagery of the Oriental bath, the exotic female nude, or the sensuous rituals of beauty, but his provocative interpretations beginning with *Moorish Bath* of 1872 would come to represent some of the most potent forms of French exoticism in the nineteenth century.

Set in a private Cairo bath, *Moorish Bath* (Figure 6.4) is animated by an array of differences anchored by the blackness of the female servant juxtaposed with the creamy whiteness of the nude bather, a device he previously used to

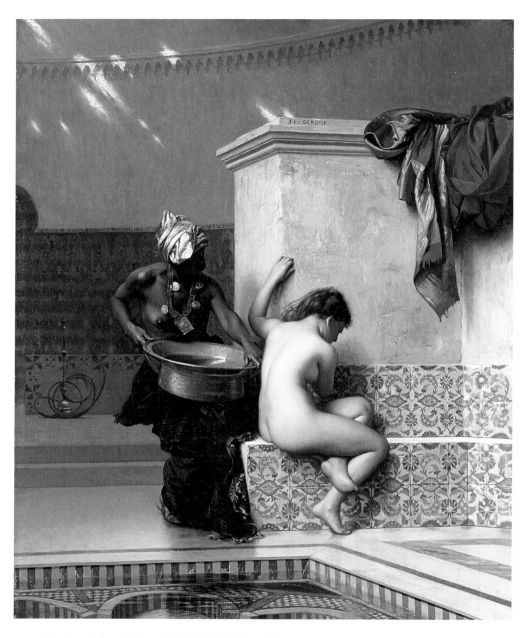

6.4 Jean-Léon Gérôme, *Moorish Bath*, 1872. Oil on canvas. Museum of Fine Arts, Boston, Massachusetts / Gift of Robert Jordan from the collection of Eben D. Jordan / The Bridgeman Art Library. Photo: © Museum of Fine Arts, Boston. All rights reserved

great effect in *The Slave for Sale*. Gérôme's carefully crafted oppositions create a reaction that evokes exoticism in a manner that neither figure could achieve alone. Exploiting the perceived binaries between Europe and Africa, black and white, civilized and savage, servant and served, Gérôme formulates an intricate oppositional interplay between the two figures, as in *The Slave for Sale*. A review of *Moorish Bath* after it was exhibited in the 1878 Universal Exposition in Paris articulates in no uncertain terms the rhetorical importance of Gérôme's use of binary oppositions as a structural framework. For reviewer Fanny Field Hering, American Gérôme biographer, friend, and devotee, it spelled perfection:

> The ebony body of one and the ivory form of the other, first with a yellow Madras kerchief on her head, the second with her wealth of golden tresses, are bathed in the ambient air, the high lights being adjusted with remarkable flexibility; there is nothing to criticize in this little gem, no fault of style or orthography; one could write perfect from one end of the canvas to the other. The drawing, the color, the action, are equally irreproachable.[34]

Indeed, a litany of contrasts defines the subject of bather and servant, as well as the composition, both of which reinforce the ideological binaries. The black figure stands facing front, and the white bather sits facing back.[35] An enclosed seating area on the right is juxtaposed with an empty space on the left. The black servant wears a turban, a typical headdress of the exotic slave, while the nude wears no headgear. The servant's drapery is a dark, rough-hewn cloth while the bather's discarded robe is a finely woven, vibrant silk in bright shades of green and red.

The black woman in *Moorish Bath* (Figure 6.5) was central to the dramatic tension of the scene and hence the issue of ethnographic authenticity became critical. Gérôme wrote in his memoirs that he could not even complete *Moorish Bath* in London because he did not have the proper model for the African slave.[36] He returned to Paris from London in June of 1871 to find an appropriate black female to model for this character.[37] This anecdote puzzled Gérôme biographer Gerald Ackerman, who wrote that the artist seemed to paint his white bathers from memory, prompting him to question "So why not the slave?"[38] In a related move to increase the veracity of his harem imagery, Delacroix added a contrived black servant to his 1834 painting *Women of Algiers*, even though she was not present during his storied visit to an Algerian harem. Both Gérôme and Delacroix used the black body, real or imagined, to enhance the authenticity of their Orientalist tableaux.

For Gérôme there were several well-known black models working in Paris during the 1860s and 1870s that were available to him and apparently preferable than those he could have found in London. In the second half of the century, black women famously appear in works by French artists such as Manet, Frederick Bazille, Charles Cordier, and Jean-Baptiste Carpeaux. Gérôme's desire to employ a black model in Paris reveals not only the availability of "proper" black models in the city, but perhaps he

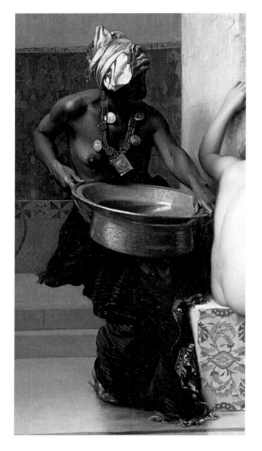

6.5 Jean-Léon
Gérôme, *Moorish
Bath*, 1872, detail.
Oil on canvas.
Museum of Fine
Arts, Boston,
Massachusetts /
Gift of Robert
Jordan from the
collection of Eben
D. Jordan / The
Bridgeman Art
Library. Photo:
© Museum
of Fine Arts,
Boston. All
rights reserved

saw *Moorish Bath* as an academic response to Impressionist offerings such as Manet's *Olympia* (1863) and Bazille's *La Toilette* (1870), works that scandalously transported the traditionally exotic pair from the Orient to contemporary Paris. Again, Gérôme seems to dance with the contemporary avant-garde while maintaining a firm position as an academic orientalist.[39]

Just as Turkish tiles, Egyptian fabrics, and numerous decorative objects added an aura of accuracy to Gérôme's works, the black woman's attire was operative in the decorative program in *Moorish Bath* (Figure 6.5). She is draped in coarse striped cloth of undetermined ethnic origin. Stripes were often associated with slaves and people at the lower registers of society.[40] Black females featured in several subsequent exotic bath tableaux by Gérôme wear a similar striped cloth. Her Moroccan-style necklace is an unusual and striking ornament. It is a large and elaborate piece comprised of a series of circular coins and square pendants interspersed with red coral, a composition typical of Moroccan metalwork and jewelry design.[41] Gérôme's interest in adorning the black slave with North African "ethnic" items signals a transformation in the historical representation of the black servant. Prior to the Orientalist interest in authentic ethnicities, black servants were typically dressed in European livery or generic exotica such as a feathered turban and tunic. Black bodies were often adorned with pearl necklaces and earrings that contrasted with their dark skin, marking them as objects of luxury and of course trading on the fashion for contrasts. Gérôme's pastiche of ethnic costume and jewelry moved toward differentiating black ethnicities within the Orient rather than treating all of the types with a universal Orientalist brush. This movement toward a more ethnographic approach to the black woman reflects Gérôme's larger interests in physiognomies and costumes as well the rise in popular anthropology and ethnography in mid-nineteenth-century Europe.

Moorish Bath was the first in this series of exotic bathers that eventually resulted in approximately 27 works, three of which share the title *Moorish Bath*.[42] Most of the bath scenes include at least one black female slave. Dating from 1872 through the 1890s, they range from intimate groups of two such as the 1872 *Moorish Bath* discussed here and the 1880 canvas of the same name to multi-figured compositions such as his *Grand Bath at Bursa* of 1885 where three black women attend to nude ladies and children in a large communal bath.

The American art critic Edward Strahan described Gérôme's variations on the theme of the Moorish bath as an opportunity to show the versatility of his skill. In his compilation of one hundred photogravures by Gérôme, Strahan described the series of bathhouse scenes as a study in contrasts: "... the contrast of graceful, warm-tinted nudity and the coolness of color and largeness of space in those vaulted marble halls, with the occasional and exceeding blackness of the Nubian slaves to give an accent, this contrast and harmony is enough to tempt a painter"[43]

Indeed, the myriad potential of contrast and harmony did tempt Gérôme, leading him to revisit the aesthetic possibilities in combinations and permutations of "exceeding blackness" and "graceful, warm-tinted nudity" for a quarter century. While the African women in the series of paintings were essential to grounding the scenes in the ostensible reality of the Orient, their individuality and ultimate humanity were incomprehensible. Commentators likened the black woman to "ebony" and "jet," decorative luxury commodities or accents that punctuate the primary subjects. With their black faces often obscured by drapery, or their backs turned to the viewer, it was their dark, ornamented bodies that activated the scenes. Often the only clothed or partially clothed figures, like tiles, costumes, and minarets in his Orientalist landscapes, black women were among the objects that definitively marked the scene as exotic. Their presence was as much a formal as a narrative device, drawing upon the nineteenth-century fascination with contrast.

"Occasional and exceeding blackness"

With smooth surfaces, hypnotic colors, and entrancing details, Gérôme's artistry conveys the sensual and seductive pleasures of the Orient while mediating European ideas of slavery, racial degeneracy, and sexual domination. Black African females in his Orientalist catalogue are slaves and servants whose racial and sexual outlandishness puts them in a dialectical relationship with white women,[44] one in which the white female is exoticized, therefore Orientalized, through to her proximity to extreme blackness. The black slave is then humanized only through her service to the white Oriental woman. The African woman's "excessive" and incomprehensible blackness exist beyond the comfort and familiarity of the "warm-tinted" (Strahan) nudes or the "beauty we know" (Nerval). Although they may exceed comprehension, they are necessary props rendered authentic, knowable, and palatable in the imagined spaces of Orientalism.

The art of Jean-Léon Gérôme has come to embody some of the core values and fundamental conflicts of Orientalist imagery, particularly in terms of representing the black female. Gérôme's images of exotic Africans are possibly the best examples of the tensions of art and ethnography of the period. Black figures are often crucial to Gérôme's construct of the Orient as a raced space, a seductive antithesis to normative European whiteness.

At times his fidelity to the physiognomy resulted in strikingly sensitive representations of individualized black figures. Yet they were often pastiches of exotica, a reanimation of the stock figures of exotic blackness dating back centuries. Today, Gérôme's brand of ethnographic exotica seems emblematic of a flawed and insidious system through which Europeans defined their own racial and cultural supremacy in opposition to others. Yet in his time, Gérôme exploited the alchemy of racial oppositions to ignite the erotic/exotic spaces of the Orientalist imaginary.

Notes

1 Author's translation; Gérard de Nerval, *Voyage en Orient* (Paris: Gallimard, 1998), 221.

2 Ibid., 221–2.

3 Edward W. Said, *Orientalism* (New York: Vintage Books, 1979).

4 Gerald M. Ackerman and Jean Léon Gérôme, *The Life and Work of Jean-Léon Gérôme: With a Catalogue Raisonné* (London: Sotheby's Publications, 1986).

5 Linda Nochlin, "The Imaginary Orient," in *The Politics of Vision: Essays on Nineteenth-Century Art and Society* (New York: Harper & Row, 1989).

6 Scott Allan and Mary Morton, eds., *Reconsidering Gérôme* (Los Angeles: J. Paul Getty Museum, 2010).

7 Griselda Pollock, *Differencing the Canon: Feminist Desire and the Writing of Art's Histories* (London: Routledge, 1999), 294.

8 David Bindman and Henry Louis Gates Jr., eds., *The Image of the Black in Western Art*, vol. 3, *From the "Age of Discovery" to the Age of Abolition*, part 1, *Artists of the Renaissance and Baroque* (Cambridge, MA: Belknap Press of Harvard University Press, 2010).

9 David Bindman and Helen Weston, "Court and City: Fantasies of Domination," in *The Image of the Black in Western Art*, vol. 3, *From the "Age of Discovery" to the Age of Abolition*, part 3, *The Eighteenth Century*, ed. David Bindman and Henry Louis Gates Jr. (Cambridge, MA: Belknap Press of Harvard University Press, 2010), 152.

10 Perrin Stein has characterized the toilette of the sultana as a stage in the process of the sultan's selection of a favorite from the ranks of the odalisques; Perrin Stein, "Amédée Van Loo's *Costume turc*: The French Sultana," *Art Bulletin* 78, issue 3 (1996): 424.

11 Kathleen Nicholson, "Practicing Portraiture: Mademoiselle de Clermont and J.-M. Nattier," in *Women, Art and the Politics of Identity in Eighteenth-Century Europe*, ed. Melissa Hyde and Jennifer Milam (Burlington, VT: Ashgate, 2003), 79.

12 Abigail Harrison Moore, "*Voyage*: Dominique-Vivant Denon and the Transference of Images of Egypt," *Art History* 24 (2002): 531–49.

13 Said, *Orientalism*.

14 Philippe Mariot, "Chronology," in *The Spectacular Art of Jean-Léon Gérôme: 1824–1904* (Paris: Skira, 2010), 341–7.

15 James Clifford, *The Predicament of Culture: Twentieth-Century Ethnography, Literature, and Art* (Cambridge, MA: Harvard University Press, 1988), 25.

16 Author's translation. Théophile Gautier, "Gérome: Tableaux, Etudes et Croquis de Voyage," *L'Artiste*, December 28, 1856. See also Miller's discussion of this article and Gérôme's ethnography as a realist project; Peter Benson Miller, "Gérôme and Ethnographic Realism at the Salon of 1857," in *Reconsidering Gérôme*, ed. Allan and Morton, 115.

17 Gautier, "Gérome," 34.

18 Ibid., author's translation.

19 Christopher L. Miller, *Blank Darkness: Africanist Discourse in French* (Chicago: University of Chicago Press, 1985), 16.

20 Ruth Bernard Yeazell, *Harems of the Mind: Passages of Western Art and Literature* (New Haven: Yale University Press, 2000).

21 Lane's book has been in print continuously since 1860; Edward William Lane, *An Account of the Manners and Customs of the Modern Egyptians: The Definitive 1860 Edition*, 5th ed., intro. Jason Thompson (Cairo: American University in Cairo Press, 2003). At times problematic, Lane's general descriptions of the ethnicity of Egyptian slaves have been confirmed by twentieth-century historians. See Gabriel Baer, "Slavery in Nineteenth Century Egypt," *Journal of African History* 8, no. 3 (1967): 417–44.

22 Ibid., 184.

23 Ehud R. Toledano, "Late Ottoman Concepts of Slavery (1830s–1880s)," *Poetics Today* 14, no. 3 (1993): 483.

24 The practice of keeping black slaves continued in Egypt throughout the nineteenth century. See Baer, "Slavery in Nineteenth Century Egypt"; Robert O. Collins, "The Nilotic Slave Trade: Past and Present," *Slavery and Abolition* 13, no. 1 (1992); Alice Morre-Harell, "Slave Trade in the Sudan in the Nineteenth Century and Its Suppression in the years 1877–80," *Middle Eastern Studies* 34, no. 2 (1998).

25 Baer, "Slavery in Nineteenth Century Egypt," 419.

26 Lane, *Manners and Customs*, 185–6.

27 Ronald Segal, *Islam's Black Slaves: The Other Black Diaspora* (New York: Farrar, Straus, and Giroux, 2001), 109.

28 Gerald M. Ackerman, *Jean-Léon Gérôme: Monographie revisée, catalogue raisonné mis à jour* (Paris: ACR Editions, 2000), 90.

29 Ibid., 92.

30 M.D.E.B. Shuldham, "The Royal Academy," *Dark Blue* (1871): 472.

31 Alison Smith makes the astute point that the male spectator is both denouncer and potential client. See Alison Smith, *The Victorian Nude: Sexuality, Morality and Art* (Manchester: Manchester University Press, 1996), 172.

32 This same type of sword is featured in Gérôme's portrait of the black soldier in the painting *Bashi-Bazouk* (1868–69) in the collection of the Metropolitan Museum of Art.

33 Julie Berger Hochstrasser, *Still Life and Trade in the Dutch Golden Age* (New Haven: Yale University Press), 211.

34 In her biography of Gérôme, Hering quotes "Art of the Nineteenth Century" by de Pesquidoux; see Fanny Field Hering, *Gérôme: The Life and Works of Jean-Léon Gérôme* (Cassell: New York, 1892), 226.

35 Linda Nochlin points out that Gérôme's bather signifies tradition by referencing the "original Oriental backview" of Ingres's *Valpinçon Bather*; see Linda Nochlin, "The Imaginary Orient," in *The Politics of Vision* (New York: Harper & Row, 1989), 47.

36 Author's translation; see Ackerman, *Jean-Léon Gérôme*, 272.

37 See time line of Gérôme's life and work in Hélène Lafont-Couturier, *Gérôme* (Paris: Editions Herscher, 1998), 117–26.

38 "Alors, pourquoi pas l'esclave?" Ackerman, *Jean-Léon Gérôme*, 272.

39 Peter Benson Miller proposes that we expand our conception of Gérôme beyond the antiquated and fantastic to think of his Orientalist works in relation to contemporary realist modes, particularly a kind of ethnographic realism; see Miller, "Gérôme and Ethnographic Realism."

40 Michel Pastoreau, *The Devil's Cloth: A History of Stripes*, trans. Jody Gladding (New York: Washington Square Press, 1991), 35–41.

41 Jacques Rabaté and Marie-Rose Rabaté, *Bijoux du Maroc: Du Haut Atlas à la vallée du Draa* (Aix-en-Provence: Edisud/Le Fennec, 1996), 40–42.

42 Ibid. This number is a result of a survey of the images in Ackerman's monograph, the most complete assemblage of Gérôme's work to date. Many of these paintings were published as prints or photogravures.

43 Edward Strahan, ed., *Gérôme: A Collection of the Works of J.L. Gérôme in One Hundred Photogravures* (New York: Samuel L. Hall, 1881), n.p.

44 Charmaine Nelson, *Representing the Black Female Subject in Western Art* (New York: Routledge, 2010), 107.

Visualizing racial antics in late nineteenth-century France

James Smalls

In 1886 the French artist Henry Somm (also known as François Clément Sommier) (1844–1907), in collaboration with the poet and graphic designer George Auriol (1863–1938), initiated the puppet theater that soon evolved into a shadow play created by the painter and designer Henri Rivière (1864–1951) for the Chat Noir cabaret.[1] Somm designed the first piece for the shadow play entitled *L'éléphant* which, beginning in 1887, was used by the founder and owner of the Chat Noir, Louis Rodolphe Salis (1851–97), to raise the curtain for each evening's performance. The commentator Paul Jeanne described this seminal comic-symbolic shadow vignette that became the most frequently performed work at the Chat Noir:

A Negro, his hands behind his back, pulls on a rope. He moves forward, disappears [offstage],—the rope stretches horizontally [across the stage]. Then, a knot in the rope [appears]. The rope continues extending, endlessly! ... Then, everything comes to an end, an elephant appears who then deposits "an odiferous pearl" ... from which springs a flower, —then: Curtain![2]

This kind of racial and scatological humor appealed to many bohemian and avant-garde artists and writers of the late nineteenth century in France and constitutes one of many instances of racial "antics"—specifically, racial jokes manifested visually along with images generated from the transplantation and reception of blackface minstrelsy into France during the late nineteenth century. It was through such maneuverings and imagery, closely associated with mass entertainment and French popular culture, that the performativity and productive ambiguity of blackness became significant to a simultaneous cultural and national sense of uniqueness and definition, incorporation, and differentiation of French selfhood set against and apart from cultural and racial alterity. This chapter considers the work of an array of French artists who used blackness as a signifier to consolidate both French national and cultural distinctiveness and difference through visual and performative strategies of a simultaneously deployed racial acknowledgement and obfuscation.[3]

The dialectic nature of incorporation and exclusion, acknowledgement, and obfuscation operated as a sign constitutive of the instability and uncertainty of a French national ideal born out of the abstract principles of liberty, equality, and brotherhood as these had been formulated in the aftermath of the French Revolution. It was during this early period of France's re-formation as a democratic nation that "radical policies of racial equality and the erasure of racial categories coexisted with new, insidious forms of racial exclusion."[4] The abstract tenets on which the First French Republic was based fostered a tension between simultaneously held principles of inclusion and practices of exclusion of both racial and cultural others that were subsequently carried over into and perpetuated by the French Third Republic (1870–1940), a period in which there was a noticeable avoidance of a "formal recognition of race as a legally recognizable marker of difference, even as the country embarked on its most aggressive period of colonial expansion."[5] This is also the era that serves as historical backdrop for the racial antics I want to discuss. Indeed, France's complex colonial history in the latter decades of the nineteenth century weighs heavily on the ambiguous ways in which racial attitudes and issues in France were and still are un- or mis-recognized and debated.[6]

The Third Republic began on a note of defeat and doubt, the political fallout of which resulted in an era "characterized by intense nationalism and xenophobia."[7] A series of unfortunate historical events after 1870, specifically the country's defeat in the Franco-Prussian War, along with the physical and psychological devastation caused by the Commune, fostered a situation in which France came to see itself as "both a historical fatality and as a community imagined … [a] nation present[ing] itself as simultaneously open and closed," inclusive and exclusive of difference.[8] This was a period of intense nationalism and xenophobia, and one in which the definition of Frenchness itself underwent challenge. Not coincidentally, it was also a time when different kinds of racialized imagery, including minstrelsy, proliferated in popular culture and were transplanted across national borders, providing visual evidence that in the French context, race and culture were not separate and distinct categories, but rather formed an inextricably linked bond to which the French chose to relate for a variety of objectives.

Indeed, it was more so in the popular art forms (that is, graphic, textual, and performance-oriented) rather than in works of high art that racial and cultural differences could be most easily identified, scrutinized, adapted, obfuscated — that is, made relevant and irrelevant all at the same time. Visualized racial antics "had the power to mold or reinforce (French) ideas about race," here defined as "the category of human difference based on [a combination of] phenotypical *and* cultural traits."[9] The imagery under examination illuminates the simultaneously deliberate and ambiguous instrumentality of blackness in popular spectacle used to provide a foil for the identity of France as a nation with a distinct culture.[10] These visual shenanigans of racialized spectacle are important to consider in that they draw artists, their subjects and viewers, into the whirlwind of contradiction, fragmentation, and ambivalence

that is generally characteristic of modernist encounters, experiences, and expressions.[11] Simply put, this chapter investigates the kinds of symbolic work that images of blackness and racialized performance can do in the modern French context.

Blackness hidden in plain sight

L'éléphant, the Chat Noir's shadow theater piece mentioned above, was part of the artistic ferment that surrounded the cabarets of late nineteenth-century Paris. In such establishments, works were created by progressive artists such as the members of the *Incohérents*, whose exhibitions, organized in the 1880s by writer and publisher Jules Lévy (1857–1935), were irreverent and politically biting.[12] Some of the more prominent among the *Incohérents* were, in addition to Somm, Alphonse Allais (1854–1905), Paul Bilhaud (1834–1933), Caran D'Ache (called Emmanuel Poiré) (1858–1909), Jules Chéret (1836–1933), Adolphe-Léon Willette (1857–1926), and, for a very brief time, Henri de Toulouse-Lautrec (1864–1901). The imagery created by this group of artists anticipated many of the aesthetic techniques and satirical attitudes that would become attributed to subsequent twentieth-century avant-garde art movements. The *Incohérents* set out to engage class, gender, and, to a very limited extent, racial mores of contemporary society by making stinging use of satire, parody, pastiche, puns, caricature, and comedy to critique the various social, cultural, and political events of the day.Included in the *Incohérents'* first exhibition was an all-black monochrome "painting" entitled *Combat de nègres dans un tunnel* (Battle of negroes in a tunnel) by the French poet and dramatist, Paul Bilhaud, and first illustrated in the issue of October 3, 1882 of *La Presse*. As François Caradec has noted, it was with its title that this work entered into the cultural heritage of France.[13] The image shows a black monochrome rectangle enframed within a drawn simulated frame. For the 1883 and 1884 *Incohérent* shows, the French humorist Alphonse Allais expanded on Bilhaud's idea by presenting a white and then a red monochrome "painting" conceived in the same manner. Then, over a decade later, in 1897, Allais decided to publish his *Album primo-avrilesque* (April Fool-ish album) in which he included seven monochromatic images with such titles as "Manipulation of Ochre by Jaundiced Cuckolds" (yellow), "Tomato Harvest by Apoplectic Cardinals on the Shores of the Red Sea" (red), "First Communion of Chlorotic Young Girl During a Snowfall" (white). Without attribution, he included in this list Bilhaud's black rectangle with the title changed to "Combat de nègres dans une cave, pendant la nuit" (Battle of negroes in a cave at night) (Figure 7.1).[14] In the art-historical literature, these works are typically referred to only in terms of their pre-Dada and pre-Surrealist avant-gardism. Bilhaud's black rectangle is often discussed singularly in reference to its forward-looking anticipation of Kazimir Malevich's 1915 *Black Square*. In the context under consideration here, I designate Bilhaud's image not as an exercise in avant-

COMBAT DE NÈGRES DANS UNE CAVE, PENDANT LA NUIT
(Reproduction du célèbre tableau.)

7.1 Paul Bilhaud, "Combat des nègres dans une cave, pendant la nuit," 1897, from *Album primo-avrilesque* by Alphonse Allais (Paris: Paul Ollendorf) [original 1882, titled *Combat des nègres dans un tunnel*]

gardism, but rather as a work of French racialism. Indeed, the title itself knowingly references a racial joke that was conceived and received in terms of skin color difference. Surprisingly, nowhere in either past or contemporary critique is there ever mention of this work's racial, if not racist, dimension. As will become apparent later, such a penchant for obfuscating race—of subsuming racial difference within the purview of (white) modernist practice, critique, and control—was not all that unusual in the French context of assimilation, republicanism, and the attempt by individual modernists at forging and defining a unique national and cultural identity for themselves.

Bilhaud's image constitutes one of many works produced by artists and intellectuals of the bohemian and avant-garde strain of late nineteenth-century Montmartre that approximates what has been called "ingenious techniques of social outrage," but here imagined in distinctly racial/ethnic terms.[15] The designation *"fumisme"* has been given to this general attitude pervading the intellectual and artistic life of Montmartre in the 1880s and 1890s. *"Fumisme"* is an approach to contemporary life characterized by satire and practical jokes, mocking official values and societal norms, including those that governed traditional notions of art, class, sexuality, and race/ethnicity. Apropos to the discussion at hand is the fact that, in 1888, the poet Emile Goudeau described this outlook as "a kind of disdain for everything … an internal madness evidenced externally by countless *buffooneries*."[16] In this respect, Bilhaud's image and its modernist reception operate in much the same way as minstrelsy in that it constitutes a visualized racial/racist joke within *fumisme*'s critical and obfuscatory operations. With Bilhaud's image,

blackness as a potentially explosive racial matter has been defused and conveniently subsumed within the rhetorical sanctuary of (white) modernist thinking and practice. Here, bohemianism and avant-gardism are implicated in the manipulation of race for French identificatory purposes. The strategy highlights the ambiguous and ambivalent instrumentality of racial matters within French republican desires—an equivocation that is seen most forcefully in the topic I would like to turn to now— the visual representation and reception of minstrelsy in late nineteenth-century France.

The "*là-bas*" of blackness

In an 1886 edition of *Paris Illustré*, the critic Maurice Vaucaire penned the following about the appearance of a troupe of blackface minstrel performers at the Parisian cafés-concert:

> … these English or Americans soiled of black, swaddled of black, nimble, and heavy at the same time. Heavy so as to best impress the public who get excited listening to the reverberations of the floor beneath their feet as a result of their foolish falls. They (the audience) get excited at the fists across the face, the swift kicks in the pants, in the kidneys, on the head! They toil the poor devils and the sweat falls in waves as it removes the blackface that they have applied on their cheeks, forehead, and neck. Their white eyes, their white teeth give their black physiognomy an air of the good Negro. In this way, they are likeable as they are terrifying.[17]

This description could have easily referenced the 1886 two-page spread in *Le Courrier Français* depicting a troupe of blackface minstrels from London (Figure 7.2). The illustration, titled "Les minstrels anglais" (The English minstrels), by the painter and printmaker Jean-François Raffaëlli (1850–1924), presents a group of frolicking performers amidst musical lyrics and one-liners associated with American minstrelsy.[18] In light of Raffaëlli's image, Vaucaire's commentary is interesting in the ways in which it references slavery ("they toil the poor devils") and its equation of whiteness with likeability, so that the performers are all at once terrifying in their otherness (performing blackness and toiling like slaves) and "safe" in that they are under control as whites in blackface and as "likeable" blacks ("the good Negro"). Such dualities speak to the meaningful ambiguity of blackness engaged by French artists as a way of managing the identity of the other while participating in the process of defining the self.

By the mid-nineteenth century, the minstrel show had crossed the Atlantic and was accepted in several European countries as an "original American Institution."[19] It was introduced into France via Britain sometime in the 1840s and helped bring the idea of racial and cultural difference to popular attention and appeal. Because minstrelsy was one of several cultural imports into France, it developed a hybrid character following along a different historical and cultural trajectory than did the American or British forms.

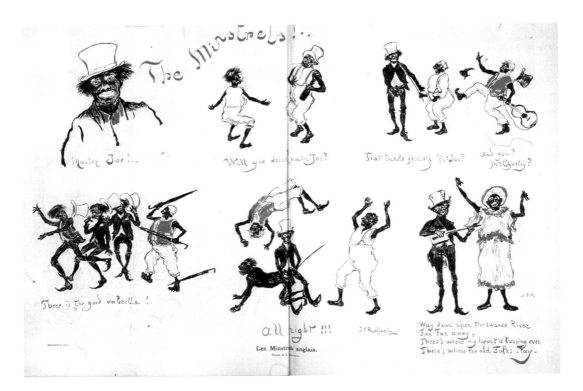

7.2 Jean-François Raffaëlli, "Les minstrels anglais," in *Le Courrier Français*, December 26, 1886, no. 52

Minstrelsy's transplantation and reception into France via Britain has much to do with the unique past historical engagement that each of these countries had undertaken in transatlantic slavery and their attempts to define themselves as sovereign nations and singular cultures. Although chattel slavery had been forbidden on French soil since the Middle Ages, that fact did not prevent the practice from taking place in that country's distant Caribbean colonies. Unlike in the US, however, where the minstrel and his theatrics oftentimes served as a humorous foil to deflect fears of blacks in close physical proximity, in France, minstrelsy became a consumable product resulting from a distanced exoticism. The encounter with blackness was born and played out *là-bas*, over there, in the French colonial possessions and not on French soil proper. For France, physical distance and that country's complicated engagement in colonial slavery affected the perception and the representation of blacks and blackness, both of which were not to become as threateningly interwoven into French cultural consciousness as would be the case in the US. For most Frenchmen, blacks in general were alien and, hence, perceived as intriguing and only potentially frightening. As well, the *là-bas* of blackness for France extended more generally to American culture, which was also seen by most Frenchmen as removed, peculiar, markedly un-French.

In addition to the exoticism of blackness, in France, minstrelsy's reception depended on the ways in which it combined with other older European theatrical traditions such as pantomime, the circus, operettas, the ballet,

the *commedia dell'arte*, and escapist forms of entertainment in popular institutions such as the cafés-concerts, cabarets, and the music hall. The result was a culturally and aesthetically unique form of public distraction that both challenged and solidified the boundaries of race and class. In addition, the minstrel show evolved not only in tandem with a complex French colonial and theatrical history, but also with the human "zoos" of the universal, colonial, and ethnographic exhibitions (where black Africans were presented as spectacular entertainment combining the scientific and theatrical);[20] and with the promotion of science (anthropology, ethnography, Darwinian evolution) as a sign of social and cultural progress; the growing popularity of primitivism, orientalism, and africanist art; commercial capitalism; grand shifts in gender and class relationships; and intensified colonialist and imperialist ventures after 1870. Although I am unable to address in any great detail all of these areas in the short amount of space allotted here, it is important to point out that in order to appreciate minstrelsy and the spectacle of blackness in its French context, we must at least acknowledge a complex and often contradictory French history constitutive of "Americanization" and the desire and need for race-making and nation-building.

Blackness transplanted

In the course of my research to find the earliest documented date at which minstrelsy was introduced into France, I stumbled upon an illustration and short essay in the March 1859 issue of the popular paper *Le Monde Illustré*, announcing the arrival of *Les Bouffes Américains* (American comedy shows) into France via Britain. The cover design depicts vignettes of American minstrel performers in the act of singing and dancing. Among other things, the image provides visual confirmation of the prescribed arrangement of the minstrel show: chairs were set up in a semicircle, with the tambourine and bones players on the ends. It was they who introduced the spectacle with what was to become standard instrumentation—the tambourine, banjo, fiddle, triangles or bells, and bones. A comic repartee between songs and dances was standard. Located on the lower register of the illustration, on either side of a banjo-playing performer (the iconic symbol of minstrelsy), are individuals engaged in dances (namely, the cakewalk) associated with American plantation life.[21] The accompanying article, written by the journalist Maxime Vauvert, instills excitement in the reader by announcing that the concert halls of Paris have enthusiastically inaugurated this new kind of mimicry and spectacle as popular amusements (called *divertissements nègres*) for French audiences. Vauvert confirms that this new form of diversion came to French shores via Britain: "around 1840 a troupe of black American singers arrived in London to perform. This troupe was composed of several musicians playing 'strange' instruments such as banjos (a kind of African gourd), tambourines, tam-tams, fiddles, and primitive castanets made of flattened bones held

between the fingers." These instruments, Vauvert observed, served as accessories to accompany "bizarre," "frenetic" songs and "epileptic" dances. Lastly, the author noted that "the primary attraction of these spectacles were in the scenes of plantation customs, elegies to the life of the African-American slave, his trials, tribulations, and loves."[22]

Vauvert was not alone in believing in cultural authenticity displayed through the transplanted minstrel performance. The French traveler and writer Oscar Comettant noted in 1857 that before visiting New York he had never seen anything like the minstrel show and was convinced of its faithful presentation of slave "realities."[23] With minstrelsy, the plantation South provided a compelling *mis-en-scène* in which supposed "authentic" slave re-enactments "brought the plantation yard into the theater."[24] Indeed, in the American context, minstrelsy grew out of that country's reality—that of the brutality and absurdity of slavery. Cognizant of the fact that the US continued to indulge in the horrors of bondage in the 1850s, the French prided themselves publicly on demonstrating their wisdom in abolishing that institution in their own distant colonies in 1848—a fact that made blackness and the spectacle of minstrelsy remote yet simultaneously tantalizing and commodifiable. Both Vauvert's and Comettant's observations suggest that, as a type of foreign cultural performance and blackness as an equivocating aspect of it, minstrelsy was reduced, albeit not benignly, to an imported exotic (that is, distanced) product of amusement and consumption for the French.

Despite American-style minstrelsy's sporadic forays into France during the 1840s and 1850s, the minstrel show did not really take hold there until the 1870s and 1880s when, along with colonial expansion, foreign immigration, and rampant consumerism, a burgeoning leisured class of *nouveaux riches* began demanding novel and more extravagant forms of diversion.[25] Alterity was everywhere and it seemed that the French public could not get enough. At the same time, however, patriotism and nationalism—that is, what constituted and defined the distinction between "Frenchness" and otherness—were being promoted and hotly debated by some cultural observers.[26]

It is believed that the late start of the minstrel show in France had a lot to do with the language barrier—that is, the culturally specific badinage associated with the spectacle may have been lost on the French audiences who, nevertheless, appreciated the exaggerated gesticulations and epileptic buffoonery of the performers. Indeed, as will become evident further along and as Rae Beth Gordon has pointed out, the appeal of the minstrel show in France had less to do with the spoken word and more to do with the visual power of body language.[27]

When blackface minstrelsy caught on in the 1870s, it was performed in well-known establishments of popular entertainment such as music halls, cabarets, cafés-concerts, and circuses. The owners and promoters of these businesses understood the importance of advertising and the pull of an unusual act, and frequently commissioned both known and obscure artists and illustrators to create posters designed to announce upcoming spectacles. It was by way of

the poster or *affiche*, as well as through popular daily print and mass illustrated papers such as *Le Courrier Français*, *Le Petit Parisien*, *Fantasio*, *L'Illustration*, *Le Monde Illustré*, and *Le Rire*, that the presence of American blacks and blackness as a mimetic concept, along with their attendant stereotypes, most effectively entered into French popular culture and imagination. It is no accident that these were also venues for advocating expansionist positions and colonialist messages. Posters and illustrations were encountered in the daily home environment of the everyday consumer and "had the power to mold or reinforce ideas about race"[28] and to help shape the average Frenchman's attitudes about race and its relation to culture.

In France, the high-keyed visualization of racial and cultural difference by way of the poster and other popular forms of representation played an active role in the impulse to consume. The poster commodified everything from colonial items (including the colonial exhibitions) to minstrel performances. Thus, racial and cultural alterity became consumable items during the Third Republic. As a means of promoting and selling a product, the *affiche* had to be effective in its appeal to all classes. As such, the poster became situated between "high" art and popular culture—a sticking point of debate for many French social and cultural observers from the late nineteenth into the early twentieth century.[29] For example, the critic Georges d'Avenel linked the *affiche* to negative aspects of the democratic process itself, acknowledging that it was evidence of a disturbingly "intimate mingling of the classes."[30] Although not mentioned by d'Avenel but exploited by a handful of French bohemian and avant-garde artists of the period, racial difference among and between the sexes also played into this process of collapsing "high" and "low."

It was particularly during the 1870s that Paris saw an explosion of minstrel performers/performances and their advertising via the poster. In 1878, the African-American burlesque team of *Jilson and Reed* successfully fascinated the French public at the café-concert Alcazar d'Hiver. The colorful and animated *affiche* for their performance, designed by Emile Lévy, no doubt contributed to the troupe's success and sold-out performances.[31] In 1879, Charles Lévy (not related to Emile) produced an advertisement for a performance at the Folies-Bergère of a minstrel duo called *Les Raynors*. In 1885, he fashioned another poster for the same venue, this time showcasing the *Bellonini Brothers*, a pair of European blackface minstrels who promoted themselves as the "white-eyed Hottentots."[32] These and other representations not only attest to the popularity and ubiquity of minstrelsy in France, but they also indicate to what extent blacks and blackness became part and parcel of the spectacle of modernization through the poster.[33] As well, such performances, as already seen with Raffaëlli's *The English Minstrels*, deliberately confound the distinction between black minstrels and whites in blackface—collapsing and confusing the "authentic" and the mimetic as a way to produce and reproduce stereotypes that became part of racial and cultural curiosity, ambiguity, and comparison.

Minstrelsy and other forms of racial antics in France involve a "complex interplay of desire and repulsion, adoration and vilification, mimesis

and alterity … that characterize the construction of race generally …."[34] These aspects that substitute for white desires and fears are, according to Homi Bhabha, also integral to the dynamics of colonialism and the stereotype—as part of "productive ambivalence."[35] The excess and repetition of the stereotype are necessary for its legitimation. As well, stereotypes use various "discursive and psychical strategies of discriminatory power—whether racist or sexist, peripheral or metropolitan."[36] The stereotype is adopted and adapted to articulate difference. So, whether it is homegrown or imported (as is the case with minstrelsy in France) does not matter because the objective for its use remains consistent. In this context, blackface minstrelsy becomes a form of "metonymy of presence" and functions as a means of gaining knowledge and control over that which is considered different, apart, other.[37]

In his exhaustive study of British minstrelsy, Michael Pickering has provided a good working definition of stereotypes that I find apropos to the operations of various racial antics in France, particularly in their function in defining and solidifying cultural differences:

Stereotypes homogenize traits held to be characteristic of particular categories of people, whether these are "lesser orders" or "inferior races," and are shared and consensual to the extent that they reproduce notions of Otherness among the social groups in which they circulate and are widely diffused. They go beyond simply lumping people together under a general category, for they also seek to fix the putative characteristics of those stereotyped as if they are absolute, unchanging, and applicable for all times and places … Whether positive or negative, stereotyping creates symbolic boundaries between peoples and cultures.[38]

As a means of reinforcing stereotypes, images of blackface minstrelsy are very effective in their operations as mimicry, or the "deliberate and playful performance of a role" that is rarely a true or accurate reflection of a culture or its practices. Minstrelsy transplanted allowed for a distorted semblance of black ontology and experience that, in France, just so happened to possess "too powerful a commercial potential to be ignored."[39] Michael Taussig has suggested that "when a mimetic process such as minstrelsy takes the form of commodity fetishism, the copy swallows up 'the real' object of desire."[40] What such images make clear is that the exaggeration and commodification associated with minstrelsy in the French context reinforce the declaration of racial and cultural difference and comparison, and exemplify the desire to witness and experiment with boundary crossings in which cultural differences are defined and held in place by the fiction of race.

The conversion of minstrelsy into commodity in late nineteenth-century France was one way in which the threat of blacks and blackness to "Frenchness" was neutralized, serving, to a certain extent, as a defense mechanism against perceived loss of French cultural identity in a rapidly changing society. Indeed, it was during the last two decades of the nineteenth century that black minstrel troupes arrived in Paris in large numbers and were perceived by many French performers as an invading threat. According to Gordon, there was palpable fear that these *exotiques*, as they were labeled, would steal

the spotlight, swallow up profits, and threaten the disappearance of other café-concert genres.[41] This trepidation was realized in an 1887 review of the program at the Eden Theater indicating the replacement of many previously featured acts with minstrel shows.[42]

The sight of dark skin and the perception of different physiognomies in minstrel performances were thrilling and yet unsettling for the average French person who rarely encountered blacks in their daily lives. Blacks were held in such wonderment due to the way they moved their bodies, the way they laughed and gestured. As Gordon has noted, "excessive or bizarre movements and unfamiliar rhythms excited the French public," who drew a parallel with the black Africans or the semblance of blackness that they were watching with the ethnological exhibitions that were themselves extremely popular and that "considerably augmented the reaction of surprise … and the experience of strangeness" or alterity.[43] According to Gordon, the immense popularity of epileptically gesticulating blacks was "based largely on negative racial stereotypes and Darwinian notions of evolution that had infiltrated popular culture." However, at the same time, as Gordon also notes, "other attributes of blackness emerged that were positive," albeit equally stereotyped (that is, notions of black rhythm, gesture, vitality)—attributes that were eagerly appropriated to help shape a new popular aesthetic.[44]

As a form of exotic theater known for its corporeal and physiognomic exaggeration, the minstrel show paralleled in development and was combined with both the *commedia dell'arte* and with pantomime, both of which have a long history in France.[45] This correlation can be seen in an unusual 1887 illustration produced by Raffaëlli for *Le Courrier Français* titled "Minstrel agaçant une Colombine dans les coulisses" (Minstrel pestering a Colombine backstage) (Figure 7.3), showing a minstrel performer in blackface interacting backstage with a Colombine. In this print, the authentic and mimetic aspects of blackness are joined in the context of the *commedia*, the ballet, and the theater. Raffaëlli's image also links the modernist aspects of blackface minstrelsy with the black dandy (*le dandy nègre*) or *flâneur* as a modern type (the theoretical implications of which I have written about elsewhere) in that this representation was conceived in specific reference to the iconography of the backstage "prowlings" of bourgeois gentlemen at the Opéra Garnier made popular by Edgar Degas and Jean-Louis Forain.[46]

In the same year that he produced "Minstrel agaçant une Colombine," Raffaëlli decided to place the minstrel theme in a touristic setting and raise it to the level of high art by way of a modestly sized impressionistic painting called *The Minstrels* (Plate 6, Figure 7.4)—a work that demonstrates the two areas in which the artist would devote most of his energies—the life of the social marginal and the activity of the Parisian boulevards (as manifested here via the enthralled bourgeois onlookers). Stylistically, Raffaëlli's painting is interesting in that it combines a sketchiness and lightness of line associated with aspects of printmaking and popular illustration (both considered as "low" art forms) with the "high" art of Impressionist painting, both mediums

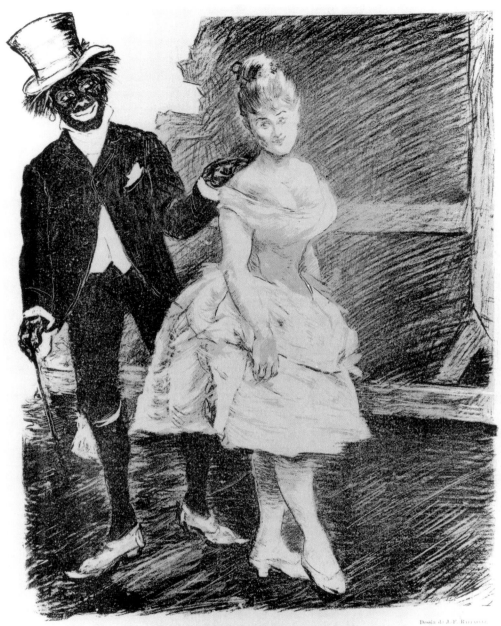

Minstrel agaçant une Colombine dans les coulisses.

7.3 Jean-François Raffaëlli, "Minstrel agaçant une Colombine dans les coulisses," in *Le Courrier Français*, 1887

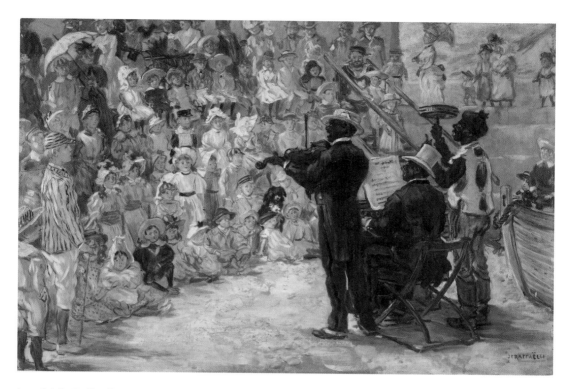

in which Raffaëlli practiced and excelled.[47] As this work and the two prints mentioned previously reveal, Raffaëlli harbored an interest in minstrelsy that grew out of his early experiences in music and theater.[48] From 1876 on, his subject matter included social types such as vagabonds, ragpickers, and working-class folk upon which he devised an entire theory of the common man as symbol of alienated individualism in modern industrial society. Unlike other artists who also focused on such social figures, Raffaëlli was unique among them in that he included blackness as an integral part of his visual repertoire and positivist theory of *caractérisme*, a philosophy of art that advocated the portrayal of human types expressive of what the artist aptly described as the "moral *complexion* of modern life."[49]

7.4 Jean-François Raffaëlli, *The Minstrels*, 1887. Oil on canvas. Philadelphia Museum of Art

Despite his liberal politics and humanitarian concerns over social marginality, Raffaëlli's minstrel imagery, just as had been the case in Britain, contributed to a developing racist ideology in France.[50] However, contrary to widespread assumption, the French did make a distinction between Africans and African-Americans in terms of culture. It was the phenomenon of blackness, or "all that was black," that was homogenized and made undifferentiated. Along with blackness, there was a tendency in France to embrace a totalizing view of non-Europeans (most of whom were considered to be of non- or premodern cultures).[51] This proclivity toward the totalizing of racial and cultural differences was underscored by the reception and exploitation of select stereotypes associated with blacks. The racism that germinated in France by way of the application of

stereotypes varied according to cultural context, conditions, and circumstances. In France, black stereotypes were chosen and exploited in relation to many of those already existing of black Africans. For example, standard stereotypes of blacks that had their origins in the US, such as watermelon-gouging bumpkins, chicken-stealing coons, and razor-toting brutes, did not take hold in France. This may have been due to the fact that such representations were "out of place in a society where difference [was] primarily understood as cultural."[52] Conversely, however, the stereotype of blacks as docile, mischievous, dimwitted, ignorant, infantile, and at times insubordinate, did become recognizable to French audiences due to the familiar depiction of the *bon noir* or *bon nègre* encapsulated in the *bamboula* character.[53] Bamboula was the proverbial black type adapted to a particularly French colonial character. He was always represented as cheerful and clever, and was typically shown wearing striped britches, dancing, smiling, and playing a musical instrument such as the tambourine or banjo (attributes that visually relate him to the minstrel tradition). Unlike the Zip Coon or Sambo figure in American representation, the bamboula type developed out of a French colonial context of distanced exoticism that had little to do with the experience of a visceral fear associated with the brutality of slavery and he was thus not perceived as a threat or transformed into a brute.[54] By the end of the nineteenth century, the bamboula type was used repeatedly by papers that specialized in caricature and satire, such as *Le Rire, Le Journal Amusant, La Caricature, Le Courrier Français, Le Pêle-Mêle, Le Sourire, L'Assiette au Beurre, Le Canard*, and *Le Témoin*. Interestingly, many of these same publications periodically featured images of black and blackface minstrels throughout their pages.

Critical *clownerie*

In addition to its correlation with the *commedia dell'arte* and pantomime, minstrelsy was, when it arrived in France, combined with various aspects of many a circus act. Minstrelsy's impact on *clownerie* was noted in two books on the circus and other popular amusements written by Hugues Le Roux (1860–1925)—*Les jeux du cirque et la vie foraine* (Circus games and the itinerant life) (1889), and *Acrobats and Mountebanks* (1890).[55] In a chapter on clowns in the latter publication, the author observed that

the jester … looked around to see if he could not gather some useful hints … and naturally he studied the colored minstrels. It is impossible to write a serious history of the clown without making some allusion to these Negro performers. The modern clown, acrobat, magician, and mime were produced by the union of the clown and the minstrel.[56]

In an interesting illustration by the artist Jules Arsène Garnier (1847–89) to the opening page of Le Roux's section on clowns in *Le jeux du cirque*, minstrelsy and *clownerie* are indeed visually linked (Figure 7.5). In this image, Tambo and Bones are shown holding the attributes that identify them while seated on

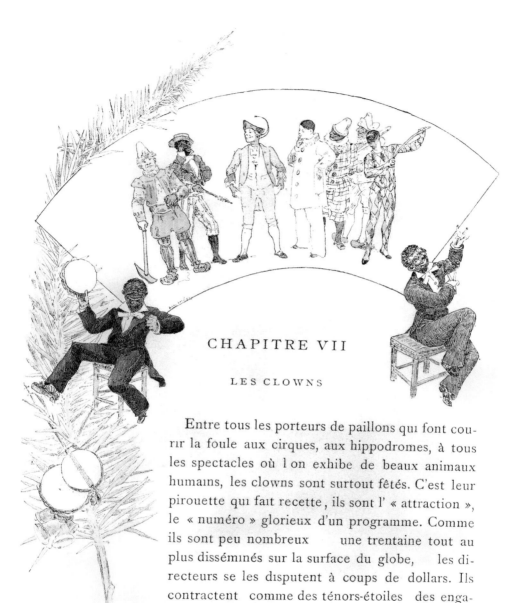

CHAPITRE VII

LES CLOWNS

Entre tous les porteurs de paillons qui font courir la foule aux cirques, aux hippodromes, à tous les spectacles où l on exhibe de beaux animaux humains, les clowns sont surtout fêtés. C'est leur pirouette qui fait recette, ils sont l' « attraction », le « numéro » glorieux d'un programme. Comme ils sont peu nombreux une trentaine tout au plus disséminés sur la surface du globe, les directeurs se les disputent à coups de dollars. Ils contractent comme des ténors-étoiles des engagements à des lustres de distance ils touchent des traitements d ambassadeurs. Et leurs exigences vont croissant avec leur succès. On m'a dit dans les agences que jamais leur cote n'avait été aussi élevée que dans ces dernières années.

7.5 Jules Arsène Garnier, "Les clowns," in Hugues Le Roux, *Le jeux du cirque et la vie foraine* (Paris: E. Plon, Nourrit & Cie, 1889)

either side of a decorated fan shape intended to represent a theatrical stage. The scene is anchored by a decorative branch at the left to which is attached the musical symbols of minstrelsy. On the fan-shaped platform are shown various theatrical personages associated with the European troubadour and circus traditions. Assembled characters from the *commedia dell'arte* and the minstrel show are shown paying homage to Footit and Chocolat—the most famous and successful black-and-white clown duo in nineteenth-century France.[57]

Footit and Chocolat were especially known for their original parodies rich in dialogue, popular pantomimes, and comedic sketches in which both men demonstrated their abilities as accomplished acrobats, horse riders, and mimes.[58] A significant part of their unchanged success as a clown team was due to innovative ways in which they exploited their racial and cultural differences. They were successful at weaving their distinctions of personality, costume, characterization, and skin color into their numerous routines.[59] They conscientiously played off their differences of color and culture and understood the ways in which these could be commodified, manipulated, and exploited performatively. For sure, many of their routines were full of racial, if not racist, clichés.

Their presence before and enthusiastic acceptance by French audiences showed to what extent skin color difference was only "one term in a complex ideology defining belonging and foreignness in France."[60] During their heyday, Footit and Chocolat became such a household name that verbal allusions (articles and poems in particular), toys (children especially adored them), dolls, and other visual references to them abounded in the popular press, especially in advertisements for consumer products such as soap, cameras, coffee, and, of course, chocolate.[61]

The duo demonstrated their comedic talents and their knowledge of the racial and cultural dynamics of minstrelsy in their clowning roles. George Tudor Hall (called George Footit) (1864–1921) was a British equestrian, acrobat, tightrope walker, trapezist, and whiteface clown from Manchester. He became well-schooled in the rudiments of American-style minstrelsy and taught these to Chocolat. Footit wore a baggy outfit and frequently applied white powder and glitter to his face. Chocolat did not have to wear make-up—for his dark and shiny skin contrasted well against Footit's exaggeratedly expressive white-powdered countenance. Chocolat (1868–1917), whose real name was Raphaël Padilla (some accounts erroneously refer to him as Raphaël de Leios), was born the son of a slave in Havana, Cuba. Orphaned at a young age, he was purchased by a merchant from Bilbao. He ran away from that situation and subsequently held a series of odd jobs. Then, at the age of 16, he was paid out as a servant to the family of a professional whiteface clown from England named Tony Greace who groomed Chocolat as his assistant. Under Greace, Chocolat became a famously accomplished acrobat and was known for perfecting an act in which he would ride a bucking mule and inevitably be thrown off of it and out of the circus ring unharmed.[62] Chocolat was the first

truly successful *Auguste*, a type of clown derived from the dimwitted bumpkin type popular in British theater. Although the origins of the *Auguste* remain a topic of debate among clown aficionados, Chocolat's role was that of the idiot whose laughable clumsiness and mischievous behavior were set in contrast with his impeccable clothing as a dandy type. It was not until Chocolat teamed up with Footit in 1886 and perfected the intricacies of minstrelsy, combining these with other forms of *clownerie*, that the two became immensely popular throughout France.

In their numerous comedic acts, Footit always played the haughty, authoritarian, and physically abusive one while Chocolat took on the role of the slow and dimwitted fool who was the inevitable victim of Footit's constant pranks, slaps, kicks, and punches.[63] In 1905, while at the height of the duo's popularity at the Folies-Bergère, the writer Curnonsky (also known as Maurice Edmond Sailland) referred to Chocolat as "Footit's shadow," "the inseparable Chocolat … The public never tires of the clowning of the joyous Negro who is, in his way, also a philosopher … since the most recent invention of philosophy consists of receiving blows without striking back."[64] It was with the catch-phrases "Chocolat, c'est moi" or "Je suis Chocolat!" that Chocolat drew enthusiastic applause from the spectators at the Nouveau Cirque as soon as he entered the ring.[65]

As was the case with the dandified Zip Coon character on the American minstrel stage, Chocolat was noted for his adept use of misnomers, malapropisms, and figures of speech, all the while demonstrating fluency in both French and English but speaking these with a heavy Cuban accent. In 1897, Henry Frichet, who wrote an exposé on the circus and *clownerie* in *La Revue Mame*, devoted coverage to the brilliant comedic abilities of the pair and described Chocolat as using "imaginative" and "picturesque" language, characterizing him as "mischievous, performing ridiculous capers" and an expert at setting himself in "*contorsions simiesques*" (monkey-like contortions).[66] The article contained drawings by the French illustrator and poster artist Henry Gerbault (1863–1930) that illustrated one of the duo's numerous acts in which racial difference, word play (in different languages), and dubious innuendos predominated. In 1900, a colorful print by the writer, caricaturist, and graphic artist André Rouveyre (1879–1962) brought to visual life one of the pair's more popular stunts in which Chocolat is shown skillfully turning a phrase. While in the ring Footit exclaims: "Chocolat, you don't have the appearance of being sick with worry!" Chocolat then replies with a clever play on words: "Oh no, I don't have a care in the world, I don't worry about it" (that is, "I'm not even thinking about you, Footit") ("*je m'enfootit*" as a play on "*je m'en fous*" or "I could not care less about you").

Although the French were, by and large, familiar with minstrelsy by the time Chocolat arrived on the entertainment scene, the public and the critics alike singled him out as a unique performer. By 1895, Chocolat had become legendary and the favorite amuser of the crowds. He performed solo as well as with other famous white clowns such as Kesten, Gugusse, and Medrano.

To a certain extent, his presence and fame on the popular scene represented a change from the version of minstrelsy rooted in American performance and culture. Chocolat was neither French nor American but was, for French audiences, appreciated as representative of a curious hybridity and homogenization of blackness and exotic culture. He was both a comic buffoon and an *exotique*, thus combining the American and French minstrel traditions. In France, his spectacle carried with it a different signification of blackness in relation to other minstrel performers. For the majority of the French public, Chocolat constituted a figure emblematic of racial and cultural alterity, and it was mainly for this reason, in addition to his comedic talents and artistry at *clownerie* and minstrelsy, that he became highly revered.[67] For the theater critic of *Le Courrier Français*, writing under the pseudonym "Le Rideau de Fer," it was Chocolat's astonishing "flabbergasted reactions" and the stupidity of his laughter that made him irresistible. For the critic, Chocolat was "an inimitable clown," but also "a true circus artist."[68] This kind of simultaneous laudatory and denigrating critique regarding the spectacle and talents of Chocolat abounded in the literature of the period and, as will be discussed shortly, can also be detected in images of him by the artist Henri de Toulouse-Lautrec, who was particularly taken with the dynamic clown twosome, illustrating them numerous times in lithographs, drawings, and painted studies. For Lautrec, Footit and Chocolat epitomized the ambivalence of high and low, attraction and repulsion, white and black inherent in the discursive and lived social dynamics of both the stereotype and modern life in France.

The power of testing and teasing at the boundaries of race and modernity through *clownerie* were not lost on Lautrec, who saw in Chocolat especially more than simply an amusing Negro performer. It should come as no surprise that it was in the late nineteenth century that Lautrec, who held a fondness for minstrelsy and the circus as well as a high regard for Degas and Raffaëlli, used the works of both artists as models for many of his own visual musings over blackness and mimicry.[69] One of Lautrec's rarely seen early paintings called *Danseuse dans sa loge* (Dancer in her dressing room) appropriates an iconographical formula for which Degas was known but for which Forain had popularized; the ballerina offstage, in the wings or at her dressing table with a male admirer looking on. In Lautrec's image, the male figure's physiognomy is curiously distorted. Here, the artist clearly follows in the caricatural vein of Raffaëlli in treating the male figure as a minstrel in blackface (a combined racial distortion as well as obfuscation tactic), incongruously sporting the costume of a bourgeois gentleman of leisure and privilege. As with Raffaëlli's "Minstrel agaçant une Colombine," the equivocal play of race and gender here creates a critical ambiguity, forcing us to question whether this is intended as a tribute to or as a satire on Degas's influence and/or a conscious satirical correlation (and thus a modernist critique) among the blackface minstrel, the *flâneur*, and the white woman.[70] Both Raffaëlli's and Lautrec's act of bringing together racial and gender difference in association with minstrelsy, along with hybrid theatrical practices and *flânerie*, play upon the

slippages of those differences and the desire for the transgression of racial and gender boundaries in the modern context. With both artists, it is difficult to determine with certainty if the figures are intended to be black minstrels or whites performing in blackface. In these cases, blackness becomes a floating signifier, a malleable trope that can be exploited as spectacle for multiple purposes such as for stimulating consumerism, as social critique, and/or as racist utterance.

For Lautrec, Chocolat was a marginalized social type who had come to the attention of avant-garde artists in the bohemian subculture of Montmartre, where racial, interracial, and class taboos were often tested and exploited, and where transgressive racialized maneuverings, both blatant and subtle, germinated and flourished. Not surprisingly, it was through the various entertainment venues situated in Montmartre where many Parisians were first introduced to both "authentic" and mimetic forms of racialized theater such as minstrelsy (recall the racial antics of the *Incohérents*). In Montmartre, "low-brow" amusements became magnets for bohemian and avant-garde artists and writers of the time. Circus acts and individual circus performers, such as Footit and Chocolat, constituted a significant symbolic segment of this world.[71]

As already indicated, it was during the 1880s that minstrelsy and the equivocation of blackness grew in popularity among artists and the French public. It should come as no surprise then that Lautrec drifted toward the avant-garde during this very moment. At the same time, he was also establishing his career as an illustrator of popular journals. In fact, as Gale Murray notes, it was the artist's engagement with popular illustration "… [that became] instrumental in his choice of new themes" and their treatment.[72] It is no wonder then that during this period of artistic development Lautrec settled on his preferred subject matter: modern urban entertainments (the ballet, circus, dance hall, and café-concert), and marginal social types such as prostitutes, lesbians, alcoholics, impoverished workers. He came to view the circus as a particularly modern phenomenon, as the ideal space and spectacle of modernity.[73] The circus act was a mixture of skill and studied buffoonery, and the circus environment was one ripe for sensationalized social and artistic experimentation. In this context, Lautrec's near-obsessive fixation on the racial antics of Footit and Chocolat should come as no surprise. For him, the duo constituted the ultimate symbolic embodiment of marginality and/as modernity. Of the pair, it was Chocolat who became the focus of Lautrec's preoccupations.

Lautrec's *Chocolat Dancing at the Irish and American Bar* (Figure 7.6) is a drawing featuring Chocolat that was later reproduced in *Le Rire*—the most successful of the late nineteenth-century *journaux humoristiques*—to accompany a popular song called "Serenade of the Street" (La sérénade du pavé). The upscale Irish and American Bar, located on the right bank in Paris, was notorious for its ragtag clientele. Amidst the smoky interior one could encounter people from all walks of life and from all social classes. It has been

7.6 Henri de Toulouse-Lautrec, *Chocolat Dancing at the Irish and American Bar*, 1896. Toulouse-Lautrec Museum, Albi, France. Photo: Alfredo Dagli Orti / The Art Archive at Art Resource, NY

described as "a place where truly hardened drinkers would silently sit lost in contemplation of the bottles."[74] Lautrec, himself a regular, "was frequently the last client to leave the bar when closing-time came." In this establishment, all present would dance and sing "to the sound of a banjo and mandolin, played by an Englishwoman and her son, whose father had been a Texan mulatto."[75] The bartender at the left of Lautrec's image is identified as Randolph (known as Ralph), a man of mixed racial background (Chinese and Native American), born in San Francisco, and who had garnered a reputation among habitual clients of the establishment for mixing elaborate alcoholic concoctions. The hybridity or "*métissage*" of such company and such acts speaks to the combined fluidity and critique of racial, cultural, and class boundaries so typical of the period and so dear to Lautrec's sensibilities as a modern artist.

In Lautrec's image, Chocolat is shown dancing after one of his performances at the Nouveau Cirque. As was the case in some of the criticism of the period (we are reminded of Le Rideau de Fer, for example), Chocolat is here delineated with combined disdain and admiration, ridicule and wonder. The image pays homage and tribute to his elegant "rubber-legged" finesse, his litheness, agility, and muscular development while simultaneously caricaturing him— rendering him in a prognathic simianesque profile—perhaps as an intentional play on Chocolat's speciality known as the "*saut de singe*" or monkey-jump, an acrobatic move for which he became renowned.

Again, as Rae Beth Gordon has suggested in the context of minstrelsy, Chocolat's unprecedented popularity rested on the ways he moved that, for the French public, recalled "the loose-limbed walk" and "cadenced limping" of the African along with incredible changes in physiognomy.[76] This characterization was held firmly in tandem with and operated to underscore the Darwinian-inflected simianization of black people prevalent in popular culture throughout the nineteenth century. Indeed, as the American philosopher Noël Carroll has observed, "[s]imianization can be orchestrated for horrific as well as comic effect."[77] As such, it is a process that is closely likened to the uncanny simultaneity of negrophobia *and* negrophilia and one that, as we have seen, was already prevalent in Raffaëlli's *The English Minstrels* and in Vaucaire's account of minstrel performers at the Parisian cafés-concerts. Indeed, as a visualized racial joke and exemplar of *fumisme, Chocolat Dancing* relies on the metonymic nature of minstrel performance and the stereotype that plays upon the slippages of difference and desire, fear and fascination, horror and amusement. This was the relationship with black people to which French audiences of the *fin de siècle* had not only grown accustomed, but had expected.

During his time, Chocolat was one of the most famous artists to whom all of France came to applaud. In 1907, Jules Claretie, writer and director of the Théâtre Français, wrote the following praiseworthy declaration:

Chocolat triumphs. We go to see Chocolat. We give Chocolat special roles. *La Noce de Chocolat* is as famous today as are the excellent blunders of Janot

of the eighteenth century. There are no good evenings without Chocolat.
For the thrilled Parisian youngsters, Chocolat's entrances have the value of the
appearance of Caruso in *La Bohème*. Chocolat is king. Chocolat is the master.
Long live Chocolat![78]

Although laudatory, Claretie's proclamation is interestingly paradoxical.
Chocolat was a comic genius but was also the purveyor of popular negative
stereotypes about blacks. He was king, but one made to appear ridiculous.
He was a master in the art of laughter, but was also a sad puppet of Footit.
Chocolat's success was largely dependent on his skin color and on his
reputation as the contemporary *folie nègre* associated with minstrelsy, the
cakewalk, jazz, banjos, and tap dancing. He was successful because his
buffooneries were combined with the spectacle of his complexion and with
the more familiar and expected specialties associated with the *Auguste* clown
type.[79] In the French public imagination, Chocolat was both a *nègre* and a
clown all at once. The image of the *Auguste* and that of the black man was
very similar in that, through the former, the latter could be perceived easily
as an idiot, naïve, childlike, passive with bouts of benign savagery thrown in
for good measure. Thus, Chocolat represented the clichés of both the *Auguste*
clown and the black man; he was a comic and tragic figure of alterity all rolled
into one.[80] In France, he was the ultimate Pierrot Lunaire. As a person and as a
representation, Chocolat was symbolic of the ambiguities of race and national/
cultural identity in the French imagination during the Third Republic. Despite
his partnership with Footit, who never had to bear the racial burden of his
sidekick, Chocolat suffered from a "crushing objecthood," pegged as eternally
exotic and other, forever locked into association with "servants, slaves, and
other subalterns."[81]

Chocolat and the afterlife of blackness

Footit and Chocolat worked together as a team until 1910, the year when
Parisian audiences became bored with and less enamored of their antics. After
the duo split up, each attempted a solo career, but was unsuccessful. Both men
eventually fell into obscurity and remain virtually unknown to most French
people today. However, Footit, who died in 1921, still enjoys a modicum of
notoriety in the history of the circus and has been immortalized in French
historical memory as a result of his interment at Père Lachaise Cemetery in
Paris. Chocolat, on the other hand, succumbed to alcoholism and died in
poverty and anonymity in Bordeaux in November 1917, where he was buried
in a pauper's grave in a Protestant cemetery.[82]

Despite their decline in popularity in the early twentieth century, the
"afterlife" of Footit and Chocolat is significant. Not only were the pair
painted, drawn, and studied numerous times by artists of renown such as
Lautrec, they were also filmed by the Lumière brothers (*Chaise à bascule*, 1899)
and celebrated by the author Colette in *Gigi* (1944). As well, it is believed

that Chocolat may have served as the model for the slave Lucky in Samuel Beckett's *Waiting for Godot* (1948). The poet and filmmaker Jean Cocteau became so enamored with Footit and Chocolat that he devoted pages of his memoir to recounting the various acts he saw the twosome perform when he was a child.[83] Likewise in his poetry, Cocteau found profound meaning in the relationship of what he called "eternal humiliation" between the white clown and the black *Auguste*. Chocolat appeared, if for only a fleeting instant, as the character *Le Chocolat*, played by the African-American actor Deobia Oparei, in the 2001 film *Moulin Rouge* directed by Baz Luhrmann. As late as 2009, the noted French historian Gérard Noiriel had the black clown well in mind when he mounted a theatrical play, titled *Chocolat*, that grappled with the timely subject of immigration and racism in contemporary France.

During their heyday, the immense popularity that Footit and Chocolat enjoyed underscored the sheer complexity of and fascination with the conundrum of blackness as spectacle in late nineteenth-century France. Between 1886 and 1910, the duo charmed French audiences of all classes with their antics—foregrounding the spectacle of blackness as part and parcel of modern experience while also helping to define and solidify French identity itself through a persistent and insistent visual and performative demarcation of racial and cultural alterity. Footit and Chocolat remain important because as clowns they were not merely clowning around but were conscientiously exploiting and deconstructing cultural and racial differences with highly nuanced skill. To a large extent they brought full circle what the minstrel show had left unfinished. That is to say, the exotic and distinctly American nature of blackface minstrelsy not only allowed for its facile commodification in France, but it also fostered a cross-cultural fertilization of blackness as a cultural trope. As a British-trained, Afro-Cuban, and *Auguste* clown schooled in the intricacies of American-style minstrelsy, and considered a consummate artist by both the French public and those of the artistic avant-garde, Chocolat exemplified a meaningful racial and cultural pollination across cultures, languages, and races.

Conclusion

On stage, in the audiences and on the streets, American-style minstrel conventions and other forms of racial antics provided the discursive grist and the performative substance for fashioning and expressing a search for French identity and concerns in the national and cultural uncertainties and destabilizations that characterized the Third Republic.[84] Visualized racial antics provided the French with the means for displacing anxieties over difference while creating a culturally and racially distinct identity for themselves. The spectacle of blackness exemplified by the cross-cultural transplantation of minstrelsy from the US into Britain, and then into France, constitutes one of many significant examples of the intricate ways in which

racial and cultural otherness was integrated and excluded all at the same time as part of modernity's complications and the striving by France for a distinct national culture that its subaltern actors helped to construct and define. Minstrelsy's association with and incorporation into the French Republic, and yet its simultaneous separation from it, was predicated on the cultural absorption of blackness as alterity and the employment of visual strategies for setting the racial and cultural other as apart and distinct from what was deemed uniquely French. It is in this light that this study has considered blackness as a simultaneously marked and unmarked modernist signifier of "contradiction, fragmentation, and ambivalence" used as viable strategy by an array of French artists and their eager public to affirm difference as a way of defining the national and cultural self.[85] It is my hope that this study's perspective on the visual and conceptual strategies of racialized play by French artists in the late nineteenth century will add to future explorations and critical interrogations of France's cultural and art-historical *pas de deux* with blackness that is part and parcel of a process of forging and claiming a stake in the modern world.[86]

Notes

1 On the Chat Noir, see Mariel Oberthür, *Le Chat Noir, 1881–1897* (Paris: Réunion des Musées Nationaux, 1992).

2 Quoted in Phillip Dennis Cate and Patricia Eckert Boyer, *The Circle of Toulouse-Lautrec: An Exhibition of the Work of the Artist and of His Close Associates* (New Brunswick, NJ: Jane Voorhees Zimmerli Art Museum, 1986), 153–4.

3 The Latin word for "obfuscate" (*obfuscare*), which means "darkened" or "to darken," is particularly appropriate as a term in the context of minstrelsy and other racial antics discussed in this chapter.

4 Laurent Dubois, "Republican Anti-Racism and Racism: A Caribbean Genealogy," in Herrick Chapman and Laura L. Frader, eds., *Race in France: Interdisciplinary Perspectives on the Politics of Difference* (New York and Oxford: Berghahn Books, 2004), 24.

5 Herrick Chapman and Laura L. Frader, "Introduction," in *Race in France*, 1–19, at 8.

6 Dubois, "Republican Anti-Racism," 33.

7 Lisa Simeone, "Dangerous Classes, Races and Sex": Modeling Equality and Protecting the French Motherland during the Second Half of the Nineteenth Century" (unpublished paper, February 23, 2006), 1–21, at 1. Accessed at http://humanrights.uchicago.edu/workshoppapers/simeone.pdf.), 2.

8 See Benedict Anderson, *Imagined Communities* (New York: Verso, 1983), 146; Leora Auslander and Thomas C. Holt, "Sambo in Paris: Race and Racism in the Iconography of the Everyday," in Sue Peabody and Tyler Stovall, eds., *The Color of Liberty: Histories of Race in France* (Durham, NC: Duke University Press, 2003), 167; Simeone, "Dangerous Classes," 3.

9 My emphasis. Quoted from Dana S. Hale, "French Images of Race on Product Trademarks During the Third Republic," in Peabody and Stovall, *Color of Liberty*, 131, 145 n. 1.

10 Auslander and Holt, "Sambo in Paris," 167.

11 Ibid., 159.

12 On the art and history of the *Incohérents*, see Catherine Charpin, *Les arts Incohérents (1882–1893)* (Paris: Editions Syros Alternatives, 1990). For a more theoretical perspective, see Jorgelina Orfila, "Blague, Nationalism, and Incohérence," in June Hargrove and Neill McWilliam, eds., *Nationalism and French Visual Culture, 1870–1914* (Washington, DC: National Gallery of Art, 2005), 173–93. Unfortunately, neither study investigates, or even mentions in passing, the volatile potential of racial alterity in the construction of French nationalism and avant-gardism.

13 François Caradec, "Préface: Le Big Bang de la modernité," in Charpin, *Les arts Incohérents*, 7.

14 See the preface to Alphonse Allais, *Album primo-avrilesque* (Paris: Ollendorf, 1897).

15 I use the terms "bohemian" and "avant-garde" interchangeably here, even though there are nuances of differences between them. On the distinction, see Mike Sell, "Bohemianism, the Cultural Turn of the Avantgarde, and Forgetting the Roma," in *TDR: The Drama Review* 52, no. 2 (T194) (Summer 2007): 41–59; César Graña, *Bohemian versus Bourgeois: French Society and the French Man of Letters in the Nineteenth Century* (New York: Basic Books, 1964), 74.

16 My emphasis. Quoted from Emile Goudeau's 1888 memoir *Dix ans de Bohème*, cited in Daniel Grojnowski, "Hydropathes and Company," in Phillip Dennis Cate and Mary Shaw, eds., *The Spirit of Montmartre: Cabarets, Humor, and the Avant-Garde, 1875–1905* (New Brunswick, NJ: Jane Voorhees Zimmerli Art Museum, 1996), 104. *Fumisme* initially began as a theory of discourse and literary practice in late nineteenth-century France. See Charles-Etienne Tremblay, "Emergence du fumisme dans la production d'un nouvel esprit littéraire" (PhD diss., Université de Montréal, 2010).

17 Quoted in Maurice Vaucaire, *Paris Illustré* 50 (1 August 1886): 131–2.

18 Raffaëlli's print is from *Le Courrier Français*, December 26, 1886, no. 52. Many British minstrels adopted and adapted such songs as "Camptown Races," "The Old Folks at Home," "My Old Kentucky Home," and "Jeanie with the Light Brown Hair" by Stephen Foster for a Victorian public. It is unclear how familiar the French were with these songs. See Michael Pickering, *Blackface Minstrelsy in Britain* (Burlington, VT: Ashgate, 2008), 60.

19 Roger D. Abrahams, *Singing the Master: The Emergence of African American Culture in the Plantation South* (New York: Pantheon Books, 1992), 134.

20 Rae Beth Gordon, *Dances with Darwin, 1875–1910: Vernacular Modernity in France* (Farnham (UK) and Burlington, VT: Ashgate, 2009), 150; Nicolas Bancel et al. *Zoos humains. Au temps des exhibitions humaines* (Paris: La Découverte, 2002); Pascal Blanchard et al., *Human Zoos: Science and Spectacle in the Age of Colonial Empires* (Liverpool: Liverpool University Press, 2008).

21 For an in-depth discussion of the cakewalk and its cultural impact in France, see Jody Blake, *Le Tumulte Noir: Modernist Art and Popular Entertainment in Jazz-Age Paris, 1900–1930* (University Park, PA: Pennsylvania State University Press, 1999), 15–23. Also see Brooke Baldwin, "The Cakewalk: A Study in Stereotype and Reality," *Journal of Social History* 15 (Winter 1981): 205–18.

22 Maxime Vauvert, "Les Bouffes Américains," *Le Monde Illustré* (March 5, 1859), 150.

23 Quoted in John Blair, "Blackface Minstrels in Cross-Cultural Perspective," *American Studies International* 28, no. 2 (1990): 52–65, at 65 n. 29.

24 Abrahams, *Singing the Master*, 133.

25 Between 1886 and 1891, foreigners accounted for nearly 80 percent of the French population. See O. Rabut, "Les étrangers en France," *Population* 28 (1974): 147–60; also see Gérard Noiriel, *Le creuset français: Histoire de l'immigration, XIX–XX siècles* (Paris: Seuil, 1988).

26 See Raoul Girardet, *Le nationalisme français: Anthologie 1871–1914* (Paris: Editions du Seuil, 1983), esp. 85–96.

27 Gordon, *Dances with Darwin*, 165.

28 Hale, "French Images of Race," 131. See William H. Schneider, *An Empire for the Masses: The French Popular Image of Africa, 1870–1900* (Westport, CT: Greenwood, 1982); Raymond Bacholet et al., *Négripub: L'image des noirs dans la publicité depuis un siècle* (Paris: Somogy, 1992).

29 On the history of the poster and late nineteenth-century French debates about its status as art, see Marcus Verhagen, "The Poster in Fin-de-Siècle Paris: 'That Mobile and Degenerate Art,'" in Leo Charney and Vanessa R. Schwartz, eds., *Cinema and the Invention of Modern Life* (Berkeley: University of California Press, 1995), 103–29.

30 Georges d'Avenel, "La publicité," in *Le Mécanisme de la vie moderne* (Paris, 1902), 125–7, 175–8, 211.

31 See Bacholet et al., *Négripub*, 37.

32 Sylvie Chalaye, *Du Noir au Nègre: L'image du Noir au théâtre de Marguerite de Navarre à Jean Genet (1550–1960)* (Paris: Editions L'Harmattan, 1998), 319. In a footnote, the author indicates that "Jim Crow first arrived in Europe in 1841 via a show called *Le Nègre de New York.*" In Paris, this show was not successful. Chalaye illustrates this with an image of the Boston Minstrels that is titled *The Celebrated Ethiopian Melodies* and dated 1843. This provides further evidence that the French were introduced to blackface minstrelsy as early as the 1840s, but to virtually no public or critical interest. See Chalaye, *Du Noir au Nègre*, 319 n. 1.

33 On the poster as pervasive medium signaling modernity, see Vanessa R. Schwartz, *Spectacular Realities: Early Mass Culture in Fin-de-Siècle Paris* (Berkeley: University of California Press, 1999); Verhagen, "Poster."

34 Auslander and Holt, "Sambo in Paris," 151–2.

35 Homi K. Bhabha, "The Other Question," *Screen* 24, no. 6 (November–December 1983): 18–19.

36 Ibid., 18.

37 Bhabha, "Of Mimicry and Man: The Ambivalence of Colonial Discourse," *October* 28 (Spring 1984): 130.

38 Pickering, *Blackface Minstrelsy*, 120–21.

39 Gordon, *Dances with Darwin*, 146. On metonomy and mimicry, see Bhabha, "Mimicry and Man," 130; Auslander and Holt, "Sambo in Paris," 163.

40 Auslander and Holt, "Sambo in Paris," 163; Michael Taussig, *Mimesis and Alterity: A Particular History of the Senses* (New York: Routledge, 1993), 20–21.

41 Gordon, *Dances with Darwin*, 172.

42 See "Actualité française étrangère artistique et littéraire illustrée," *Courrier des Théâtres*, June 11, 1887, 3.

43 Gordon, *Dances with Darwin*, 146. On the "human zoos" at the colonial and international exhibitions in Europe and North America in the nineteenth and twentieth centuries, see Bancel et al., *Zoos humains*; and Blanchard et al., *Human Zoos*.

44 Gordon, *Dances with Darwin*, 146. Indeed, this "new popular aesthetic" would soon evolve into the vogue for primitivism in France. Also see Blake, *Le Tumulte Noir*.

45 On the history of the Commedia dell'Arte, see Martin Green and John Swan, *The Triumph of Pierrot: The Commedia dell'Arte and the Modern Imagination* (University Park, PA: Pennsylvania State University Press, 1993); Lynne Lawner, *Harlequin on the Moon: Commedia dell'Arte and the Visual Arts* (New York: Harry N. Abrams, 1998); R.J. Broadbent, *A History of Pantomime* (New York: B. Blom, 1964); Marcus Verhagen, "Refigurations of Carnival: The Comic Performer in Fin-de-Siècle Parisian Art" (PhD diss. University of California, Berkeley, 1994).

46 On the relationship between the dandified minstrel and the *flâneur*, see my essay "Race as Spectacle in Late Nineteenth-Century French Art and Popular Culture," *French Historical Studies* 26, no. 2 (Spring 2003): 351–82. The black dandy is, of course, an urban type found in American minstrelsy and is exemplified by the character of Zip Coon. The black dandy type became known in France by way of advertisements, postcards, and illustrations in the popular press. See Bacholet et al., *Négripub*.

47 Raffaëlli, who lived in Montmartre, was introduced to the circle of Impressionists in 1877 at the brasserie Nouvelle Athènes at Place Pigalle in Paris. As a result of his interest in physiognomic studies and truthful gestures, he became close friends with Edgar Degas who, in turn, invited Raffaëlli to exhibit in the 1880 and 1881 Impressionist exhibitions against fierce opposition from other Impressionists, most notably from Claude Monet.

48 On Raffaëlli's biography, see Arsène Alexandre, *Jean-François Raffaëlli: Peintre, graveur et sculpteur* (Paris: H. Floury, 1909); Marianne Delafond and Caroline Genet-Bondeville, *Jean-François Raffaëlli* (Paris: Musée Marmottan, 1999); Barbara Schinma Fields, "Jean-François Raffaëlli (1850–1924): The Naturalist Artist" (PhD diss. Columbia University, 1979). Also see G. Coquiot, "Jean-François Raffaëlli," *Gazette des beaux-arts* 5 (1911), pt. 1: 53–68, pt. 2, 136–48; J. Isaacson, *The Crisis of Impressionism, 1878–1882* (University of Michigan Museum of Art, Ann Arbor, 1979), 41–2, 161–2; A. de Lostalot, "Oeuvres de J.-F. Raffaëlli," *Gazette des beaux-arts* 29 (1884): 334–42. None of these sources discuss Raffaëlli's scenes of minstrelsy.

49 My emphasis. See Gale B. Murray, *Toulouse-Lautrec: The Formative Years, 1878–1891* (Oxford: Clarendon Press, 1991), 159. On Raffaëlli's connection to the positivist philosophy of Hippolyte-Adolphe Taine, see Fields, "Jean-François Raffaëlli."

50 Compared to the paucity of information on the reception and development of minstrelsy in France, the literature on minstrelsy in Britain is rather substantial. See Michael Pickering, *Blackface Minstrelsy in Britain* (Burlington, VT: Ashgate, 2008); Blair, "Blackface Minstrels" ; Sarah Meer, *Uncle Tom Mania: Slavery, Minstrelsy and Transatlantic Culture in the 1850s* (Athens, GA and London: University of Georgia Press, 2005); J.S. Bratton, "English Ethiopians: British Audiences and Black-Face Acts, 1835–65," *Yearbook of English Studies* 2 (1981):

126–42; Barry Anthony, "Early Nigger Minstrel Acts in Britain," *Music Hall* 12 (1980): 118–123; Dale Cockrell, *Demons of Disorder: Early Blackface Minstrels and Their World* (Cambridge: Cambridge University Press, 1997); Michael Pickering, "Mock Blacks and Racial Mockery: The 'Nigger' Minstrel and British Imperialism," in J.S. Bratton, ed., *Acts of Supremacy: The British Empire and the Stage, 1790–1930* (Manchester: Manchester University Press, 1991), 179–236; Michael Pickering, "White Skin, Black Masks: 'Nigger' Minstrelsy in Victorian England," in J.S. Bratton, ed. *Music Hall Performance and Style* (Milton Keynes: Open University Press, 1986), 70–91.

51 David Beriss, "Culture-as-Race or Culture-as-Culture: Caribbean Ethnicity and the Ambiguity of Cultural Identity in French Society," in Herrick Chapman and Laura L. Frader, eds., *Race in France: Interdisciplinary Perspectives on the Politics of Difference* (New York: Berghahn Books, 2004), 126–27. The art historian Jody Blake has posited a different view, claiming that the "willingness to gloss over the cultural distinctions between Africans and African Americans attests to the hold that the intellectual construction or fiction of 'Africa' exerted over Europeans in the modern period." See Blake, *Le Tumulte Noir*, 19.

52 Beriss, "Culture-as-Race," 126.

53 Hale, "French Images of Race," 139. Originally, the term "bamboula" referred to a type of hand-held drum played at an African circle dance, transported to and common in the Caribbean. Today, the term is derogatory in colloquial language and signifies uninhibited partying (*faire la bamboula*). See Jan Nederveen Pieterse, *White on Black: Images of Africa and Blacks in Western Popular Culture* (New Haven: Yale University Press, 1995), 161.

54 For historical and ideological studies of the Zip Coon and Sambo figures in American minstrelsy, see Joseph Boskin, *Sambo: Rise and Demise of an American Jester* (New York: Oxford University Press, 1986); Robert C. Toll, *Blacking Up: The Minstrel Show in Nineteenth-Century America* (New York: Oxford University Press, 1974); Annemarie Bean, James V. Hatch, and Brooks McNamara, eds., *Inside the Minstrel Mask: Readings in Nineteenth-Century Blackface Minstrelsy* (Hanover, NH: Wesleyan University Press, 1996).

55 Hugues Le Roux, *Les jeux du cirque et la vie foraine* (Paris: E. Plon, Nourrit, 1889); Hugues Le Roux, *Acrobats and Mountebanks* (London: Chapman and Hall, 1890).

56 Le Roux, *Acrobats and Mountebanks*, 280.

57 Our knowledge of Footit and Chocolat comes to us from the only authoritative book on the duo called *Les mémoires de Footit et Chocolat* (Paris: Pierre Laffitte, 1907), written by Maurice Etienne Legrand (1872–1934), called Franc-Nohain.

58 Throughout his career, Chocolat appeared in such popular pantomimes as "le téléphone perfectionné," "le policeman," "la bonne d'enfant," "la couveuse artificielle," and "la noce à Chocolat." Some of these were illustrated in *Le Courrier Français*. See Denys Amiel, *Les spectacles: A travers les ages* (Paris: Editions du Cygne, 1931), 231.

59 Nathalie Coutelet, "Chocolat, une figure de l'altérité sur la piste," *Les cahiers de l'idiotie (Le clown: Une utopie pour notre temps)*, no. 3 (2010): 101.

60 Beriss, "Culture-as-Race," 124.

61 See Bacholet et al., *Négripub*.

62 In the late 1890s, Toulouse-Lautrec famously illustrated this routine. See Henri de Toulouse-Lautrec, *Personnage à cheval*, Bibliothèque nationale de France, Banque d'images (NB-C-172836).

63 Footit and Chocolat became known for perfecting what is known as the *"comédie des claques"* (slapstick) at the Nouveau Cirque. This form of entertainment became extremely popular throughout much of France and was performed in a variety of entertainment venues.

64 Curnonsky, "Numéros de cirque," *Paris qui chante* (December 10, 1905), 7; Gordon, *Dances with Darwin*, 160.

65 "Etre Chocolat" became a French colloquial expression in the late 1890s and is attributed to Chocolat. The expression refers to being gullible, naïve, or an easy victim. "Je suis Chocolat" became a vernacular expression signaling frustration and disappointment at being duped or fooled (*je suis berné*)—"je suis chocolat." The Nouveau Cirque was a modern permanent structure built in 1886 by Joseph Oller on the rue Saint-Honoré. It was the first circus in Paris to have a large pool of water in its center to accommodate spectacular aquatic performances.

66 Henry Frichet, "Le cirque et les forains," *La Revue Mame* (July 18, 1897), 1500–1503.

67 Coutelet, "Chocolat," 98.

68 See Le Rideau de Fer, "Nouveau Cirque," *Le Courrier Français* (December 8, 1895), 4; Gordon, *Dances with Darwin*, 160.

69 Murray, *Toulouse-Lautrec*, 159.

70 On the racial and racist dimensions of Degas's work, see Marilyn R. Brown, "Miss Lala's Teeth: Reflections on Degas and 'Race,'" in *Art Bulletin* 89, no. 4 (December 2007): 738–65; Christopher Benfey, *Degas in New Orleans: Encounters in the Creole World of Kate Chopin and George Washington Cable* (Berkeley: University of California Press, 1997); and Smalls, "'Race' as Spectacle."

71 See Noëlle Giret, ed., *Les arts du cirque aux XIXème siècle* (Paris: Anthèse, 2001); Pascal Jacob, *Le Cirque. Du théâtre équestre aux arts de la piste* (Paris: Larousse, 2002).

72 Murray, *Toulouse-Lautrec*, 82.

73 Toulouse-Lautrec's attraction to the circus had been whetted during his childhood. It was through his friend, René Princeteau, that the artist was introduced "to the world of acrobats and clowns, jugglers and trained animals." See Gerstle Mack, *Toulouse-Lautrec* (New York: Alfred A. Knopf, 1953), 215.

74 Philippe Huisman and M.G. Dortu, *Lautrec par Lautrec* (Paris: Edita Lausanne, La Bibliothèque des Arts, 1964), 190.

75 Ibid., 193–4.

76 Gordon, *Dances with Darwin*, 153; see E.P., "Chez l'Almamy Samory," *La Revue Illustrée* 2 (1886): 684.

77 Noël Carroll, "Ethnicity, Race, and Monstrosity: The Rhetorics of Horror and Humor," in Peg Zeglin Brand, ed., *Beauty Matters* (Bloomington and Indianapolis: Indiana University Press, 2000), 46.

78 Jules Claretie, *La vie à Paris* (Paris: Bibliothèque Charpentier, 1907); quoted in Coutelet, "Chocolat," 112. The French text reads: "Chocolat triomphe. On va voir Chocolat. On fait à Chocolat des rôles spéciaux, *La Noce de Chocolat* est aussi célèbre aujourd'hui que les bêtises fameuses de Janot au XVIIIème siècle. Pas de bonne soirée sans Chocolat. L'entrée de Chocolat, pour les gamins parisiens emballés, a la valeur de l'apparition de Caruso dans *La Bohème*, en Amérique. Chocolat est roi. Chocolat est maître. Vive Chocolat!"

79 Coutelet, "Chocolat," 112.

80 Ibid., 113.

81 Ibid. "Crushing objecthood" is a psychoanalytic term borrowed from the black psychiatrist from Martinique, Frantz Fanon, and refers to a predicament of postcolonial black ontology and lack of agency. See Frantz Fanon, *Black Skin, White Masks* (New York: Grove Press, 1967), 109–40.

82 The majority of the scarce accounts of Chocolat's life indicate that he died in 1917. On Chocolat's interment, see Boris Thiolay, "L'amer destin du clown Chocolat," at www.lexpress.fr/actualite/societe/l-amer-destin-du-clown-chocolat 760572.html (last accessed July 6, 2009). Also see Philippe Landru, "Chocolat (Raphaël Padilla: 1868–1917)," at www.landrucimetieres.fr/spip/spip.php?article2598 (last accessed July 17, 2010).

83 Jean Cocteau, *Portrait-Souvenirs, 1900–1914* (Paris: Editions Grasset, 1935), 67–75. On page 69, Cocteau includes a quick outline sketch of Footit and Chocolat in the circus ring performing one of their pranks.

84 Auslander and Holt, "Sambo in Paris," 161.

85 Ibid., 159.

86 As the historian Eric Bleich has pointed out, "France's historical *pas de deux* with race has yet to be fully explored." See Erik Bleich, "Anti-Racism Without Races: Politics and Policy in a 'Color-Blind' State," in Herrick Chapman and Laura L. Frader, eds., *Race in France: Interdisciplinary Perspectives on the Politics of Difference* (New York and Oxford: Berghahn Books, 2004), 167.

Staging ethnicity: Edvard Munch's images of Sultan Abdul Karim

Alison W. Chang

The rise of the ethnographic exhibition in the late nineteenth century created a new form of spectacular entertainment in *fin-de-siècle* Europe and America. As an integral part of World's Fairs and traveling circuses, these exhibitions provided European audiences the opportunity to view people from faraway cultures. In these displays, exhibition participants donned native costumes, sang songs, and performed dances, all in a display that was a re-creation of their homeland. These exhibitions created a full-scale fantasy, an immersive entertainment that surrounded the spectator with the paraphernalia of another culture—its people, its objects, its traditions, and its architecture—creating a panoply of sensory delights and transporting the viewer to another part of the world, all without having to leave one's own country. For many, this was their first encounter with people of other races and ethnicities, and these exhibitions were instrumental in shaping and reinforcing the perception of foreign cultures in European minds. Despite the show organizers' claims at authenticity, these exhibitions were highly staged. From the clothing to the participants' surroundings, each aspect of the ethnographic exhibition was carefully selected and choreographed.

Circus Hagenbeck, which traveled throughout Europe, was one of the première presenters of ethnographic exhibitions, and the troupe made its way to Oslo in November 1916. The Norwegian painter Edvard Munch and his cousin, Ludwig Ravensberg, attended the circus to sketch, and it was there, according to Ravensberg, that Munch had met and "hired a fine and attractive negro, Sultan Abdul Karim, as a servant, driver, and model."[1] Although Munch had hired models steadily since the turn of the century, this was his only attempt at depicting a person of African origin. These images remain under-examined, overshadowed in the critical literature by his 1890s Symbolist imagery. Munch executed seven canvases and one lithograph featuring Karim.[2] The largest and best known is *Cleopatra and the Slave* (Plate 7a, Figure 8.1; Plate 7b, Figure 8.2), a large-scale work depicting a clothed, light-skinned woman lounging on a bed and a nude African man standing alongside it.

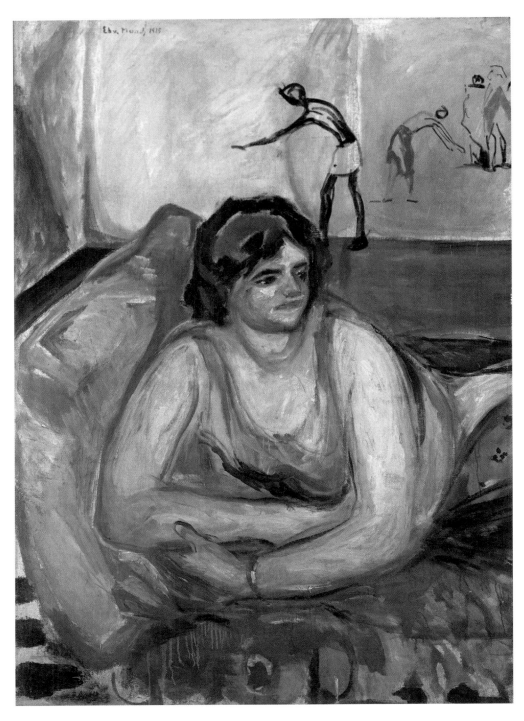

8.1 Edvard Munch, *Cleopatra*, 1916. Oil on canvas. Munch Museum, Oslo MM M 307 (Woll M 1218).
© 2014 The Munch Museum / The Munch-Ellingsen Group / Artists Rights Society (ARS), NY

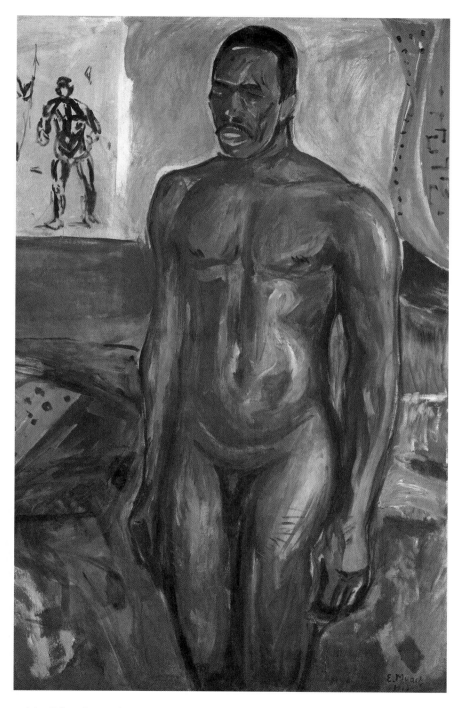

8.2 Edvard Munch, *Standing Naked African*, 1916. Oil on canvas. Munch Museum,
Oslo (Stenersen Collection), RES A 8 (Woll M 1219). © 2014 The Munch Museum
/ The Munch-Ellingsen Group / Artists Rights Society (ARS), NY

A bed, covered in multiple layers of boldly colored cloth, stretches horizontally across the front of the picture plane. Cleopatra lounges on the bed, and she, too, is swathed in layers of heavily patterned green and blue fabrics. In depicting the bedroom with richly colored decorations, Munch portrays Cleopatra and her slave in a generic "exotic" interior. Standing near the foot of the bed is a nude African man, whose unnaturally rigid posture is only heightened by the contrast between his pose and that of Cleopatra. Munch models the contours of his musculature in cool blues and greens, as well as touches of white and magenta. In the background of the composition, Munch has rendered, in sketchy black brushstrokes, approximately five figures wearing only loincloths. One of these figures appears to be inside the bedroom with Cleopatra and her slave, but Munch places the remainder outside, visible through a doorway at the back of the bedroom. At least two of these figures are dark-skinned; Munch realizes the figure inside the room and another who approaches the doorway holding a spear almost entirely in black paint, while the rest are merely outlined. The painting was inexplicably split in half within a few years of its completion, dividing the woman from the man. At first glance, *Cleopatra and the Slave* is a scene of the famed Egyptian queen and an African slave, evoking allusions both to French nineteenth-century Orientalist painting and contemporary political unrest in colonial Africa.[3]

During the same year in which Munch produced *Cleopatra and the Slave*, he also painted several images of Karim dressed in modern Western clothing, including three half-length portraits. In creating such wide-ranging depictions of Karim, Munch went beyond presenting his model in the guise of the exotic "other." Munch's paintings of Karim are ambivalent in their endorsement and rejection of colonialist stereotypes of Africans. Each composition presents an amalgamation of varying sources and references, responding to historical events, artistic tendencies, literature, and other works in the artist's own œuvre. Rather than voicing a single, straightforward message, Munch's images of Karim present conflicting points of view. The compositional structure of *Cleopatra and the Slave* evokes the orchestrated nature of interracial interactions at ethnographic exhibitions, and was made more apparent when Munch showed both *Cleopatra and the Slave* and one version of *African with a Green Scarf* (Figure 8.3) in 1918 and 1921 exhibitions at Blomqvist, the most prominent gallery in Oslo. Neither condemning nor endorsing a single perspective, Munch capitalizes on the tension inherent in these images, accentuating the mutability of identity and the staged nature of encounters with other races in this period.

The 1914 *Jubileumutstilling*

The long-standing Western stereotype of the "uncivilized" African was well engrained in the Norwegian psyche by the time *Cleopatra and the Slave* was first exhibited in 1918. The Congo display at the 1914 *Jubileumutstilling*,

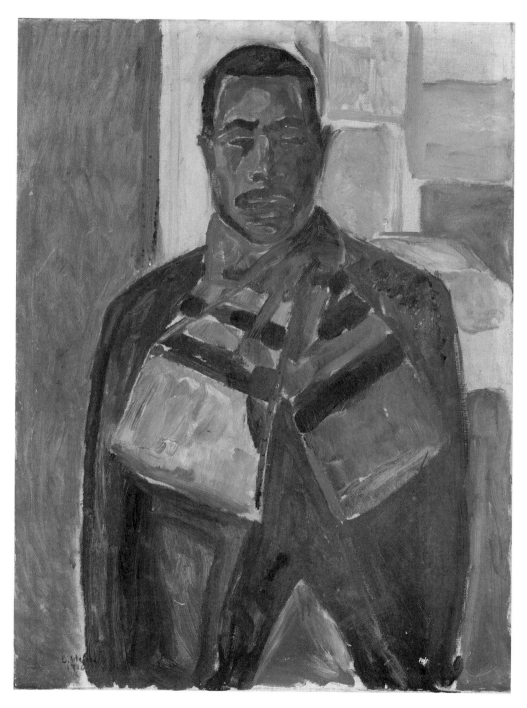

8.3 Edvard Munch, *African with a Green Scarf*, 1916. Oil on canvas. Munch
Museum, Oslo, MM M 261 (Woll M 1212). © 2014 The Munch Museum /
The Munch-Ellingsen Group / Artists Rights Society (ARS), NY

or Jubilee Exhibition, reinforced the exoticized fantasy of Africa and its people in the Norwegian imagination. This exhibition, which celebrated the 100th anniversary of the signing of the Norwegian constitution, was similar to a World's Fair, showcasing the best in Norwegian culture and industry from all over the world. In addition to sections devoted to art, religion, athletics, shipbuilding, and outdoor recreation, the exhibition organizers created a *Kongolandsby*, or "Congo village," complete with people in native costumes and reproductions of indigenous dwellings. The 80 village inhabitants also held singing, dancing, drumming, and cooking demonstrations.[4] On view were various types of craft, particularly metalwork in gold, including weapons and jewelry, and many of these objects were for sale.

Although the Scandinavian countries had no official presence in the Congo, beginning at the end of the nineteenth century, nearly two thousand citizens from Sweden, Denmark, Norway, and Finland spent time there in varying capacities. While some were in the Congo serving King Leopold II of Belgium's efforts at colonization, others were there actively opposing such developments. Some Scandinavians traveled to the Congo as missionaries, and others worked in the Belgian colony as explorers, tradesmen, and doctors. The Scandinavian involvement in the Congo held great interest for those back home.[5]

Thus, it comes as no surprise that the Congo village was one of the most popular displays at the exhibition. Approximately 1.4 million people visited the *Kongolandsby* at a time when Norway's population numbered around 2 million. Many of the attendees later recalled that it had been their favorite attraction, and it was there that they first saw people of African heritage. The exhibition was also widely covered in the press. The reactions were varied, yet all of the newspaper accounts focused on the spectacle of the *Kongolandsby*, reinforcing widely-held early twentieth-century stereotypes about Africans. Some journalists commented on the inhabitants' bad hygiene, eating habits, and "grotesque" dances.[6] *Aftenposten* and *Dagbladet*, the two largest newspapers in Oslo, reported on the exhibition from different angles. *Dagbladet*'s article on the village took on a distinctly prejudiced tone, using the term "barbaric" repeatedly when describing the Africans on display, and likening their visages to those of grinning apes.[7]

Aftenposten's coverage of the Congo village was more positive, taking note of the realism of the exhibition: "the entire village seems so strikingly realistic that visitors will feel as though they have been transported to Africa's interior."[8] In a longer article from May 21, 1914, the reporter took note of the Africans' appearance, observing that, "[t]here are, by the way, many beautiful people. The grayish complexion of their dark skin gives them a warm tone. They have bright eyes, brilliant smiles."[9] Evidently awestruck by the Africans' physiognomy, the author's exoticizing point of view is far less virulent and strident than that of the reporter from *Dagbladet*, yet it still emphasized the Congo village inhabitants' "otherness"; the African participants in the *Kongolandsby* became figures of fascination. The media made a clear division

between "us" and "them," emphasizing the differences between the residents of the Congo village and their audience. Even those who did not see the exhibit in person would have been influenced by the portrayals of Africans in newspaper reports through the duration of the Jubilee Exhibition.

The inclusion of ethnographic displays at European World's Fairs or at exhibitions such as the *Jublieumutstilling* served to highlight the importance of the other achievements on view. The politics of display enacted at the *Kongolandsby* reinforced the power disparity between those being viewed and the audience: the Africans were there for the entertainment of those attending the fair; the people, their culture, and their way of life became spectacularized and objectified by the audience and the exhibition organizers. Furthermore, the Africans' tribal costumes stood out against the garments worn by the exhibition attendees. Placing Africans in the exhibition in huts and displaying their lifestyle at an event that celebrated the newest innovations and achievements in European (or specifically Norwegian) science, culture, and technology made the contrast even more apparent—their rudimentary weapons and tools seemed only more antiquated in comparison. Difference was emphasized by the physiognomic variances between the Africans on display and the European viewing public, as well as by the perceived inferiority of their culture.[10] The *Kongolandsby* and its message to its viewers would have resonated with those who saw *Cleopatra and the Slave* on display four years later.

Carl Hagenbeck's *Völkerschau*

The ethnographic displays included in Carl Hagenbeck's traveling circus were also integral to shaping the public perception of non-Western cultures. When the Hagenbeck circus arrived in Oslo in 1916, the ethnographic exhibitions reinforced what Norwegian audiences had seen at the Jubilee Exhibition two years earlier. Today, Carl Hagenbeck is best known as the father of the modern zoo, pioneering the concept of what is now known as the wild animal park. He sought to keep and display animals in surroundings that mimicked their natural habitat. His belief in the benefits of the exhibition of animals in a recreation of their native environment, both for the animals and the viewers, was derived from his success in showing native cultures in a simulation of their own local surroundings.

Hagenbeck came to the animal trade through his father, who was an amateur animal trainer. The young man established a thriving business in the 1860s, providing wild animals for zoos, circuses, and private collections throughout Europe. In 1874, at a time when ethnographic displays of people from far-flung

locales were gaining popularity, Hagenbeck expanded his business to include the procurement of individuals from numerous countries and regions including Egypt, Somalia, Sri Lanka, India, Siberia, Mongolia, North America, Chile, Cameroon, and Australia. He contacted his business associate and directed him to import, in addition to the shipment of reindeer he requested from Lapland, a group of Lapps, whose native land lies in the northernmost region of Scandinavia, near the Arctic Circle. Not only did Hagenbeck bring a family of Laplanders to Hamburg, but he also imported the accoutrements of their daily life. Visitors were charged a fee to watch them go about their daily activities, including the breast-feeding of the family's child and the milking of the reindeer.[11] In his memoirs, Hagenbeck noted, "Our guests, it is true, would not have shone in a beauty show, but they were so wholly unsophisticated and so totally unspoiled by civilization that they seemed like beings from another world."[12] It was the Lapps' lack of sophistication and their unfamiliarity with European culture, or their presumed inferiority, that made them worthy of public display.

Although the Lapland exhibition was not a financial success, its popularity inspired Hagenbeck to pursue the creation of other ethnographic exhibitions. Hilke Thode-Arora observes that the circus impresario had several criteria when selecting an ethnic group for a show: "the group must be strange in some way; it must have particular physical characteristics; and it must have picturesque customs."[13] In essence, the more "exotic" a particular culture was to European eyes, the greater appeal it held for Hagenbeck. As the renown of these shows grew, he took them on tour, beginning initially in Germany and then expanding into other countries within Europe. By the mid-1880s, Hagenbeck's *Völkerschau* had grown from a single, small show in his backyard in Hamburg to multiple, large-scale productions that toured the major European capitals and drew hundreds of thousands of visitors. Even though Hagenbeck's exhibitions were not unique, he was adamant in differentiating his *Völkerschau* from those of others. He emphasized his show's "authenticity," implying that those of his competitors were highly theatricalized performances and that the participants were well acquainted with the vices of the Western world, including cigars, alcohol, and German currency.[14] In contrast, Hagenbeck claimed that the individuals that he displayed were merely going about their everyday activities, and that audiences were witnessing a genuine representation of a particular culture. Although Hagenbeck asserted that visitors were privy to the everyday activities of the exhibition participants, Thode-Arora argues that the shows were highly staged:

By 1895 at the latest, the performances were no longer a series of unconnected parts, but were turned into dramatic narratives with a peaceful opening scene, a dramatic incident and climax (for example, an abduction or an attack on the village), which allowed a fight to be staged, followed by a happy ending (for example, a peace treaty or a marriage ceremony) which provided the opportunity for singing, dancing, and the animal procession.[15]

Undoubtedly, the ethnographic exhibitions were scripted spectacles, despite their appearance of genuineness. This heavily orchestrated aspect was also common in ethnographic displays other than Hagenbeck's.[16] Although some of the individuals who were recruited were novices, others had worked on Hagenbeck's shows on several occasions over a long period of time. Eric Ames notes that "[t]rained performers such as acrobats, snake charmers, and elephant drivers had often been recruited for Hagenbeck's troupes," thus populating some of his shows with seasoned performers.[17] Additionally, it was common for the groups to sign contracts with their employers, including stipulations as to how often and under what conditions they were to perform, their salaries, the types of props they were to wear and carry, and their medical coverage.[18] "By the early 1910s," observes Ames, "the process of collecting foreign peoples had indeed become a form of casting, with recruiters looking not for 'anthropological types,' but for actors to fill scripted roles that would literally be assigned to them."[19] As troupes moved from city to city, they were sometimes asked to "perform" as another culture in a different venue, so that the same group of individuals could be billed as, for example, from Dahomey during a performance in Berlin and from Somalia at a Parisian show.[20] Despite the clearly orchestrated performance that masqueraded as the inhabitants' "everyday life," most viewers were sufficiently persuaded by the authenticity of the shows' participants, architecture, costumes, and ethnographic objects. It is the staged and performative nature of these cultural displays that perhaps Munch sought to evoke in *Cleopatra and the Slave*.

Cleopatra and the stage

Munch utilizes a number of unusual compositional strategies to heighten *Cleopatra and the Slave*'s artificiality. Rendered in different styles and with discrepancies of scale, the image as a whole appears disjointed. Many of the choices that Munch made are similar to those employed in theater designs that he executed in 1906. The artist had a long history of working in the theater; his interactions with the *Théâtre de l'Oeuvre* began in 1896, when he designed playbills for productions of Henrik Ibsen's *Peer Gynt* and *John Gabriel Borkman*. Munch and another Norwegian painter, Frits Thaulow, also collaborated on the design for the stage sets for *Peer Gynt*.[21] Munch did not have the opportunity to participate in theater projects again until he was living in Berlin nearly a decade later. In 1906, Munch was commissioned by Max Reinhardt, the founder of the Deutsches Theater, to create decorative murals for the theater foyer, as well as set designs for a production of Ibsen's *Ghosts*. The similarities between the visualization of the stage and Cleopatra's bedroom perhaps indicate that Munch felt that his experimentations with the expressive potential inherent in a performance space were appropriate for his rendering of the Egyptian queen and her slave. Both Cleopatra and the slave are pushed far into the foreground, leaving a large empty space between the two protagonists and the group in the distance.

8.4 Edvard
Munch, *Stage
Design for
"Ghosts"*, 1906.
Tempera on
unprimed canvas.
Munch Museum,
Oslo, MM M 984
(Woll M 699).
© 2014 The
Munch Museum
/ The Munch-
Ellingsen Group
/ Artists Rights
Society (ARS), NY

Munch's spatial arrangement in *Cleopatra and the Slave* is similar to that in *Stage Design for "Ghosts,"* which depicts three of the main characters, Osvald Alving, Mrs. Alving, and Pastor Manders, in the Alvings' sitting room (Figure 8.4). This production was set in Reinhardt's new *Kammerspiele*, a new type of theater design that eliminated the orchestra pit, bringing the audience closer to the activity on the stage. In Munch's sketches for the stage design of *Ghosts*, he creates distinct spatial zones, pushing the protagonists to the foreground of the picture plane, forming a wide gulf between the primary activity of the composition and the backdrop. In both *Stage Design for "Ghosts"* and *Cleopatra and the Slave*, Munch creates a clear upstage, center stage, and downstage.

Furthermore, the abbreviated style in which Munch executed the background is at odds with the higher degree of finish he employed to render Cleopatra and, above all, her slave. Like the figures in loincloths, the landscape in the background of the stage designs is sketchily rendered, lacking the same level of attention paid to the figures and furnishings in the foreground. In an actual stage production, the backdrop was a painted artificial boundary, meant to provide the viewer with the illusion of the back wall, window, or door of the "room" in which the scene is taking place. In fact, for the stage production of *Ghosts*, Munch created a landscape painting that was inserted into the backdrop as a stand-in for the view out the window. In *Cleopatra and the Slave*, the background's similarity to Munch's stage designs and the artist's division of the space in much the same way he rendered a performance stage, transform *Cleopatra and the Slave* into a *Kammerspiele*-like composition, thus emphasizing the staged nature of the scene, and perhaps referring to the artificiality of interracial encounters in ethnographic exhibitions.

Mixed messages

Cleopatra and the Slave both participates in and rejects art-historical tropes in the portrayal of African men, and this duality also contributes to the composition's staged quality. Munch would have been exposed to the tradition within French nineteenth-century painting of portraying a white woman with a black servant, as demonstrated by the work of Eugène Delacroix, Jean-Auguste-Dominique Ingres, Jean-Léon Gérôme, and Edouard Manet, during his intermittent stays in Paris during the 1890s. *Cleopatra and the Slave*'s place within this discourse remains ambivalent, as Munch simultaneously embraces and rejects some of the visual tropes of Orientalism. In *Cleopatra and the Slave*, Munch has paid a great deal of attention to the bedclothes and Cleopatra's raiment, yet he leaves the rest of the room empty, which runs counter to nineteenth-century depictions of Orientalist harems. Such scenes are typically full of "exotic" decorative objects including patterned rugs, throw pillows, *objéts d'art*, and water pipes. The décor often radiates luxury, usually featuring rich fabrics and ornate architectural details, creating the impression of an excess of wealth not present in *Cleopatra and the Slave*. The choice of Cleopatra as a subject evokes references to French nineteenth-century Orientalism, yet Munch did not remain entirely faithful to this aesthetic. In fact, the individuals he has placed in the background wearing loincloths and carrying spears appear more closely related to images of sub-Saharan African tribal groups than to North African or Middle Eastern life, at least as it was perceived by Europeans. This conflation of two very different depictions of Africans in *fin-de-siècle* visual culture further enhances the disjointed nature of the composition.

Munch may have also taken inspiration for *Cleopatra and the Slave* from the fourth act of Henrik Ibsen's *Peer Gynt*, which takes place in Morocco and Egypt.[22] The artist was well acquainted with the play—he had designed the program for an 1896 production at the *Théâtre de l'Oeuvre* in Paris. He also remarked in a letter to his friend Jappe Nilssen that he was re-reading *Peer Gynt* during his stay at a Copenhagen clinic in 1908.[23] In one of the major scenes of the fourth act, Gynt disguises himself with Bedouin clothing and is mistaken for a prophet by a local tribe. He tries to seduce the chieftain's daughter, Anitra, upon their first meeting, when she and a group of dancing girls are ordered to entertain the visiting prophet. It is this encounter that Munch's images of Anitra depict. He drew several images of this motif between 1911 and 1915, using his model, Ingeborg Kaurin, as a stand-in for Anitra.[24] In the drawings, Anitra appears in a bustier top and flowing harem pants. In one scene, she dances before Gynt, whose face resembles the artist's own. Although Anitra is of Bedouin ancestry, Munch envisions her as a European woman, in the same way he portrays Cleopatra. Anitra's clothing and the heavily patterned décor serve as the only indications of their North African surroundings. Although Gynt falls in love with her, she ultimately betrays him and rides away on his horse, taking the jewelry he has given her.

Although the subject of *Cleopatra and the Slave* is not drawn directly from the plot of *Peer Gynt*, his drawings of the fourth act may have inspired the setting and theme that Munch ultimately chose for the 1916 canvas. Cleopatra and Anitra are both North African seductresses who use men for personal gain. Cleopatra notoriously seduced both Julius Caesar and Mark Antony in order to influence their political decisions, and Anitra romanced Gynt in order to take jewels from him, only to abandon him in the desert. Although both *femmes fatales* were of non-Western ethnicities, Munch portrayed each of them as fair-skinned European women, perhaps to underscore that their deceitful nature was inherent to their gender and not their race.

Munch may have also found inspiration from Congolese sculpture that would have been on view at the Ethnographic Museum in Oslo and at the *Jubileumutstilling* in 1914. Munch seems to have derived Karim's stiff posture in *Cleopatra and the Slave* from wooden sculptural figures from the Congo, rather than a live model. Made all the more apparent in contrast to Cleopatra's languid pose, the slave's posture—with his shoulders thrown back, inert arms at his side—appears uncomfortably rigid, as though he were sculpted from the trunk of a tree. Many of the Norwegians who had returned from voyages to the Congo at the end of the nineteenth century donated the art objects that they had collected while abroad to the Ethnographic Museum's collection. A group of professors at the University of Oslo founded the ethnographic collection in 1857; one of whom was the painter's uncle, P.A. Munch.[25] Although the collection was initially displayed in one of the buildings on campus, it eventually outgrew its space, and moved to a building nearby, where it remains today. The new building opened in 1902 and in 1904, a permanent display of African art was made available to the public, filling the entire third floor. Most of the collection of African art came from the Belgian Congo. Dr. Inge Heiberg, a member of the Belgian colonial administration in the Congo, donated the majority of the African art objects given to the museum in the early twentieth century.[26] It is likely Munch would have visited the Ethnographic Museum either in its early years at the university, or upon its re-opening in 1902, due to his uncle's involvement in the founding of the collection.

The amalgamation of motifs, forms, and ideas from varying cultures into a single composition was the hallmark of many of the artist's contemporaries, including Paul Gauguin and Ernst Ludwig Kirchner. They considered these forms and motifs to be "primitive," meaning that they were unencumbered by the trappings of modern life.[27] Rather than taking inspiration from a single source, these artists derived their inspiration from a variety of cultures to create a primitivist "bricolage."[28] Because many of the artists who incorporated imagery from other societies believed that they were reaching a more honest and unmediated level of visual communication, the differences among the cultures from which they appropriated were unimportant. Despite the stamp of authenticity that his sojourn to Tahiti and the Marquesas Islands gave to his Polynesian works, many of Gauguin's compositions drew from visual models as wide-ranging as the famed heads of Easter Island to carved bone

ear plugs from the Marquesas Islands.[29] Although Gauguin sought to live and paint the "primitive" by retreating to Polynesia, Kirchner incorporated motifs from other cultures into the décor of his working space, in an effort to transcend the division between the everyday reality of the room and the realm of his paintings.[30] Most of his decorative objects were derived from Oceanic, South Asian, and African works of art that the artist had seen at the Dresden and Berlin ethnographic museums, as well as photographs in books. The multi-ethnic decorations in Kirchner's atelier, including batik textiles and wood carvings, made their way into the artist's studio imagery, serving as the background for portraits of his models and lovers.

In *Cleopatra and the Slave*, Munch creates a pastiche similar to those of Gauguin and Kirchner. Although the title and subject of the painting evokes a North African aesthetic, Munch's possible use of Congolese sculpture as a model for the slave's posture and the individuals he placed in the background wearing loincloths and carrying spears are more closely related to images of tribal groups from sub-Saharan Africa, at least as it was perceived by Europeans during this period. This conflation of two very different depictions of Africans in *fin-de-siècle* visual culture underscores the disjointed nature of the composition. *Cleopatra and the Slave* is more than a mere homage to French Orientalist motifs. All of the elements—the stylistic inconsistencies, the slave's rigid posture, the stage-like use of space, and the heterogeneous non-Western ethnographic references—create a composition that appears unnatural and disjointed. The lack of cohesion within the canvas emphasizes the artificiality of the image; instead of forming a unified whole, *Cleopatra and the Slave* is a mixture of references to non-Western sources.

Fin-de-siècle ethnographic exhibitions served to both establish and, more importantly, reinforce cultural stereotypes. When the Hagenbeck Circus featured a group of Native Americans, members of the Bella Coola tribe from British Columbia, Canada, attendance was unusually low. Viewers were more familiar with, and wanted to see, the types of "Indians" portrayed in Buffalo Bill's Wild West show, which was touring around Germany at the same time.[31] One journalist noted, "Well, they are not those proud, red-skinned figures with cunningly bowed eagle noses, dark-black, shimmering bushes of hair, and colorful feathers, which school boys reveling in Cooper and *Leatherstocking* like to dream about."[32] Thus, the ethnographic exhibition functioned for viewers as a way to fulfill the fantasy of the popular vision of "exotic" cultures. Because *Cleopatra and the Slave* does not conform to a single vision of "African-ness" as Europeans conceived it, its generic rendition of exoticism only highlights its artificiality.

Cleopatra-mania and interracial sexuality

Cleopatra was a favorite subject of artists: the stories surrounding her many love affairs, extravagant lifestyle, and her dramatic death by poisonous snakebite were also popular subjects among Renaissance and Baroque artists.

In all of their depictions, the Egyptian queen was portrayed as a European woman. It was not until the early nineteenth century, after Napoleon's 1798 entry into Egypt, that representations of Cleopatra began to reflect her Macedonian roots, depicting her with olive skin, kohl-rimmed, almond-shaped eyes, and her jet-black hair styled in a blunt bob at her shoulders, with thick, eyebrow-grazing bangs. Delacroix, Gérôme, Alexandre Cabanel, and Gustave Moreau all created images of Cleopatra informed by contemporary discoveries regarding the culture of ancient Egypt and the history of the queen herself. In addition to emphasizing her ethnic background, painters eliminated the typical neoclassical garb in which she had been previously portrayed. Rather, their sartorial choices reflected the stereotypes that surrounded the myth of Cleopatra's life. She was often scantily clad in vaguely Orientalist clothing that emphasized her overly sexualized persona, and adorned with large quantities of ornate jewelry that denoted her life of luxury. During the nineteenth century, not only did representations of Cleopatra's physiognomy change to correspond to discoveries regarding her ethnicity, but her costume and settings were altered in order to mirror her purported life of excess and sexual abandon.[33]

Munch's portrayal of Cleopatra coincided with a turn-of-the-century cultural Egyptomania and, in particular, a specific vogue for Cleopatra herself. She was the main character in numerous novels, plays, ballets, operas, and films at the turn of the century. Onstage, the *Ballet Russes* performed *Cléopâtre* in 1909 and again in 1918.[34] The iconic actress Sarah Bernhardt also portrayed Cleopatra at least three times between 1880 and 1900.[35] The drama of Cleopatra's story was apparently well suited to the emerging medium of cinema, as at least twenty films about her were made within the first thirty years of film production.[36] The 1901 Pan-American Exhibition in Buffalo featured an entire "Temple of Cleopatra," which housed a large and very realistic image of the Egyptian queen.[37] In addition to appearing in varying forms of cultural production, she materialized in advertisements, including one selling Palmolive shampoo in a 1908 *Vogue Magazine*.[38] Although she had died nearly two thousand years earlier, Cleopatra was a prominent figure in the cultural landscape of the turn of the century.[39]

However *au courant* Munch's choice of Cleopatra as a subject was in 1916, his portrayal of her as a fair-skinned European woman harkens back to earlier conceptions of her ethnicity. By 1916, artists had changed their vision of Cleopatra's appearance, orientalizing her features and placing her in settings that reflected Pharaonic Egypt. Munch's choice to depict her as a European woman highlights the contrast between her and Karim. It is likely Munch intended his audience to identify with his rendition of Cleopatra, thus accounting for her physical similarity to Norwegian women. If Munch had painted Cleopatra as a woman of Mediterranean origin, viewers would have received the entire composition as an Orientalist motif. By portraying Cleopatra as a European woman, Munch changed the scene of one from a fantasy grounded in difference to one focused on the slave's "otherness."

In casting Cleopatra as a European woman, Munch also addresses the taboo of the white female/black male couple. For many white women, African men fulfilled an erotic and exotic fantasy; they were stereotypically portrayed as possessing large genitalia and strong sexual appetites. The *"blanche/noir"* relationship, as described by Roger Little, was a transgression that threatened social isolation and danger, the prospect of which was most likely thrilling for many women.[40] While it was more acceptable for white men to engage in relationships with black women in this period, a black man and a white woman upended the power hierarchy: the black man's gender dominance challenged the white woman's racial superiority. Interracial sexuality posed a threat to white masculinity and the perceived dominance of the white race. Late nineteenth-century anthropologists connected the physical appearance of the black to simians, particularly monkeys and gorillas.[41] This purported resemblance led to a correlation between appearance and behavior, and giving credence to the "bestiality" of black men. The myth of the violent, aggressive black man taking advantage of the white woman was a prevalent *fin-de-siècle* social and literary topos and continued well into the twentieth century. Writing in 1935, the French author Henry Champly discussed the phenomenon in his book *White Women, Coloured Men*, noting,

For I am convinced that we are concerned here with *one of the greatest metamorphoses which have taken place in human consciousness, possibly ever since the advent of Christianity, and certainly ever since the Reformation*: a metamorphosis heretical, dangerous and sinister. It may even prove a mortal sin. It is, in any case, a tremendously big thing.[42]

Champly concludes his preface with a call to arms for the white man, stating, *"Beware, White race! The Coloured races have discovered your supreme treasure, the White Woman!* What are you going to do about it?"[43] Munch's casting of Cleopatra as a European woman was perhaps meant to evoke in his viewers the same stereotypes and fears associated with a *"blanche/noir"* relationship.

The extreme horizontal and vertical polarity present in *Cleopatra and the Slave* relates to the positioning of figures in an earlier series of paintings from 1906–7, with a reversal of the male and female roles. The series, entitled *Death of Marat*, refers both to the French revolutionary figure Jean-Paul Marat as well as to Jacques-Louis David's 1793 portrait of him.[44] However, the content of the paintings allude to an argument that took place in 1902 between the artist and his former lover, Tulla Larsen.[45] Their tumultuous relationship came to its climax at the painter's beach house in Åsgårdstrand, a small seaside town south of Oslo on the Oslofjord. Larsen and Munch quarreled, and eventually the pair fought over a loaded revolver. The gun discharged accidentally, wounding Munch in the hand.[46] In *Death of Marat* (Figure 8.5) (1907) Munch lies naked on a bed, the sheets stained red from his injured finger.[47] The redheaded female figure, who resembles photographs of Larsen, is also nude, and stands alongside the bed while holding the male figure's hand. Touches of red echo throughout the canvas, creating the illusion that Munch's blood

8.5 Edvard Munch, *Death of Marat*, 1907. Oil on canvas. Munch Museum, Oslo, MM M 351 (Woll M 767). © 2014 The Munch Museum / The Munch-Ellingsen Group / Artists Rights Society (ARS), NY

is everywhere—on the walls, the table, and Larsen's legs. In invoking the reference to Marat, Munch casts Larsen in the role of the assassin Charlotte Corday, linking his former lover with a woman who was considered deceitful and conniving.[48] In fusing Tulla Larsen with Charlotte Corday, Munch creates the quintessential *femme fatale*, both seductive and deadly.[49]

Munch was certainly no stranger to depictions of the *femme fatale*; he gained fame in the 1890s for his compositions that showed the pain of heterosexual relationships, often centered on a man at the mercy of a callous female lover. Many scholars, both during and after Munch's lifetime, link this theme to Munch's biography, emphasizing his tumultuous relationships with women and the early deaths of his mother and sister. Because his images of hapless men at the hands of predatory women were presumed to be autobiographical, the artist has been characterized in the critical literature as a misogynist. However, as Patricia Berman has noted, it is more likely that previous scholars have conflated Munch's examination of the *fin-de-siècle* "Woman" with a generic portrayal of women.[50] Although the *Death of Marat* canvases refer to a specific event in Munch's life, the image of the *femme fatale* had become so closely identified with Munch and his biography that by the time he executed his *Marat* paintings, they were viewed by critics and scholars as the climax of a lifetime of misogynistic beliefs.

In both the *Cleopatra and the Slave* series and the *Marat* canvases, Munch creates a power dynamic between the two figures, yet in each instance, the female is the dominant one, reversing the hierarchy typical of a *"blanche/noir"* relationship. Munch renders Larsen in a stiff pose similar to that of the slave, yet in this instance, her rigidity accentuates her severity and remorselessness; she stares out at the viewer, with no apparent interest in the prostrate, bleeding figure on the bed. Her pose remains consistent throughout the four canvases and the lithograph, yet she appears at varying distances from the picture plane. Although both groups of works are similarly composed, it is significant that Munch transforms a composition derived from a personal experience to one that is quasi-historical. *Cleopatra and the Slave* moves away from Munch's biography, instead creating an image of the *femme fatale* that is not grounded in personal trauma but in the myth of a historical figure's notoriously aggressive sexuality. This reversal of the roles in an interracial relationship between a black man and a white woman undermines viewers' preconceived notions of African male sexuality.

Munch's portraits of Sultan Abdul Karim

Munch's three half-length portraits of his model are a significant departure from his depiction of Karim in the *Cleopatra and the Slave* images. In two of the portraits, Karim wears a green-and-black-striped scarf. The scarf, due to its bold color and its size, is the most visually arresting element of the composition, yet closer examination of the brushstrokes shows that Munch exerted the most effort in rendering Karim's face, using a varied palette to model its contours. This level of detail was not present in any of the Cleopatra images; here, Munch transforms Karim from a generic figure, representative of his entire race, to an individual with very clearly rendered features.

Although the same model was used in the portraits and *Cleopatra and the Slave*, they could not be more different in their depiction of an African man. Notably, *African in a Green Coat* (Figure 8.6) resembles a group of four half-length self-portraits that Munch executed around 1915. The four works show the artist in a suit and tie, and in two of them, he also wears an overcoat and hat, possibly the same garments that clothe Karim. In these images, Munch also renders his own face a pastiche of varying hues, modeling the contours of his face with touches of green and mauve, identical to the palette he employed on Karim's face in *African in a Green Coat*. In particular, *Self-Portrait in Hat and Coat* (Figure 8.7) is practically a mirror image of *African in a Green Coat*. Both half-length portraits depict Munch and Karim in hats, overcoats, a jacket, suit, and tie. Their faces are turned in three-quarter profile; Karim faces to the left and Munch faces to the right. In dressing Karim in similar clothing, modeling his face with the same palette, and employing nearly identical compositional strategies in their respective portraits, Munch effectively casts Karim as a stand-in for the artist.

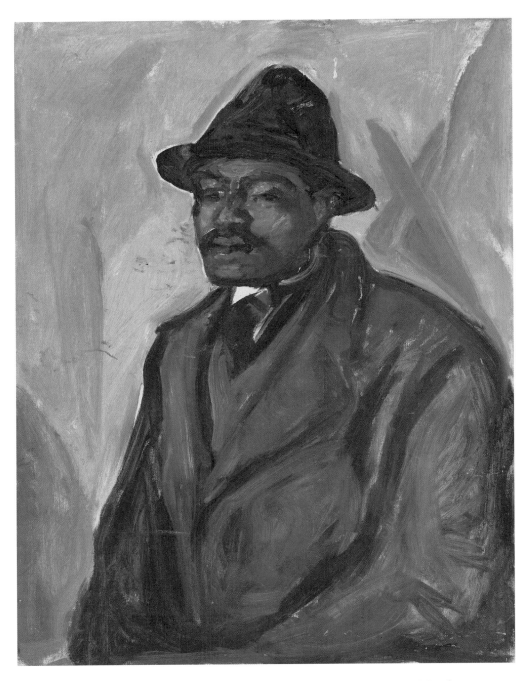

8.6 Edvard Munch, *African in a Green Coat*, 1916–17. Oil on canvas. Munch
Museum, Oslo, MM M 92 (Woll M 1214). © 2014 The Munch Museum /
The Munch-Ellingsen Group / Artists Rights Society (ARS), NY

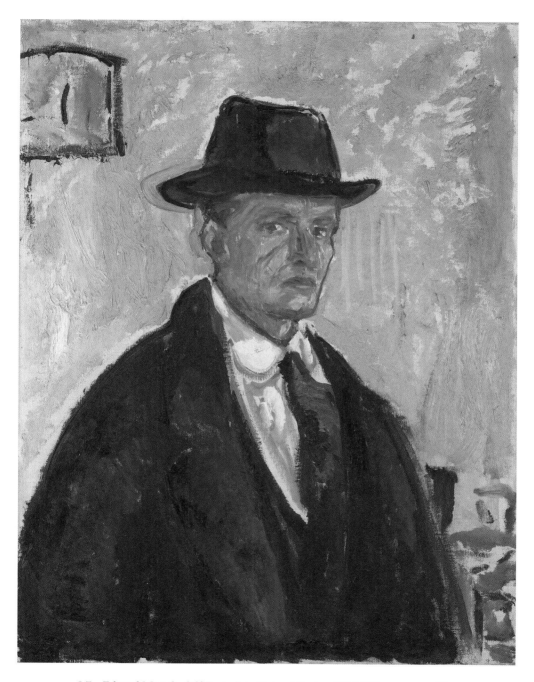

8.7 Edvard Munch, *Self-Portrait in Hat and Coat*, c. 1915. Oil on canvas. 90 × 68 cm., Munch Museum, Oslo, MM M 601 (Woll M 1143). © 2014 The Munch Museum / The Munch-Ellingsen Group / Artists Rights Society (ARS), NY

The similarities between Munch's self-portrait and that of Karim in the green coat simultaneously present the African man as a contemporary Westernized figure and evoke the artist's own inner "primitive" nature. When Munch's career began to gain critical attention in the 1890s, the concept of the "primitive" was often evoked in conjunction with his style of painting, his choice of motif, and his own national identity. In 1894, a monograph entitled *Das Werk des Edvard Munch: Vier Beiträge* was published in Germany. The volume featured contributions by the Polish writer Stanislaw Przybyszewski and the art critic Julius Meier-Graefe, as well as two other members of the Berlin bohemian circle *Zum Schwarzen Ferkel*, Willy Pastor and Franz Servaes.[51] These essays began to crystallize much of the critical rhetoric associated with Munch, even today; the authors focused on his sensitivity, his authenticity, and his "primitivism," attributing these traits to his inherent Nordic nature, which allowed him to access his emotions on a more primordial, almost supernatural level. Servaes compared Munch to Gauguin, stating, "he doesn't need to travel to Tahiti to see and experience the primitive in human nature. He carries his own Tahiti with him."[52] Much of Munch's identity as an outsider and as primitive in the nineteenth century was couched in the French and German stereotype of Norway as a primitive land, steeped in its Viking past.

This perception of Norway as one of the remaining "primitive" places in Europe was in part due to its peripheral geographic location. The Scandinavian people were "primitive" in the sense that their connection to nature was unmediated and untainted by industrialization and modernization, making them more in touch with their emotions. Because Norway was a "younger" nation in the early part of the century, at least in comparison to France and Germany, it was perceived as being at an earlier, almost child-like stage of development. The French and the Germans both saw Norwegian art and culture as somewhat crude and rough, but found appeal in it. The French art critic Maurice Hamel noted such characteristics in his review of the Salon of 1889:

> Norwegian art does not have this lively allure or this urban grace. In it one
> sees the backwardness of gesture and the deliberate sensibility associated with
> countries of scattered populations, the breadth of shoulders of a race cut out by
> hatchet-strokes, tender under a rude outer skin. This art is sinful and peasant-like,
> a bit rough, very sincere, imprinted with a brusque cordiality: one senses that it
> grew up in a virgin nature, in the enchantment of the fjords, [out of] steep cliffs,
> with glaciers that descend into the ocean.[53]

According to this view, Norway was innocent, pure, and deeply rooted in its rural traditions, allowing Munch to more easily access his own inherent "primitivism" derived from his national identity.[54]

Munch's reference to his own internal "primitive" nature links the latter half of his career with the early work of the 1890s, a body of images that scholars have long viewed as completely separate from the artist's late oeuvre. In creating this dialogue between his own self-portraits and the portrait of Karim in the green coat, Munch emphasizes the mutability of identity and

the performative nature of painting; an African man can be portrayed as the slave of an Egyptian queen or a Western man sitting for a portrait, and likewise, a European man can, too, be the slave (or victim) of a dominant lover and find the "primitive" within himself. Munch uses Karim's blackness as a vehicle for self-examination during a turning point in his career. After completing a cycle of monumental, nationalist canvases for the University of Oslo's Festival Hall (Aula), the artist was widely touted as a Norwegian artist, a form of acceptance from his homeland he had never previously achieved.[55] It is perhaps the designing of these murals, a project that prompted a close examination with Norwegian identity and its place within the larger European community, that compelled Munch to reconsider the idea of the primitive and his role within this discourse. In the wake of the nationalist fervor that surrounded the completion of the Festival Hall paintings, Munch embarked upon a reassessment of his career, his legacy, and his future. The images Munch created of Karim, both as himself and in the guise of Cleopatra's slave, gave the artist the opportunity to simultaneously reflect on the past and at his future, to examine himself and scrutinize the world around him.

The *Cleopatra and the Slave* images draw from a wide variety of visual, cultural, and social references, each of which participates in the reinforcement of stereotypes about non-Western peoples. In creating canvases that resist a clear narrative or a unified composition, Munch's Cleopatra paintings appear disjointed. The lack of cohesion and consistency in all of his paintings that feature Karim render the images a series of performative acts, not unlike the types of performances staged at ethnographic exhibitions at the beginning of the twentieth century. In *Cleopatra and the Slave*, Karim "performs," in that he plays the role of a slave, but also in that he comes to embody African-ness and the primitive, through Munch's fusing of him with African wooden sculpture.[56] This transience of identity was made more apparent when the *Cleopatra and the Slave* images were exhibited with Karim's portraits.

In a review of Munch's January 1921 exhibition at Blomqvist Gallery, the art critic Jappe Nilssen wrote one of the few critical responses to the paintings when the two halves of the composition were reunited. He noted, "Directly opposite us on the long wall, is the large, bold figure painting with the odalisque and the nude, animalistic negro, in which the colors are pushed up to the highest intensity, to its greatest yield. It is like the flourish of a fanfare."[57] Nilssen's comments take note not only of the bold color palette that Munch employed but also the "animalistic negro," which was perhaps more a reflection of the wider conception of Africans in Europe at the time, particularly in Norway, than the actual depiction of the man in the painting. Nilssen's use of the term "animalistic" conjures up the image of a wild, uncontrolled, even predatory being, which neglects the multiple layers of meaning that appear in both depictions of Karim. The ambivalence with which Munch approached this motif is apparent in the individual compositions, the variation with which Munch portrayed his model within the series, and in his decision to the exhibit the paintings together. Unfortunately, the complexity of Munch's

canvases went unnoticed—Nilssen's review indicates that the painting was received primarily as an exploration of the "primitive," merely one aspect of these multilayered works.

Notes

I would like to thank Christine Poggi, Karen Beckman, Patricia Berman, Gerd Woll, Lasse Jacobsen, Inger Engan, Susan Libby, and Adrienne Childs for their assistance with this essay at various stages.

1 LR 566 28.11.1916, Munch Museum archives. "Jeg anbefalede Munch at engagere en rigtig brav og tiltalende Neger, Sultan Abdul Karim som tjener kusk og model." Unless noted otherwise, all translations are my own.

2 In addition to *Cleopatra and the Slave*, three canvases and the lithograph are smaller versions of the same motif. Three of the canvases are half-length portraits of Karim in Western clothing.

3 Of particular interest to the Scandinavians was Belgium's colonization of the Congo in 1908. Thousands of citizens from Denmark, Sweden, Norway, and Finland traveled to the Congo both to promote and to thwart King Leopold II's colonization efforts.

4 In celebration of the 200th anniversary of the signing of the Norwegian constitution, two artists, Fadlabi and Lars Cuzner, have proposed a re-creation of the *Kongolandsby* as a way to spur conversation regarding race in contemporary Norway.

5 For more on the Scandinavian presence in the Congo and other parts of Africa, see Peter Tygesen and Espen Wæhle, *Kongospor: Norden i Kongo—Kongo i Norden* (Oslo: Kulturhistorisk Museum, 2007); and Kirsten Alsaker Kjerland and Anne K. Bang, eds., *Nordmenn i Afrika—Afrikanere i Norge* (Bergen: Vigmostad & Bjørke AS, 2002).

6 Olav Christiensen and Anne Eriksen, "Kongolandsbyen på Frogner: Fornøyelser på Jubileumutstilling," *Byminner* 1 (1993): 22–3.

7 "I Babylon og Kongo," *Dagbladet*, May 19, 1914.

8 "De forskjellige attraktioner ved fornøielseafdelingen," *Aftenposten*, May 7, 1914. "Den hele landsby vil virke saa skuffende realistisk at den besøgende vil føle sig direkte hensat til Afrikas indre."

9 "Hvor man morer sig paa udstillingen," *Aftenposten*, May 21, 1914. "Det er forresten meget vakre mennesker. Det askegraaislæt i deres sorte hud giver dem en varm lød. De har smukke øine, straalende tænder."

10 The practice of exhibiting "other" cultures as a way to reinforce the exhibitor's dominance can be traced back as early as ancient Egypt. See Pascal Blanchard et al., "Human Zoos: The Greatest Exotic Shows in the West: Introduction," in *Human Zoos: Science and Spectacle in the Age of Colonial Empires*, ed. Pascal Blanchard et. al., (Liverpool: Liverpool University Press, 2008), 4–6.

11 Carl Hagenbeck, *Beasts and Men: Being Carl Hagenbeck's Experiences for a Half Century Among Wild Animals*, translated by Hugh S.R. Elliot and A.G. Thacker (London: Longmans, Green & Co., 1909), 20.

12 Ibid., 16.

13 Hilke Thode-Arora, "Hagenbeck's European Tours," in *Human Zoos: Science and Spectacle in the Age of Colonial Empires*, ed. Pascal Blanchard et. al. (Liverpool: Liverpool University Press, 2008), 167. Eric Ames believes that these guidelines

were never explicitly stated, but implied in Hagenbeck's correspondence with his agents. See Eric Ames, *Carl Hagenbeck's Empire of Entertainments* (Seattle: University of Washington Press, 2008), 41–2.

14 Nigel Rothfels, *Savages and Beasts: The Birth of the Modern Zoo* (Baltimore: Johns Hopkins University Press, 2002), 88–9.

15 Thode-Arora, "Hagenbeck's European Tours," 170.

16 Blanchard et al., "Greatest Exotic Shows in the West," 20.

17 Ames, *Carl Hagenbeck's Empire of Entertainments*, 47.

18 Ibid., 50.

19 Ibid., 51. Some of the individuals who were recruited for these shows were domestic workers who were already living in Europe, and one group arrived in Hamburg wearing European clothing, much to Hagenbeck's dismay. Ibid., 53–4.

20 Blanchard et. al., "Greatest Exotic Shows in the West," 33.

21 Patricia Eckert Boyer, *Artists and the Avant-Garde Theater in Paris 1887–1900* (Washington, DC: National Gallery of Art, 1998), 142.

22 *Peer Gynt* is a five-act satirical play loosely based on the fairy tale *Per Gynt*. The titular character is arrogant, manipulative, and dishonest, and the plot of the play unfolds as he embarks on a series of adventures in varying parts of the world.

23 Joan Templeton, *Munch's Ibsen: A Painter's Visions of a Playwright* (Seattle: University of Washington Press, 2008), 72. It is noteworthy that in this letter, Munch indicated that he was "reading [Peer Gynt] as me."

24 Munch revisited the motif of Anitra's dance in the 1930s, this time rendering her as a dark-skinned woman. In these drawings, she also dances provocatively in front of her "prophet," although she is nude.

25 P.A. Munch (1810–63) was one of the preeminent scholars of Norwegian history in the nineteenth century. He was the author of an eight-volume history of the Norwegian people, *Det Norske Folks Historie* (History of the Norwegian people) (1852–9), and was also known for his translations of the Norse Sagas.

26 For more on the Ethnographic Museum's collection, see Jostein Bergstøl et. al., *Kulturhistorier i Sentum: Historisk Museum 100 år* (Oslo: Universitetet i Oslo, 2004).

27 The literature on *fin-de-siècle* primitivism is vast: some of the seminal texts on the topic include Jill Lloyd, *German Expressionism: Primitivism and Modernity* (New Haven: Yale University Press, 1991); James Clifford, *The Predicament of Culture: Twentieth-Century Ethnography, Literature, and Art* (Cambridge, MA: Harvard University Press, 1988); and Abigail Solomon-Godeau, "Going Native," *Art in America* 77 (1989): 118–29, 161. Mark Antliff and Patricia Leighten, "Primitive," in *Critical Terms for Art History*, ed. Robert S. Nelson and Richard Shiff (Chicago: University of Chicago Press, 2003), provide an excellent summary of the topic.

28 Abigail Solomon-Godeau, "Going Native: Paul Gauguin and the Invention of Primitivist Modernism," in *The Expanding Discourse: Feminism and Art History*, ed. Norma Broude and Mary D. Garrard (New York: Icon Books, 1992), 328. Solomon-Godeau uses this term specifically in reference to Gauguin, but her classification of Gauguin's borrowing of motifs from a variety of cultures, could equally apply to the way in which Kirchner, for example, utilized a variety of non-Western motifs together to create a generic "primitive" aesthetic.

29 For more on Gauguin's appropriation of motifs from the varying Polynesian cultures, see George T.M. Shackelford and Claire Frèches-Thory, eds., *Gauguin Tahiti* (Boston: Museum of Fine Arts, 2004).

30 Jill Lloyd, "Kirchner's Metaphysical Studio Paintings," in *Ernst Ludwig Kirchner: The Dresden and Berlin Years*, ed. Jill Lloyd and Magdalena M. Moeller (London: Royal Academy of Arts, 2003), 15.

31 Ames, *Carl Hagenbeck's Empire of Entertainments*, 107–9.

32 Quoted in ibid., 109.

33 Lucy Hughes-Hallet, *Cleopatra: Histories, Dreams, and Distortions* (New York: Harper & Row, 1990), 2–3.

34 Juliet Bellow, "Fashioning Cléopâtre: Sonia Delaunay's New Woman," *Art Journal* (Summer 2009): 7–8.

35 Bernhardt played Cleopatra in 1880, 1890, and in 1899; the latter two performances were productions of Victorien Sardou's *Cléopâtre* (1890).

36 Francesca T. Royster, *Becoming Cleopatra: The Shifting Image of an Icon* (New York: Palgrave Macmillan, 2003), 61. The first film about Cleopatra, Gaston Méliés' *Le vol de la tombe de Cléopâtre*, was produced in 1899. Although Shakespeare's *Antony and Cleopatra* was performed on stage relatively few times during this period, four film adaptations of the play were produced: one in 1908, two in 1913, and one in 1929. For more on Egyptomania and early cinema, see Antonia Lant, "The Curse of the Pharaoh, or How Cinema Contracted Egyptomania," *October* 59 (Winter 1992): 86–112.

37 Michael Leja, *Looking Askance: Skepticism and American Art from Eakins to Duchamp* (Berkeley: University of California Press, 2004), 158.

38 Reproduced in Hughes-Hallett, *Cleopatra*, fig. 36.

39 For more on the cultural phenomenon of Cleopatra, see Hughes-Hallett, *Cleopatra*; Royster, *Becoming Cleopatra*; and Mary Hamer, *Signs of Cleopatra: Reading an Icon Historically*, 2nd ed. (Exeter: University of Exeter Press, 2008).

40 For more on this topic, see Roger Little, *Between Totem and Taboo: Black Man, White Woman in Francographic Literature* (Exeter: University of Exeter Press, 2001).

41 William B. Cohen, "Literature and Race: Nineteenth-Century French Fiction, Blacks, and Africa 1800–1880," *Race and Class* (1974): 192–5.

42 Henry Champly, *White Women, Coloured Men*, trans. Warre Bradley Wells (London: J. Long, 1939), 6. Emphasis in original.

43 Ibid., 7. Emphasis in original.

44 Jean-Paul Marat was a Swiss-born journalist and politician who played an important role in the French Revolution. He was a member of the radical Jacobin group, and was murdered in his bathtub by Charlotte Corday, a Girondin sympathizer. Corday gained entrance to Marat's home by claiming to have information about a Girondist uprising in Caen. When she saw Marat, who was soaking in a bathtub (a medicinal treatment for a skin ailment), she stabbed him in the chest.

45 For more on Munch and Larsen's relationship, see Frank Høifødt, "Kvinnen, kunsten, korset. Edvard Munch anna 1900," (PhD diss., University of Oslo, 1995).

46 Munch lost part of the ring finger of his left hand. He was obsessed with his injured hand, calling it his "fatal hand," showing it prominently, with its truncated finger, in photographs.

47 Although Munch was shot in the left hand, he depicts himself as injured in his right hand in the paintings, possibly to make the possible consequences of such an injury more dire, since he painted with his right hand. Additionally, in two related works, *Murder* (1906) and *Still Life, the Murderess* (1906), Munch has painted a large red area on his upper torso, insinuating that he was also mortally wounded in the chest, though that was not the case.

48 For more on the iconography of Charlotte Corday and the evolution of depictions of the murderess, see Michael Marrinan, "Images and Ideas of Charlotte Corday: Texts and Contexts of an Assassination," *Arts Magazine* 54 (April 1980): 158–76.

49 The other two paintings in this group are entitled *Murder* and *Still Life, the Murderess*, both executed in 1906. Each one depicts essentially the same scene as the *Death of Marat* paintings, but the figures are clothed.

50 For more on the complex relationship between Munch and women, see Patricia Berman, "Edvard Munch: Women, "Woman," and the Genesis of an Artist's Myth," in *Edvard Munch: Image and Myth*, ed. Patricia Berman and Jane Van Nimmen (Alexandria, VA: Art Services International, 1997).

51 For more on Munch's involvement with *Zum Schwarzen Ferkel*, see Carla Lathe, *Edvard Munch and His Literary Associates* (Norwich: University of East Anglia Press, 1980).

52 Franz Servaes, *Das Werk des Edvard Munch: Vier Beiträge* (Berlin: S. Fischer Verlag, 1894), 37. Translated in Arne Eggum, "Edvard Munch: A Biographical Background," in *Edvard Munch: The Frieze of Life*, ed. Mara-Helen Wood (London: National Gallery Publications, 1992), 15. "… er braucht auch nicht nach Tahiti zu gehen, um die Primitivität der Menschennatur zu erblicken und zu durchleben. Er trägt sein eigenes Tahiti in sich."

53 Maurice Hamel, "Les écoles étrangères," *Gazette des beaux arts* (October 1889): 379. Translated in Kerry Brita Herman, "Modernism's Edge: Nationalism and Cultural Politics in Fin-de-Siècle Europe; Norwegian Painters 1880–1905" (PhD diss., Brown University, 1999), 99.

54 For more on this topic, see Herman, "Modernism's Edge," esp. ch. 3.

55 Patricia Berman, in her dissertation, "Monumentality and Historicism in Edvard Munch's University of Oslo Festival Hall Paintings" (PhD diss., New York University, 1989), discusses the particulars of the Aula competition in great detail.

56 Carol Armstrong elaborates upon the concept of model performativity in "To Paint, To Point, To Pose," in *Manet's Le Déjeuner sur L'Herbe*, ed. Paul Hayes Tucker (Cambridge: Cambridge University Press, 1998), 90–118.

57 Jappe Nilssen, "Edvard Munch," *Dagbladet*, January 19, 1921. "Rett mot oss paa langveggen det store, dristige figurbillede med odalisken og den nakne dyriske neger, hvor farven er drevet op til den høieste intensitet, til dens ytterste ydeevne. Det virker som en fanfare."

Race and beauty in black and white: Robert Demachy and the aestheticization of blackness in Pictorialist photography

Wendy A. Grossman

"Something is changing, or going to change in the aesthetics of black and white,"[1] wrote French critic Robert de La Sizeranne in an 1897 essay that would become a virtual manifesto of the Pictorialist photographic movement. In suggesting the notion of a black-and-white aesthetic in a treatise titled "La photographie est-elle un art?" (Is photography an art?), he not only referenced intrinsic qualities of the medium but also unwittingly pointed to a well-established binary construct that would accrue new symbolic complexities in aesthetic and racial discourses at the *fin de siècle*. Indeed, the black-and-white aesthetic with which La Sizeranne was concerned embraced not only ideas of beauty, antiquity, and modernity central to the Pictorialist ethos of the era, but also in the ensuing decades would become a multivalent leitmotiv in photographic practice encompassing notions of racial difference.

This complex matrix of significations is epitomized in Robert Demachy's Contrasts (Plate 8, Figure 9.1), a photograph created in 1901 by one of France's leading Pictorialist photographers that has become an iconic image of the movement. Realizing the formal and conceptual thematization of the black-and-white aesthetic invoked in La Sizeranne's essay four years earlier, Demachy (1859–1936) composed this photograph as one of a series of images in which a pre-pubescent model of color is juxtaposed with a classically inspired white plaster bust of a young child. The ambiguous reading of the gender of both the model and the bust in all variants echo the sitter's indeterminate racial identity, complicating the concept of contrasts suggested in the title. However, this study establishes the female identity of the model and the male identity of the bust, offering new insights into this little-examined photograph and the cultural contexts in which it has acquired meaning.[2]

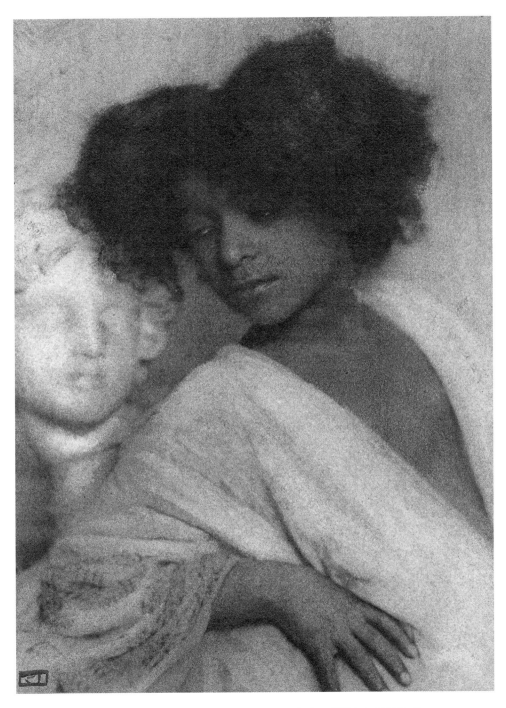

9.1 Robert Demachy, *Contrasts (A Study in Black and White)*, 1901/3. Gum-bichromate print. Division of Culture and the Arts, National Museum of American History, Behring Center, Smithsonian Institution, Washington, DC

Disseminated between 1903 and 1911 through international photography exhibitions and journals, Demachy's *Contrasts* and its variants (Figure 9.2) reformulate the paradigm of the binary black-and-white aesthetic as a racialized trope of difference shaped to fit within the lexicon of Pictorialism and its concept of beauty.[3] At the same time, they illustrate the unique manner in which photographs, with their indexical qualities and infinitely reproducible nature, contributed to notions of difference and spectacles of blackness in this period.

In Demachy's highly aestheticized compositions, the animate and inanimate forms serve as coded cultural signifiers evoking the Western concern with racial and gendered difference. The young model is positioned as a counterpoint to the white plaster bust and thus implicitly understood as being other (regardless of her indeterminate racial identity), an assumption made explicit in the photograph's title itself. Indeed, while the image was first reproduced in 1904 with the title *Contrasts*, its subsequent appearance in 1910 as *Black and White* makes explicit the notion of racial difference as the principal concern animating the juxtaposition of these elements. In this manner, notions of classical Greek civilization are set in opposition to perceptions of a primal Africa embedded in a discourse characterized by Christopher Miller as "black and white in color."[4] This dichotomous "Africanist discourse" linked to constructed notions of an imaginary "Africa" reaching back to antiquity was one of the unifying characteristics of an aesthetic ideology in Europe since the eighteenth century undergirding notions both of beauty and its counterpoint.[5]

In the context of colonialism and immigration at the turn of the twentieth century, however, this oppositional black-and-white conceit in which race was an unequivocal construct would become increasingly destabilized by the phenomenon of mixed-race unions and their hybrid progeny. Demachy's photograph of a model of indeterminate race—an unwitting reminder of the cultural, racial, and sexual comingling that colonialism had brought to bear—thus participated in undermining notions of clearly defined racial boundaries and reflected new paradigms of racial discourse at the *fin de siècle*.

This chapter examines the rhetoric of the image—the embedded messages and significations that inflect the way we read and understand photographs—and the context in which Demachy's composition was produced and disseminated.[6] In so doing, I aim to provide insight into the manner in which this work complicates the "aesthetics of black and white" and notions of race and beauty on the cusp of the new century, reflecting the burgeoning of modernity and its attendant modernisms.

Pictorialism

Although Demachy is little known today outside a specialized circle of photography aficionados, the Parisian artist and critic was, in fact, one of the leading figures of the international Pictorialist movement, highly respected

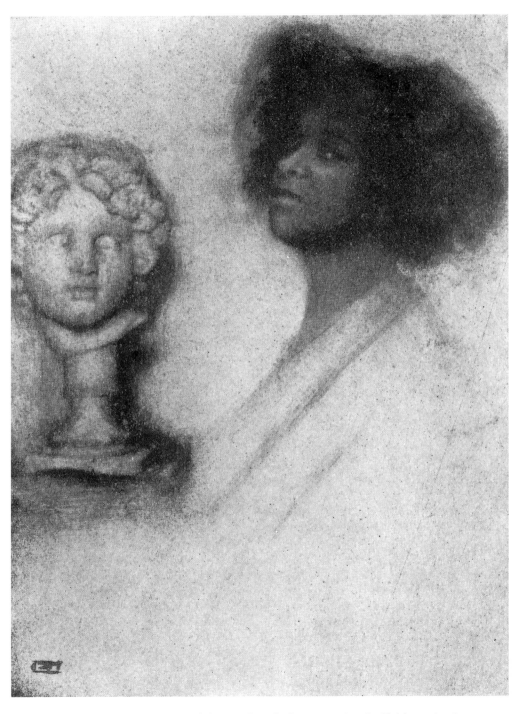

9.2 Robert Demachy, *Untitled*, 1901. Gum-bichromate print. Société française de Photographie. Reproduced in *Photograms of the Year*, 1903. Photo: private collection, Paris

both for his photographs and his voluminous theoretical and practical writings on the medium.[7] Pictorialism emerged in the latter half of the nineteenth century as a philosophical and aesthetic approach to the photographic medium that strove to differentiate itself from popular and commercial practice and, by century's end, evolved into the first international movement of "high art" photography.[8] Inspired by Impressionism, Symbolism, and deeply indebted to artists of the Aesthetic Movement—James McNeill Whistler chief among them—Pictorialists embraced the motto of "art for art's sake" and the cult of beauty as their own. An international circle of photography clubs and societies established in major European and American cities and the prestigious journals they produced served to link the movement's diverse practitioners, a number of whom held multiple memberships beyond national boundaries.

Paging through the journals of international photographic clubs at the turn of the century and exhibition catalogues documenting Pictorialist activities, one is struck by the atmospheric pastoral idylls, romanticized portraits tinged with nostalgia, picturesque rural land- and cityscapes, and theatrical tableaux. The images feature languishing nudes, and Edenic genre scenes peopled largely by white (predominately female) bodies and faces where the classical concept of beauty reigns supreme.[9] This practice underscores photo historian Peter Bunnell's observation in his introduction to a compilation of key writings from the Pictorialist movement that "Selection [of subject matter] as well as treatment became pivotal in the concept of beauty in photography."[10] Demachy's choice of a model of indeterminate racial identity and gender in the compositions under consideration here is thus noteworthy both for the unorthodox selection and the treatment they were given.

The aim of the Pictorialist movement was to fundamentally redefine ongoing debates about photography's scientific status and its artistic standing. "Science versus art," notes Bunnell, "became the conspicuous issue underlying pictorialism and the most critical concept behind this modern movement."[11] Rejecting the camera's descriptive and empirical role as a conveyor of a presumed reality, participants in this movement embraced photography as a vehicle for personal artistic expression and the elevation of the aesthetic experience. In other words, the medium's capacity to create beauty was trumpeted over its allegiance to truth. While the Pictorialist ideology and style were largely sidelined in the first decades of the twentieth century by the valorization of a formalist modernist aesthetic and desire to promote the medium's unique qualities, the movement's impact and continuing legacy endure.

Demachy was the leading Pictorialist in France, where he was a founding member of the Photo-Club de Paris. His international credentials included being an elected member of the prestigious Linked Ring Brotherhood and honorary member of the Royal Photographic Society in the UK and maintaining a close alliance with photo impresario Alfred Stieglitz and the Photo-Secession in New York. Demachy's writings and photographs, including *Contrasts* and its variants, appeared frequently in the internationally disseminated publications associated with these organizations.

The place of *Contrasts* in the Pictorialist canon was inevitably tied to its appearance in the January 1904 issue of Stieglitz's highly acclaimed international journal *Camera Work* and its subsequent association with the celebrated international *Exhibition of Pictorial Photography* at the Albright Art Gallery in Buffalo, New York in 1910. Captioned with the title *Black and White*, Demachy's composition was one of only nine of the 600 photographs from that exhibition reproduced in *Wilson's Photographic Magazine* a year later in a photographic supplement accompanying critic Sadakichi Hartmann's review.[12] The status of this work was further bolstered by the acquisition of the original gum-bichromate print from Stieglitz in 1913 by the Smithsonian Institution's National Museum of American History in Washington, DC.[13]

The character of the Pictorialist movement with its international network and elaborate publications meant that the work of its participants circulated in an international arena in a manner distinct from other forms of fine art in this period. Inevitably, we must consider the diverse context(s) in which *Contrasts* was consumed—both publicly in exhibition and privately in reproduction—in order to fully appreciate the manner in which its racial subtext would have been perceived by its various audiences. For instance, the meanings derived from Demachy's photograph undoubtedly differed when seen within the framework of European colonial discourse or alternatively through the lens of an early twentieth-century American culture profoundly shaped by racial prejudices rooted in the legacy of slavery. While the comparison of these two different contexts is outside the parameters of this analysis, these frameworks inform the far-reaching implications of representing bodies and cultures at the nexus of black and white.

Moreover, encountering the original gum-bichromate print of Demachy's *Contrasts* in a public exhibition space or privately viewing a photogravure plate of the composition in *Camera Work* would have resulted in different experiences. The photogravure process, a technique descended from the printmaking process of etching, produced images with a charcoal-like finish, tactile quality, and subtle tonalities. The high quality of the gravures—which were made directly from original negatives or prints, printed on Japan tissue, and produced under Stieglitz's supervision—contributed not only to the prestige of the journal but also to the consideration of the value of the plates themselves on a par with the original print versions.[14] Nonetheless, distinctions between the two processes are evident in a shift from the warmer, more compressed tonal range of the original gum-bichromate print to the higher contrast between the black and white tones of the photogravure.

Produced in deluxe editions of 1,000 in this early period, *Camera Work* reached an international audience and was instrumental in advancing the acceptance of photography as a fine art. This forum of dissemination provided the journal's subscribers a form of symbolic ownership with the power to view, hold, and possess on their terms the individuals captured through the camera lens. Individually pasted into each copy, the artistic hand-pulled plates of Demachy's novel image enhance the aura of quality to the publication and defy easy categorization as original art or reproduction.

A variant of *Contrasts* from the same 1900–1901 sitting was published in 1904 in *La Revue de Photographie* illustrating a review of that year's photographic salon (Figure 9.3). Captioned *"Blanc et noir,"* this photograph was cropped to provide a frame within which to set one page of the review. In this composition, which was reproduced as a halftone from a straight, unmanipulated print, Demachy altered the positioning of bust and model. The bust now stands alone in the upper left corner of the picture frame while the model crouches below pressed up against the fireplace upon with the sculpture sits. In lieu of the downcast eyes and demure disposition in the first version or the sideward glance of the second, here the model peers upward from her slightly cocked head and unabashedly returns the viewer's gaze in a subtly coquettish mode. While the playful aspect of the photograph and the quality of the unaestheticized nature of the print undermine the sense of high art to which *Contrasts* clearly strives, the underlying themes of white versus black/cultured versus primitive are sustained and, indeed, given a visual hierarchy.

Blanc et noir. R. Demachy

9.3 Robert Demachy, *Blanc et noir*, page detail from *La Revue de Photographie*, 1904. Photo courtesy of Julien Faure-Conorton

Between art and ethnography: the aestheticized black body and photography's indexical image

Due to photography's indexicality—the trace of the real world that imprints itself on the photographic surface—and its history as a modern means of visualization, images in this medium operate beyond a purely aesthetic level and thus occupy a unique place in the representation of race in pictorial practices of the long nineteenth century. As ostensibly faithful witnesses to a historical reality, photographic depictions of people of color such as *Contrasts* function differently from those in painting, drawing, and sculpture and encourage a deeper political reading. Indeed, photography's indexicality means, as Roland Barthes famously noted, that one "can never deny that *the thing has been there*."[15] Although photographers—like engravers, painters,

or artists working in any medium—certainly took great liberties in their rendering of the objects and individuals before their cameras, their endeavors were further complicated by the intractable faith in the reality of photographs. In other words, as Barthes further elucidates, "every photograph is a certificate of presence."[16] Thus, the anonymity of Demachy's model notwithstanding, the viewer is confronted with an individual whose actual existence at a particular time and place is key to the work's meaning.

Photography emerged in the age of colonial expansion concurrent with nascent fields of anthropology, ethnography, physiognomy, phrenology, and social Darwinism. Playing key, and often insidious, roles as tools in these burgeoning fields of inquiry, photographs were implicated in efforts to present a veneer of scientific justification for ongoing racial discrimination and brutal exploitation rooted in the history of the slave trade.[17] As a number of scholars have chronicled, within the colonial endeavor itself, the camera was ubiquitously present as witness and interpreter not only of the physical, social, and political landscape of subjugated countries but also of colonized bodies.[18]

Largely absent in this wealth of critical literature on representation of the colonized body and ethnographic photography, however, is an examination of self-consciously artistic Pictorialist photographs featuring people of color, such as *Contrasts*. Because scholarship on this movement and its photographs is conventionally focused on aesthetic style and the methods employed in transforming the photographic image—such as soft focus, diffused lighting, special filters and lens coatings, heavy darkroom manipulation, labor-intensive printing processes, sepia toning, and textured printing papers—far less attention has been paid to issues of race or to racial subtexts embedded in a number of Pictorialist works.[19] While the focus on formalist concerns at the expense of recognition of racial content is of course not unique to responses to Pictorialist practice, the intrinsic qualities of the black-and-white medium and the aesthetic ethos of the movement undoubtedly have contributed to this propensity.[20]

Despite the perceived contrast between the aesthetic and subjective goals of Pictorialism and the purportedly scientific and objective goals of ethnography, slippage between the two arenas is evident in images such as Arthur Da Cunha's *Etude* (Figure 9.4). This 1896 portrait of an unidentified black female illustrates the manner in which photographs that otherwise would have been perceived as thinly veiled ethnographic studies were masked under an aesthetic veneer and enfolded into Pictorialist discourse. In this image, the French Pictorialist photographer Da Cunha posed his model in stark profile with her bare shoulder directly exposed to the camera's gaze, invoking conventional ethnographic conceits. Wearing a headscarf into which her hair is neatly bound, the anonymous sitter is marked as a colonial subject for whom proscriptions against uncovered hair reflected anxieties over the unbridled sexuality such individuals were presumed to possess.[21] The model's pose, dress, and racial identity inevitably evoke comparisons between this photograph and the profile variant of Nadar's *Portrait d'une Antillaise (Maria)*

9.4 Arthur Da Cunha, *Etude*, 1896. Carbon print. Photo courtesy of PhotoSeed

from half a century earlier portraying a black female from the Antilles, a term that encompassed the French colonial possession of the islands of the West Indies. Despite their similarities, Nadar's endeavors were not considered to be art during his time; artistic aspirations notwithstanding, for the first decades of the photographic medium's rapid proliferation into every aspect of modern life, it was singularly perceived as handmaiden to science and commerce.[22]

Da Cunha's *Etude*, in contrast, was clearly intended and received as a work of art within the Pictorialist ethos. The most significant qualities distinguishing Da Cunha's image from any of a number of nineteenth-century ethnographic or anthropological studies are common Pictorialist tools of costume, diffused lighting, soft focus, and use of the carbon printing process. The photographer's aesthetic intentions are conveyed through this laborious printing technique that produces luminous tonalities and long scale of values held to be unique to the expressive character of the medium.[23] Moreover, the folds of undecorated cloth in which the model is neatly draped and the bust-like quality of the otherwise disembodied figure evoke a classical air. This presentation is in sharp contrast to the busy floral motif of the skirt sported by Nadar's model (yet another marker of her exotic otherness) that dominates the lower third of the picture plane and bursts beyond the frame in his composition.

The fact that form prevailed over content in the reception of Da Cunha's image is evident in a review of the 1896 Paris Salon in the *Bulletin du Photo-Club de Paris* in which the female sitter's otherness took backstage to the aesthetic quality of the print. Accompanying a small halftone reproduction of the "*négresse*," as she was referred to, were words of admiration for the "superior study" that was "boldly portrayed."[24] Even though the photograph is little known today, its Pictorialist credentials at the time were solidified in the April 1900 issue of the prestigious French journal *L'Art Photographique*, where it was reproduced as a large halftone with the title *Portrait à l'atelier* (Portrait in the studio).[25]

Despite its positive reception, the question remains as to how this image was understood within the Pictorialist dedication as depicting beauty at a time in which social Darwinism and other racist ideologies were promulgating the notion of racial hierarchies in which the black model would have been relegated to the lowest rungs. In Demachy's and Da Cunha's decisions to sympathetically depict individuals whose racial identities positioned them outside European society, they were perhaps influenced by romantic notions of "exoticism as an aesthetic of the diverse," a concept articulated in the writings of their contemporary, the French ethnographer and art critic Victor Segalen. Claiming that "[i]t is through Difference, and in the Diverse, that existence is exalted," Segalen adopted a vision of the emerging modern world that embraced rather than decried its changing racial complexion.[26]

Interpretations of Gertrude Käsebier's 1903 gum-bichromate print—notably titled *Black and White* (Figure 9.5)—provide yet another example of how the proclivity to blindly accept Pictorialism's subjugation of content to form have served to deflect attention from issues of racial representation.

9.5 Gertrude Kasebier, *Black and White*, 1903. Gum-bichromate print. Digital Image
© The Museum of Modern Art / Licensed by SCALA / Art Resource, NY

In this photograph by one of the founding members of Stieglitz's Photo-Secession group in New York, a black washerwoman is set against the backdrop of white laundry and dark stockings hanging on an outdoor clothesline, creating an interplay between the black and white forms and horizontal and vertical lines. The formal qualities of the image are enhanced by the diffused, graphic quality of the photograph's surface, an effect produced by the gum-bichromate printing process. Exhibited at Stieglitz's 291 Gallery in New York in 1906, *Black and White* was celebrated both at the time and subsequently for its sense of aesthetic harmony, with little attention paid to the racial dynamics at play.

In the catalogue accompanying a major exhibition of Käsebier's work at the Museum of Modern Art in 1992, for example, the photographer's conception of *Black and White* is presented by author Barbara L. Michaels as simply "an informal portrait and an exercise in contrasts."[27] Michaels further argues that "the picture nods to tradition, harking back to numerous French paintings of laundresses and more specifically referring to the bent figures of Millet's *Gleaners*." Despite the author's apparent afterthought that "the photograph also synthesizes Käsebier's earlier photo of a white laundress with an 1893 sketch of a black train porter that she also considered a study in black and white," race as a subject meriting examination is totally disregarded.

In *The Black Female Body: A Photographic History*, Deborah Willis and Carla Williams challenge such conventional readings of Käsebier's photograph. They argue that the complexity of the composition lies in the representation of the smiling laundress and the tension between the "black body as worker and the black body as object [transforming] into poetry what is essentially a social document."[28] However, Käsebier's *Black and White* is one of the few Pictorialist images discussed or reproduced in their otherwise comprehensive study on racial representations of the black female body. The only other Pictorialists the authors briefly mention are Edward Curtis, F. Holland Day, and Alvin Coburn, three photographers whose aestheticized representations of Native Americans and African Americans have been singled out and garnered a modicum of critical attention elsewhere. However, despite acknowledging that "ethnographic subjects were popular among the Pictorialist photographers," Willis and Williams make only passing mention of an artistic movement that has largely remained marginal in critical discourses on race and representation.[29]

The aestheticized practice by Pictorialist photographers such as Käsebier and Demachy was based on the movement's contention that an alliance between photographic and other graphic arts would secure the acceptance of photography as a legitimate art form. They adopted new techniques and styles through which contemporaneous artistic practices could be evoked. The gum-bichromate process used to create both Käsebier's *Black and White* and Demachy's *Contrasts*, for example, produces a painterly effect through the manipulation of the photograph's surface during the printing process; this endows the work with a sense of singularity as a carefully crafted fine art object.

Demachy is credited for rediscovering and popularizing this obscure process, which was soon embraced by other Pictorialist photographers as a means for advancing the aesthetic pretensions of their movement and enhancing the print's value as a unique work of art.

Pictorialism and Orientalism

By masking the descriptive or documentary quality of the medium with the marks of artistry, Pictorialist photographers, paradoxically, inverted the goals of many nineteenth-century academic painters, particularly those working in the Orientalist tradition such as Jean-Léon Gérôme.[30] Unlike the Pictorialists, who strove to make their photographs appear like paintings, these artists made their canvases look photographic to give them a "reality effect" (in some estimations as a documentary impulse to mask the artistry). This correlation underscores the dynamic dialogue between realism and artifice and the reciprocal influences that were at the heart of artistic developments in all media over the course of the nineteenth century.[31] Indeed, a rich exchange between painters and photographers fueled Orientalist practice over the course of the nineteenth century, fostered by a generation of itinerant photographers anxious to exploit the possibilities offered by the expansion of colonial activities.[32]

Although the painterly effect in Demachy's images such as *Contrasts* worked against the grain of both the academic style of Orientalist painters and the documentary style of ethnographic photographers, his compositions, too, were indebted to such practices in which the construct of an imaginary "other" served to advance Western fantasies and reveries. As Adrienne Childs elucidates in her contribution to this volume and elsewhere, the use of contrast as an aesthetic device in Orientalist compositions such as *Gérôme's Moorish Bath* (1872) (Figure 6.4) underlies much of the appeal of a number of eighteenth- and nineteenth-century paintings in which blackness and whiteness are juxtaposed.[33] Although Demachy's *Contrasts* clearly draws on this tradition in its artistic aspirations, it is also on another level implicated in ethnographic photography that was premised on notions of difference in other, more overtly colonialist ways.[34]

The multifaceted manner in which both colonialist activities and Orientalist discourse intersected in Demachy's work is illustrated in his own creative practice. Visiting the 1889 Exposition Universelle in Paris and the 1895 Exposition Coloniale at the Trocadéro and the Champs-de-Mar, he created a body of photographs documenting "natives" staged in ersatz natural habitats in the Sudanese and Javanese pavilions.[35] As Anne Maxwell notes in her study of the role of photography in these and other colonial exhibitions, the "close connection between the camera and the Great Exhibitions … transform[ed] the fleeting spectacles of racial and cultural difference into permanent, portable objects that could function as memorabilia and collectors' items."[36]

With the aesthetic veneer of works he exhibited or published in Pictorialist journals removed, Demachy's photographs from these colonial enterprises underscore the thin line often dividing ethnographic and artistic photographic activities during this period and the mutability of photographic meaning based on context.

Additionally, Demachy's brief excursion into Orientalist fantasies is evident in a c. 1912 print of his composition *Séance* featuring a (presumably) nude North African female seductively drawing back a curtain and is further confirmed by several other works in his inventories.[37] And in *Contrasts*, where the plunging neckline on the delicate robe of the young model lends a seductive air, a recurrent trope reflected in a passage from Gerard de Nerval's *Voyage en Orient* describing the "natives" is once again evoked: "… apart from this strange physiognomy which nature had endowed them with, their bodies were of a rare and exceptional beauty; pure and virginal forms were clearly visible under their tunics."[38]

Nonetheless, the young girl's pre-pubescent figure in *Contrasts* imparts an androgyny that disrupts an overtly sexualized reading of the photograph even as the aestheticized presentation resists a reading of the image as one of ethnographic documentation. Departing from the principal iconography of the black female body disseminated in Europe since the eighteenth century, the model is represented in a manner that challenges prevailing stereotypical representations of the black female across nineteenth-century literary and visual arts. She is clearly neither a cartoonish character presented to the white viewer for ridicule nor a hyper-sexualized "Hottentot Venus" of European fantasies. Nor does she evoke the *Vénus Africaine* envisioned with ethnographic accuracy by Charles Henri Joseph Cordier in his 1851 sculptural rendering.[39] Even the exotic undertones of the adolescent figure's seductive pose and state of undress fails to evoke the wanton *femme fatale* pervading the arts and popular culture at the *fin de siècle*.[40] Filtered through Demachy's Pictorialist prism where both gender and race are ambiguously rendered, the concept of beauty framed within the black-and-white conceit takes on new layers of meaning.

Beauty, antiquity, and racial hybridity

In his 1901 treatise *Photography as a Fine Art*, the art critic Charles Caffin noted: "There are two distinct roads in photography, the utilitarian and the aesthetic; the goal of one being a record of facts, and the other an expression of beauty."[41] Indeed, the promotion of beauty through artistic manipulation was a central tenet of Pictorialism, as Demachy exemplified in his practice. As one scholar of the movement notes, the French artist "manipulated reality and gave his creations no purpose other than beauty: the ennoblement of the subject aestheticized by sophisticated means."[42]

Among the sophisticated means through which subjects were ennobled in Pictorialist practice was the employment of objects evoking antiquity such

as the bust featured in *Contrasts* and its variants, mirroring the embrace of antiquity at the heart of the classical revival that arose in the eighteenth century. Neoclassical objects also served as metaphor for the normative white body, revealing the racial implications imbedded in the aesthetic predilection for the classical. In her study of nineteenth-century representations of black female subjects, Charmaine Nelson argues, "The nineteenth century's stylistic dependence upon classical sculpture, broadly termed neoclassicism, located the privileging of the white body as the aesthetic paradigm of beauty. Quite simply, the term *classical* was not neutral, but a racialized term that activated the marginalization of blackness as its antithesis."[43]

Operating within this framework, Demachy's *Contrasts* illustrates how race has served as a touchstone in defining age-old Western ideas of beauty and difference. As David Bindman observes in his study of the relationship between the idea of race and aesthetic ideas of the Enlightenment, "attitudes towards non-European peoples were almost always linked to some notion of physical beauty."[44] Indeed, the physiological markers of the white race at the heart of the Greek classical ideal—fair skin, narrow nose, slender lips, facial symmetry, sinuously flowing locks of hair, and lithe body—became the bedrock of Western notions of beauty just as deviations from such characteristics came to define notions of otherness.

This paradigm and oppositional construct are famously personified in Anne-Louis Girodet's *Portrait du Jean-Baptiste Belley* (1797) (Figure 2.6), in which the artist posits a contrast between the figure of Jean-Baptiste Belley, former colonial slave turned deputy to the French assembly, and a white plaster bust of the French abolitionist of the Enlightenment, the Abbé Raynal.[45] Girodet's emphasis on the physiological differences between the forms in the classicized white bust of the illustrious Raynal and Belley's head rendered in what was considered to be typically African physiognomy underscores the common conception that European whites were physiologically, culturally, and aesthetically superior no matter how illustrious the black person might be. In Girodet's painting, as Susan Libby argues in her insightful essay on this image, "black identity coheres only in relation to whiteness and then vacillates among degeneracy, authority and deference."[46]

In Demachy's photograph, the scale, placement, and function of the classically inspired plaster bust of an anonymous young boy serve to construct racial identity in a far more equivocal manner. Tightly cropped by the picture frame and its facial features abraded through pictorial effect, the small-scale bust figures far less prominently in Demachy's composition than in Girodet's. It not only lacks the authority and monumentality of the prominently featured bust of Raynal in Girodet's painting, but it is also relegated to a subordinate position behind the girl, literally overshadowed by her hair. Although the identity of the bust in Demachy's photograph appears uncertain, it was in fact—as Demachy scholar Julien Faure-Conorton recently discovered—a partial cast of a full-length 1818 marble of an idealized young boy by the Italian sculptor Lorenzo Bartolini (1777–1850) titled *L'ammostatore* (The grape presser).[47]

The notion of childhood innocence evoked in this sculpture harkens back to Greek ideas about human perfectibility and became a pervasive theme in nineteenth-century Europe. European society at this time, as Anne Higonnet notes, equated childhood "with nature, hence with an innocent purity of vision and creativity."[48] In selecting the classicized bust of a young boy for his prop, an object the artist singularly employed in his photographs featuring this model, Demachy infused an element of empathetic correspondence between the animate and inanimate youths, creating a dissonance within the composition's overarching construct of difference. Thus, rather than striking a purely discordant note of contrast, the two central elements in the photograph share in evoking a sense of youthful innocence, a perception underscored by their seemingly fused locks of hair.

Operating in an elliptical *in-between* state of racial and cultural identity, to borrow from Homi Bhabha, the young model of indeterminate racial identity in *Contrasts* further complicates the fixity of racial types inherent in the rhetoric of black-and-white binaries.[49] While photography had a unique capacity to explore the aesthetic possibilities of value contrasts and other photographers expressed this fascination using racial contrasts in human subjects, Demachy created a composition in which difference is not only encoded and perpetuated but also challenged. His composition thus exploits photography's intrinsic qualities while paradoxically using the medium to destabilize rather than solidify notions of racial difference.

Ebony and Ivory (Figure 9.6), a composition by leading American Pictorialist F. Holland Day, provides a striking contrast to the French photographer's photograph. Day's far better-known image, in which a classically inspired object is similarly juxtaposed with a black model, is firmly grounded in the symbolism of chromatic polarity.[50] Posing a seated black male nude on a leopard skin, the photographer placed a miniature plaster copy of an antique sculpture in the model's hand, employing the prop as a marker of Western measures of beauty. *Ebony and Ivory* was exhibited in 1897 in London at the Fifth Photographic Salon of the Linked Ring and concurrently published in *Photograms of the Year*, providing a prototype and inspiration upon which Demachy would draw four years later. Day's celebrated image was also reproduced in two issues of the American Pictorialist journal *Camera Notes*, including one in 1898 in which earlier work by Demachy also appeared.[51] It is arguably not merely coincidental that Demachy created his series in 1901, the same year that Day's photograph was on display in Paris at the exhibition Demachy himself organized, *New American Photography / Oeuvres de Fred Holland Day et de la nouvelle école américaine.*

Unlike in Demachy's composition, however, the racial identity of the model in Day's photograph was unambiguous. Indeed, the black skin of the nude male was rendered in the velvety deep hues characteristic of the platinum print, which served to emphasize the tonal distinctions between the black body and white cast figurine. This quality was not lost on the French visitors to the exhibition. Commenting on the *New American Photography* exhibition and what he called Day's "Negro cycle," leading member of the Photo-Club de Paris Constant Puyo wrote:

9.6 F. Holland Day, *Ebony and Ivory*, c. 1899. Photogravure (derived from original c. 1897 platinum print). Image courtesy of The National Gallery of Art, Washington, DC

We discovered M. Day in France a few years ago, through the reproductions of the photographic magazines … His current show still holds several works from that first period, that first cycle we may call—innocent joke—the Negro cycle: *Ebony and Ivory, Head of a Nubian, A Nubian, African Chief*, etc.. Apparently, M. Day takes pleasure in the depiction of that shiny skin, of deep blacks.[52]

Critical accolades for *Ebony and Ivory* on the other side of the Atlantic also referenced the tonal qualities of the model's skin, albeit couched in different terms. Responding to an exhibition in which several of Day's photographs featuring this black model were displayed, the review in *Camera Notes* praised "the varying values and multitudinous gradation of flesh tones [rendered] with such appreciation, sympathy, and truth."[53] While the racial aspect of Day's photograph has drawn critical attention since its first appearance in exhibitions and publications before the turn of the century, the racial complexity of Demachy's *Contrasts* has attracted curiously little comment in either French or international photography journals since the photograph's initial appearance over a century ago.[54]

The conspicuous silence surrounding *Contrasts* can be attributed in part to the implications of a figure whose hybrid racial identification defies the clear black-and-white distinctions demarcated in Day's *Ebony and Ivory* and manifests what Françoise Vergès calls the "matrix of diversity born of colonization." "To the European imaginary," Vergès argues, "métissage was a site of both fascination and repulsion. The poetics and politics of blood invade European literature and sciences in the empire."[55] This invasion of the poetics and politics of blood finds resonance in Demachy's composition, where the racial hybridity of the young model insinuates into the image the tangled stories and demographics of colonial relationships. Even the white bust of an adolescent boy, despite its pretension of youthful innocence, could raise the specter of what Robert Young calls "'colonial desire': a covert but insistent obsession with transgressive, inter-racial sex, hybridity and miscegenation."[56]

Implicit in this obsession was anxiety over maintaining the fiction of the purity and superiority of the white race and trepidation over implications of changing racial demographics. "Miscegenation was a fear (and a word) from the late nineteenth-century vocabulary of sexuality," Sander Gilman notes. "It was a fear not merely of interracial sexuality but of its results, the [presumed] decline of the population."[57] The diplomat and racial theorist Joseph Arthur, comte de Gobineau, made this stance clear in his 1853–5 *Essai sur l'inégalité des races humaines*. "The white race, considered in the abstract, has henceforth disappeared from the face of the earth," Gobineau bemoaned. "Thus, it is now represented only by hybrids."[58] The application of racial taxonomies such as " mulatto," "quadroon," "octoroon," and "creole" to people of mixed race was the by-product of such misguided ideas and served to provide a precise code of discrimination to maintain the established order.

Demachy's composition, featuring what undoubtedly would have been perceived as a product of this love-across-the-color-line taboo, needs to be understood within its historical context and the complex discourses with

which it intersects. The taboo of interracial sex and white male desire of black female bodies—spelled out as the mating of white with black in Rider Haggard's wildly popular 1885 novel, *King Solomon's Mines*—was not only met with trepidation but, as Vergès noted, was also a subject of great fascination.[59] Indeed, it captured the imagination of a generation of French writers as diverse as Baudelaire, Balzac, Zola, Maupassant, and Loti.[60] Demachy's *Contrasts*, it could be argued, aligned itself more with literary and poetic expressions of the day in this regard than with the visual arts, where it remained an outlier. Confounding racial stereotypes that had typically defined representations of blackness in the nineteenth century, *Contrasts* bears markers of a burgeoning modernity, reflecting more nuanced attitudes towards race and anticipating the fascination with all things African that seized the European avant-garde in the coming decades.

At a time in which interracial marriages on both sides of the Atlantic— albeit still rare and viewed with great suspicion—were not unknown, racial theories justifying white superiority that had been held sacrosanct were exposed to increasing scrutiny. Writing to challenge racial prejudices of the day in his 1905 book *Le préjugé des races*, for example, French sociologist Jean Finot argued:

The idea of the races, formerly so innocent, has cast a tragic shroud, so to speak, over the surface of our soil … Peace among peoples and the crown of such peace—that is, the vast solidarity of mankind, the dream of the future—can in any case only triumph when founded on the conviction of the organic and mental equality of peoples and races.[61]

Outlining in the introduction the issues his book addresses, Finot further makes note of "the inanity of all the doctrines of irreducible racial gradations." Such protestations notwithstanding, however, among the general populace in Europe at this time, as Hugh Honour notes in *The Image of the Black in Western Art*, "a visceral horror of 'miscegenation' exacerbated by colonialist propaganda still prevailed, limiting reference to it in works of art."[62] Notably, *Contrasts* operates in this artistic void.

The manner in which Demachy grappled with the racial representation of his model and the indexicality of skin color are manifest in a comparison of *Contrasts* with another published variant of this composition. Whereas both images show obvious traces of manipulation, the artist's hand is more dramatically present in the untitled version published in London in *Photograms of the Year* in 1903 (Figure 9.2). In contrast to the harmonious sense of communion conveyed between the model and bust in the image reproduced in *Camera Work* (Plate 8, Figure 9.1), a slight tension surfaces in the variant. Here the model strains backwards away from the sculpted bust with a sideward glance toward the viewer while the exaggerated shadows around the blank eyes of this inanimate male youth create the impression that he is looking askance at the reluctant figure. The young girl's body has disappeared into an ethereal trace, transforming the figure into a bust-like

vignette and strangely equilibrating the two disembodied forms. Demachy has clearly worked this image more extensively, physically enhancing the shadows around the bust and under the model's chin in a manner that draws attention to her physiognomy. While he manipulated this print to render her skin tones more deeply, her identity remains enigmatic. Although Demachy may or may not have been aware of the contradiction posed by his ambiguous rendering of the dichotomous racial construct of black and white, the artist's repeated engagement with the compositional elements of this bust and model suggest a degree of complicity in the contemporary obsession with race.

However complex the young girl's particular ethnic background might be—North African, Caribbean, or other mix of European and African heritage—the viewer is nonetheless encouraged through the compositional juxtaposition (and title) to read her in all versions of this photograph as "black" in contradistinction to the explicit and implicit whiteness of the chalky plaster bust. In her examination of ideas of race in nineteenth-century writings in which the black female body is of central concern, T. Denean Sharpley-Whiting identifies "a particular black and white dichotomy, or Africanist construction, in which mulâtresses, even Creoles, are racialized into blackness … Race, ethnicity, cultural distinctions are collapsed into one black/*négre* stereotyped abyss."[63] Ultimately, this same phenomenon is at play in Demachy's images where the dramatic contrast between the young girl's bushy hairstyle with its distinctive texture and the sinuous curls softly framing the face of her male European sculptural counterpart serves to punctuate the photograph's embedded dualities and racialize the model into a singular "black/*nègre* stereotyped abyss" despite other factors that destabilize such racial dichotomies.

The fetishization of "African" hair as a trope of black exoticism reflected in *Contrasts* found public expression decades earlier in Baudelaire's "La chevelure," one of the most famous poems of the nineteenth century from his 1861 tour de force, *Les fleurs du mal*.[64] In his amorous poem to Jeanne Duval, the woman his mother called the "Black Venus," the poet sinks into the ecstasy of smelling and touching his mistress's "fleecy locks" and "tumultuous tresses." Baudelaire's literary evocation of black hair as a signifier of exoticized racial difference is visually echoed in the figure as she appears in all versions of Demachy's composition.

Moreover, for Parisian viewers of Demachy's images, the model's unruly coiffure would have been perceived not only as a clear marker of her racial identity but also inevitably would have evoked comparison with Jean-Baptiste Carpeaux's *Négresse* (Figure 9.7), the sculptor's masterful study for the personification of Africa on his sculpture *Four Parts of the World Sustaining the Globe* (*Les quatre parties du monde soutenant la sphère céleste*).[65]

Indeed, the untamed tresses on Carpeaux's figure, the monumental bronze version of which was installed in 1874 in the Luxembourg Gardens in Paris, are remarkably similar to those of the model in Demachy's photograph. The association between the Demachy's living model and Carpeaux's allegorical

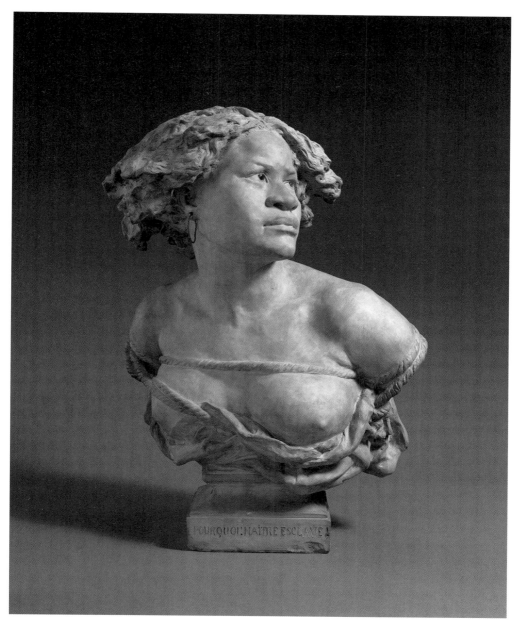

9.7 Jean-Baptiste Carpeaux, *La négresse*, 1872. Cast terracotta. The Metropolitan Museum of Art, Gift of James S. Deely, 1997, in memory of Patricia Johnson Deely, 1997 (1997.491)

Africa would have resonated with an audience familiar with this form whether as part of the public fountain sculpture, in the original plaster study on display in the Paris Salon of 1872, or in one of the celebrated terracotta casts produced by Carpeaux and his atelier. Equally significant to the similarities in hairstyle, however, are the distinctions in physiognomy, with the racial ambiguity of Demachy's model standing in contrast to the Negroid features clearly articulated in Carpeaux's "*négresse.*"

Demachy's compositions thus function on formal and conceptual levels both to perpetuate and confound the aesthetic and racial dichotomies they evoke. Even the stability of the image as a mimetic form of representation is eroded as a result of the gum-bichromate process; through the intervention of the artist's hand in manipulating the print, this technique complicates the photograph's indexical quality, challenging entrenched perceptions about the medium's fidelity to truth while undermining a reading of the work as an ethnographic study of a generalized racial "type." As a consequence, *Contrasts* blurs distinctions between photography and painting even as it complicates seemingly inviolable boundaries between black and white. Nonetheless, faced with the "photographic referent"—what Barthes identifies as "the *necessarily real* which has been placed before the lens, without which there would be no photograph"—we are forced to acknowledge the model as a particularized individual whose existence could not be dismissed as a figment of the artist's imagination.[66] Indeed, what we face is the instability of racial categories and the complexity of a shifting paradigm of racial and colonial discourse in which notions of blackness as an unequivocal construct were increasingly contested.

Even as *Contrasts* harkens back to diverse nineteenth-century tropes of blackness and ethnographic modes of representation, it prefigures racial discourses that came to be embedded in myriad creative activities over the ensuing decades. Indeed, black and white as a leitmotiv resurfaces throughout early twentieth-century artistic practice not only as reference to qualities of the medium but also as a thematic and formal concern in which race is frequently imbedded. The photograph *Noire et blanche* (Figure 9.8), by the American artist Man Ray exemplifies this phenomenon. First published in Paris *Vogue* in May 1926, this iconic photograph inverts the racial signifiers in *Contrasts* and translates issues at the heart of Demachy's Pictorialist composition into a modernist photographic syntax.[67] The darkly patinated, carved African mask in *Noire et blanche* supplants the plaster classical bust in *Contrasts* and the unmistakably white, European model epitomizing the New Woman provides an unequivocal contrast as a marker of racial difference.[68] Activated by this juxtaposition is the trope of black and white in the discourse around primitivism and modernity that permeated early twentieth-century artistic activities.[69] As an avid visitor to Stieglitz's 291 Gallery in the decade of his artistic career prior to moving to Paris in 1921 and the contributor of an homage to the gallery and its director in a special edition of *Camera Work* (the journal in which *Contrasts* was initially published), Man Ray may well have been familiar with Demachy's photograph and was perhaps even inspired by the formal and conceptual possibilities it suggested.[70]

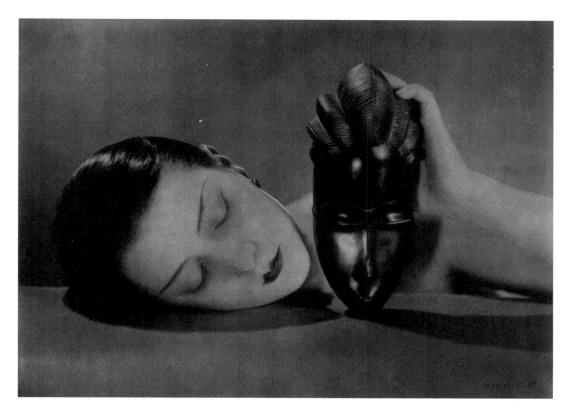

Whatever modernist aspirations or influences one might claim for Demachy's photograph, however, it was clearly a Janus-headed image firmly rooted in the ethos of the nineteenth century. Created at a time in which the moral certitudes of the oppositional black-and-white conceit based on a juxtaposition of sub-Saharan black and European white bodies were being shaken, it operated and continues to operate in the gray territory between black and white.

9.8 Man Ray, *Noire et blanche*, 1926. Silver gelatin print. © 2014 Man Ray Trust / Artists Rights Society (ARS), New York / ADAGP, Paris

Notes

I am grateful to the editors of this volume, Adrienne L. Childs and Susan H. Libby, for their encouragement and insights at every stage of this project. I would also like to thank Martha Bari, Elizabeth Harney, and Kirsten Hoving for their critical editorial eye and thoughtful input. This chapter is deeply indebted to Demachy scholar Julien Faure-Conorton whose archival research was instrumental in developing its content and whose generous support at all stages has greatly enriched the final product. Julien's and Adrienne's assistance in procuring images for reproduction is also much appreciated.

1 Robert de La Sizeranne, "La photographie est-elle un art?," reprinted in Peter C. Bunnell, ed., *The Aesthetics of French Photography: Two Studies* (New York: Arno Press, 1979).

2 The female gender of the sitter is supported through archival photographs at the Société française de Photographie in Paris and the Musée Nicéphore Niépce, Chalon-sur-Saône, of what is arguably this same model at a more mature age. Julien Faure-Conorton, "'Blanc et Noire' / 'White and Black': Note on Two 'Exotic' Models Photographed by Robert Demachy," unpublished document. On the bust, see n. 52 below. A variant of this composition that includes the same plaster bust and the same model reading from an oversized book exists as a glass-slide positive in Demachy's archives at the Société française de Photographie, Paris (accession number 99 PP 851).

3 *Camera Work* 5 (January 1904); *Wilson's Photographic Magazine* 47 (1911): 20. Variants of *Contrasts* were also reproduced in *Photograms of the Year* (1903): 11 and *Le Revue de Photographie* (1904): 279. In his unpublished inventory of Demachy's photographs, Julien Faure-Conorton accounts for negatives and prints for seven different compositions from the 1901 sitting featuring this model and bust.

4 Christopher L. Miller, "Baudelaire in the Nineteenth Century: Black and White in Color," in *Blank Darkness: Africanist Discourse in French* (Chicago: University of Chicago Press, 1985), 69–138.

5 See Simon Gikandi, "Picasso, Africa, and the Schemata of Difference," *Modernism/modernity* 10, no. 3 (September 2003).

6 See Roland Barthes, "The Rhetoric of the Image," *Image, Music, Text*, trans. Stephen Heath (New York: Hill and Wang, 1977), 32–51.

7 See Bill Jay, *Robert Demachy 1859–1936, Photographs and Essays* (New York: St. Martins Press, 1974); *Robert Demachy photographe*, exh. cat. (Paris: Contrejour, 1980). Also, forthcoming, Julien Faure-Conorton, "Contextualisation, caractérisation et réception de la production photographique de Robert Demachy (1859–1936)" (PhD diss., Ecole des hautes études en sciences sociales).

8 The literature on Pictorialism is extensive. Some of the most recent publications include: Thomas Padon, ed., *TruthBeauty: Pictorialism and the Photograph as Art, 1845–1945* (Vancouver: Vancouver Art Gallery, 2008); Philip Prodger, ed., *Impressionist Camera: Pictorial Photography in Europe, 1888–1918* (London and New York: Merrell and St. Louis Art Museum, 2006).

9 The Pictorialist canon and its historical narrative have been defined by its white participants. While a few African-American photographers such as Cornelius M. Battey represented black subjects in the Pictorialist style, they operated largely outside the parameters of the movement. See Deborah Willis, *Reflections in Black: A History of Black Photographers 1840 to the Present* (New York: W.W. Norton, 2000); Michael Bieze, *Booker T. Washington and the Art of Self-Representation* (New York: Peter Lang, 2008), 102–3.

10 Peter C. Bunnell, ed., *A Photographic Vision: Pictorial Photography, 1889–1923* (Salt Lake City: Peregrine Smith, 1980), 2.

11 Ibid., 2.

12 On the exhibition, see *Catalogue of the International Exhibition Pictorial Photography* (Buffalo, NY: Albright Art Gallery, 1910). Although this work is not included in the 20 photographs by Demachy listed in the catalogue, it was reproduced without commentary in a publication dedicated to the exhibition in *Wilson's Photographic Magazine* 47 (1911): 20. While scant records from this period make it difficult to trace full exhibition history with certainty, the only known previous exhibition of this composition was a variant displayed in London in 1903.

13 *Contrasts* was one of 26 photographs the photo entrepreneur considered
 exemplary art photography at the turn of the century. On the collection of
 photographs Stieglitz selected to sell to the Smithsonian Institution in 1913,
 see Carolyn Ureña, "The Alfred Stieglitz Collection at the National Museum of
 American History," *History of Photography* 35, no. 4 (2011): 388–93.

14 The importance Stieglitz gave to the printing process is reflected in the fact that
 a page was devoted to describing the printing methods of the illustrations in 48
 of the 50 issues published. See Marianne Fulton Margolis, *Alfred Stieglitz Camera
 Work—A Pictorial Guide* (New York: Dover Publications, 1978).

15 Roland Barthes, *Camera Lucida: Reflections on Photography*, trans. Richard Howard
 (New York: Hill and Wang, 1981), 76.

16 Ibid., 87.

17 See Melissa Banta and Curtis M. Hinsley, *From Site to Sight: Anthropology,
 Photography, and the Power of Imagery* (Cambridge, MA: Peabody Museum Press,
 1986); Elizabeth Edwards, ed., *Anthropology and Photography 1860–1920* (New
 Haven: Yale University Press, 1992); Elizabeth Edwards, "Evolving Images:
 Photography, Race and Popular Darwinism," in *Endless Forms: Charles Darwin,
 Natural Science and the Visual Arts*, ed. Diana Donald and Jane Munro (New
 Haven: Yale University Press, 2009); Phillip Prodger, *Darwin's Camera: Art and
 Photography in the Theory of Evolution* (New York: Oxford University Press, 2009).

18 See Eleanor M. Hight and Gary D. Sampson, ed. *Colonialist Photography: Imag(in)
 ing Race and Place* (London: Routledge, 2002); James R. Ryan, *Picturing Empire*
 (Chicago: University of Chicago Press, 1997); Anne Maxwell, *Colonial Photography
 and Exhibitions: Representations of the Native and the Making of European Identities*
 (London: Leicester University Press, 1999); and Christraud Geary, "The Black
 Female Body, the Postcard, and the Archives," in *Black Womanhood: Images, Icons,
 and Ideologies of the African Body*, ed. Barbara Thompson (Seattle: University of
 Washington Press, 2008), 143–61.

19 For evidence of the uneasy way in which the aesthetics of Pictorialism function
 within discourses on race and ethnographic representation, see Heather
 Waldroup, "Ethnographic Pictorialism: Caroline Gurrey's Hawaiian Types at the
 Alaska–Yukon–Pacific Exposition," *History of Photography* 36, no. 2 (2012): 172–83.

20 Griselda Pollock's insightful critique of the reception of Edouard Manet's
 Olympia (1862–63) illustrates how formalist concerns have often overridden
 attention paid to racial content. Griselda Pollock, *Differencing the Canon* (London:
 Routledge, 1999), 254–306.

21 See Shane White and Graham J. White, "Slave Hair and African-American
 Culture in the Eighteenth- and Nineteenth-Centuries," *Journal of Southern History*
 61 (1995): 45–76.

22 See Deborah Willis and Carla Williams, *The Black Female Body: A Photographic
 History* (Philadelphia: Temple University Press, 2002), 25. Nadar's photograph
 of a woman presumed to have been his servant remains outside the pantheon
 of prestigious figures for which the man considered the premier French portrait
 photographer of the nineteenth century is widely known. Indeed, it is a rare
 example from this period in which, Willis and Williams note, "the ethnographic
 aesthetic attains an artful as well as commercial purpose."

23 In contrast to typical black-and-white photographic prints, which are made from
 silver or other metallic particles suspended in a uniform layer of gelatin, a carbon
 print is a photographic print with an image consisting of pigmented gelatin.

The labor-intensive, time-consuming and technologically demanding carbon-printing process produced beautiful images of great aesthetic appeal to the Pictorialists.

24 "De M. da Cunha nous admirons une magistrale étude de négresse (n[o.]198) très hardiment campée ..." (From M. da Cunha, we admire a superior study of a negro woman very boldly depicted/portrayed). *Photo-Club de Paris — Exposition d'Art photographique, Troisième année* (1896): 200–201. I am grateful to Julien Faure-Conorton for bringing this citation to my attention.

25 *L'art photographique* (April 1900). This prestigious French publication, whose aim was to publish large reproductions of the best examples of French pictorial photography, lasted only one year (July 1899–June 1900).

26 Victor Segalen, *Essai sur l'exotism: Une esthétique du divers (Notes)* (Montpellier: Fata Morgana, 1978). The citation is from notes Segalen made between 1904 and 1918 for the essay he never completed. Cited in Hugh Honour, *The Image of the Black in Western Art*, vol. 4, *From the American Revolution to World War I*, part 2, *Black Models and White Myths* (Cambridge, MA: Harvard University Press, 1989), 229.

27 Barbara L. Michaels, *Gertrude Käsebier: The Photographer and Her Photographs* (New York: Harry N. Abrams, 1991), 96.

28 Willis and Williams, *Black Female Body*, 121.

29 Ibid., 29.

30 The little-known relationship between Gérôme and Demachy adds another twist to this narrative. Indeed, Gérôme and Demachy were well acquainted and the painter was a member of the jury of the Salons of the Photo-Club de Paris. See Julien Faure-Conorton, "Le nu d'atelier dans l'oeuvre photographique de Robert Demachy (1859–1936)," *Histoire de l'art*, no. 66 (April 2010): 95–106.

31 See Aaron Scharf, *Art and Photography* (New York: Viking Penguin, 1974); Erika Billeter and J. Adolf Schmoll gen. Eisenwerth, *Malerei und Photographie im Dialog: Von 1840 bis heute* (Bern: Benteli, 1979); Dorothy Kosinski, *The Artist and the Camera: Degas to Picasso* (Dallas, TX: Dallas Museum of Art, 1999).

32 See Ken Jacobson, *Odalisques and Arabesques*: *Orientalist Photography 1839–1925* (London: Quaritch, 2007).

33 On *Gérôme's Moorish Bath*, see also Adrienne L. Childs, "Slavery, Seduction and Ethnography in Orientalist Painting," chapter in "The Black Exotic: Tradition and Ethnography in Nineteenth-Century Orientalist Art" (PhD diss. University of Maryland, 2005), 82–140.

34 See Michel Frizot, "Body of Evidence: The Ethnophotography of Difference," in *A New History of Photography* (Cologne: Könemann, 1998), 258–71; Allan Sekula, "The Body and the Archive," in *The Contest of Meaning: Critical Histories of Photography*, ed. R. Bolton (Cambridge, MA: MIT Press, 1992); John Pultz, "Colonialism, Race, and the 'Other,'" *Photography and the Body* (London: Orion, 1995), 20–26.

35 Fifty-two photographs identified as taken at the 1889 and 1895 expositions are archived in France at the Musée Nicéphore Niépce in Chalon-sur-Saône. Two others housed in the collection of the Société française de Photographie are reproduced in *Robert Demachy photographe*, 70–71.

36 Maxwell, *Colonial Photography and Exhibitions*, 9.

37 Demachy's *Programme d'une séance chez George Legram* (1912), a print made from
 a presumably earlier negative, is in the collection of the Library of Congress:
 see http://www.loc.gov/pictures/item/2004674299/. My thanks to Verna Curtis
 for her assistance in making this print and other works by Demachy in the
 LOC collection available for study and her insights on the photographer.
 Corresponding photographs appear in Julien Faure-Conorton's unpublished
 inventory of Demachy's photographs compiled from archival sources and titled
 by Faure-Conorton *Femme d'Orient*, *Orientale*, and *L'Orient*. I am grateful to Julien
 for sharing this valuable research material with me.

38 Gerard de Nerval, *Voyage en Orient*. See discussion of this text in Adrienne
 Childs's chapter "Exceeding Blackness" in this volume.

39 See T. Denean Sharpley-Whiting, *Black Venus: Sexualized Savages, Primal Fears, and
 Primitive Narratives in French* (Durham, NC: Duke University Press Books, 1999);
 Charmaine Nelson, "*Venus Africaine*: Race, Beauty, and African-ness," in *Black
 Victorians: Black People in British Art 1800–1900*, ed. Jan Marsh (Burlington, VT:
 Lund Humphries, 2005), 46–56; and Janell Hobson, *Venus in the Dark: Blackness
 and Beauty in Popular Culture* (New York: Routledge, 2005); Laure de Margerie,
 et al., *Facing the Other: Charles Cordier (1827–1905) Ethnographic Sculptor* (Abrams,
 2004); James Smalls, "Exquisite Empty Shells: Sculpted Slave Portraits and the
 French Ethnographic Turn," in *Slave Portraiture in the Atlantic World*, ed. Agnes
 Lugo-Ortiz and Angela Rosenthal (Cambridge: Cambridge University Press,
 2013).

40 See Elaine Showalter, *Sexual Anarchy: Gender and Culture at the* Fin de Siècle
 (London: Virago Press, 1992); Bram Dijkstra, *Idols of Perversity: Fantasies of
 Feminine Evil in* Fin-de- Siècle *Culture* (New York: Oxford University Press, 1986).

41 Charles Caffin, *Photography as a Fine Art* (New York: Doubleday, Page, 1901), 9.

42 Kristina Lowis, biographical entry on "Robert Demachy," in *Impressionist Camera:
 Pictorial Photography in Europe, 1888–1918*, ed. Philip Prodger (St. Louis: St. Louis
 Art Museum, 2006), 291.

43 Charmaine A. Nelson, *Representing the Black Female Subject in Western Art* (New
 York: Routledge, 2010), 141. See also Charmaine Nelson, "So Pure and Celestial
 a Light": Sculpture, Marble, and Whiteness as a Privileged Racial Signifier," in
 The Color of Stone: Sculpting the Black Female Subject in Nineteenth-Century America
 (Minneapolis: University of Minnesota Press, 2007).

44 David Bindman, *Ape to Apollo: Aesthetics and the Idea of Race in the Eighteenth
 Century* (Ithaca, NY: Cornell University Press, 2002), 7.

45 See Helen D. Weston, "Representing the Right to Represent: The 'Portrait of
 Citizen Belley, Ex-Representative of the Colonies' by A.-L. Girodet," *RES:
 Anthropology and Aesthetics*, no. 26 (Autumn 1994): 83–99; Darcy Grimaldo
 Grigsby, "Black Revolution Saint-Domingue," in *Extremities: Painting Empire in
 Post-Revolutionary France* (New Haven: Yale University Press, 2002); and Susan
 Houghton Libby, "'A Man of Nature, Rescued by the Wisdom and Principles of
 the French Nation': Race, Ideology, and the Return of the Everyday in Girodet's
 Portrait of Belley," in *Performing the "Everyday": The Culture of Genre in the
 Eighteenth Century*, ed. Alden Cavanaugh (Newark: University of Delaware Press,
 2007), 106–19.

46 Libby, "Man of Nature," 117.

47 Bartolini's original marble sculpture is located today in the Hermitage; a plaster cast
 of the entire sculpture is located in the Galleria dell'Accademia in Florence, Italy.

The Florentine sculptor moved to Paris after studying at the Academy of Florence and found favor with Napoleon and a circle of wealthy patrons. Bartolini carved several busts and full sculptures of Napoleon bas-relief on the Vendôme column. Although *L'ammostatore* is little known today, the popularity of this sculpture in the nineteenth century is reflected in the existence of multiple casts of the figure's head, one of which was recently discovered in a Paris flea market by Julien Faure-Conorton.

48 Anne Higonnet, "What do You want to Know about Children?" in Marilyn R. Brown, ed., *Picturing Children: Constructions of Childhood Between Rousseau and Freud* (Aldershot: Ashgate, 2002), 202.

49 Homi K. Bhabha, "Interrogating Identity: Frantz Fanon and the Postcolonial Prerogative," *The Location of Culture* (1994; repr. London: Routledge Classics, 2004), 85. See also Claude Blanckaert, "Of Monstrous Métis? Hybridity, Fear of Miscegenation, and Patriotism from Buffon to Paul Broca Peabody," in *The Color of Liberty: Histories of Race in France*, ed. Sue Peabody and Tyler Stovall (Durham, NC: Duke University Press, 2003), 42–70.

50 The original was a platinum print which produced a large tonal range with rich blacks and delicate gray mid-tones, a technique favored by the Pictorialists for its artistic effects.

51 See n. 10.

52 Constant Puyo, "L'Exposition de M.H. Day et de la 'Nouvelle école américaine,'" *Bulletin du Photo-Club de Paris* (1901): 131. "Nous connûmes ici M. Day, voici quelques années, par les reproductions des magasines photographiques, comme un portraitiste distingué et comme un artiste sachant traiter avec habileté le nu masculin … Son exposition d'aujourd'hui renferme encore un certain nombre d'oeuvres de cette première période, de ce premier cycle qu'on pourrait appeler,—plaisanterie innocente—le cycle du Nègre: *Ebène et ivoire*, *Tête de Nubien*, *Un Nubien*, *Chef africain*, etc. M. Day se complaît visiblement dans le rendu de cette chair luisante, aux noirs profonds." Cited in unpublished manuscript by Julien Faure-Conorton.

53 W.M.M., "F.H. Day's Exhibition of Prints," *Camera Notes* 2, no. 1 (July 1898): 22. A similar fixation a century earlier with the juxtaposition of dark skin and white drapery in Marie Benoit's *Négresse* (1800), as discussed in the introduction to this volume, illustrates the durability of such critical reactions.

54 See Estelle Jussim, "F. Holland Day's 'Nubians,'" *History of Photography* 7, no. 2 (April–June 1983): 131–41; Barbara L. Michaels, "New Light on F. Holland Day's Photographs of African Americans," *History of Photography* 18, no. 4 (Winter 1994): 334–47; Cherise Smith, "White on Black: Power Relations in F. Holland Day's *Ebony and Ivory*," *Exposure* 4, no. 1 (Spring 2009): 33–42. *Ebony and Ivory* was exhibited in London in 1897 at the Fifth Photographic Salon of the Linked Ring and published in Gleeson White, *Photograms of 1897* (London: Linked Ring, 1897). It was subsequently reproduced in *Camera Notes* 1, no. 3 (1897) and *Camera Notes* 2, no. 1 (July 1898). *Camera Notes* was the journal published by the Camera Club of New York from 1897 to 1903 and edited, for the majority of its run, by photo impresario Alfred Stieglitz.

55 Françoise Vergès, *Monsters and Revolutionaries: Colonial Family Romance and Métissage* (Durham, NC: Duke University Press, 1999), 8.

56 Robert C. Young, *Colonial Desire: Hybridity in Theory, Culture and Race* (London: Routledge, 1995), xii. See also Ann Laura Stoler, *Carnal Knowledge and Imperial*

Power: Race and the Intimate in Colonial Rule (Berkeley: University of California Press, 2002).

57 Sander L. Gilman, "Black Bodies, White Bodies: Toward an Iconography of Female Sexuality in Late Nineteenth-Century Art, Medicine, and Literature," *Critical Inquiry* 12, no. 1 (Autumn 1985): 237.

58 Cited in Rozanne McGrew Stringer, "Hybrid Zones: Representations of Race in Late Nineteenth-Century French Visual Culture" (PhD diss., University of Kansas, 2011), 27.

59 In Haggard's book, the first English adventure novel set in Africa and credited with launching a new literary genre known as the "Lost World," an ill-fated interracial romance takes place between an African woman and a white Englishman. As the author concludes: "the sun cannot mate with the darkness, nor the white with the black." Rider Haggard, *King Solomon's Mines* [1885], cited in Young, *Colonial Desire*, 142.

60 On the issue of white male attitudes toward the black female body in the writings of Baudelaire, Balzac, Zola, Maupassant, and Loti, see Sharpley-Whiting, *Black Venus*.

61 Jean Finot, *Le préjugé des races* (1905), trans. as *Race Prejudice* (E.P. Dutton, 1907). In the introduction to the 1907 English translation of Finot's book, which had received wide critical attention on the continent, the author wrote: "Anxious only for truth on the subject of races, we meet on our way with the triumph of justice, equality and fraternity."

62 Honour, *Image of the Black*, vol. 4, part 2, 216.

63 Sharpley-Whiting, *Black Venus*, 8.

64 Charles Baudelaire, "La chevelure," in *Flowers of Evil*, ed. George Dillon and Edna St. Vincent Millay (New York: Harper and Brothers, 1936). This poem first appeared in the second edition of Baudelaire's *Fleurs du mal*, published in 1861.

65 For an insightful discussion of Carpeaux's rendering of Africa for the fountain sculpture, see Charmaine Nelson, "Allegory, Race and the Four Continents," in Nelson, *Representing the Black Female Subject*, 170–178. Demachy's own appreciation of Carpeaux's work is reflected in the fact established by Julien Faure-Conorton that the photographer possessed a small plaster reproduction of the sculptor's famous *Danse*, which he kept in his studio.

66 Barthes, *Camera Lucida*, 76.

67 On *Noire et blanche*, see Whitney Chadwick, "Fetishizing Fashion/Fetishizing Culture: Man Ray's *Noire et Blanche*," *Oxford Art Journal* 18, no. 2 (1995): 3–17; Wendy A. Grossman, "(Con)Text and Image: Reframing Man Ray's *Noire et blanche*," in *Phototextualities: Intersections of Photography and Narrative*, ed. A. Hughes and A. Noble (Albuquerque: University of New Mexico Press, 2003), 119–35.

68 Kiki (Alice Prin), the quintessential New Woman who served as model for *Noire et blanche*, was Man Ray's muse and lover and an artist in her own right. The mask from the Baule peoples of Ivory Coast is a portrait of a revered woman from the community worn by males dancers in a ceremonial performance, thus injecting an object with complex gender signifiers characteristic of this artist and the Surrealist movement in which he participated.

69 On modernist primitivism and the role of race in this discourse, see Sieglinde Lemke, *Primitivist Modernism: Black Culture and the Origins of Transatlantic*

Modernism (Oxford: Oxford University Press, 1998); Carole Sweeney, *From Fetish to Subject: Race, Modernism, and Primitivism, 1919–1935* (Westport, CT: Praeger, 2004).

70 Man Ray, "Impressions of 291," *Camera Work* 47 (dated July 1914, published January 1915), 61.

Selected Bibliography

Abrahams, Roger D. *Singing the Master: The Emergence of African American Culture in the Plantation South*. New York: Pantheon Books, 1992.

Ackerman, Gerald M. *Jean-Léon Gérôme: Monographie révisée, catalogue raisonné mis à jour*. Courbevoie: ACR, 2000.

Alhadeff, Albert. *The Raft of the Medusa: Géricault, Art and Race*. London: Prestel, 2002.

Allan, Scott, and Mary Morton, eds. *Reconsidering Gérôme*. Los Angeles: J. Paul Getty Museum, 2010.

Ames, Eric. *Carl Hagenbeck's Empire of Entertainments*. Seattle: University of Washington Press, 2008.Bacholet, Raymond, et al. *Négripub: L'image des noirs dans la publicité depuis un siècle*. Paris: Somogy, 1992.

Barthes, Roland. *Camera Lucida: Reflections on Photography*. Translated by Richard Howard. New York: Hill and Wang, 1981.

Bean, Annemarie, James V. Hatch, and Brooks McNamara, eds. *Inside the Minstrel Mask: Readings in Nineteenth-Century Blackface Minstrelsy*. Hanover, NH: Wesleyan University Press, 1996.

Bell, Caryn Cossé. *Revolution, Romanticism and the Afro-Creole Protest Tradition in Louisiana, 1718–1868*. Baton Rouge: Louisiana State University Press, 1997.

Bhabha, Homi. *The Location of Culture*. London and New York: Routledge, 1994.

Bindman, David. *Ape to Apollo: Aesthetics and the Idea of Race in the Eighteenth Century*. Ithaca, NY: Cornell University Press, 2002.

Bindman, David, and Henry Louis Gates, Jr., eds. *The Image of the Black in Western Art*. Vol. 3, *From the "Age of Discovery" to the Age of Abolition*, Part 1, *Artists of the Renaissance and Baroque*. Cambridge, MA: Belknap Press of Harvard University Press, 2010.

——. *The Image of the Black in Western Art*. Vol. 4, *From the American Revolution to World War I*, Part 1, *Slaves and Liberators*. Cambridge, MA: Belknap Press of Harvard University Press, 2010.

Blair, John. "Blackface Minstrels in Cross-Cultural Perspective." *American Studies International* 28, no. 2 (October 1990): 52–65.

Blanchard, Pascal, et al., eds. *Human Zoos: Science and Spectacle in the Age of Colonial Empires*. Liverpool: Liverpool University Press, 2008.

Boime, Albert. *The Art of Exclusion: Representing Blacks in the Nineteenth Century*. Washington, DC: Smithsonian Institution Press, 1990.

Brady, Patricia. "Black Artists in Antebellum New Orleans." *Louisiana History: The Journal of the Louisiana Historical Association* 32 (1991): 5–28.

Brody, Jennifer DeVere. *Impossible Purities: Blackness, Femininity, and Victorian Culture*. Durham, NC: Duke University Press, 2012.

Bunnell, Peter C., ed. *A Photographic Vision: Pictorial Photography, 1889–1923*. Salt Lake City: Peregrine Smith, 1980.

Cate, Phillip Dennis, and Mary Shaw, eds. *The Spirit of Montmartre: Cabarets, Humor, and the Avant-Garde, 1875–1905*. New Brunswick, NJ: Jane Voorhees Zimmerli Art Museum, 1996.

Chalaye, Sylvie. *Du noir au nègre: L'image du noir au théâtre de Marguerite de Navarre à Jean Genet (1550–1960)*. Paris: Editions L'Harmattan, 1998.

Champly, Henry. *White Women, Coloured Men*. Translated by Warre Bradley Wells. London: J. Long, 1939.

Chapman, Herrick, and Laura L. Frader, eds. *Race in France: Interdisciplinary Perspectives on the Politics of Difference*. New York: Berghahn Books, 2004.

Charpin, Catherine. *Les arts incohérents (1882–1893)*. Paris: Editions Syros Alternatives, 1990.

Christensen, Olav, and Anne Eriksen. "Kongolandsbyen på Frogner: Fornøyelser på Jubileumutstilling," *Byminner* no. 1 (1993): 18–27.

———. *Hvite Løgner: Stereotype forestillinger om svarte*. Oslo: Aschehoug, 1992.

Courbey, Raymond. "Ethnographic Showcases." *Cultural Anthropology* 8, no. 3 (1993): 338–69.

Coutelet, Nathalie. "Chocolat, une figure de l'altérité sur la piste." *Les cahiers de l'idiotie (Le clown: une utopie pour notre temps)* no. 3 (2010): 95–114.

Curran, Andrew F. *The Anatomy of Blackness: Science and Slavery in an Age of Enlightenment*. Baltimore: Johns Hopkins University Press, 2011.

Davis, Peggy. "La réification de l'esclave noir dans l'estampe sous l'Ancien Régime." In *L'Afrique au siècle des Lumières: Savoirs et représentations*, edited by Catherine Gallouët, David Diop, et al., 237–53. Oxford: Voltaire Foundation, 2009.

de Margerie, Laure, and Edouard Papet, *Facing the Other: Charles Cordier (1827–1905) Ethnographic Sculptor*. New York: Abrams, 2004.

Desdunes, Rodolphe Lucien. *Nos hommes et notre histoire: Notice biographique accompagnées de reflexions et de souvenirs personnels …*. Montreal, 1911. Translated and edited by Sister Dorothea Olga McCants, as *Our People and Our History*. Baton Rouge: Louisiana State University Press, 1973.

Dorr, David. *A Colored Man Round the World* [1858]. Facsimile edition edited by Malini Johar Schueller. Ann Arbor: University of Michigan Press, 1999.

Dubois, Laurent. *A Colony of Citizens: Revolution and Slave Emancipation in the French Caribbean, 1787–1804*. Chapel Hill, NC: Published for the Omohundro Institute of Early American History and Culture, Williamsburg, VA, by the University of North Carolina Press, 2004.

Earle, T.F., and K.J.P. Lowe. *Black Africans in Renaissance Europe*. Cambridge: Cambridge University Press, 2005.

Edwards, Elizabeth. "Evolving Images: Photography, Race and Popular Darwinism." In *Endless Forms: Charles Darwin, Natural Science and the Visual Arts*, edited by Diana Donald and Jane Munro. New Haven: Yale University Press, 2009.

Festa, Lynn. *Sentimental Figures of Empire in Eighteenth-Century Britain and France.* Baltimore: Johns Hopkins University Press, 2006.

Garraway, Doris Lorraine. *The Libertine Colony: Creolization in the Early French Caribbean.* Durham, NC: Duke University Press, 2005.

Garrigus, John D. *Before Haiti: Race and Citizenship in French Saint-Domingue.* New York: Palgrave Macmillan, 2006.

Gikandi, Simon. "Picasso, Africa, and the Schemata of Difference." *Modernism/modernity* 10, no. 3 (2003): 455–80.

Gilman, Sander L. *Difference and Pathology: Stereotypes of Sexuality, Race, and Madness.* Ithaca, NY: Cornell University Press, 1985.

Gilroy, Paul. *The Black Atlantic: Modernity and Double Consciousness.* Cambridge, MA: Harvard University Press, 1985.

Gindhart, Maria, ed. "Imaging Blackness in the Long Nineteenth Century." Special issue, *Visual Resources: An International Journal of Documentation* 24, no. 3 (2008).

Gordon, Rae Beth. *Dances with Darwin, 1875–1910: Vernacular Modernity in France.* Farnham (UK) and Burlington, VT: Ashgate, 2009.

Grigsby, Darcy Grimaldo. *Extremities: Painting Empire in Post-Revolutionary France.* New Haven: Yale University Press, 2002.

Hall, Stuart. "Cultural Identity and Diaspora." In *Diaspora and Visual Culture: Representing Africans and Jews*, edited by Nicholas Mirzoeff, 21–33. London and New York: Routledge, 2000.

Hamilton, Douglas, and Robert J. Blyth, eds. *Representing Slavery: Art, Artefacts and Archives in the Collections of the National Maritime Museum*, London: Lund Humphries, 2007.

Harris, Bernard. "A Portrait of a Moor." In *Shakespeare and Race*, edited by Catherine Alexander and Stanley Wells, 23–36. Cambridge: Cambridge University Press, 2000.

Hobson, Janell. *Venus in the Dark: Blackness and Beauty in Popular Culture.* New York: Routledge, 2005.

Honour, Hugh. *The Image of the Black in Western Art.* Vol. 4, *From the American Revolution to World War I, Slaves and Liberators.* New edition. Cambridge, MA: Belknap Press of Harvard University Press, 2012.

Kaplan, Paul H.D. "Contraband Guides: Twain and His Contemporaries on the Black Presence in Venice." *Massachusetts Review* 44, nos. 1–2 (2003): 182–202.

——. "The Earliest Images of Othello." *Shakespeare Quarterly* 39, no. 2 (1988): 71–186.

Kjerland, Kirsten Alsaker, and Anne K. Bang, eds. *Nordmenn I Afrika—Afrikanere I Norge.* Bergen: Vigmostad & Bjørke, 2002.

Korn, Bertram. *The Early Jews of New Orleans.* Waltham, MA: American Jewish Historical Society, 1969.

Kriz, Kay Dian. *Slavery, Sugar, and the Culture of Refinement: Picturing the British West Indies, 1700–1840.* New Haven: Yale University Press, 2008.

Lane, Edward William. *An Account of the Manners and Customs of the Modern Egyptians*. Reprinted from the 5th edition of 1860. Introduction by Jason Thompson. Cairo: American University in Cairo Press, 2003.

Lawner, Lynne. *Harlequin on the Moon: Commedia dell'Arte and the Visual Arts*. New York: Harry N. Abrams, 1998.

Libby, Susan Houghton, "'A Man of Nature, Rescued by the Wisdom and Principles of the French Nation': Race, Ideology, and the Return of the Everyday in Girodet's Portrait of Belley." In *Performing the "Everyday": The Culture of Genre in the Eighteenth Century*, edited by Alden Cavanaugh, 106–19. Newark: University of Delaware Press, 2007.

Lugo-Ortiz, Agnes, and Angela Rosenthal, eds. *Slave Portraiture in the Atlantic World*. New York: Cambridge University Press, 2013.

Marsh, Jan, ed. *Black Victorians: Black People in British Art, 1800–1900*. Burlington, VT: Lund Humphries, 2005.

Mason, Peter. *Infelicities: Representations of the Exotic*. Baltimore: Johns Hopkins University Press, 1998.

McElroy, Guy. *Facing History: The Black Image in American Art, 1710–1940*. San Francisco: Bedford Arts; and Washington, DC: Corcoran Gallery of Art, 1990.

Meer, Sarah. *Uncle Tom Mania: Slavery, Minstrelsy and Transatlantic Culture in the 1850s*. Athens: University of Georgia Press, 2005.

Miles, Jonathan. *The Wreck of the Medusa. The Most Famous Sea Disaster of the Nineteenth Century*. New York: Atlantic Monthly Press, 2007.

Miller, Christopher L. *The French Atlantic Triangle: Literature and Culture of the Slave Trade*. Durham, NC and London: Duke University Press, 2008.

———. *Blank Darkness: Africanist Discourse in French*. Chicago: University of Chicago Press, 1985.

Miller, Peter Benson. "Gérôme and Ethnographic Realism at the Salon of 1857." In *Reconsidering Gérôme*, edited by Scott Allan and Mary Morton, 106–18. Los Angeles: J. Paul Getty Museum, 2010.

Moore, J. Preston, "Pierre Soulé: Southern Expansionist and Promoter." *Journal of Southern History* 21 (1955): 203–23.

Morehead, Allison, and Claude Ritschard, eds. *Cléopâtre dans le miroir de l'art occidentale*. Geneva: Musée d'art et histoire, 2004.

Morgan, Jo-Ann. *"Uncle Tom's Cabin" as Visual Culture*. Columbia: University of Missouri Press, 2007.

Nelson, Charmaine. *Representing the Black Female Subject in Western Art*. Routledge Studies on African and Black Diaspora 2. New York: Routledge, 2010.

Nicholson, Kathleen. "Practicing Portraiture: Mademoiselle De Clermont and J.-M. Nattier." In *Women, Art and the Politics of Identity in Eighteenth-Century Europe*, edited by Melissa Hyde and Jennifer Milam, 64–90. Aldershot (UK) and Burlington, VT: Ashgate, 2003.

Nochlin, Linda. "The Imaginary Orient." In *The Politics of Vision: Essays on Nineteenth-Century Art and Society*, 33–59. New York: Harper and Row 1989.

O'Neill, Charles Edwards, "Fine Arts and Literature: Nineteenth-Century Louisiana Black Artists and Authors." In *Louisiana's Black Heritage*, edited by

Robert R. MacDonald, John R. Kemp, and Edward F. Haas, 74–8. New Orleans: Louisiana State Museum, 1979.

Padon, Thomas, ed. *TruthBeauty: Pictorialism and the Photograph as Art, 1845–1945*. Vancouver: Vancouver Art Gallery, 2008.

Pastoreau, Michel. *The Devil's Cloth: A History of Stripes*. Translated by Jody Gladding. New York: Washington Square Press, 1991.

Peabody, Sue, and Tyler Stovall, eds. *The Color of Liberty: Histories of Race in France*. Durham, NC: Duke University Press, 2003.

Pickering, Michael. *Blackface Minstrelsy in Britain*. Aldershot (UK) and Burlington, VT: Ashgate, 2008.

Pieterse, Jan Nederveen. *White on Black: Images of Africa and Blacks in Western Popular Culture*. New Haven: Yale University Press, 1995.

Pollock, Griselda. *Differencing the Canon: Feminist Desire and the Writing of Art's Histories*. London: Routledge, 1999.

Prodger, Phillip, ed. *Impressionist Camera: Pictorial Photography in Europe, 1888–1918*. Exhibition catalogue, Saint Louis Art Museum. London: Merrell, 2006.

Rudolph, William Keyse, Patricia Brady, and Erin Greenwald. *In Search of Julien Hudson: Free Artist of Color in Pre-Civil War New Orleans*. New Orleans: Historic New Orleans Collection, 2010.

Said, Edward W. *Orientalism*. New York: Vintage Books, 1979.

Savage, Kirk. *Standing Soldiers, Kneeling Slaves; Race, War, and Monument in Nineteenth-Century America*. Princeton: Princeton University Press, 1997.

Schreuder, Esther, and Elmer Kolfin, eds. *Black is Beautiful: Rubens to Dumas*. Amsterdam: De Nieuwe Kerk, 2008.

Schwartz, Vanessa R. *Spectacular Realities: Early Mass Culture in Fin-de-Siècle Paris*. Berkeley: University of California Press, 1999.

Sharpley-Whiting, T. Denean. *Black Venus: Sexualized Savages, Primal Fears, and Primitive Narratives in French*. Durham, NC: Duke University Press Books, 1999.

Sheriff, Mary, ed. *Cultural Contact and the Makings of European Art since the Age of Exploration*. Chapel Hill: University of North Carolina Press, 2010.

Smalls, James. "Race as Spectacle in Late Nineteenth-Century French Art and Popular Culture." *French Historical Studies* 26, no. 2 (Spring 2003): 351–82.

Sofaer, Joanna, ed. *New Interventions in Art History: Material Identities*. Oxford: Blackwell, 2007.

The Spectacular Art of Jean-Léon Gérôme: 1824–1904. Exhibition catalogue. Paris: Skira, 2010.

Stein, Perrin. "Amédée Van Loo's Costume Turc: The French Sultana." *The Art Bulletin* 78, no. 3 (1996): 417–38.

Templeton, Joan. *Munch's Ibsen: A Painter's Visions of a Playwright*. Seattle: University of Washington Press, 2008.

Thompson, Barbara, ed. *Black Womanhood: Images, Icons, and Ideologies of the African Body*. Seattle: University of Washington Press, 2008.

Tygesen, Peter, and Espen Wæhle. *Kongospor: Norden i Kongo—Kongo i Norden*. Oslo: Kulturhistorisk Museum, 2007.

Verhagen, Marcus. "The Poster in Fin-de-Siècle Paris: 'That Mobile and Degenerate Art.'" In *Cinema and the Invention of Modern Life*, edited by Leo Charney and Vanessa R. Schwartz, 103–29. Berkeley: University of California Press, 1995.

Wedekind, Gregor, and Max Hollein, eds. *Géricault: Images of Life and Death*. Frankfurt: Schirn Kunsthalle Frankfurt, 2014.

Wheeler, Roxann. *The Complexion of Race: Categories of Difference in Nineteenth-Century British Culture*. Philadelphia: University of Pennsylvania Press, 2000.

Willis, Deborah. *Reflections in Black: A History of Black Photographers 1840 to the Present*. New York: W.W. Norton, 2000.

——, and Carla Williams. *The Black Female Body: A Photographic History*. Philadelphia: Temple University Press, 2002.

Index